D1442653

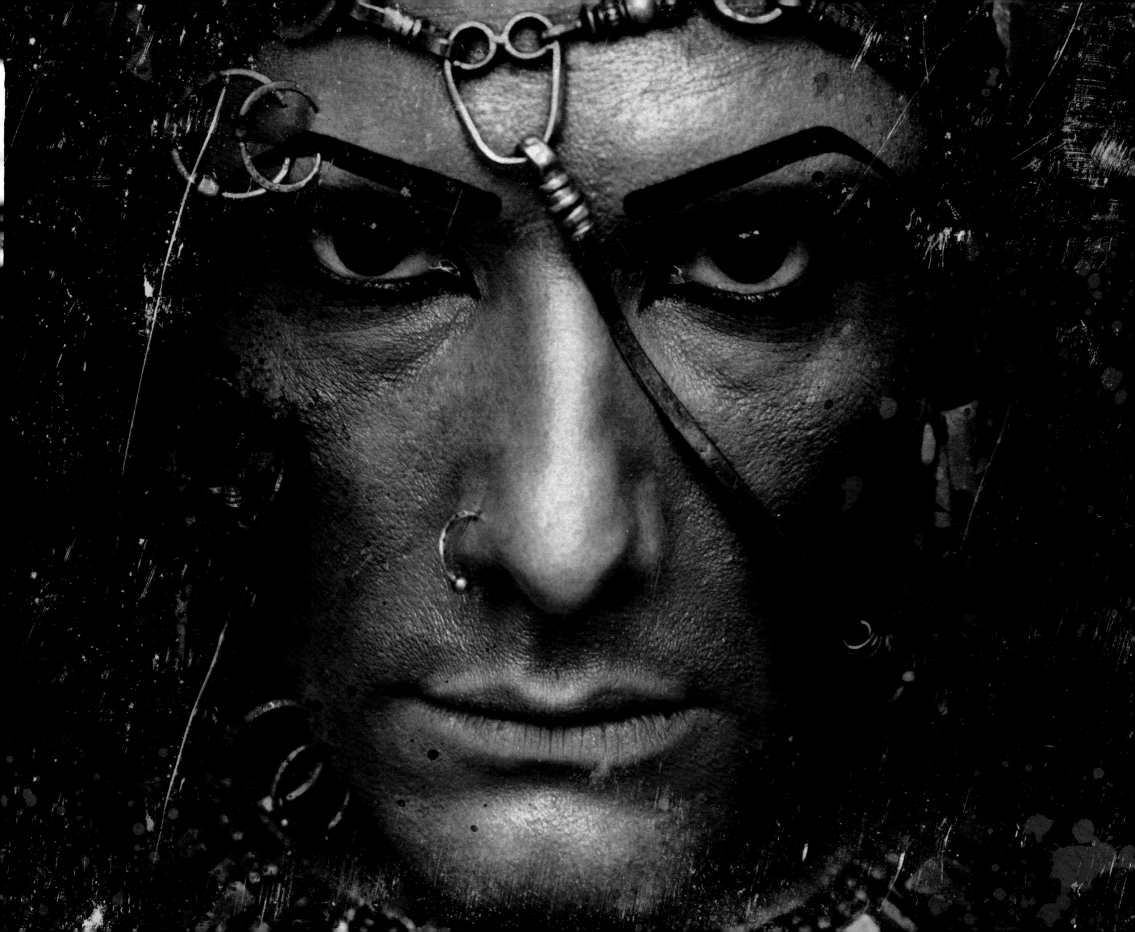

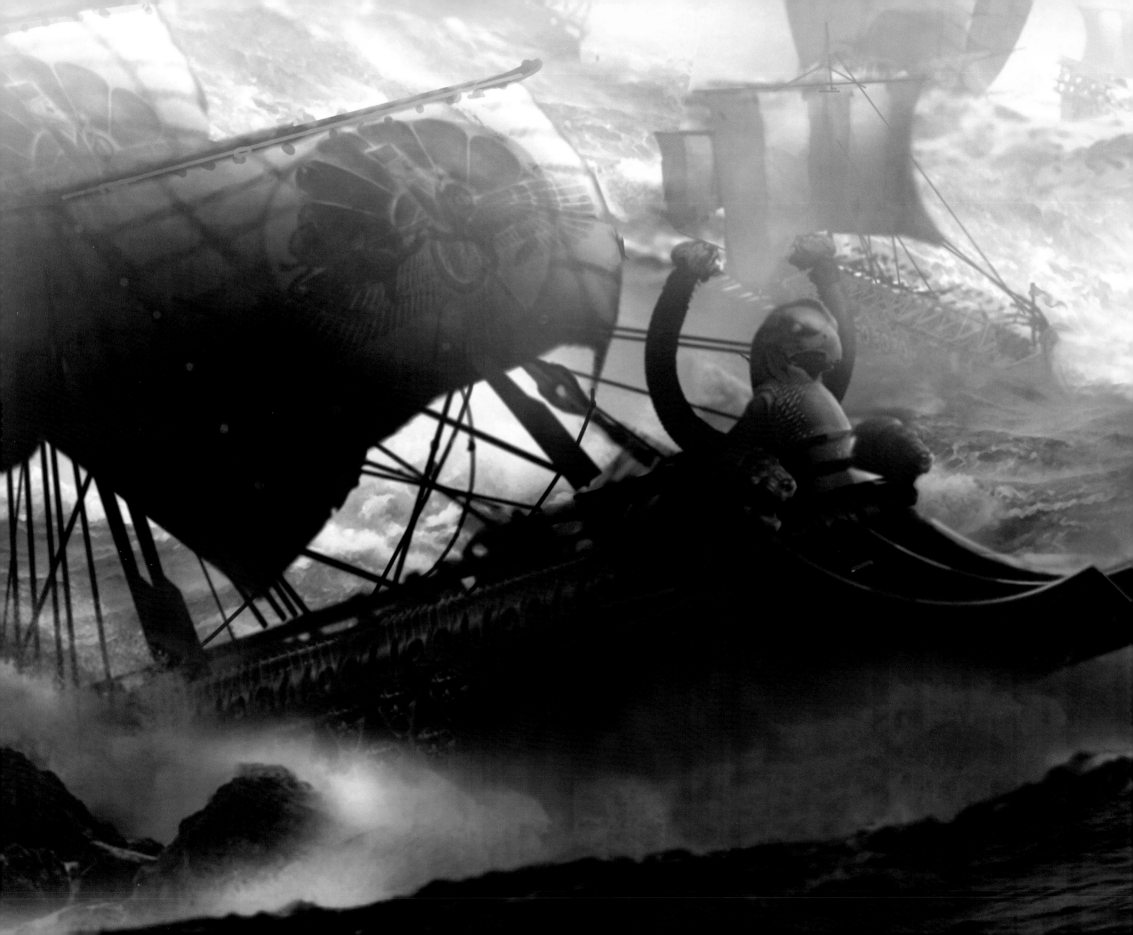

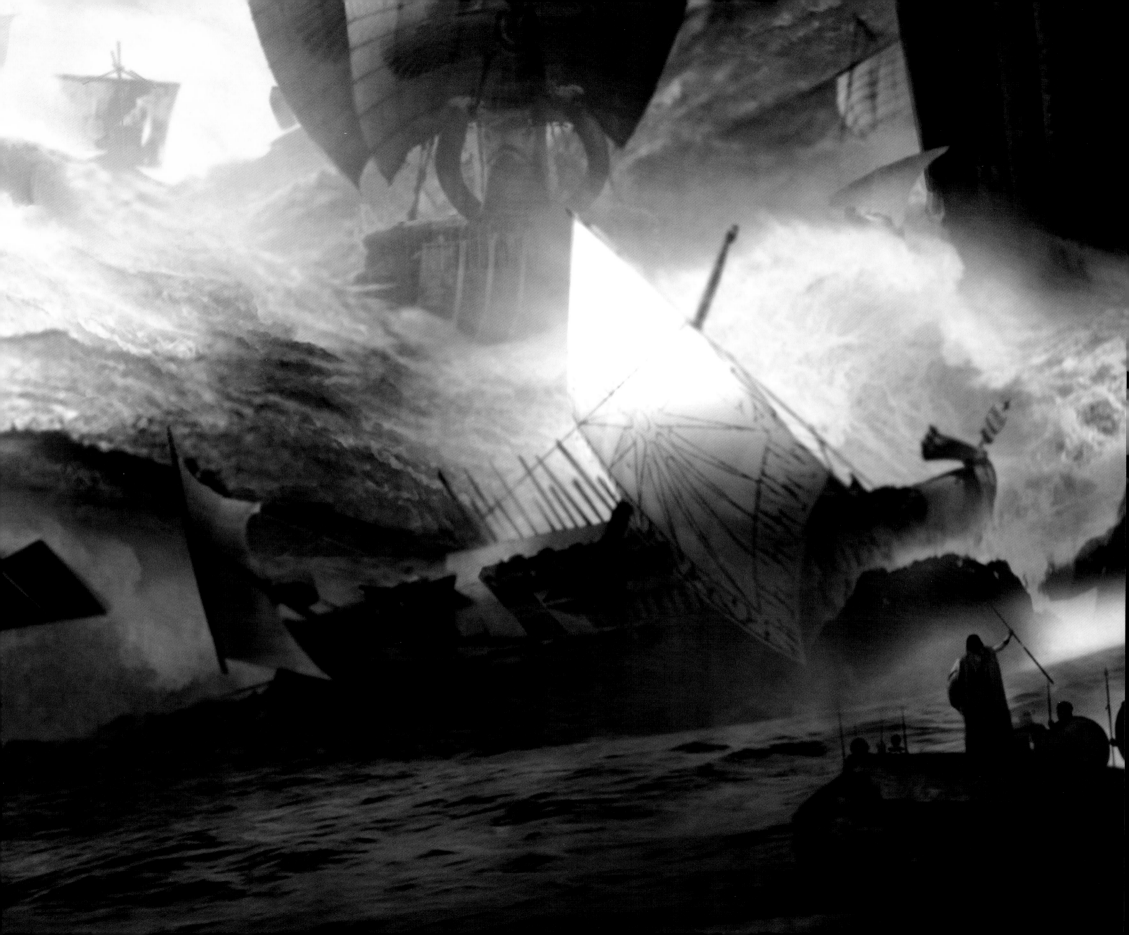

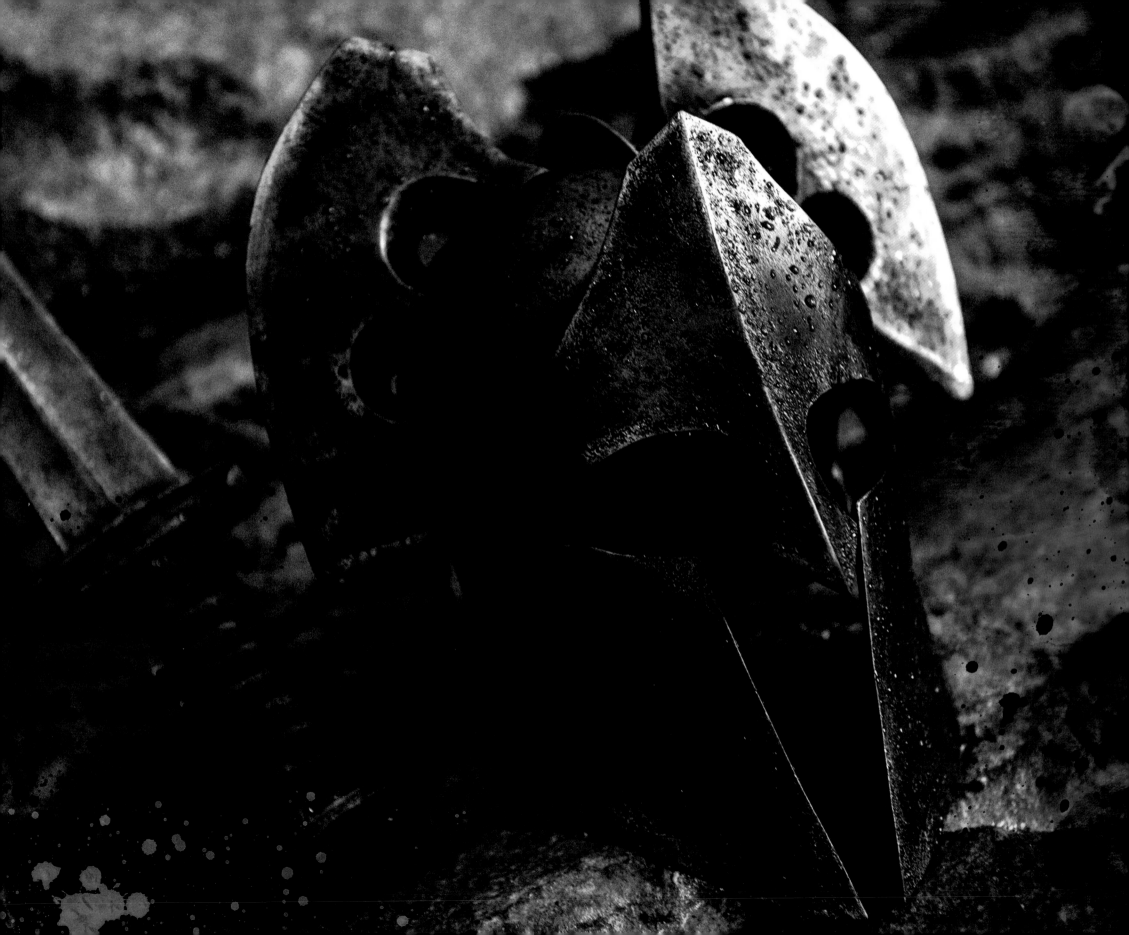

300

RISE OF AN EMPIRE

THE ART OF THE FILM

PETER APERLO

FOREWORD BY
NOAM MURRO

AFTERWORD BY
ZACK SNYDER

PHOTOGRAPHY BY
CLAY ENOS

TITAN BOOKS

300: RISE OF AN EMPIRE

THE ART OF THE FILM
ISBN: 9781781167823

Limited signed and slipcased edition:
ISBN: 9781781167830

Published by
Titan Books
A division of Titan Publishing Group Ltd.
144 Southwark St.
London
SE1 0UP

First edition: July 2013

Motion Picture Artwork (c) 2013 Warner Bros. Entertainment Inc. All rights reserved. Motion Picture Photography
© 2013 Warner Bros. Entertainment Inc. and Legendary Pictures Funding, LLC
Copyright © 2013 Warner Bros. Entertainment Inc.
300 RISE OF AN EMPIRE and all related characters and elements are trademarks of and © Warner Bros. Entertainment Inc.

To receive advance information, news, competitions, and exclusive offers online, please sign up for the Titan newsletter on
our website: www.titanbooks.com

No part of this publication may be reproduced, stored in a retrieval system, or transmitted, in any form or by any means
without the prior written permission of the publisher, nor be otherwise circulated in any form of binding or cover other
than that in which it is published and without a similar condition being imposed on the subsequent purchaser.

A CIP catalogue record for this title is available from the British Library.

CONTENTS

FOREWORD
BY NOAM MURRO

WHEN ZACK SNYDER first approached me about directing *300: Rise of an Empire*, my first question was the obvious one, the one that was already being asked in every corner of the Internet: How do you follow up on a movie in which everyone died? But the real question—and much more to the point—was: How do you follow *300*, the movie that redefined filmmaking and birthed an entire generation of films? The task was daunting, but I reminded myself that the challenge we faced in making *Rise of an Empire* was not unlike the challenge Zack and his collaborators faced when adapting the preeminent Frank Miller's graphic novel, and that challenge, in turn, was not unlike the task Frank set for himself when he decided to pay homage to the heroics of the ancient Battle of Thermopylae using only pen and paper. If this legacy was daunting, it was also inspiring. It was a collaboration that spanned genres and centuries. Each telling of the story was a new aria in this ongoing opera of death, honor, love, betrayal, and glory.

Six years after the original *300*, new technologies allowed us to take the unprecedented technical mastery of that film and apply it on an even larger scale. The terrifying beauty of war comes from its infinite detail and massive scope, its ability to contain the story of a single soldier or an entire nation. Appropriately enough for a film of such vastness, *Rise of an Empire* is set almost entirely at sea. We took the defined and monochromatic palette of *300* and blew it wide-open, creating vastly different looks for each of the five epic sea battles. In addition to varying weather systems—fog, fire, daylight, rainfall, a storm—each scene has its own action, and each scene exists in equal measure in everything from a drop of blood to the choreographed movements of an entire navy.

The battles depicted in *Rise of an Empire* helped preserve a burgeoning democracy in Athens, and, in a real sense, they helped to birth a new kind of cinema as well. Literally hundreds of people worked on this film over the course of two years, each bringing unique talents to a diverse array of crafts. We shot for 4 months on green screen in Bulgaria, and the film would undergo another 8 months of post-production in order to build in the visual effects. It was a technical feat, sure, but it was a technical feat powered, like every other human endeavor, by people's bodies and minds and lives. This large-scale collaboration is why I feel it's so appropriate that the drama and story of *Rise of an Empire*, like *300* before it, remind me so much of opera, the genre in which Wagner talked of creating a "total work of art" by combining elements of music, dance, and theater. This is why film, in my view, is the ultimate art form, and it's also why this particular kind of film, which combines the talents of actors and countless masters of their crafts on a scale comparable to a modern army, is the natural extension of that legacy.

Noam Murro

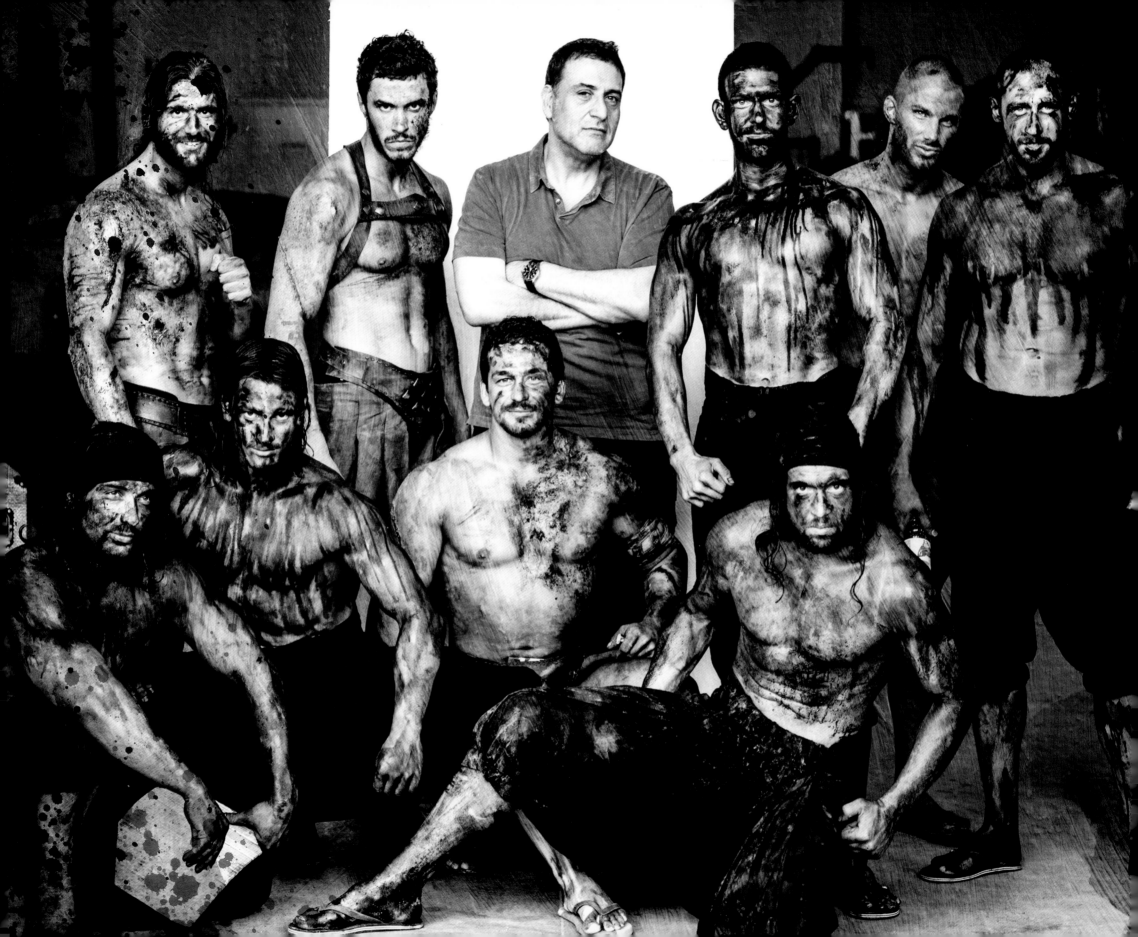

INTRODUCTION

"IF YOU POUR OIL AND VINEGAR INTO THE SAME VESSEL, YOU WOULD CALL THEM NOT FRIENDS BUT OPPONENTS."

AESKYLOS, *AGAMEMNON*

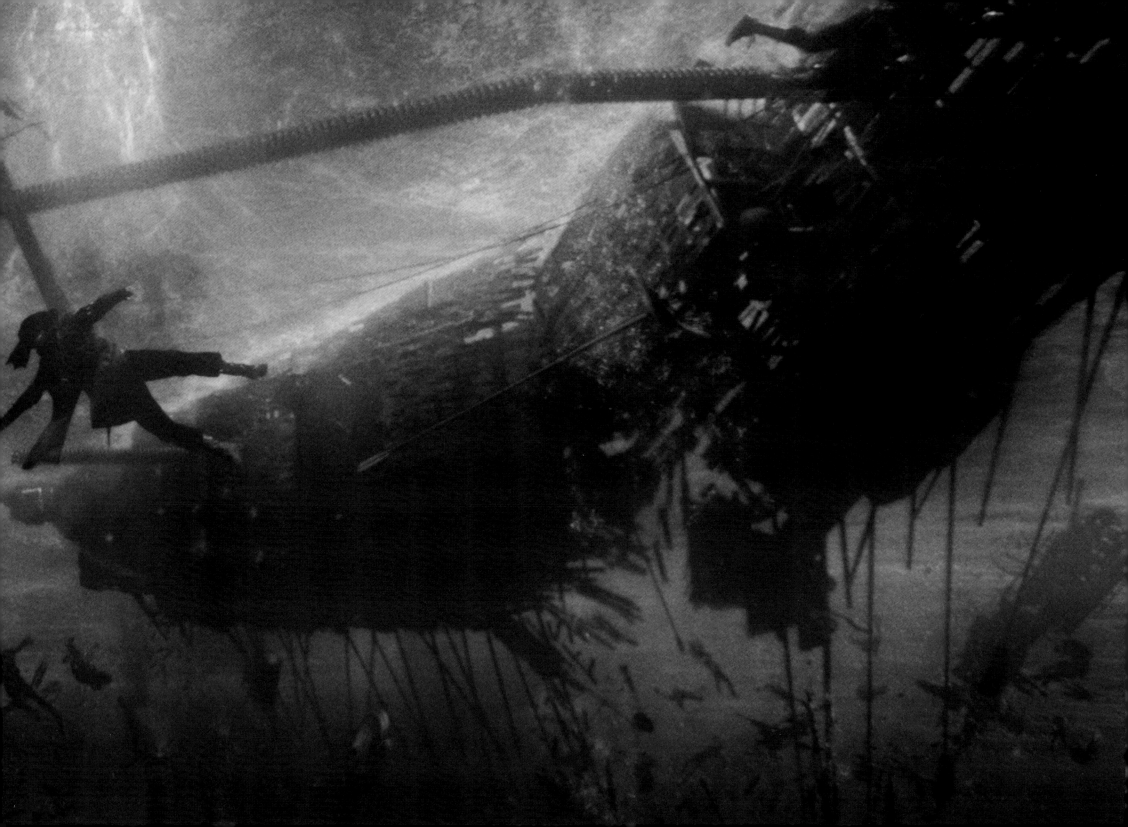

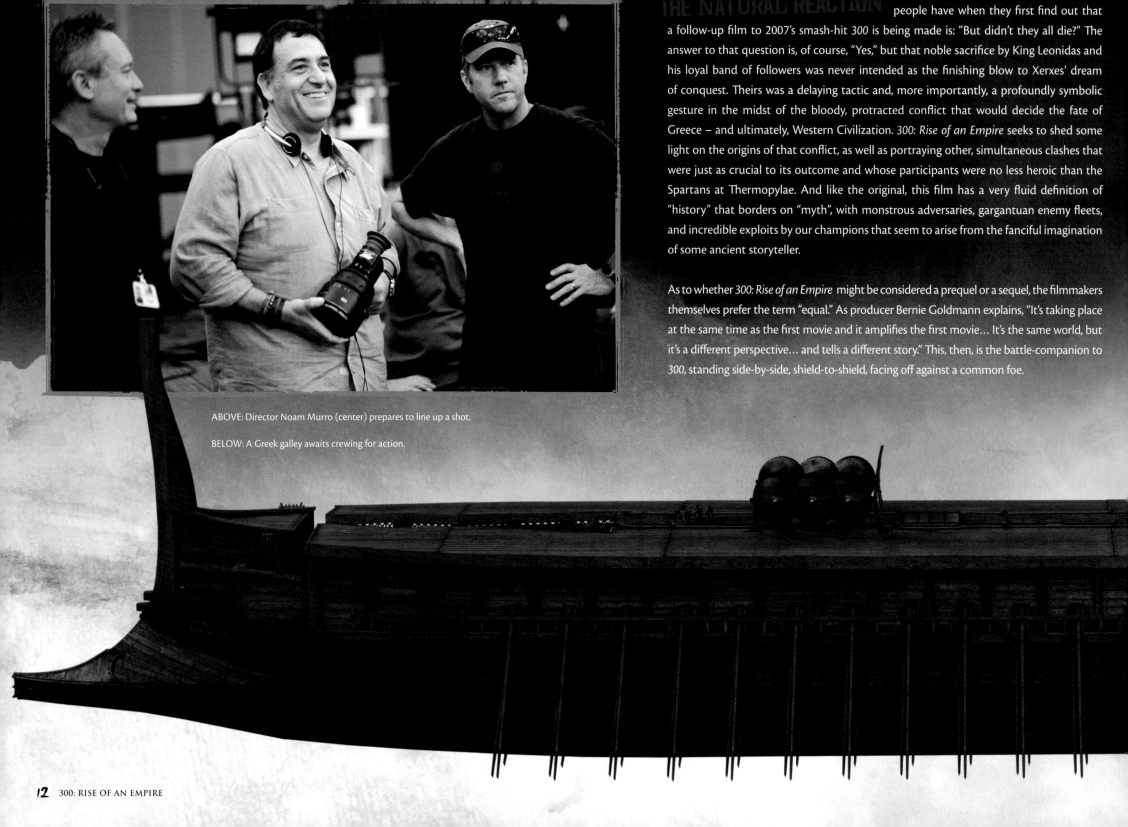

people have when they first find out that a follow-up film to 2007's smash-hit *300* is being made is: "But didn't they all die?" The answer to that question is, of course, "Yes," but that noble sacrifice by King Leonidas and his loyal band of followers was never intended as the finishing blow to Xerxes' dream of conquest. Theirs was a delaying tactic and, more importantly, a profoundly symbolic gesture in the midst of the bloody, protracted conflict that would decide the fate of Greece – and ultimately, Western Civilization. *300: Rise of an Empire* seeks to shed some light on the origins of that conflict, as well as portraying other, simultaneous clashes that were just as crucial to its outcome and whose participants were no less heroic than the Spartans at Thermopylae. And like the original, this film has a very fluid definition of "history" that borders on "myth", with monstrous adversaries, gargantuan enemy fleets, and incredible exploits by our champions that seem to arise from the fanciful imagination of some ancient storyteller.

As to whether *300: Rise of an Empire* might be considered a prequel or a sequel, the filmmakers themselves prefer the term "equal." As producer Bernie Goldmann explains, "It's taking place at the same time as the first movie and it amplifies the first movie… It's the same world, but it's a different perspective… and tells a different story." This, then, is the battle-companion to *300*, standing side-by-side, shield-to-shield, facing off against a common foe.

ABOVE: Director Noam Murro (center) prepares to line up a shot.

BELOW: A Greek galley awaits crewing for action.

That foe is, once again, Xerxes – only this time we witness the forces in his early life that led him to transform from a man to a god-king, one determined to crush tiny Greece with an army vast beyond counting. Commanding his navy is his closest advisor, the ruthless female warrior, Artemisia. Opposing them both on this front is Themistokles of Athens, heading up a fragile coalition cobbled together from a dozen, scattered city-states. It is Themistokles who realizes that to oppose the Persians on land is madness, and that the strength of the Greeks lies in their ships – swift galleys rowed by free men, equipped with rams and detachments of marines trained in the art of ship-to-ship combat. But like Leonidas, he also intends to use the geography of Greece herself to his advantage, drawing the Persian fleets into the epic and decisive sea battles of Artemisium and Salamis.

Taking on the daunting task of presiding over all that action and swordplay this time around is award-winning director of commercials and *Smart People* (2008), Noam Murro. Original director Zack Snyder is returning as well, overseeing the project as a producer in addition to penning the screenplay with Kurt Johnstad.

Snyder describes the germination of the project: "When 300 was finished, we pretty much thought there could never be a sequel. Leonidas dies, the end. Then Frank Miller called and said, "Hey, I was thinking… Maybe there is another story to be told here."

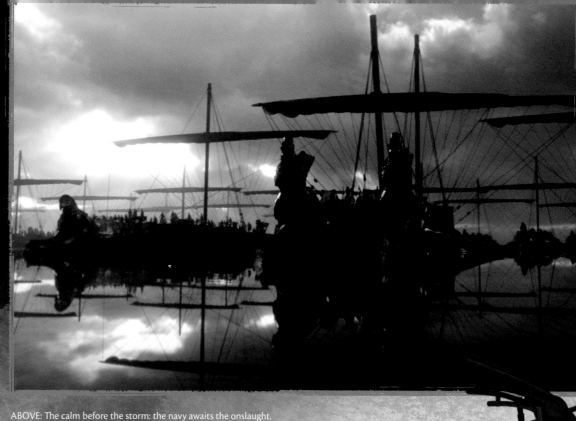

ABOVE: The calm before the storm: the navy awaits the onslaught.

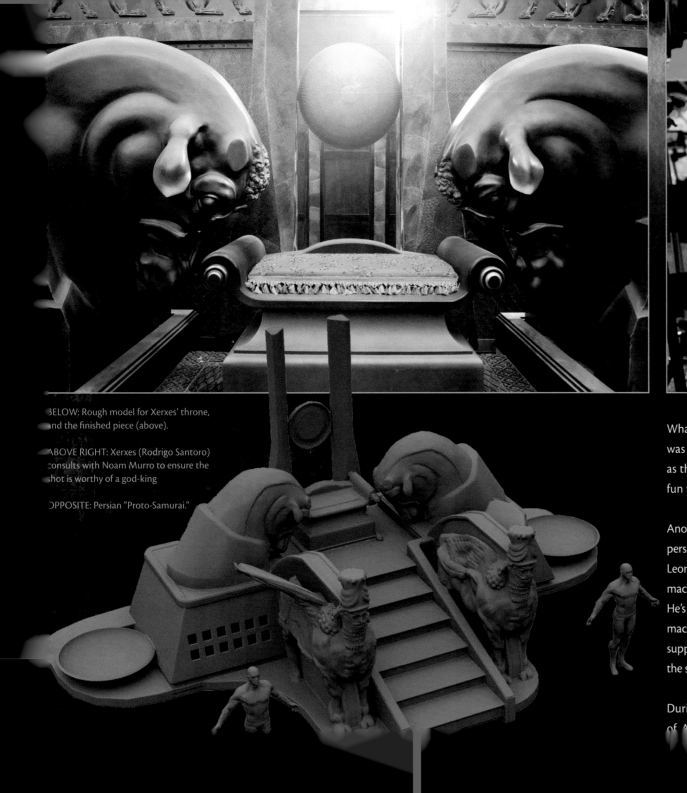

BELOW: Rough model for Xerxes' throne, and the finished piece (above).

ABOVE RIGHT: Xerxes (Rodrigo Santoro) consults with Noam Murro to ensure the shot is worthy of a god-king

OPPOSITE: Persian "Proto-Samurai."

What had captured Miller's imagination during his research on the initial graphic novel was the fact that the Battle of Artemisium had taken place during the same three days as the Spartans' stand at Thermopylae, and not very far away at that. "That's a little too fun to ignore," says Snyder.

Another thing that intrigued Miller was the character of Themistokles, a man whose personality and leadership style stood him in sharp contrast to King Leonidas. "Whereas Leonidas is just this heroic character that marches forth and is this unstoppable killing machine," explains Snyder, "Themistokles a little more like an everyman, a bit more like us.. He's just trying through force of will and his own wits to make his way through the political machine that is Greece at this time." Working from an outline as well as notes and drawings supplied by Miller from his as-yet-unfinished graphic novel, Snyder and Johnstad fleshed out the story of the politician/general and his audacious plan to save Greece.

During the course of writing, they discovered a great admiration for the citizen-soldiers of Athens and her allies, who, like Themistokles himself, audiences might find more

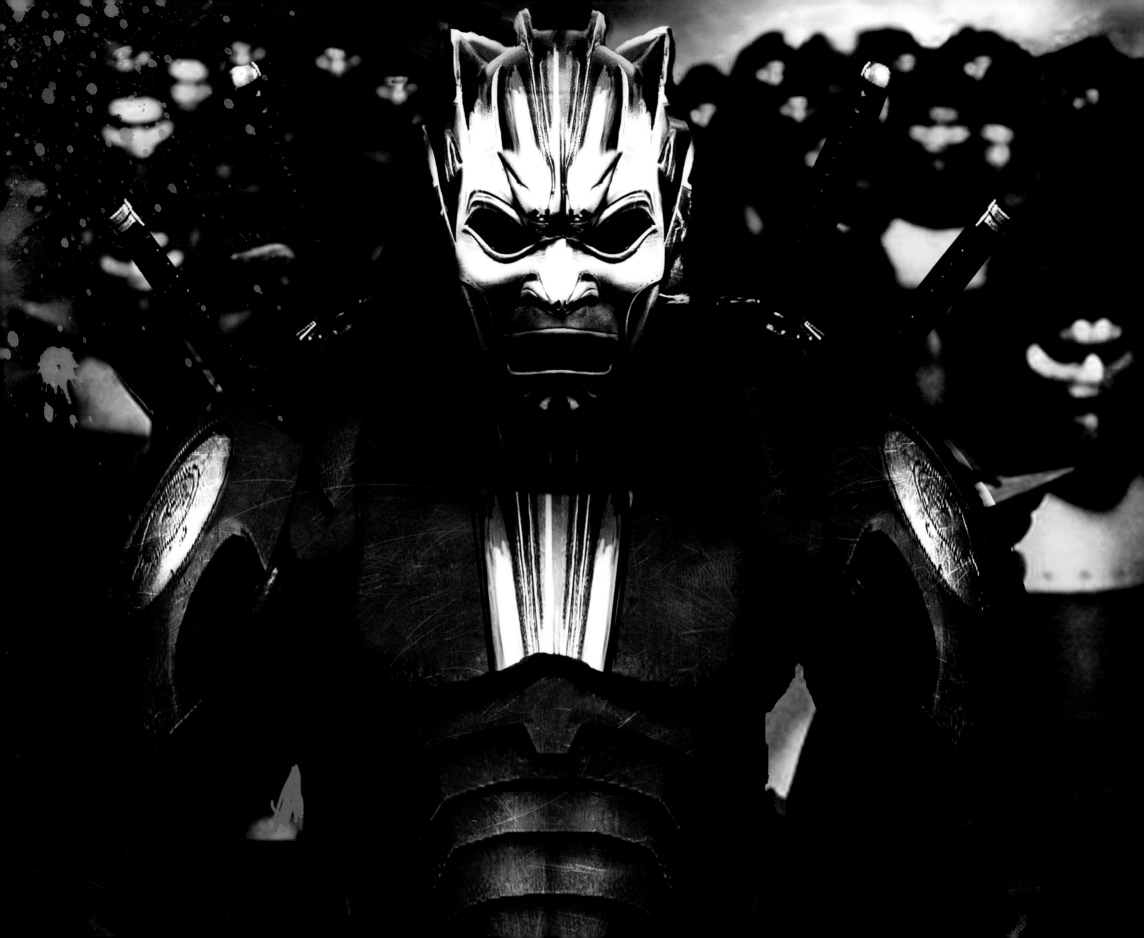

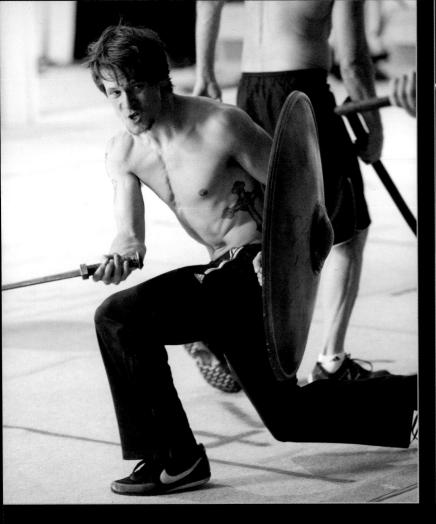
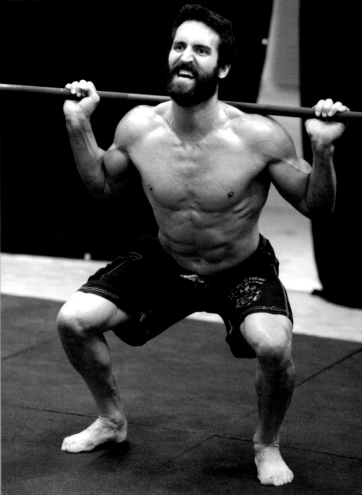
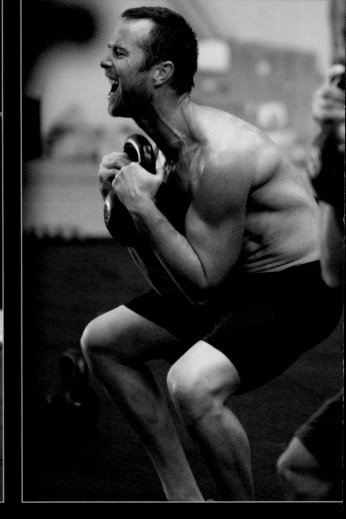

THIS SPREAD: Greeks and Persians alike get into shape and train for the impending war.

relatable than the stoic Spartans. "The big difference is, we can't be a Spartan," says Snyder. "It's fun to watch them, but this is really more like if we were there. If you were teleported to 480 B.C., you'd ask yourself, 'What would I do? I'm not a Spartan. I'm not searching for a beautiful death. How do I fight? Why do I go into battle?'" The answer for many of these artisans, merchants, and tradesmen, is to defend the nascent idea of Democracy as well as their homes – and they have to do it from the lurching decks of war galleys on the high seas.

That theme of ordinary, disparate individuals banding together for a greater cause is one that resonates for producer Mark Canton: "The Spartans were very imperfect, and Zack and Frank portrayed them that way. The whole concept of a beautiful death, sacrifice, and no surrender was one thing, but it wasn't a unifying philosophy. A unifying philosophy is taking all the bakers, the potters, the candlestick makers, and putting them together and having them become a ragtag group like in the American Civil War... And you have to have a great leader to pull all these people together."

Noam Murro echoes this sentiment that *300: Rise of an Empire* feels distinct from its predecessor in terms of its essential DNA. "The original intent," says Murro, "and that includes the studio, and even [CEO of Legendary Pictures] Thomas Tull, everybody was honestly looking to build something that is very different from *300* in a way that doesn't feel like a typical sequel, or prequel for that matter."

When searching for a director, the producers were determined that it be somebody who not only grasped the stylized world of *300*, but who also would be able to take the spectacle to new heights. "Noam has an unbelievable little factory in his own world of commercials," says producer Gianni Nunnari. "He wins every year five or six of the top awards... His commercials are quite big actually, full of huge special effects, real mega budget."

Despite that considerable experience in visual narrative, Murro – not unlike Themistokles – could never hope to accomplish this massive undertaking alone; he needed to assemble a

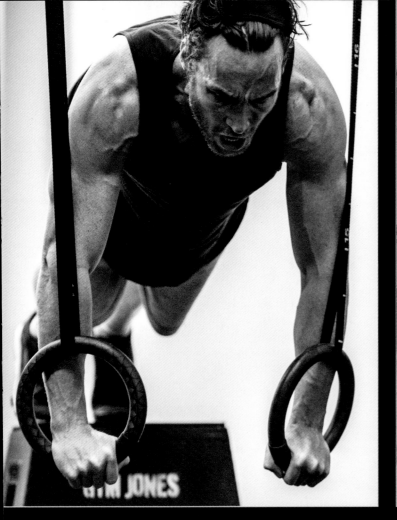

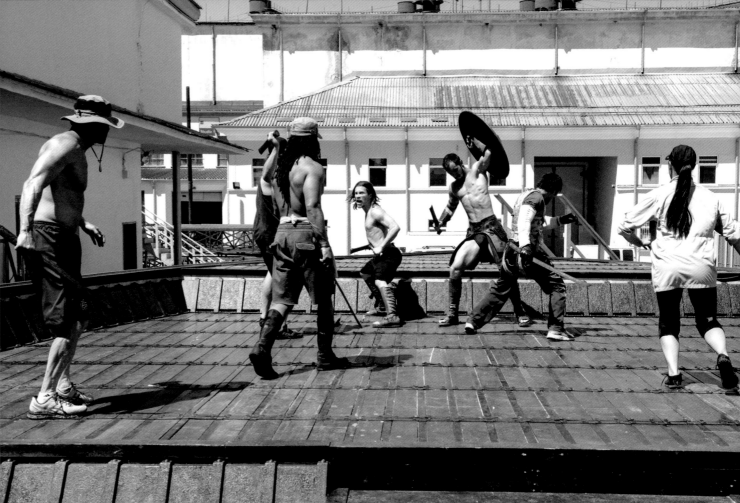

top-notch team to help him bring it about. "The thing about Noam is he's a great collaborator. He's great about giving people a lot of space, he accepts a lot of input," says Bernie Goldmann. "He's somebody who brings in people like Patrick [Tatopoulos, production designer], brings in people like Simon [Duggan, cinematographer], as well as a strong VFX team and uses them to enhance his vision, shape his vision. And to push him."

While there might be a new director at the helm, as well as host of new characters and a markedly different theater of war, filmgoers will no doubt recognize the familiar touch of the fantastic in this tale, a hallmark of the brand that goes back to Miller's original graphic novel. "Again, we tried to frame the story as a story *being told*," explains Snyder. "I understand that Xerxes wasn't eight feet tall, I understand that the Immortals weren't really monsters, but if I was telling the story to my guys in 480 B.C. to get them riled up, I might take certain liberties with the storytelling... You, the audience, are one of the guys around the campfire."

In addition to retaining these fanciful elements, Murro's aim is to push the scope and feel of the narrative to even greater heroic proportions. "I had a very specific notion going into it, which was to create something that feels like an old epic, but in a modern way," he says, adding, "I think there is a sense of grandeur, there is a sense of scale."

Creating that sense of scale in what is admittedly a very stylized world required extensive use of computer-generated imagery, something with which Murro is especially well acquainted from his commercial work. Still, he found the abstraction of working with so much green screen to be a challenge and a bit maddening – but it turned out to be an inspiration as well. "It's complicated," he says. "You can only shoot a piece of it at a time, and so you have to puzzle it together inside your head." What he found, however, was that shooting and performing on what at times could be very stark stages required a great deal of imagination that lent the production a certain theatricality it might not have had otherwise. "The beauty of it all is that it speaks to a very specific aesthetic, and that is opera," he explains, an art form he has appreciated since childhood. "What Zack did in *300*

so magnificently was to create that sense of hyperrealism," he continues. "We took that conceptual thinking and created a water opera, if you will."

Beyond the desire to explore the other incredible events surrounding this grand collision of civilizations, the producers had another reason to revisit Frank Miller's almost surreal vision of Ancient Greece: the fans. It's an exciting blend of fact and fantasy, a heroic story that people responded to in an amazing way when the original 300 film was released. The filmmakers were honored and delighted to have the opportunity to revisit such a rich world.

THIS SPREAD: Through the magic of computer-generated imagery, stunning and individualized sea battles can be created where no water exists.

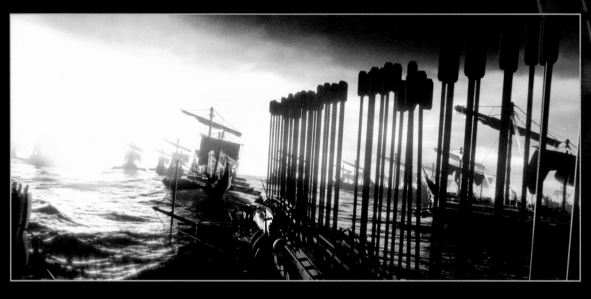

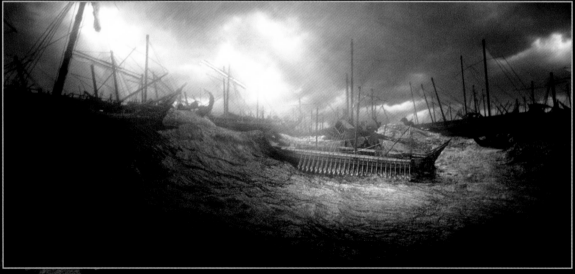

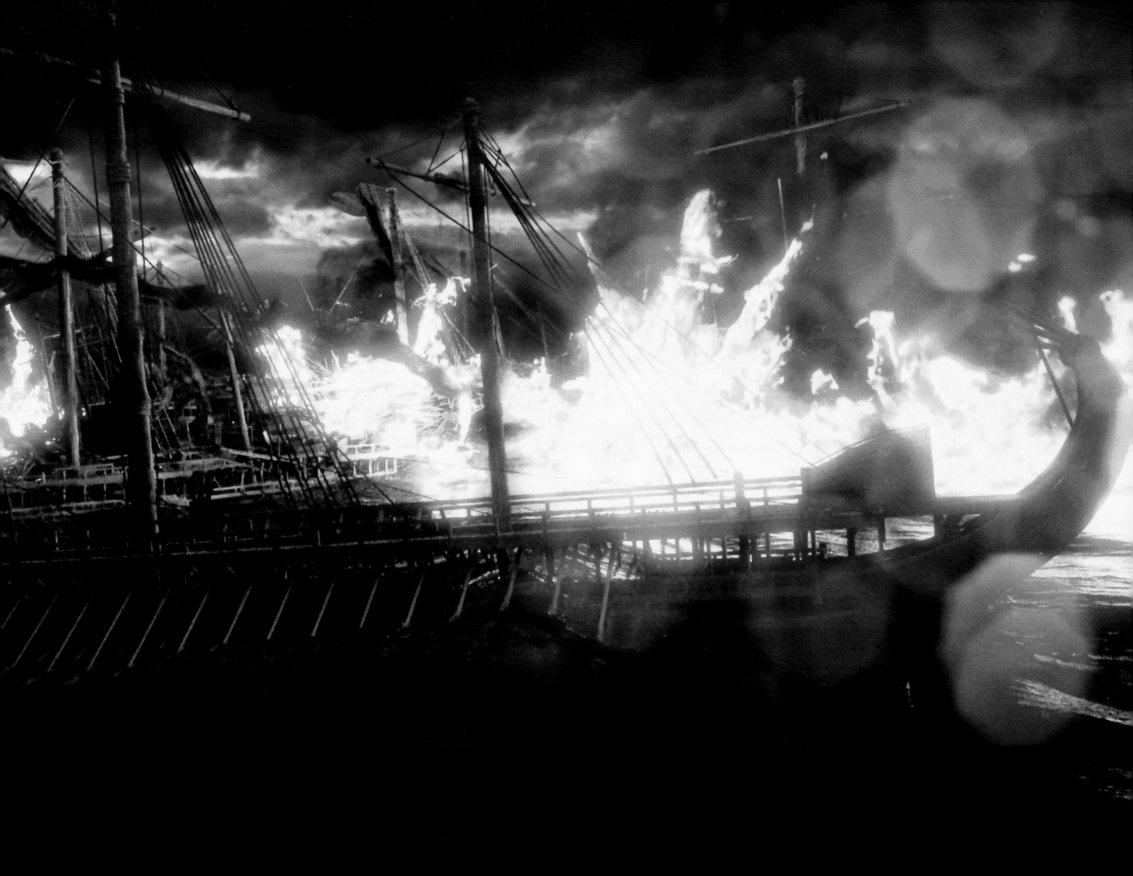

DRAMATIS PERSONAE

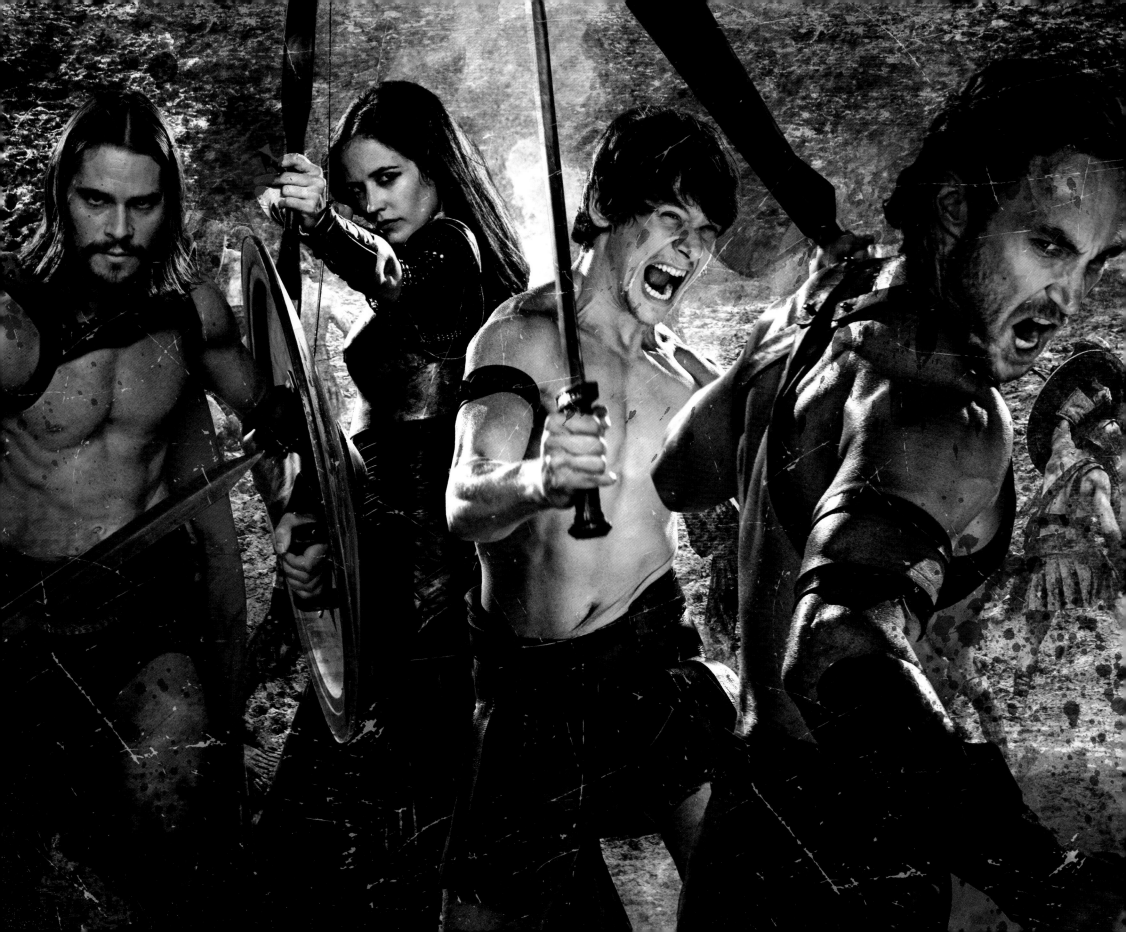

THEMISTOKLES

> "HE IS THE BEST MAN WHO, WHEN MAKING HIS PLANS, FEARS AND REFLECTS ON EVERYTHING THAT CAN HAPPEN TO HIM, BUT IN THE MOMENT OF ACTION IS BOLD."
>
> HERODOTUS, *THE HISTORY*

Taking up the unenviable task of uniting the squabbling city-states of Greece against the Persian onslaught is Themistokles, a citizen of Athens who has to be as skillful with his tongue as he is with his sword arm. "He lives in two worlds: He's a politician and he's a warrior. He's a general and he has to deal with the limits of politics," explains Bernie Goldmann. "He has to convince people emotionally that this is the right decision." Themistokles realizes that what's at stake is more than their land, their home, or even their very lives – it's the fledgling experiment known as Democracy that has just begun to take hold.

Played by Sullivan "Sully" Stapleton, who describes his character as a "people person," Themistokles leads men he regards as equals, often relying on his wit and charm to motivate them in battle. And Goldmann believes this particular casting was perfect: "It's a very, very hard thing to find somebody who's really masculine, who you can believe going into battle, but also has the warmth... to capture people's imaginations by connecting with them on a personal level. And frankly, that's what Sully does."

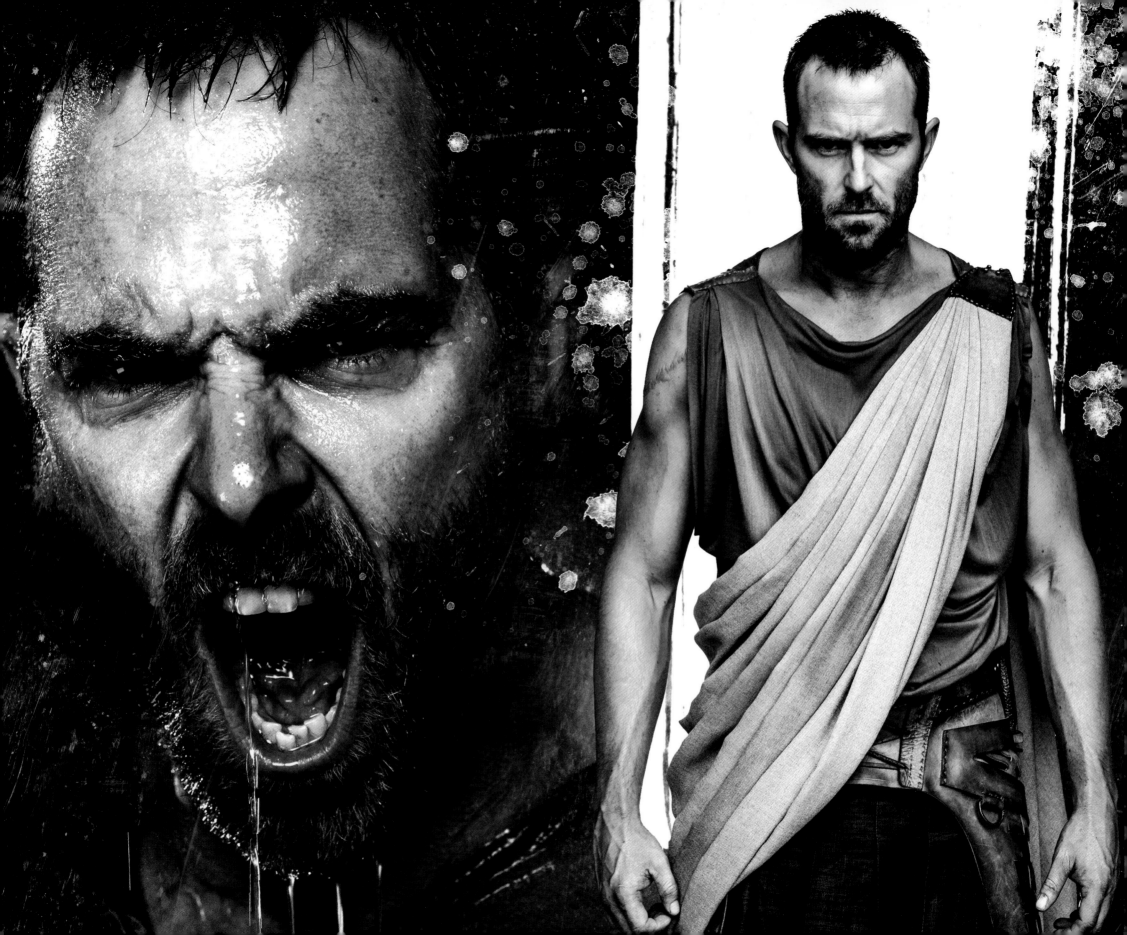

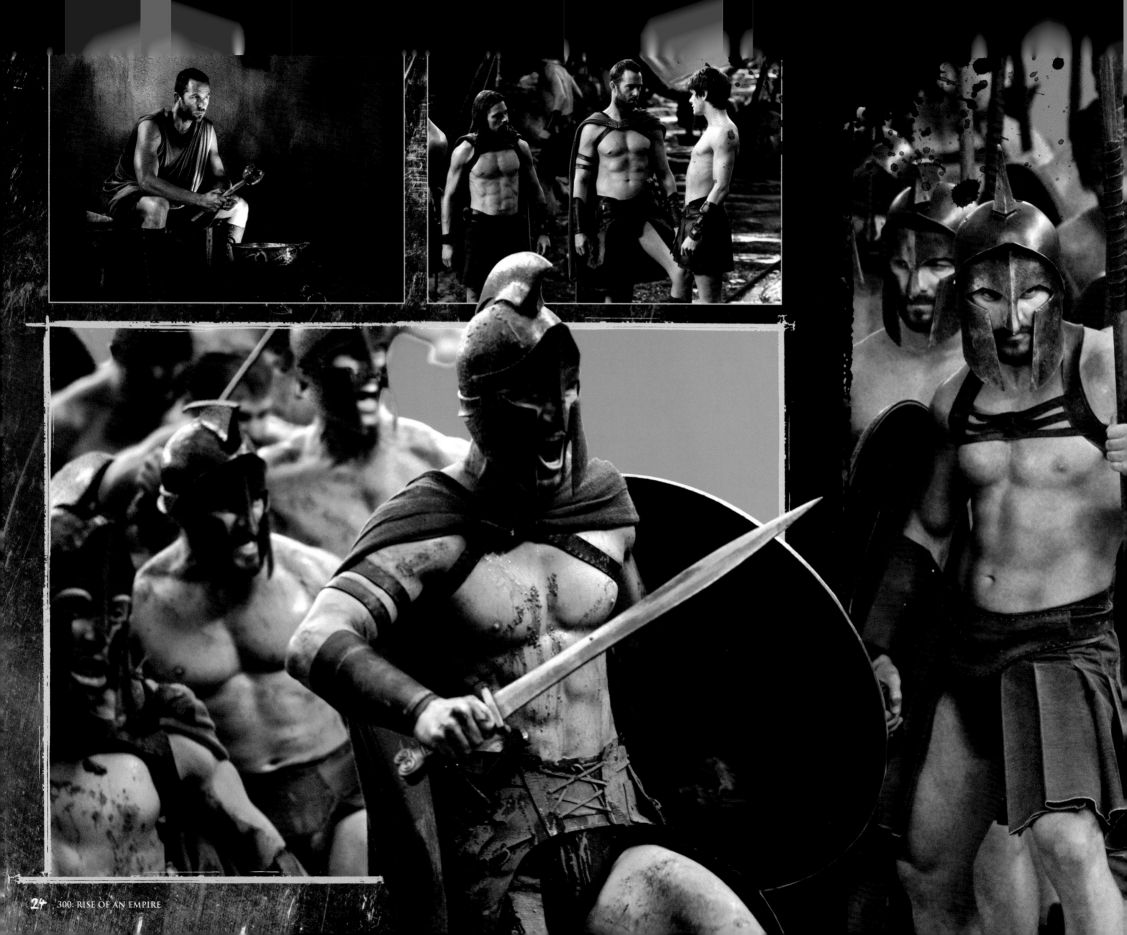

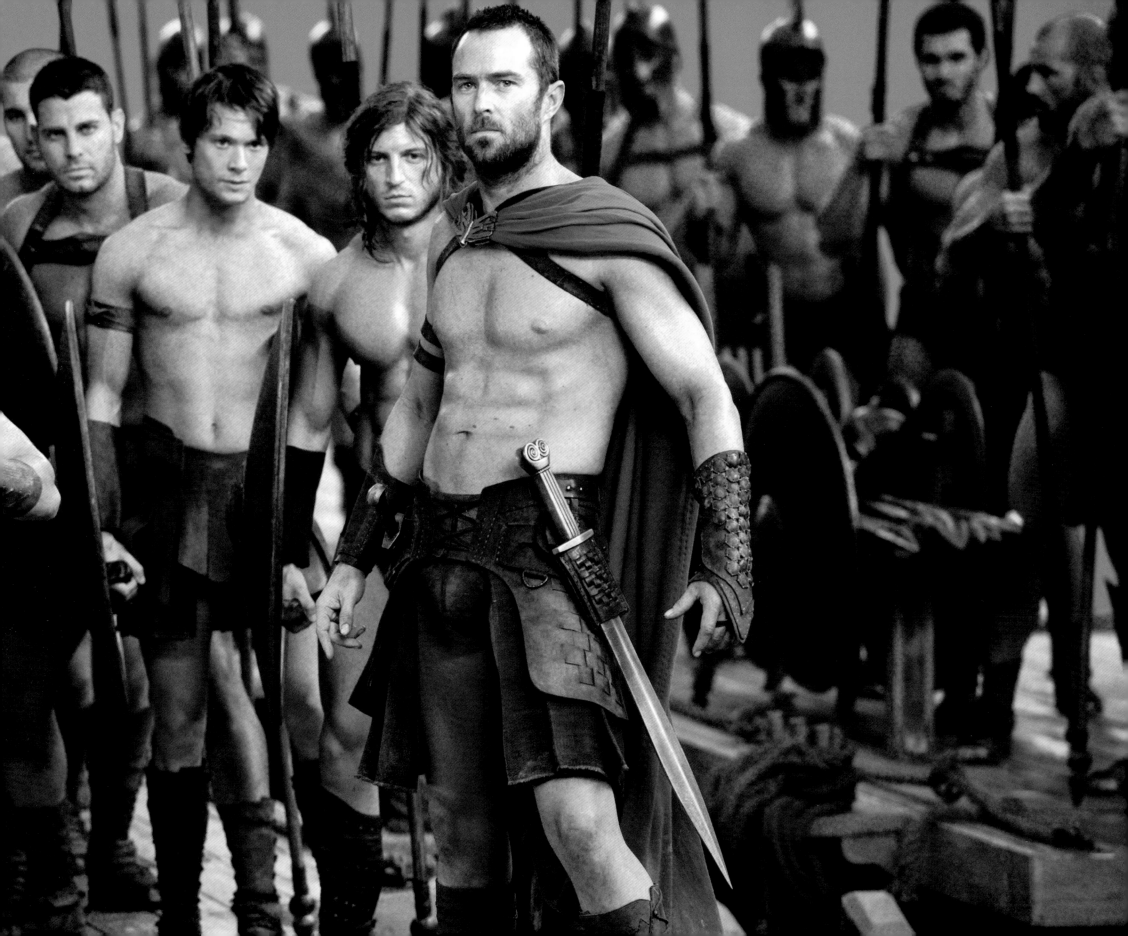

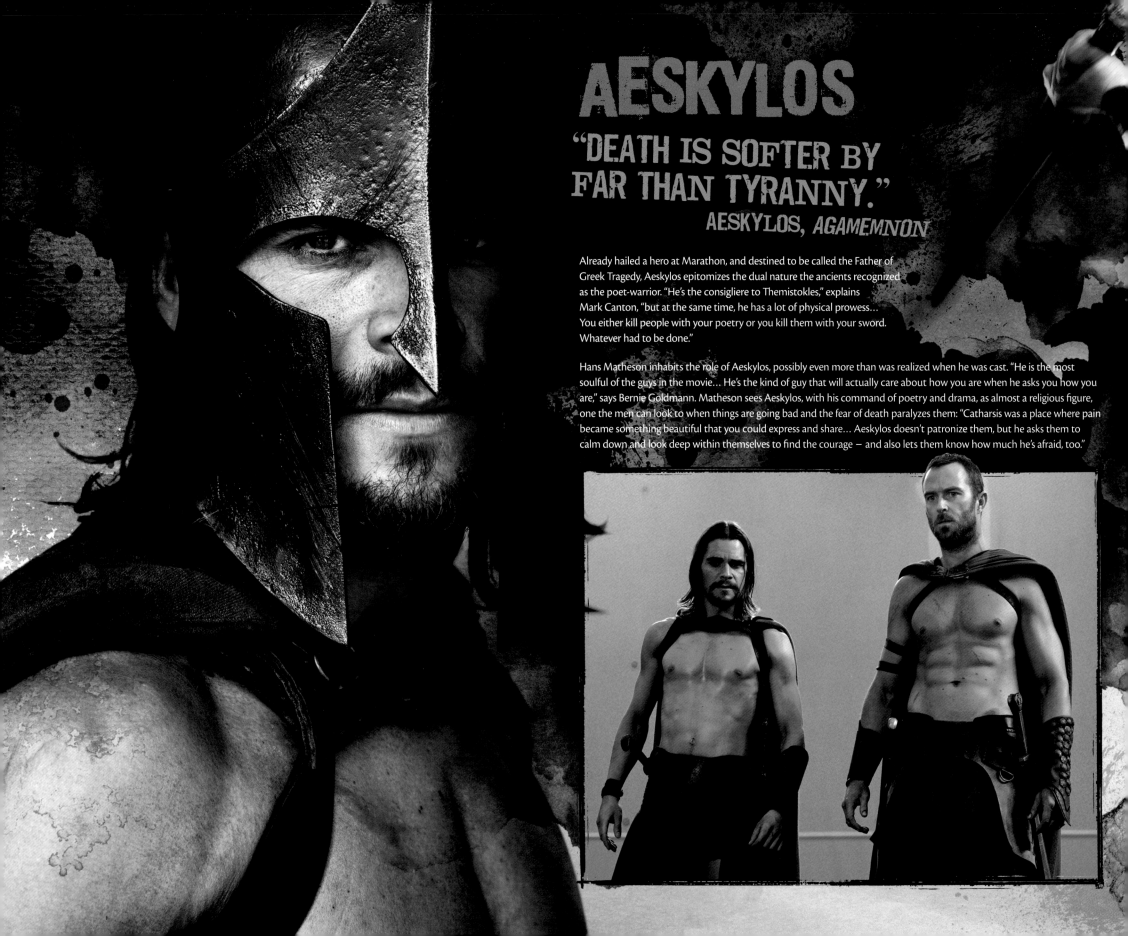

AESKYLOS

"DEATH IS SOFTER BY
FAR THAN TYRANNY."
AESKYLOS, *AGAMEMNON*

Already hailed a hero at Marathon, and destined to be called the Father of Greek Tragedy, Aeskylos epitomizes the dual nature the ancients recognized as the poet-warrior. "He's the consigliere to Themistokles," explains Mark Canton, "but at the same time, he has a lot of physical prowess… You either kill people with your poetry or you kill them with your sword. Whatever had to be done."

Hans Matheson inhabits the role of Aeskylos, possibly even more than was realized when he was cast. "He is the most soulful of the guys in the movie… He's the kind of guy that will actually care about how you are when he asks you how you are," says Bernie Goldmann. Matheson sees Aeskylos, with his command of poetry and drama, as almost a religious figure, one the men can look to when things are going bad and the fear of death paralyzes them: "Catharsis was a place where pain became something beautiful that you could express and share… Aeskylos doesn't patronize them, but he asks them to calm down and look deep within themselves to find the courage — and also lets them know how much he's afraid, too."

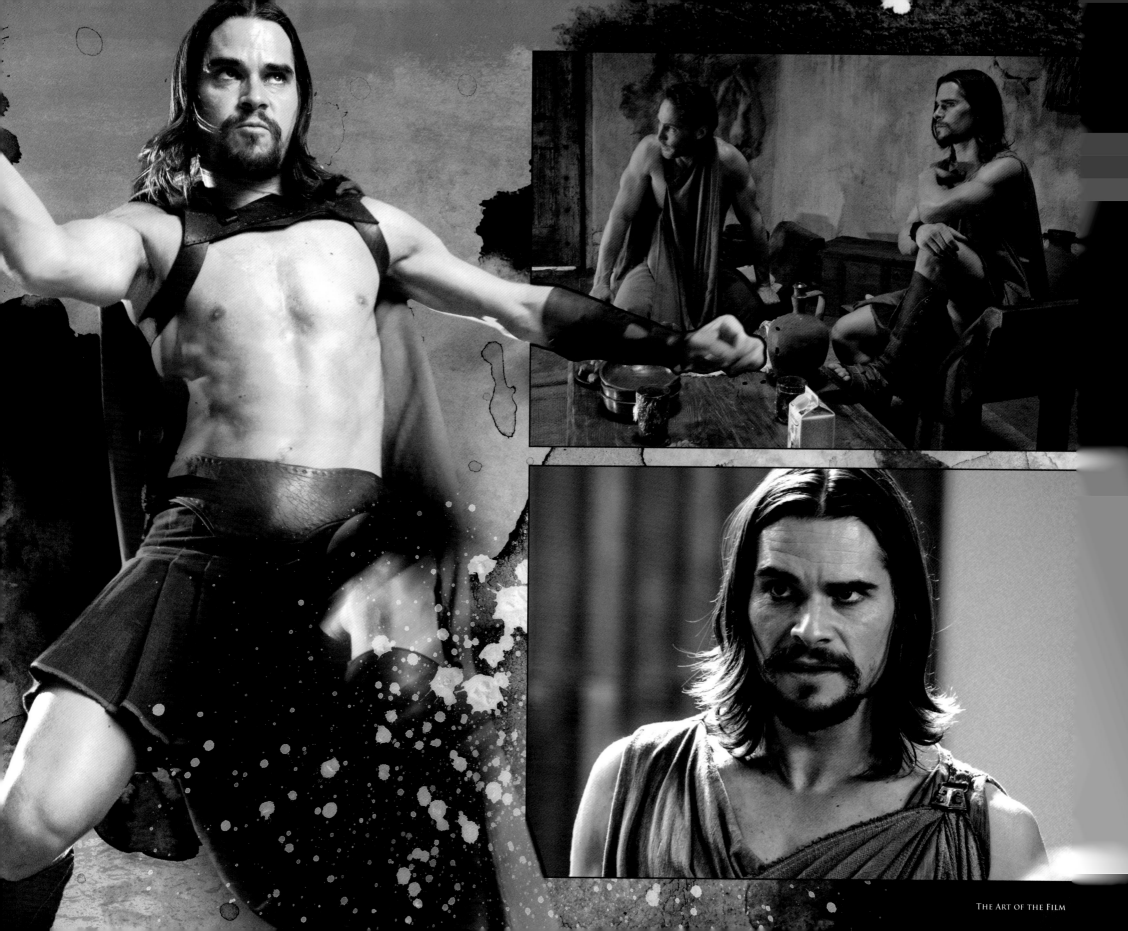

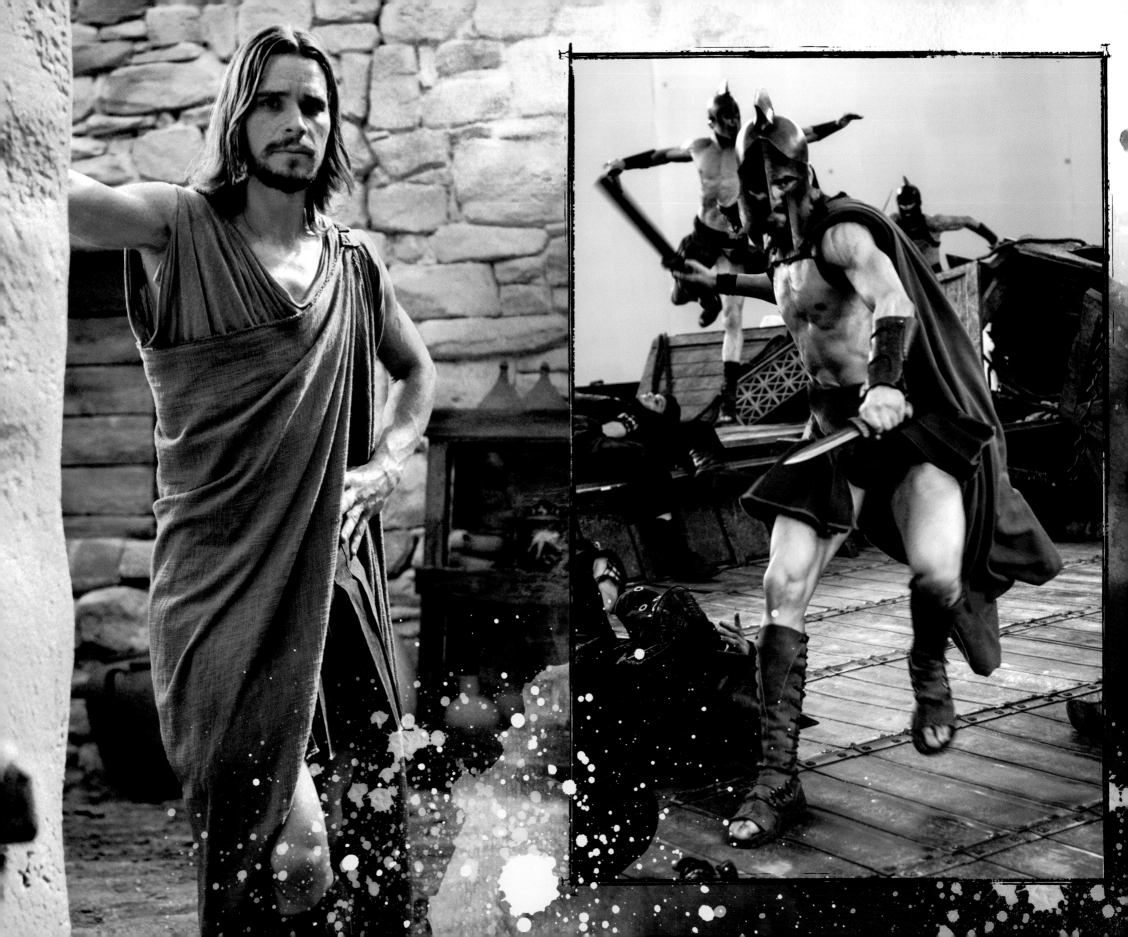

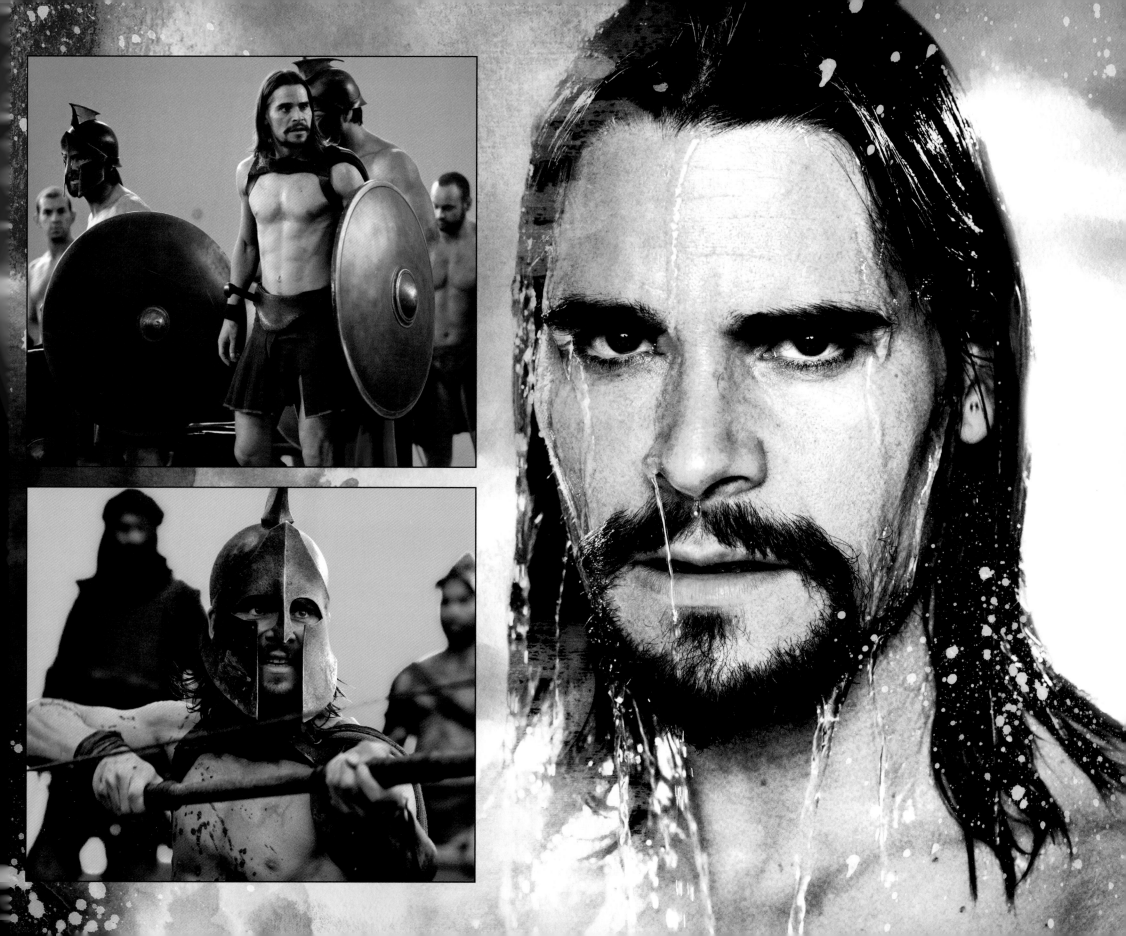

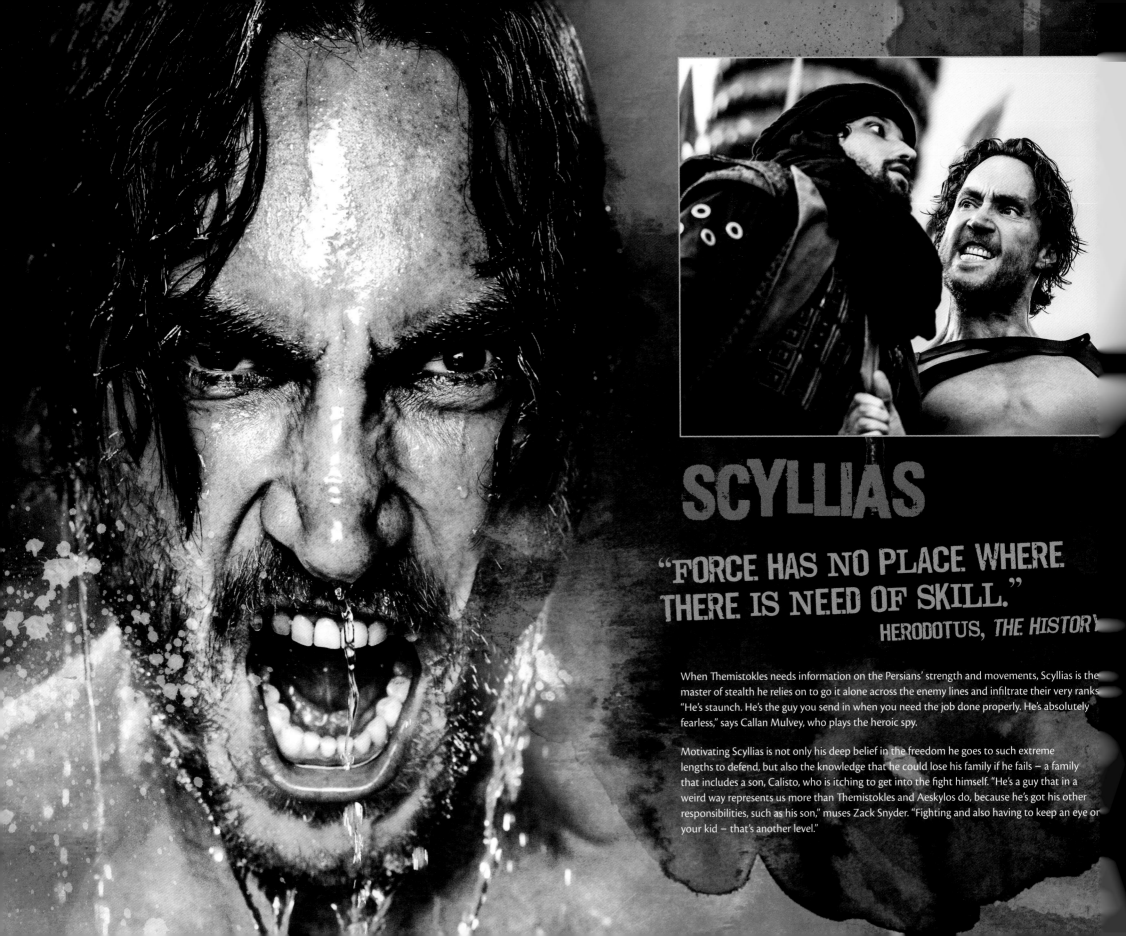

SCYLLIAS

"FORCE HAS NO PLACE WHERE THERE IS NEED OF SKILL."

HERODOTUS, *THE HISTORY*

When Themistokles needs information on the Persians' strength and movements, Scyllias is the master of stealth he relies on to go it alone across the enemy lines and infiltrate their very ranks. "He's staunch. He's the guy you send in when you need the job done properly. He's absolutely fearless," says Callan Mulvey, who plays the heroic spy.

Motivating Scyllias is not only his deep belief in the freedom he goes to such extreme lengths to defend, but also the knowledge that he could lose his family if he fails – a family that includes a son, Calisto, who is itching to get into the fight himself. "He's a guy that in a weird way represents us more than Themistokles and Aeskylos do, because he's got his other responsibilities, such as his son," muses Zack Snyder. "Fighting and also having to keep an eye on your kid – that's another level."

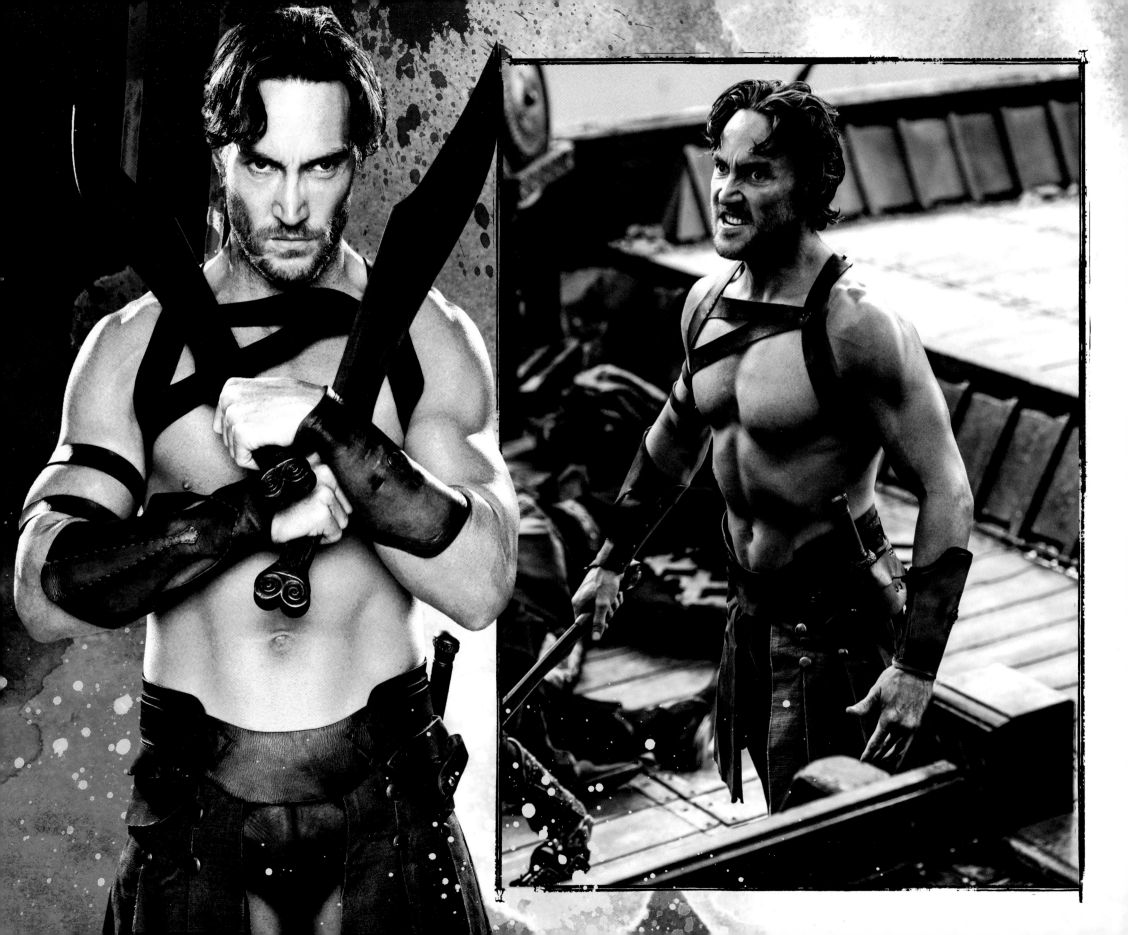

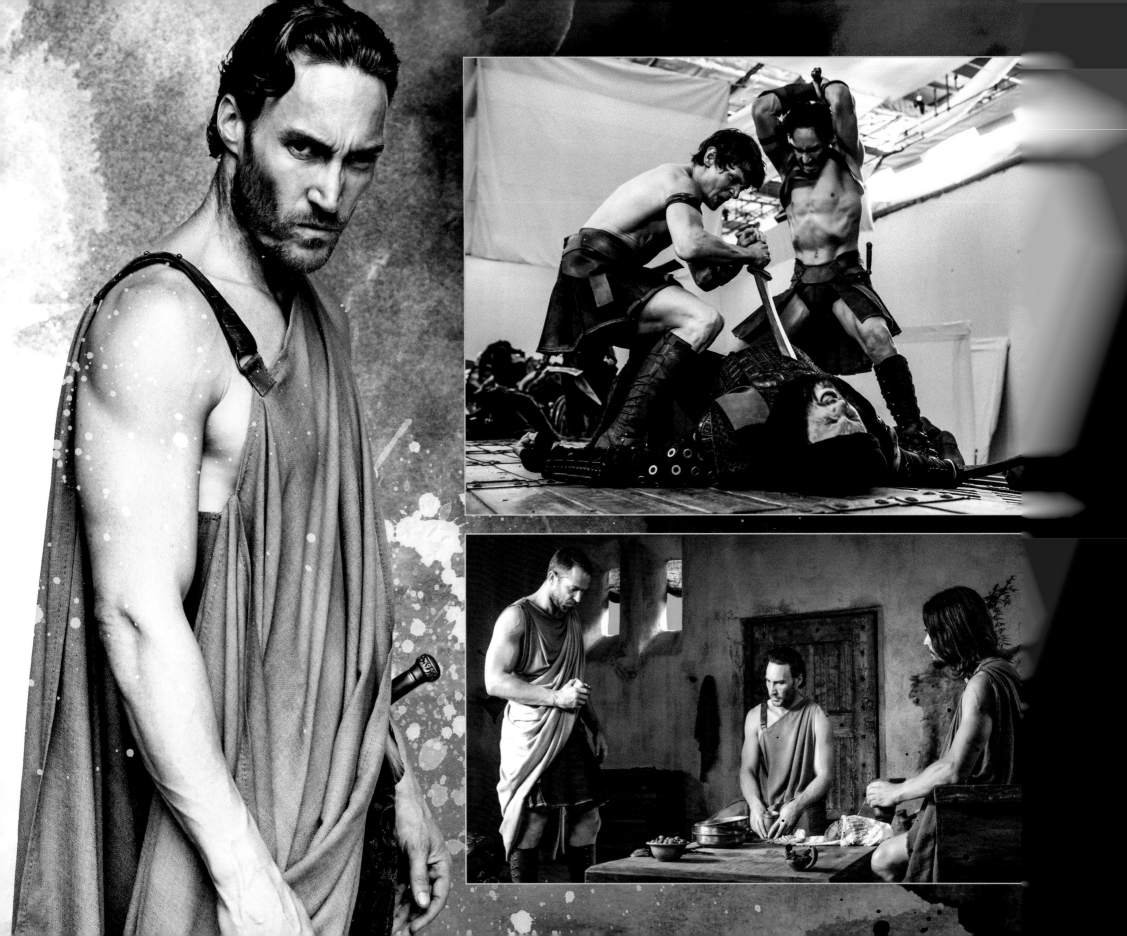

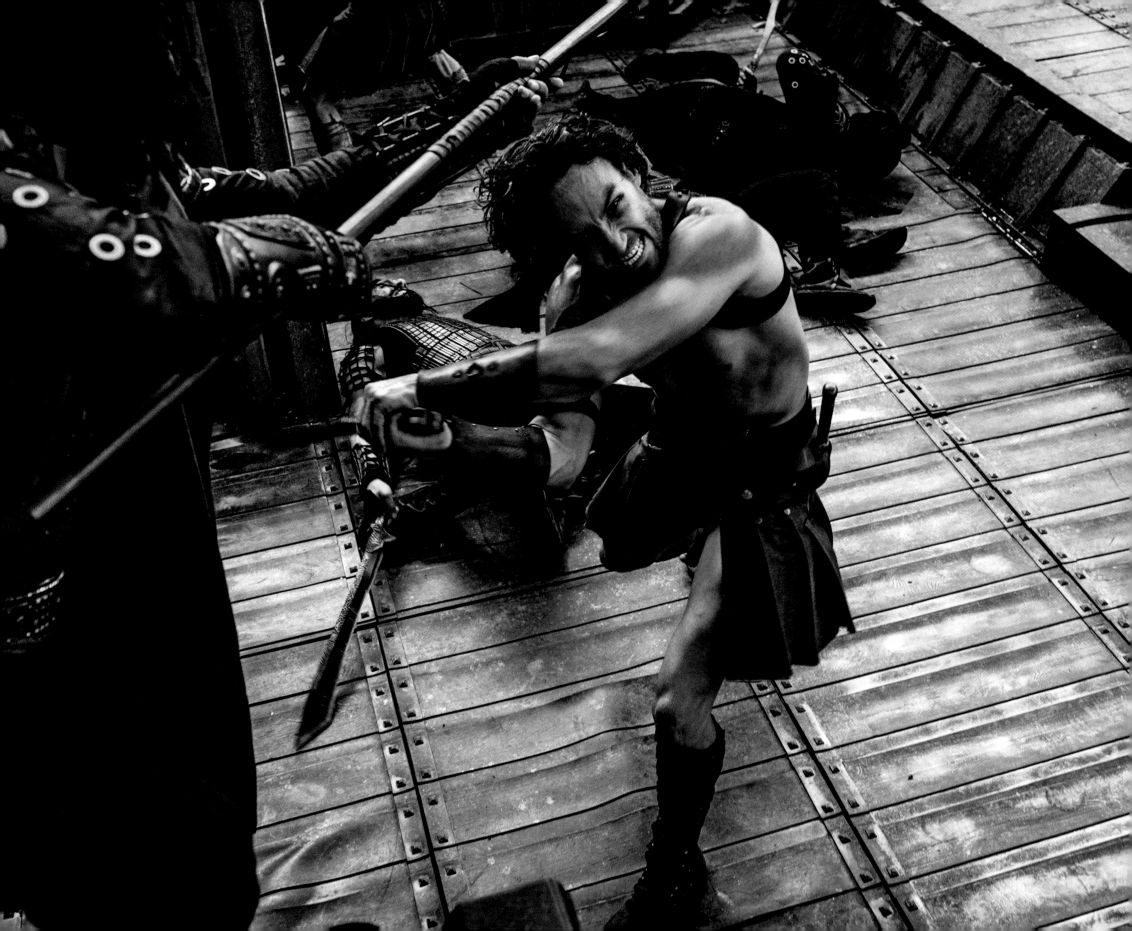

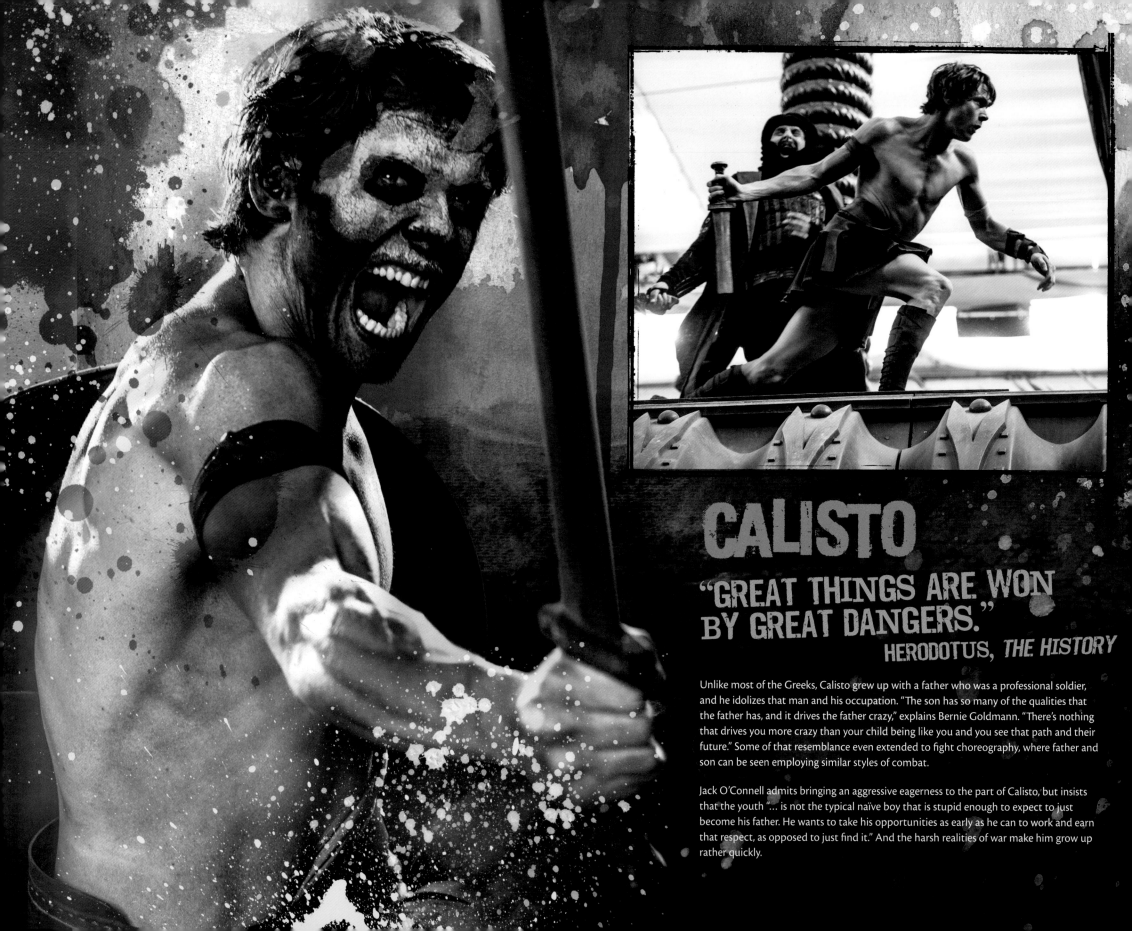

CALISTO

"GREAT THINGS ARE WON BY GREAT DANGERS."
HERODOTUS, *THE HISTORY*

Unlike most of the Greeks, Calisto grew up with a father who was a professional soldier, and he idolizes that man and his occupation. "The son has so many of the qualities that the father has, and it drives the father crazy," explains Bernie Goldmann. "There's nothing that drives you more crazy than your child being like you and you see that path and their future." Some of that resemblance even extended to fight choreography, where father and son can be seen employing similar styles of combat.

Jack O'Connell admits bringing an aggressive eagerness to the part of Calisto, but insists that the youth "... is not the typical naïve boy that is stupid enough to expect to just become his father. He wants to take his opportunities as early as he can to work and earn that respect, as opposed to just find it." And the harsh realities of war make him grow up rather quickly.

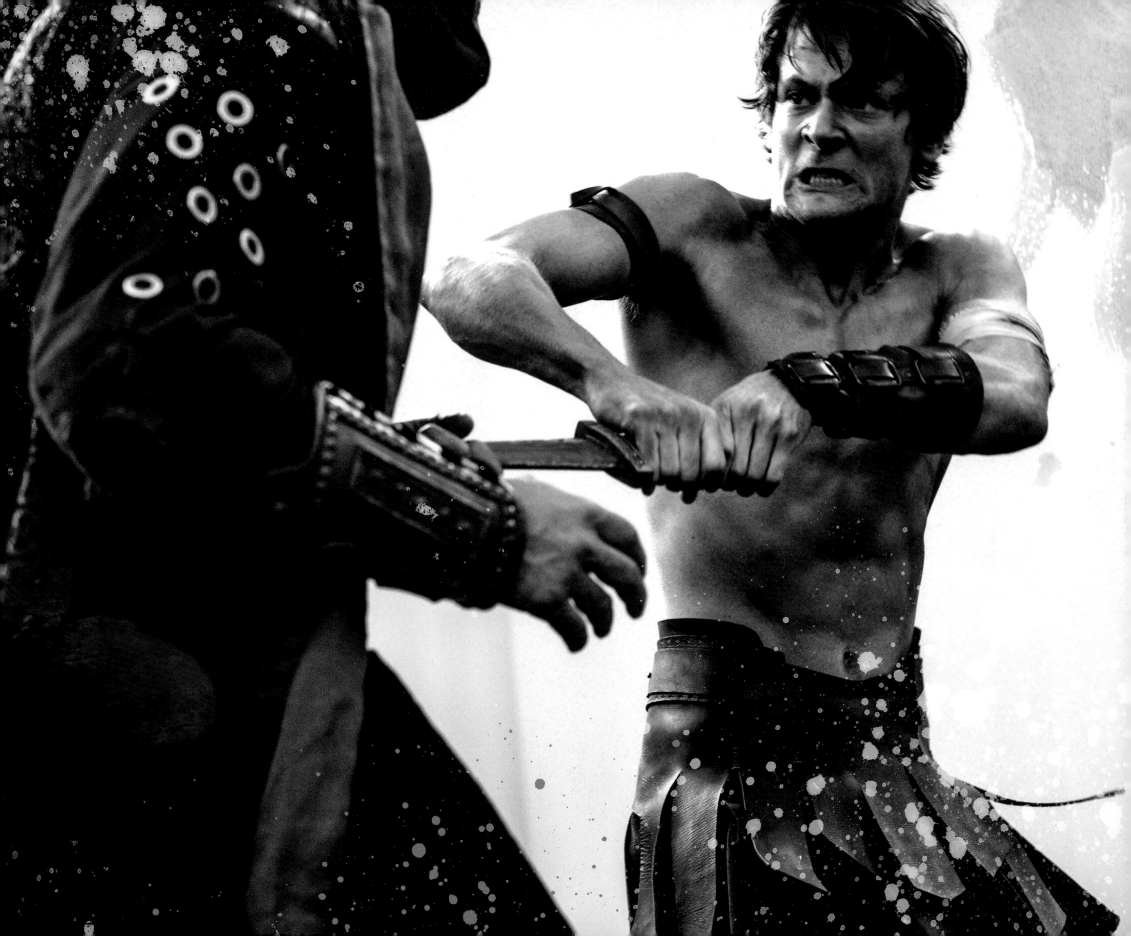

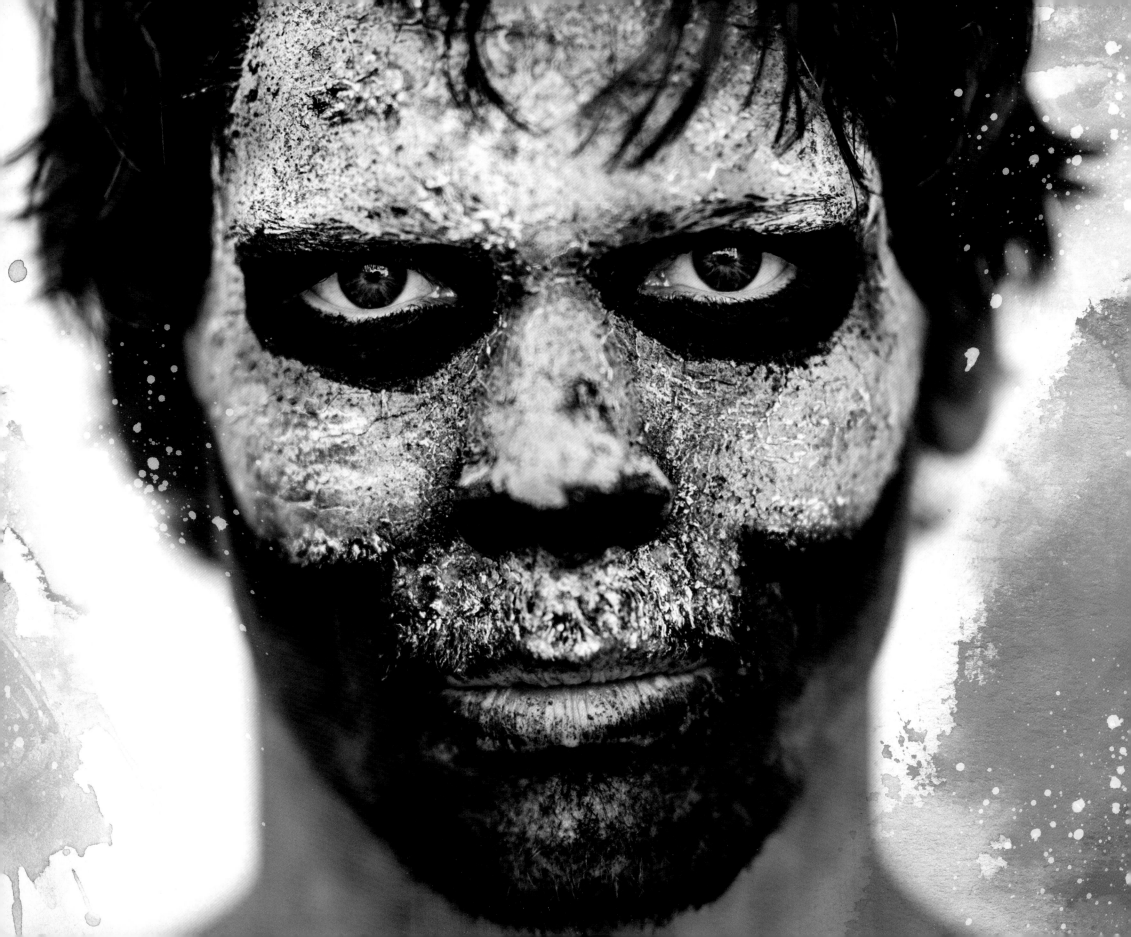

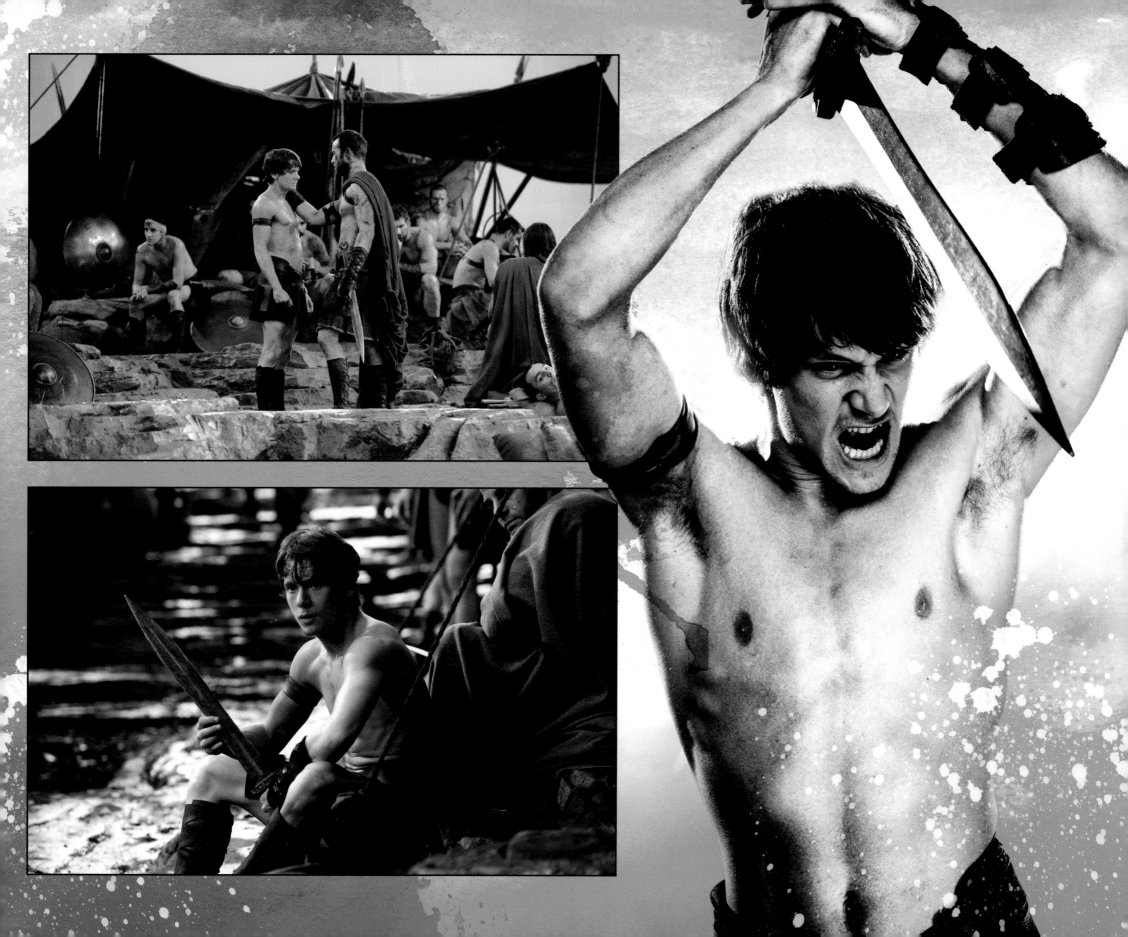

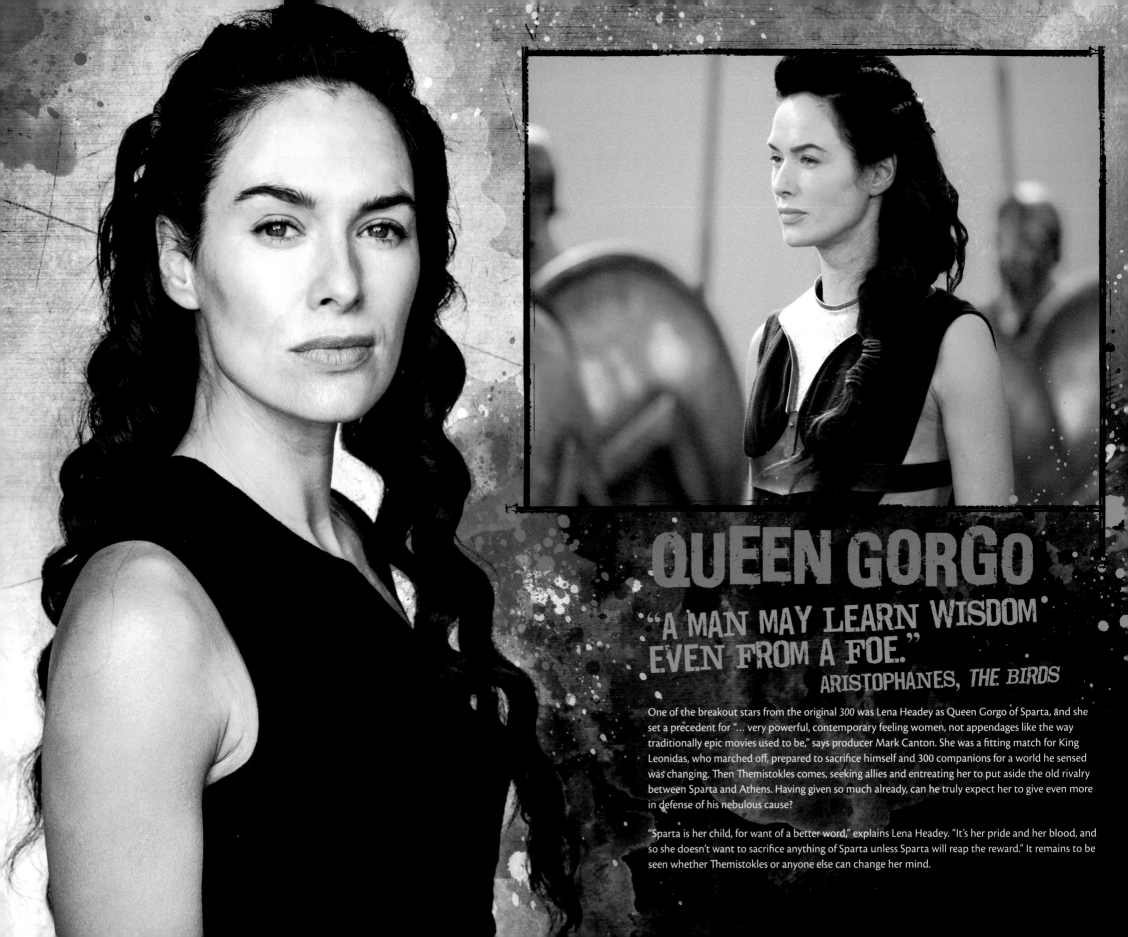

QUEEN GORGO

"A MAN MAY LEARN WISDOM EVEN FROM A FOE."
ARISTOPHANES, *THE BIRDS*

One of the breakout stars from the original *300* was Lena Headey as Queen Gorgo of Sparta, and she set a precedent for "... very powerful, contemporary feeling women, not appendages like the way traditionally epic movies used to be," says producer Mark Canton. She was a fitting match for King Leonidas, who marched off, prepared to sacrifice himself and 300 companions for a world he sensed was changing. Then Themistokles comes, seeking allies and entreating her to put aside the old rivalry between Sparta and Athens. Having given so much already, can he truly expect her to give even more in defense of his nebulous cause?

"Sparta is her child, for want of a better word," explains Lena Headey. "It's her pride and her blood, and so she doesn't want to sacrifice anything of Sparta unless Sparta will reap the reward." It remains to be seen whether Themistokles or anyone else can change her mind.

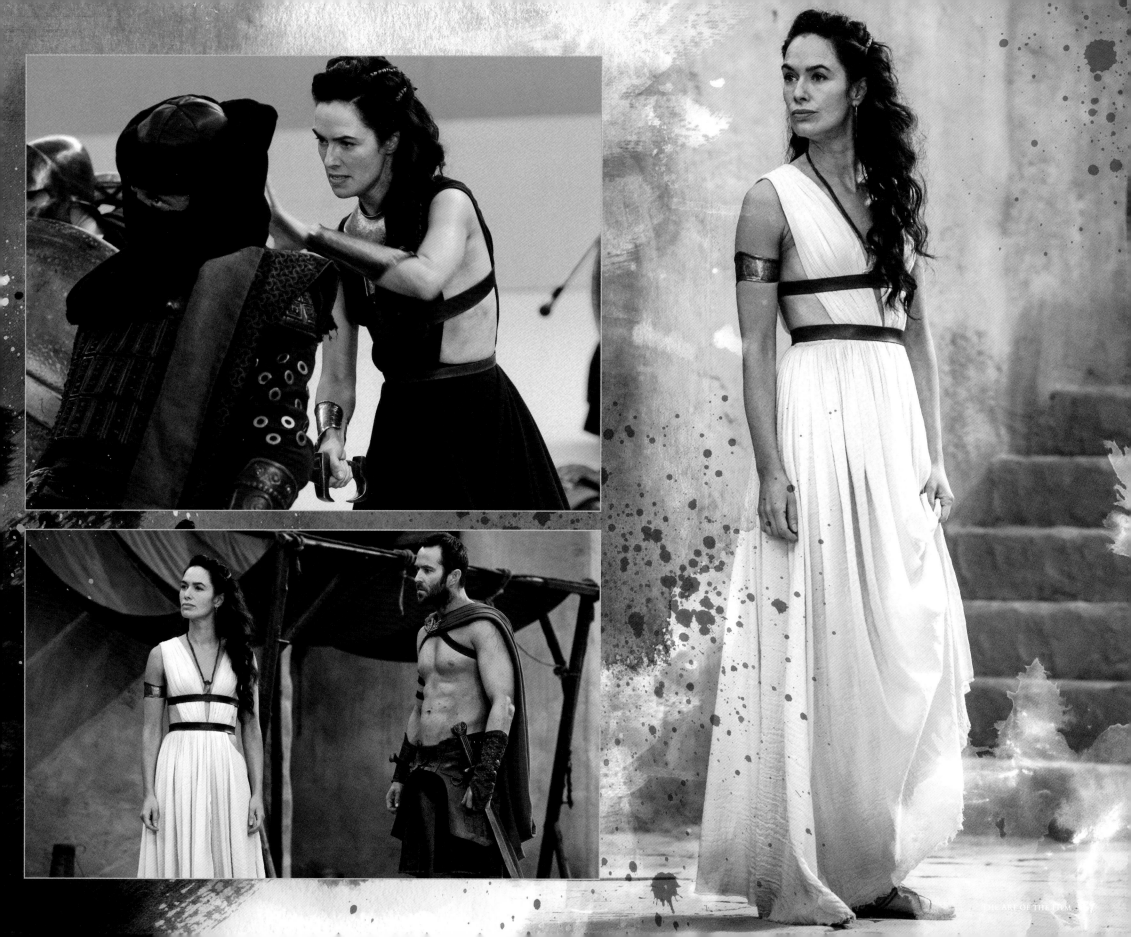

XERXES

"BEING HIMSELF OF THE RACE OF GOLD, EQUAL WITH GODS MOST HIGH."

AESKYLOS, *THE PERSIANS*

Xerxes was not always the eight-foot-tall, golden god-king we are familiar with in the first film, and in *300: Rise of an Empire* we become acquainted with the events and influences that propelled his ascent. "In 300, he just comes out of nowhere, this larger-than-life, Bizarro-land character," explains producer Zack Snyder. "We wanted to understand him a bit more. It's an attempt to put a human face on the giant."

Reprising the role of Xerxes is Rodrigo Santoro, whom director Noam Murro refers to as "A pillar. He's holding up a lot of the building." While much of Xerxes' transformation to godhood can be traced to machinations by his almost-sister, Artemisia, Murro is quick to point out that "He's not a dumb guy… He's manipulated a bit, but he's allowing himself to be manipulated." And that includes reinterpreting his father's dying words in order to launch his massive punitive expedition against the Greeks.

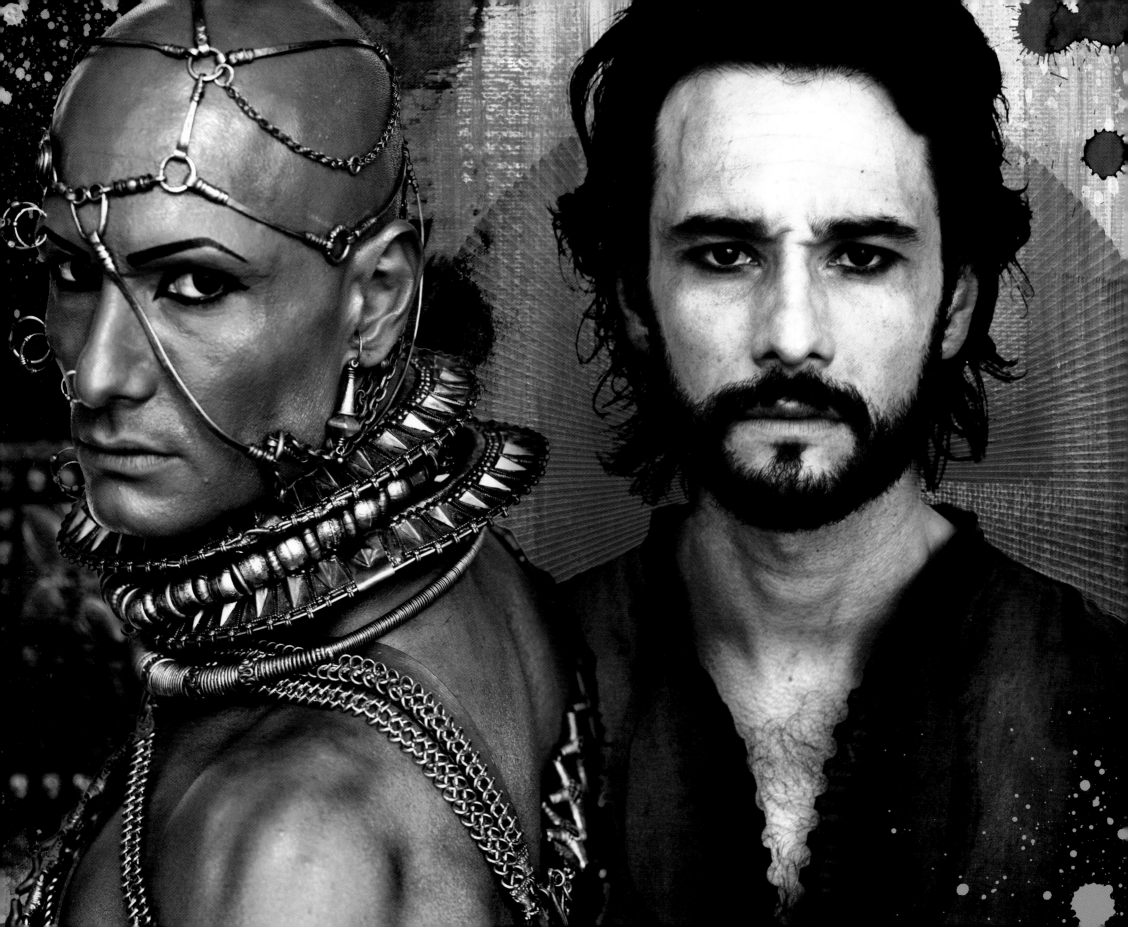

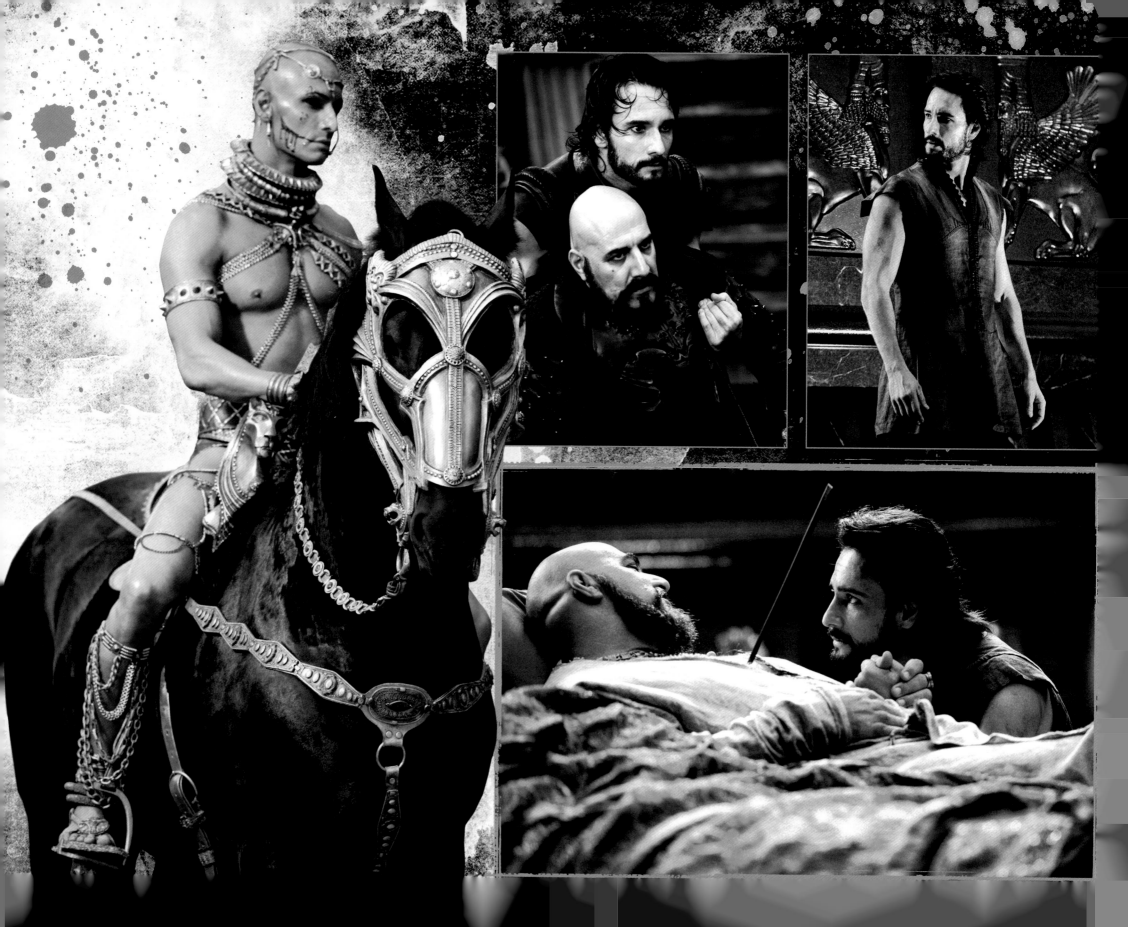

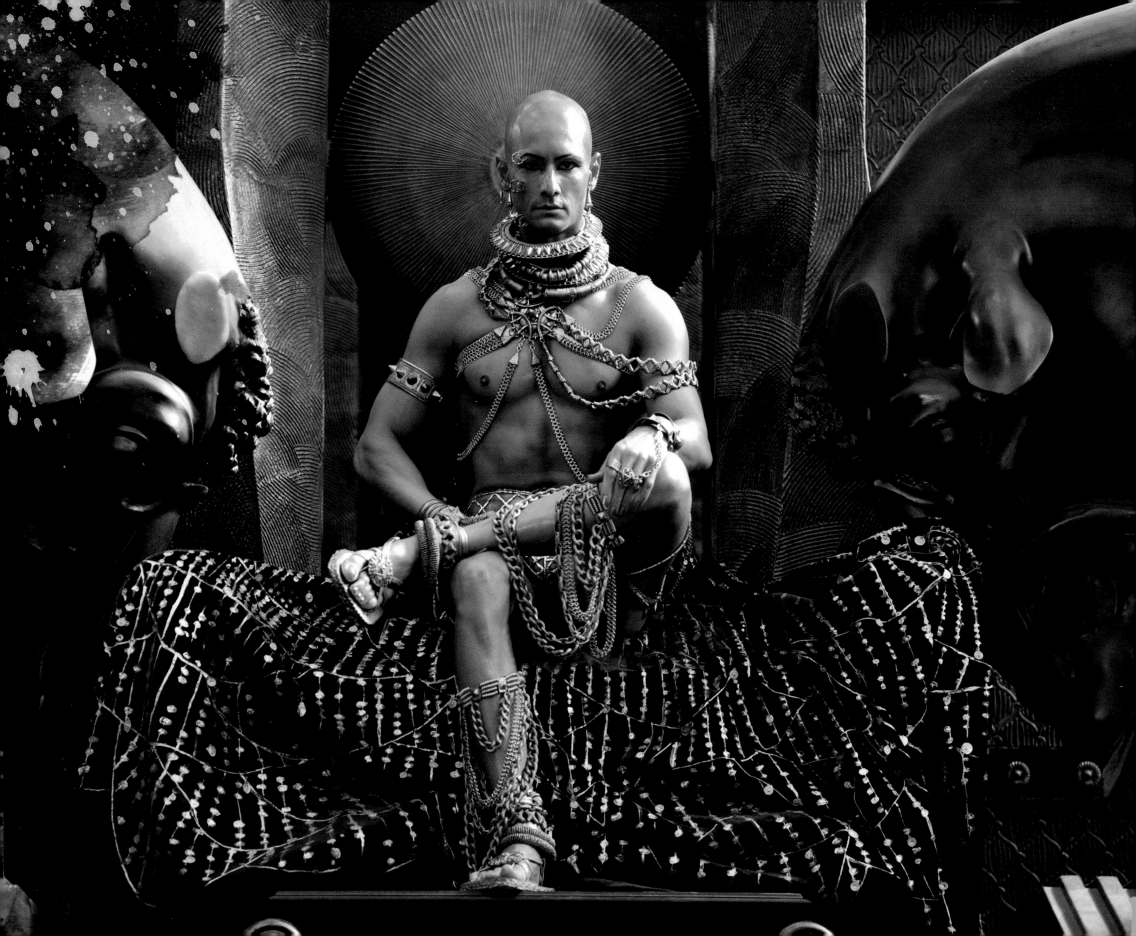

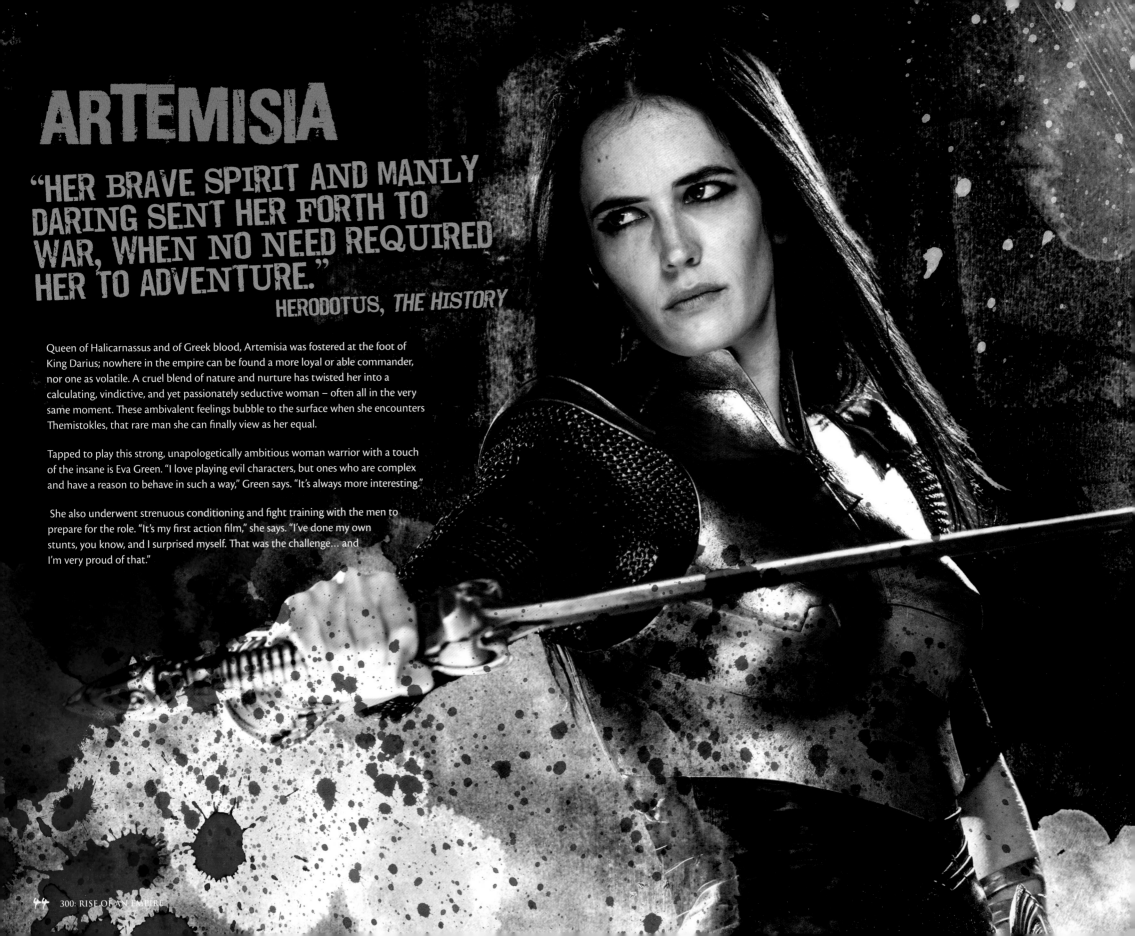

ARTEMISIA

"HER BRAVE SPIRIT AND MANLY DARING SENT HER FORTH TO WAR, WHEN NO NEED REQUIRED HER TO ADVENTURE."

HERODOTUS, *THE HISTORY*

Queen of Halicarnassus and of Greek blood, Artemisia was fostered at the foot of King Darius; nowhere in the empire can be found a more loyal or able commander, nor one as volatile. A cruel blend of nature and nurture has twisted her into a calculating, vindictive, and yet passionately seductive woman – often all in the very same moment. These ambivalent feelings bubble to the surface when she encounters Themistokles, that rare man she can finally view as her equal.

Tapped to play this strong, unapologetically ambitious woman warrior with a touch of the insane is Eva Green. "I love playing evil characters, but ones who are complex and have a reason to behave in such a way," Green says. "It's always more interesting."

She also underwent strenuous conditioning and fight training with the men to prepare for the role. "It's my first action film," she says. "I've done my own stunts, you know, and I surprised myself. That was the challenge… and I'm very proud of that."

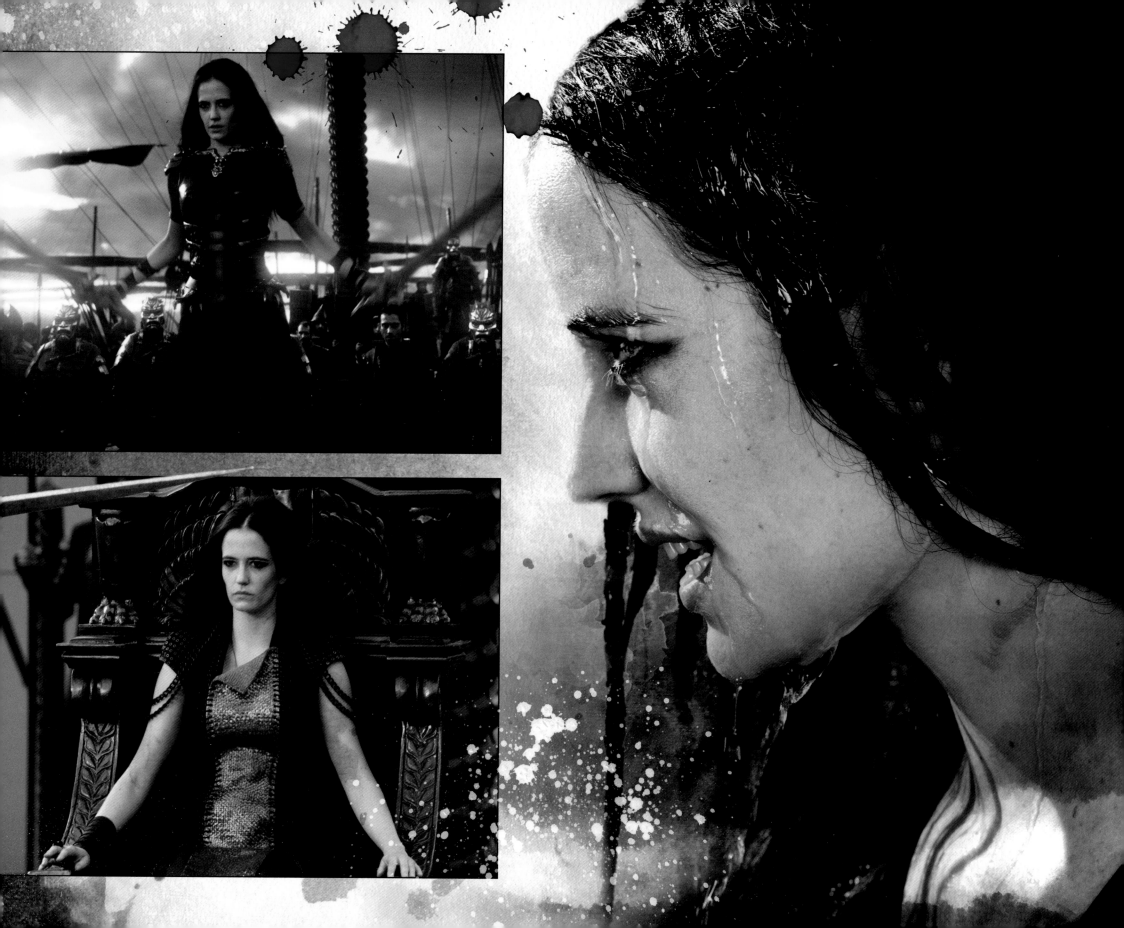

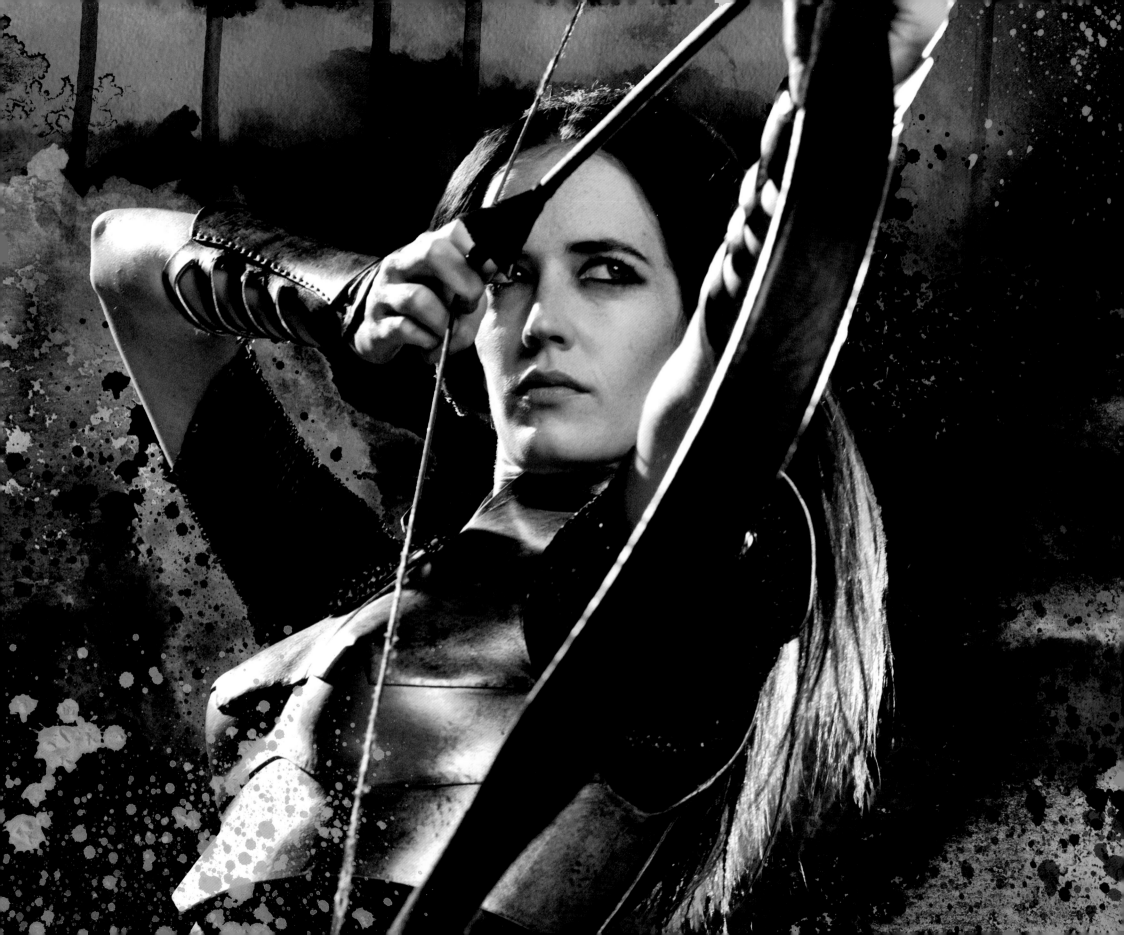

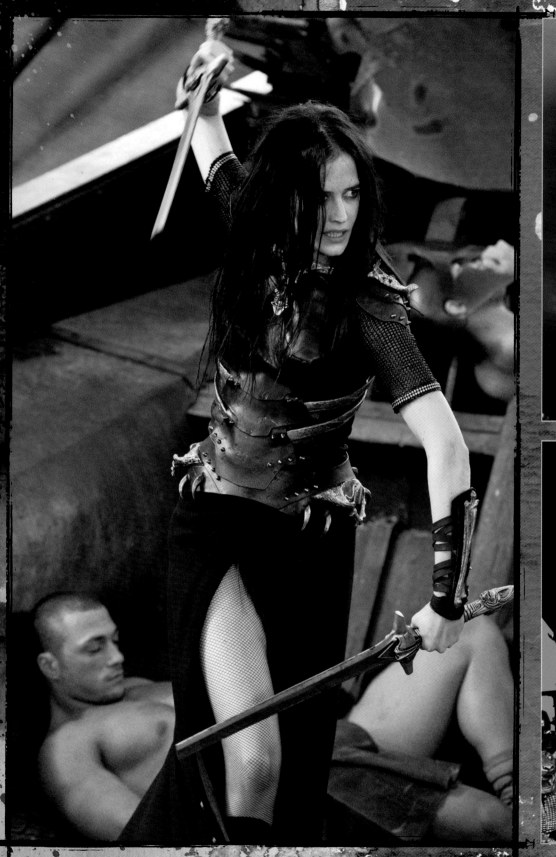

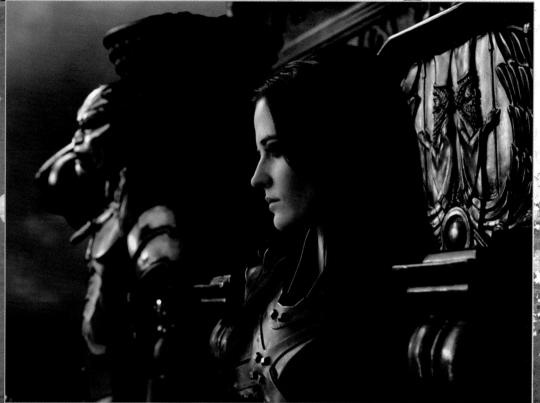

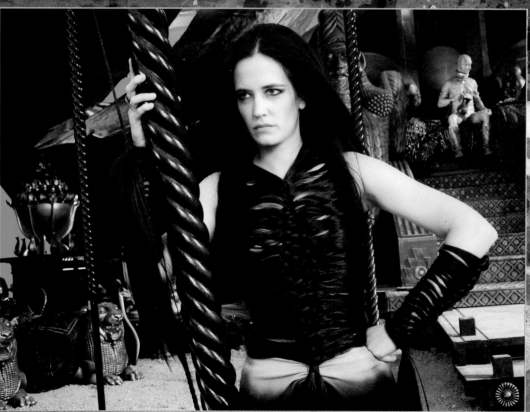

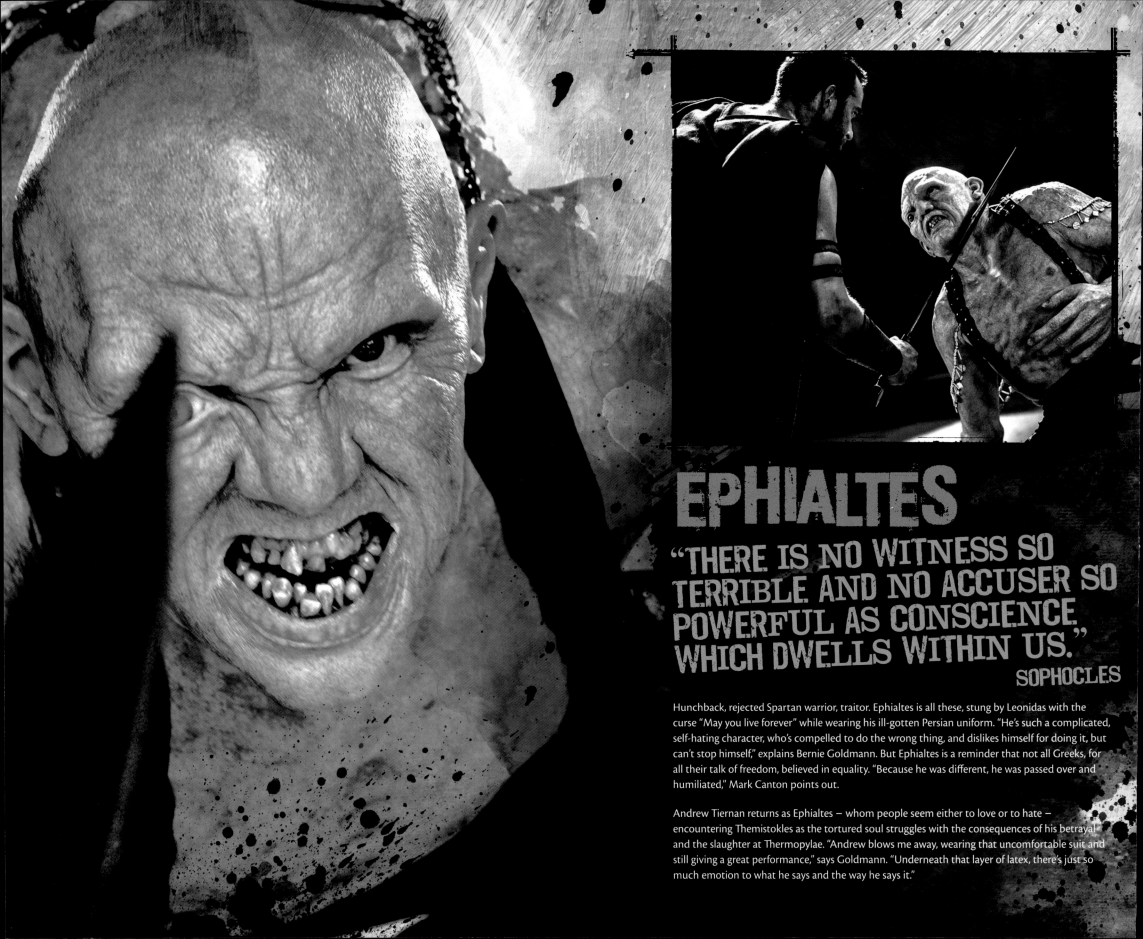

EPHIALTES

"THERE IS NO WITNESS SO TERRIBLE AND NO ACCUSER SO POWERFUL AS CONSCIENCE WHICH DWELLS WITHIN US."

SOPHOCLES

Hunchback, rejected Spartan warrior, traitor. Ephialtes is all these, stung by Leonidas with the curse "May you live forever" while wearing his ill-gotten Persian uniform. "He's such a complicated, self-hating character, who's compelled to do the wrong thing, and dislikes himself for doing it, but can't stop himself," explains Bernie Goldmann. But Ephialtes is a reminder that not all Greeks, for all their talk of freedom, believed in equality. "Because he was different, he was passed over and humiliated," Mark Canton points out.

Andrew Tiernan returns as Ephialtes – whom people seem either to love or to hate – encountering Themistokles as the tortured soul struggles with the consequences of his betrayal and the slaughter at Thermopylae. "Andrew blows me away, wearing that uncomfortable suit and still giving a great performance," says Goldmann. "Underneath that layer of latex, there's just so much emotion to what he says and the way he says it."

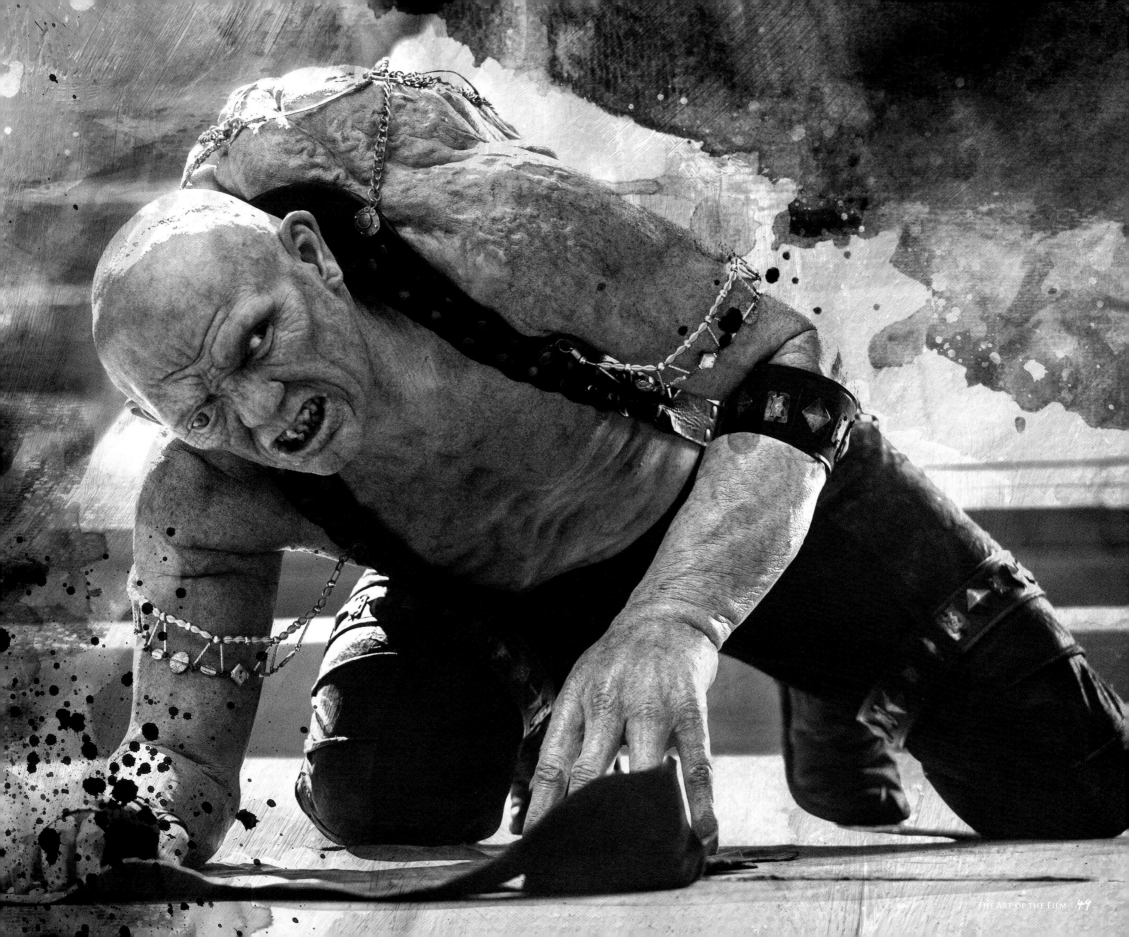

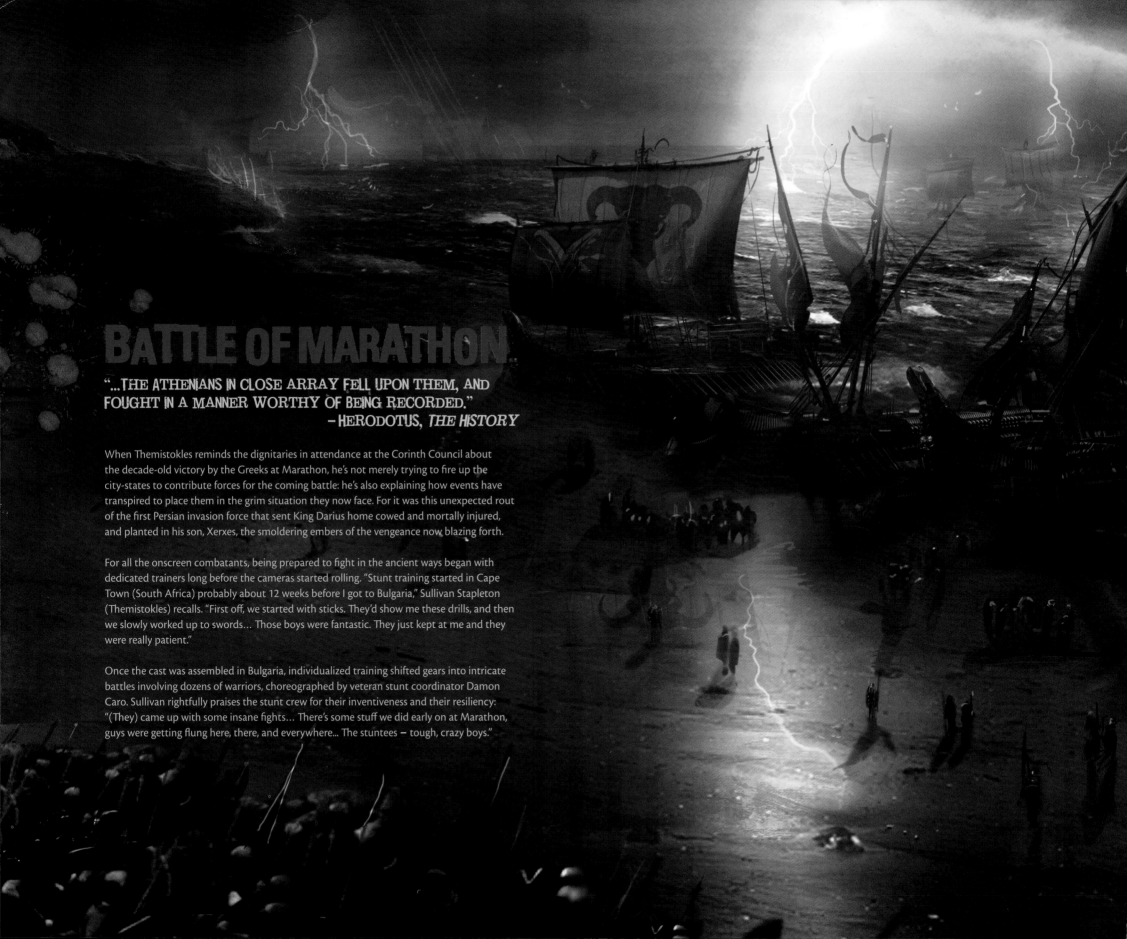

BATTLE OF MARATHON

"...THE ATHENIANS IN CLOSE ARRAY FELL UPON THEM, AND
FOUGHT IN A MANNER WORTHY OF BEING RECORDED."
— HERODOTUS, *THE HISTORY*

When Themistokles reminds the dignitaries in attendance at the Corinth Council about
the decade-old victory by the Greeks at Marathon, he's not merely trying to fire up the
city-states to contribute forces for the coming battle: he's also explaining how events have
transpired to place them in the grim situation they now face. For it was this unexpected rout
of the first Persian invasion force that sent King Darius home cowed and mortally injured,
and planted in his son, Xerxes, the smoldering embers of the vengeance now blazing forth.

For all the onscreen combatants, being prepared to fight in the ancient ways began with
dedicated trainers long before the cameras started rolling. "Stunt training started in Cape
Town (South Africa) probably about 12 weeks before I got to Bulgaria," Sullivan Stapleton
(Themistokles) recalls. "First off, we started with sticks. They'd show me these drills, and then
we slowly worked up to swords... Those boys were fantastic. They just kept at me and they
were really patient."

Once the cast was assembled in Bulgaria, individualized training shifted gears into intricate
battles involving dozens of warriors, choreographed by veteran stunt coordinator Damon
Caro. Sullivan rightfully praises the stunt crew for their inventiveness and their resiliency:
"(They) came up with some insane fights... There's some stuff we did early on at Marathon,
guys were getting flung here, there, and everywhere... The stuntees — tough, crazy boys."

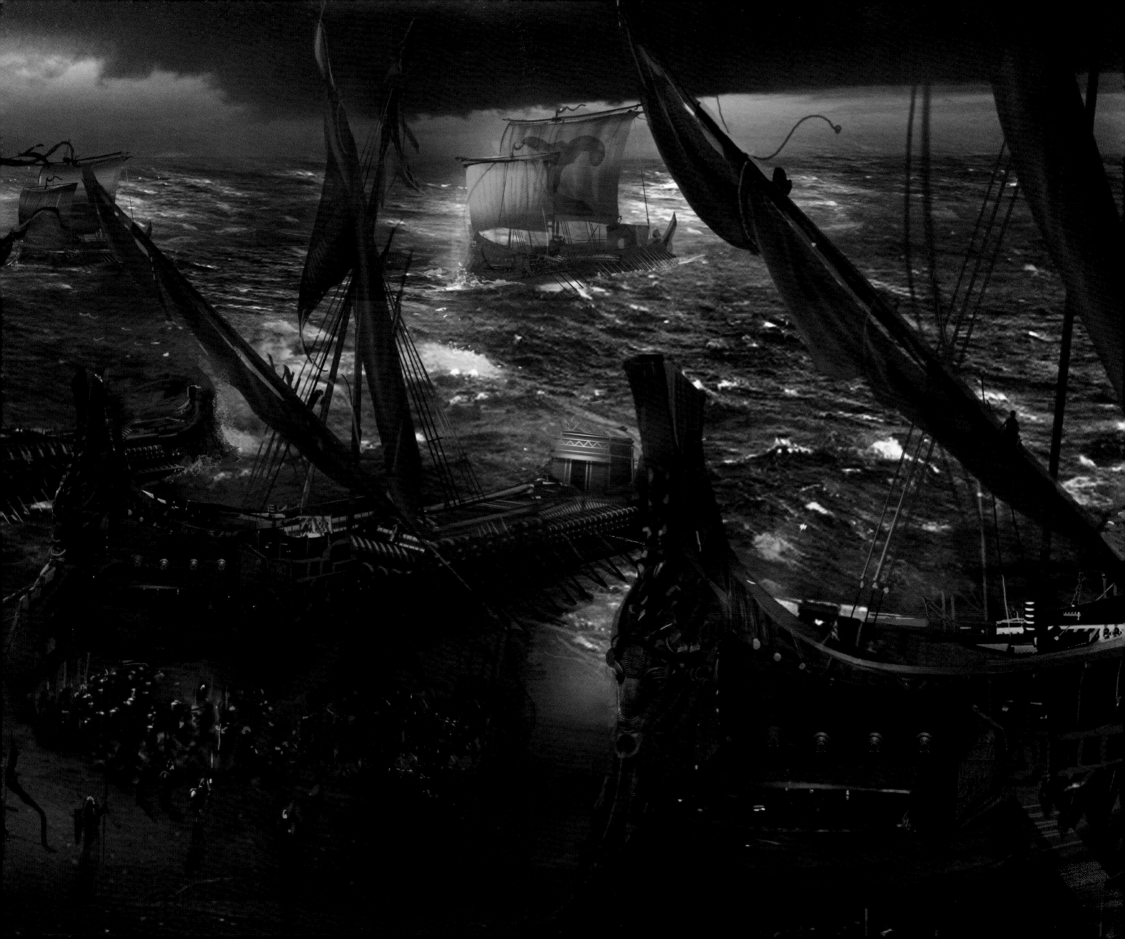

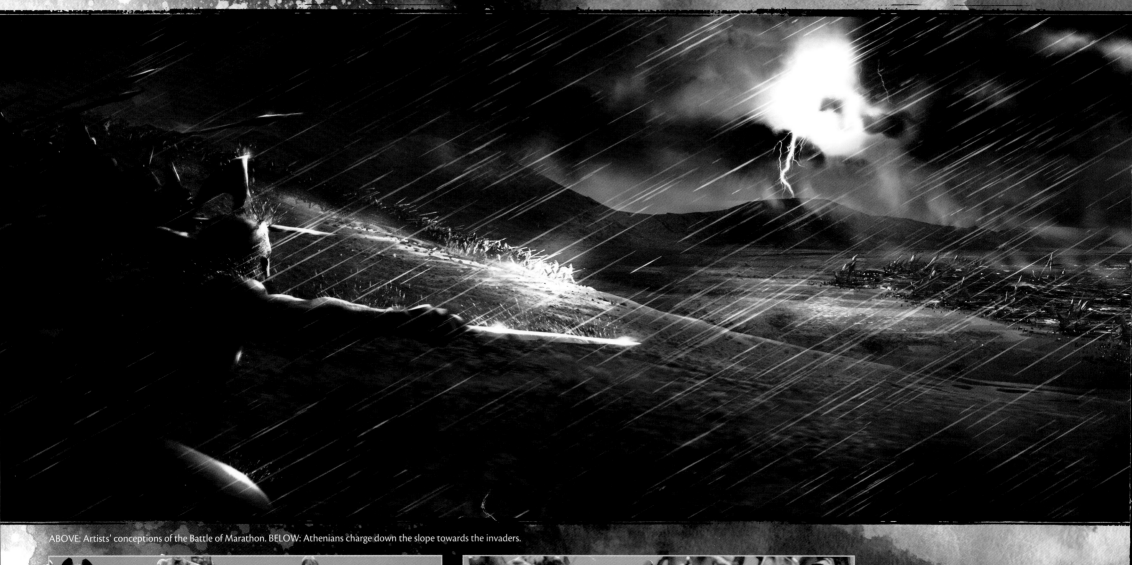

ABOVE: Artists' conceptions of the Battle of Marathon. BELOW: Athenians charge down the slope towards the invaders.

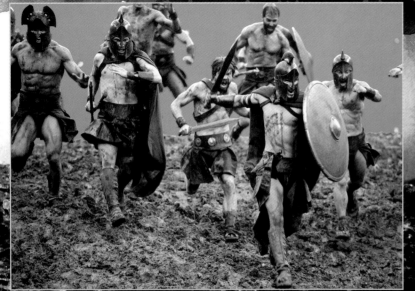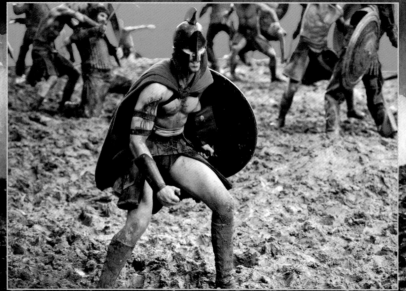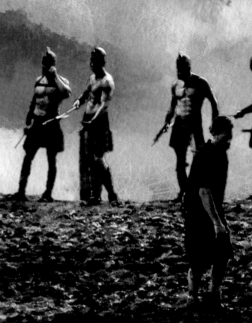

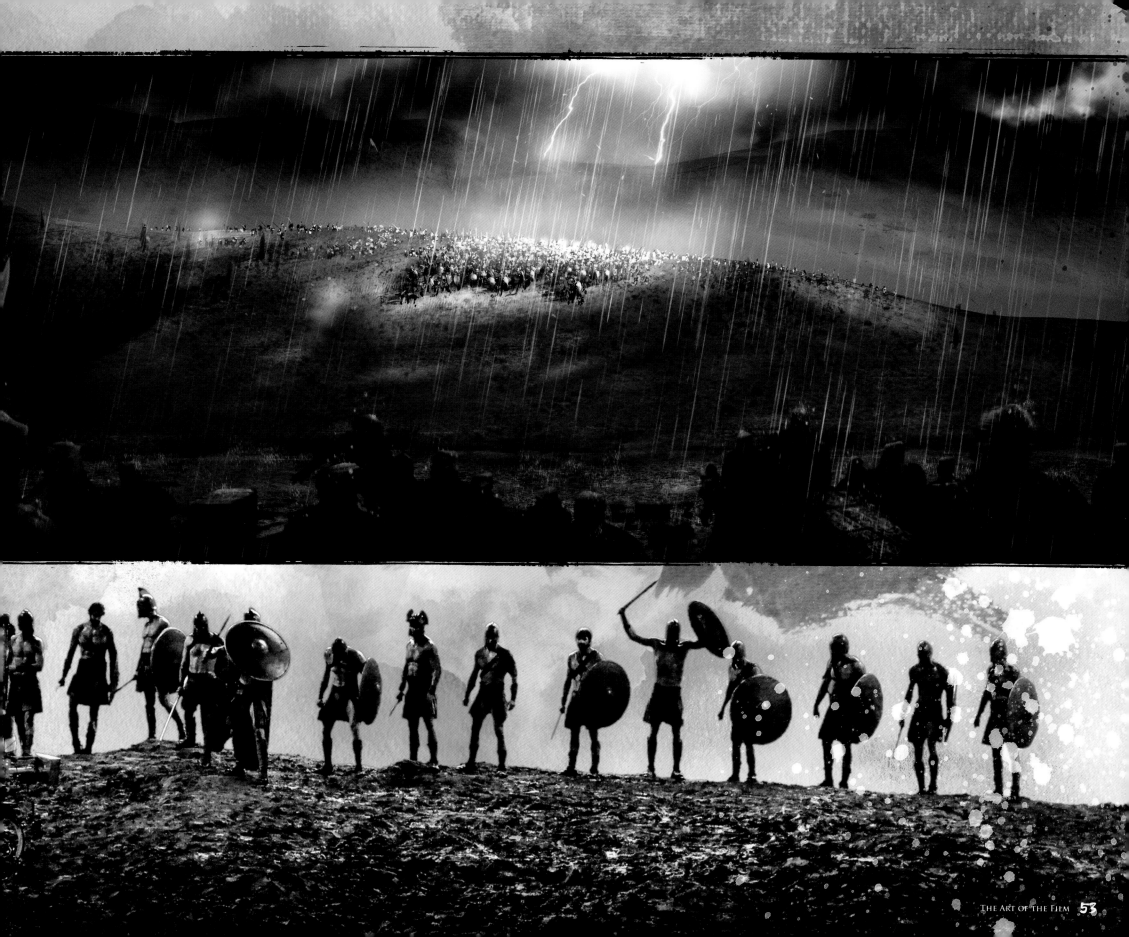

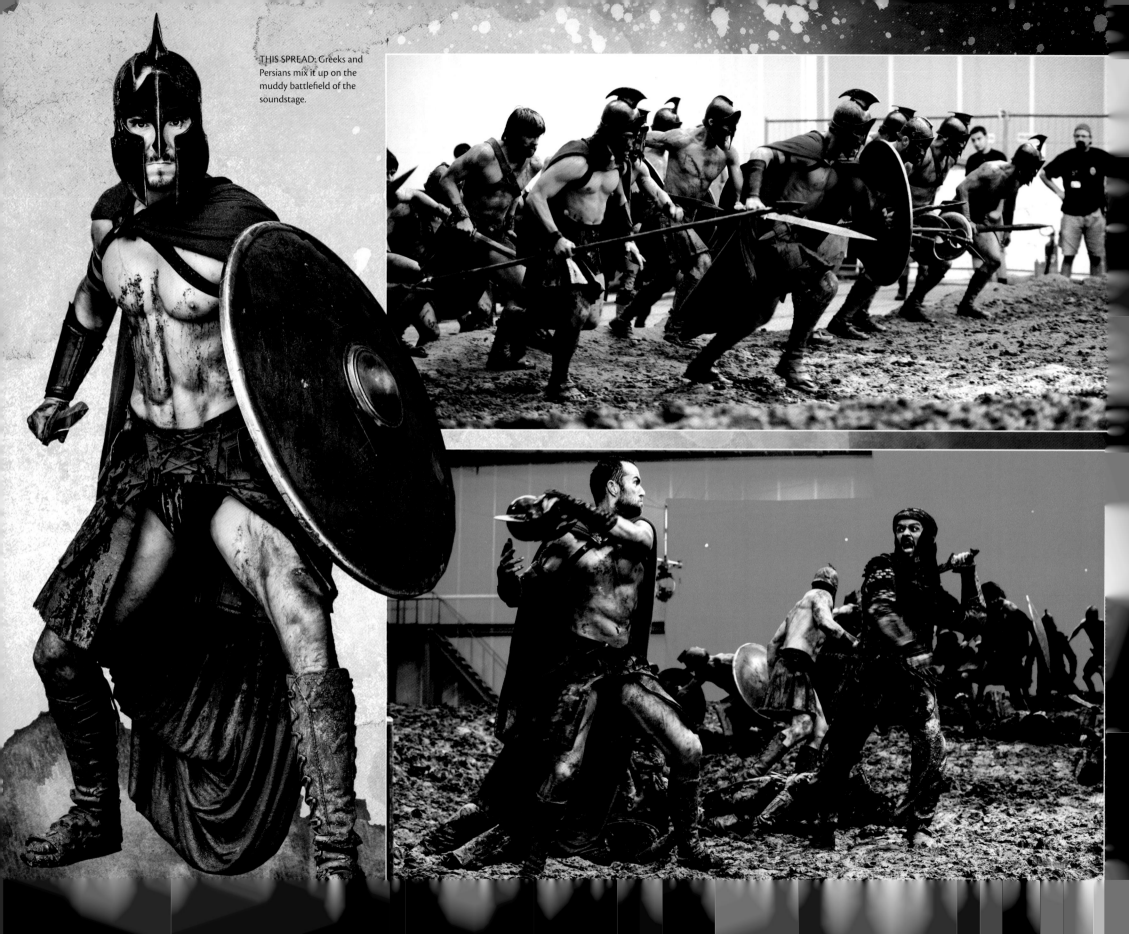

THIS SPREAD: Greeks and Persians mix it up on the muddy battlefield of the soundstage.

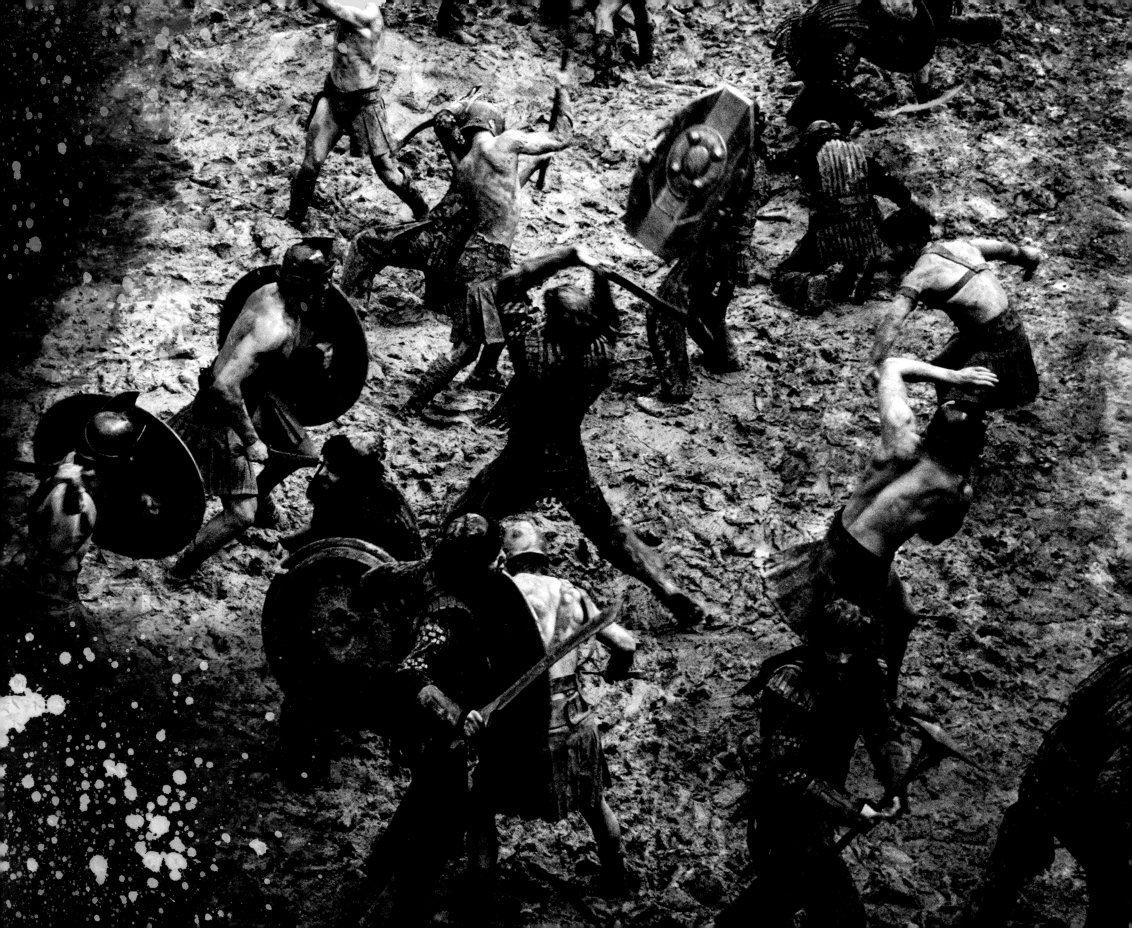

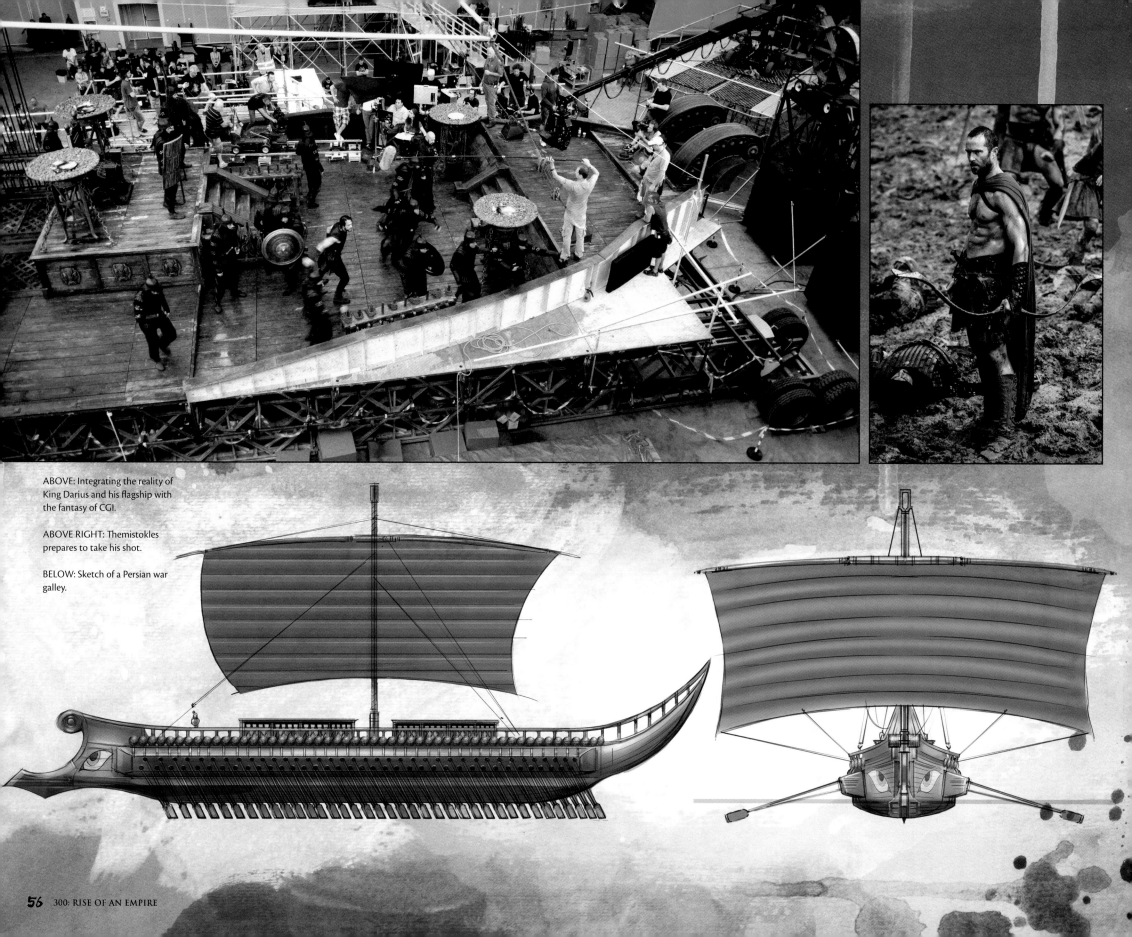

ABOVE: Integrating the reality of King Darius and his flagship with the fantasy of CGI.

ABOVE RIGHT: Themistokles prepares to take his shot.

BELOW: Sketch of a Persian war galley.

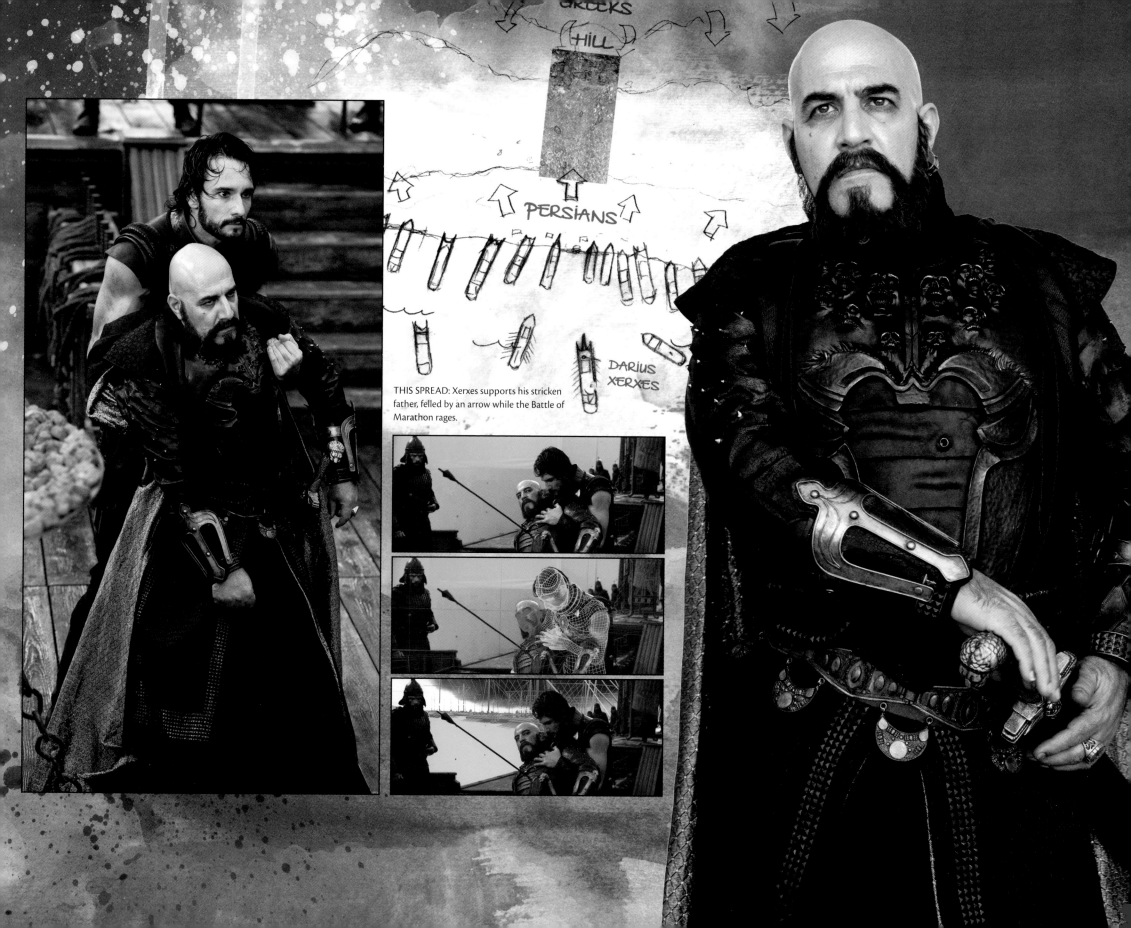

GREEKS

HILL

PERSIANS

DARIUS
XERXES

THIS SPREAD: Xerxes supports his stricken father, felled by an arrow while the Battle of Marathon rages.

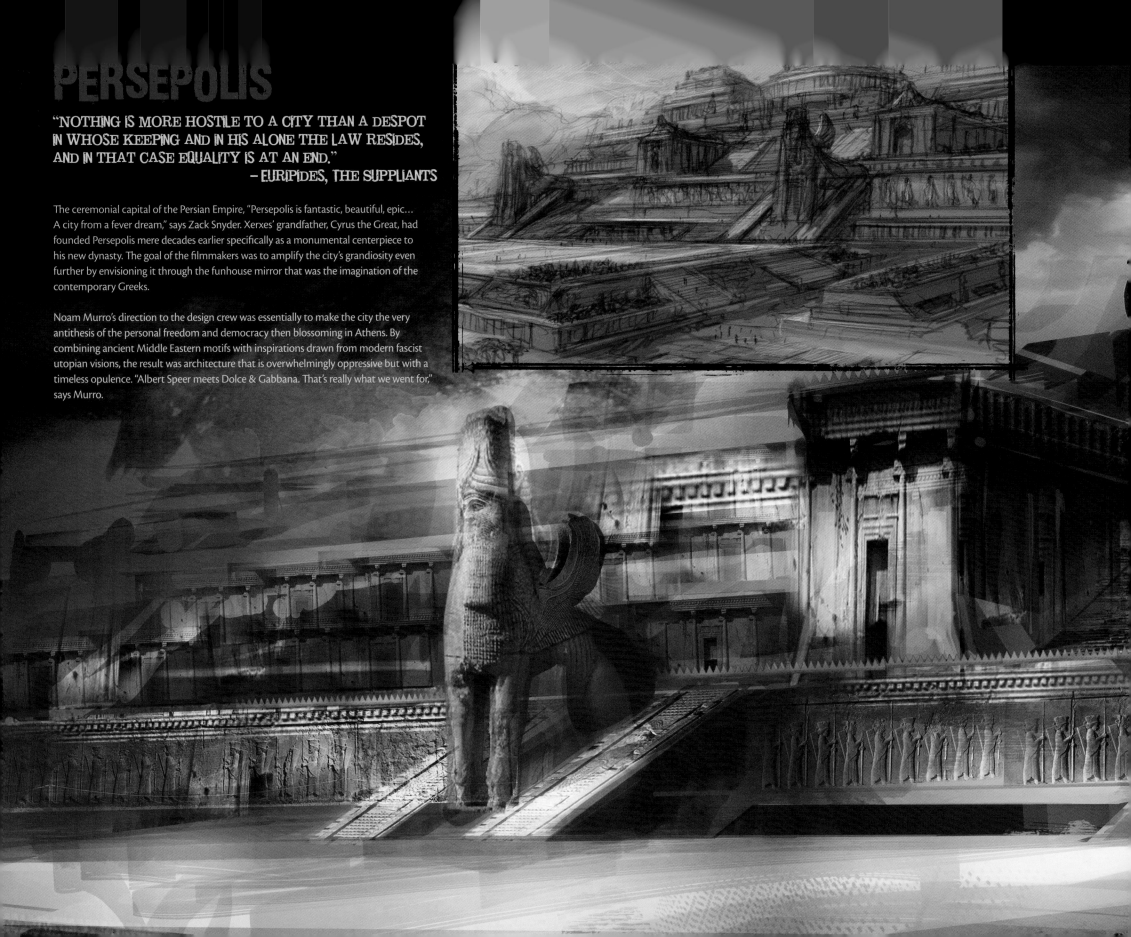

PERSEPOLIS

"NOTHING IS MORE HOSTILE TO A CITY THAN A DESPOT IN WHOSE KEEPING AND IN HIS ALONE THE LAW RESIDES, AND IN THAT CASE EQUALITY IS AT AN END."
— EURIPIDES, THE SUPPLIANTS

The ceremonial capital of the Persian Empire, "Persepolis is fantastic, beautiful, epic… A city from a fever dream," says Zack Snyder. Xerxes' grandfather, Cyrus the Great, had founded Persepolis mere decades earlier specifically as a monumental centerpiece to his new dynasty. The goal of the filmmakers was to amplify the city's grandiosity even further by envisioning it through the funhouse mirror that was the imagination of the contemporary Greeks.

Noam Murro's direction to the design crew was essentially to make the city the very antithesis of the personal freedom and democracy then blossoming in Athens. By combining ancient Middle Eastern motifs with inspirations drawn from modern fascist utopian visions, the result was architecture that is overwhelmingly oppressive but with a timeless opulence. "Albert Speer meets Dolce & Gabbana. That's really what we went for," says Murro.

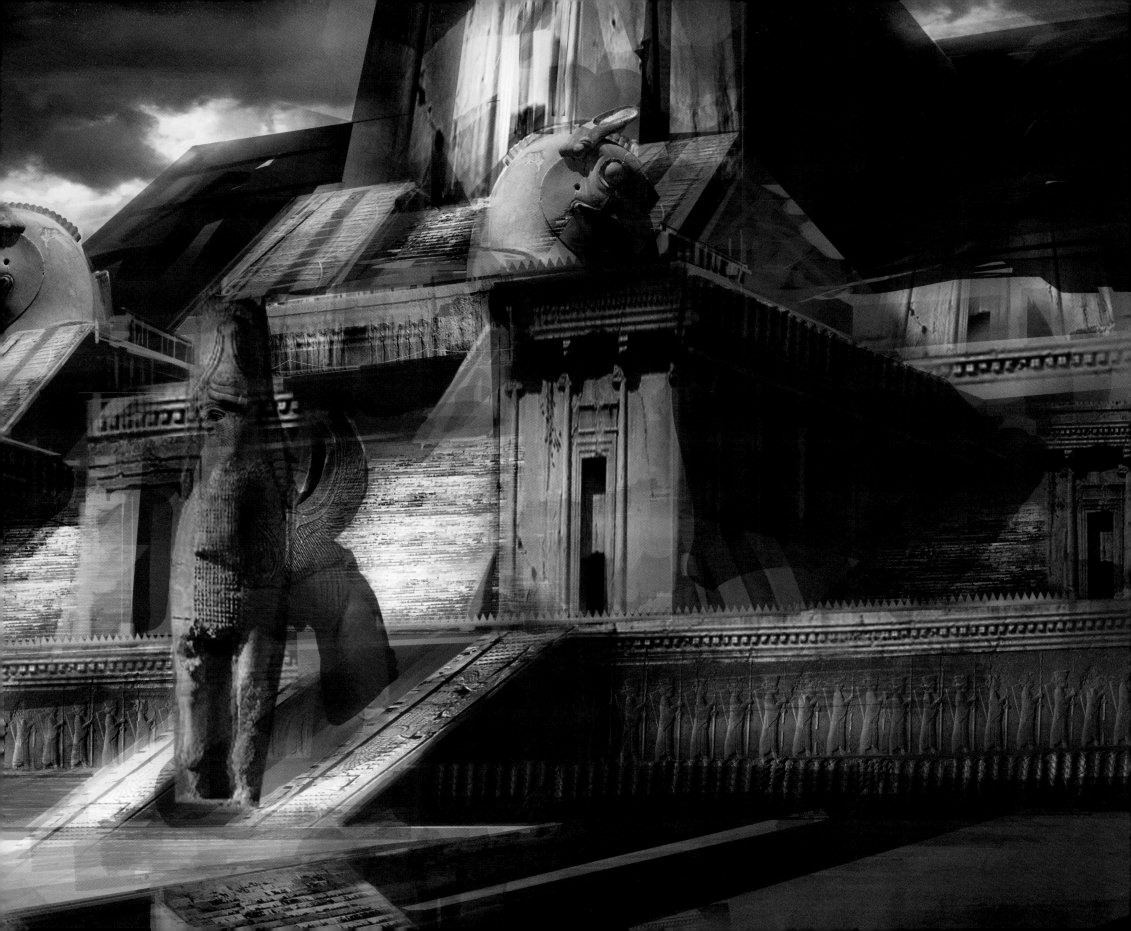

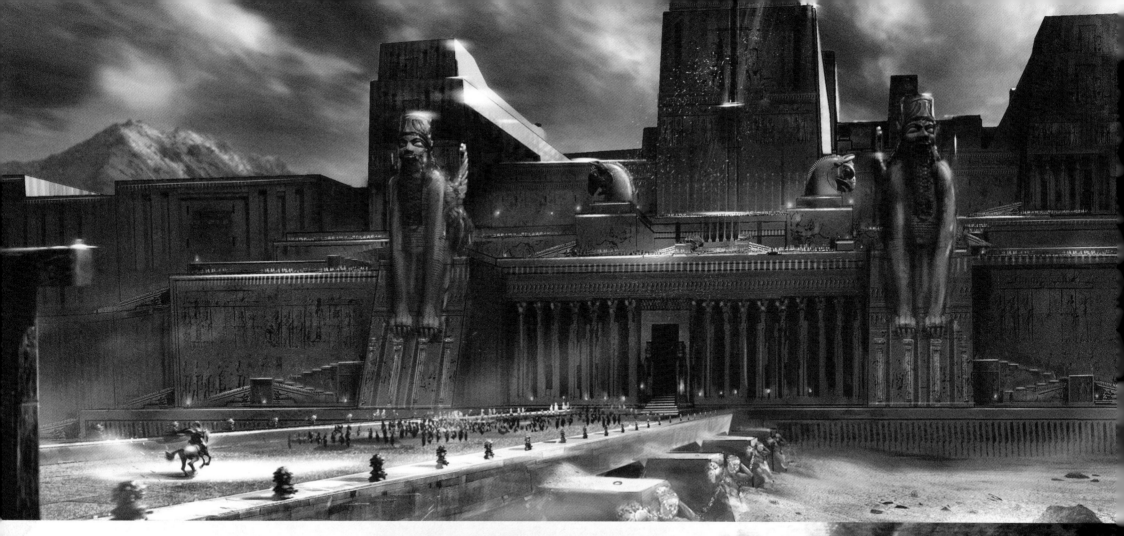

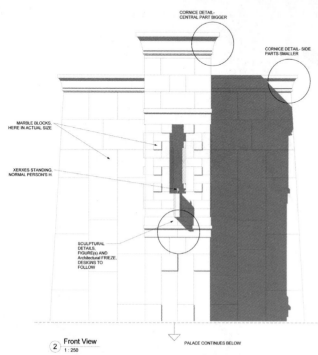

CORNICE DETAIL-
CENTRAL PART BIGGER

CORNICE DETAIL- SIDE
PARTS SMALLER

MARBLE BLOCKS,
HERE IN ACTUAL SIZE.

XERXES STANDING,
NORMAL PERSON'S H.

SCULPTURAL
DETAILS,
FIGURE(s) AND
Architectural FRIEZE,
DESIGNS TO
FOLLOW

2 **Front View**
 1 : 250

PALACE CONTINUES BELOW

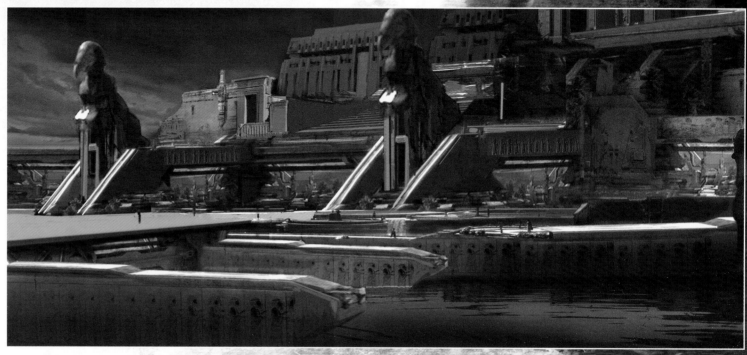

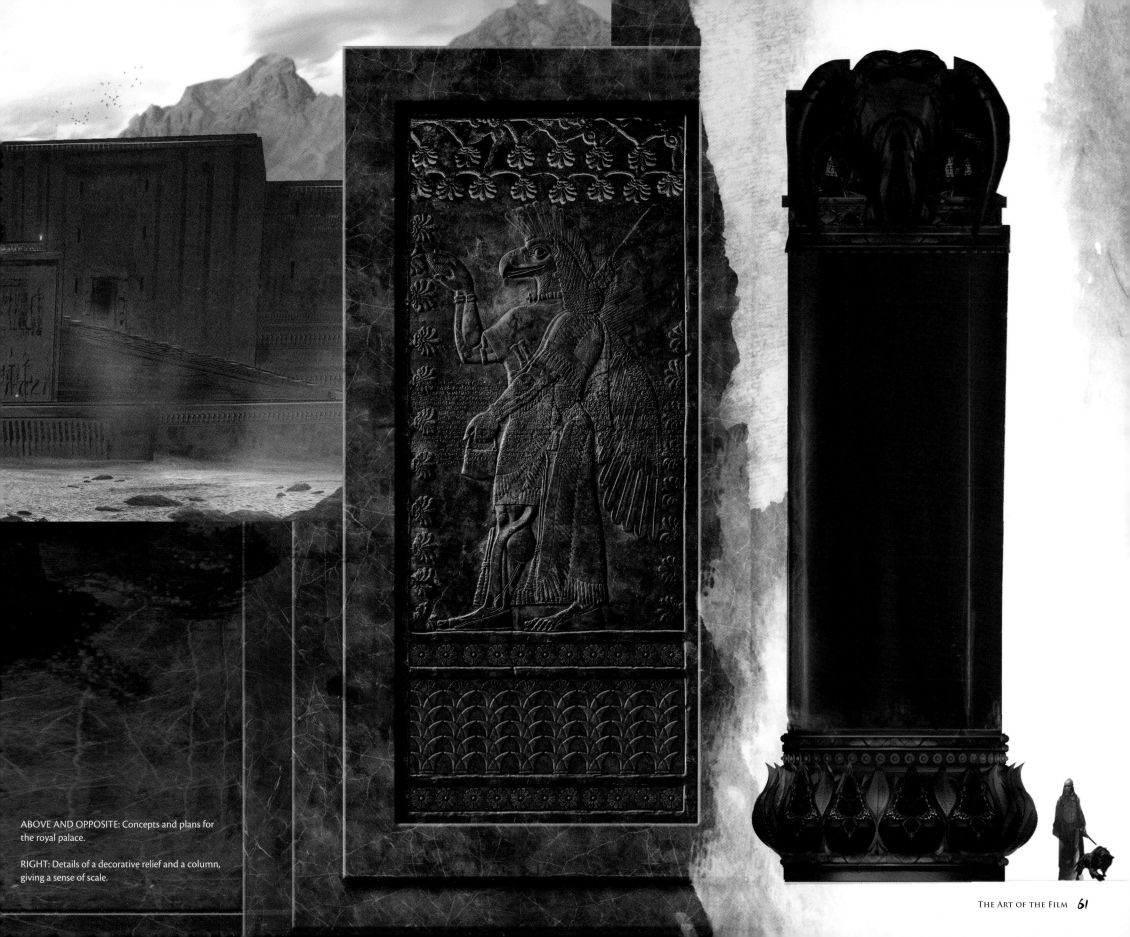

ABOVE AND OPPOSITE: Concepts and plans for the royal palace.

RIGHT: Details of a decorative relief and a column, giving a sense of scale.

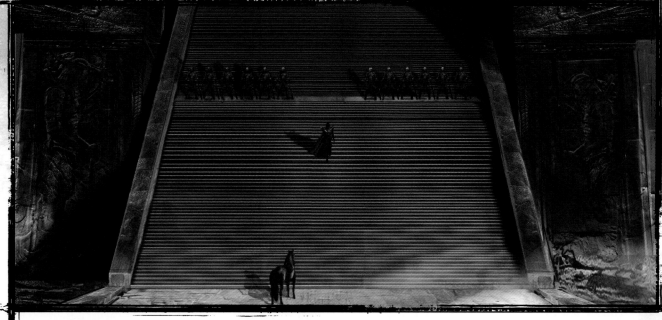

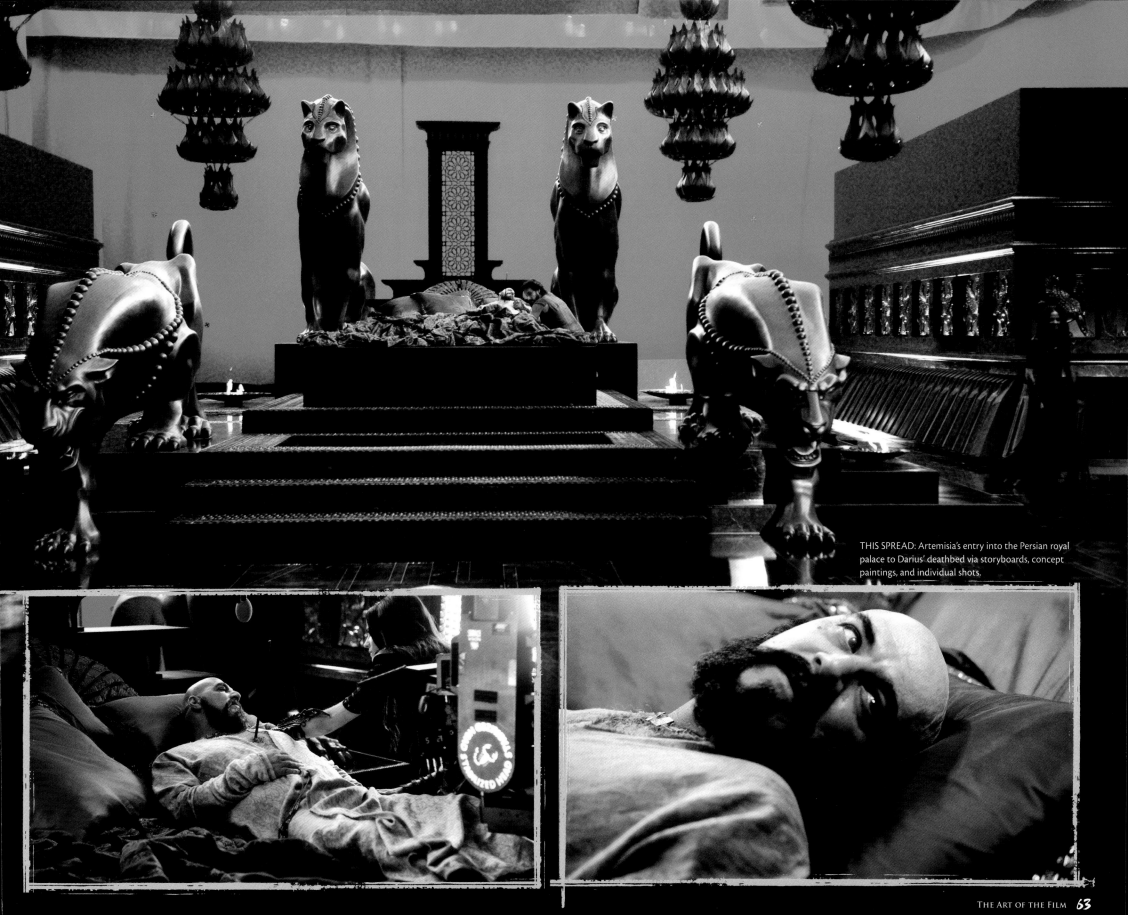

THIS SPREAD: Artemisia's entry into the Persian royal palace to Darius' deathbed via storyboards, concept paintings, and individual shots.

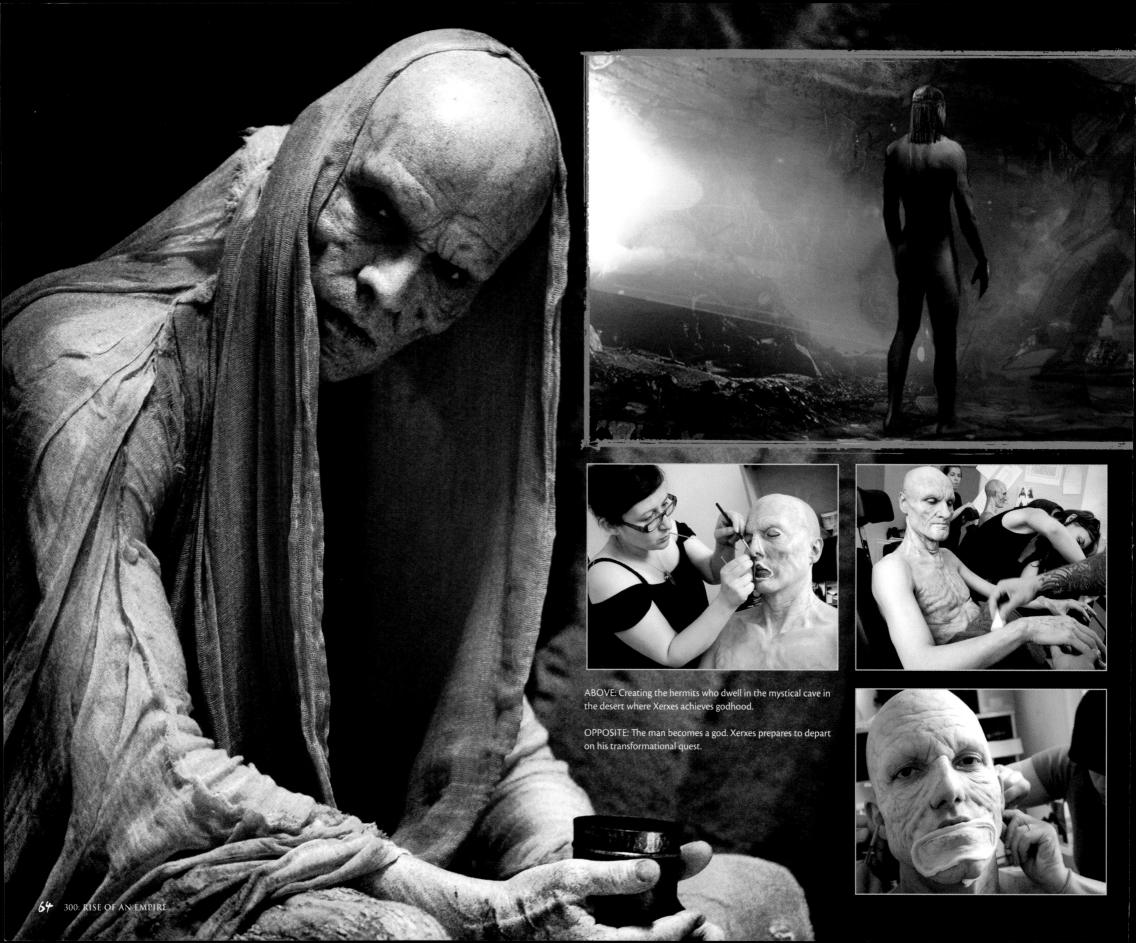

ABOVE: Creating the hermits who dwell in the mystical cave in the desert where Xerxes achieves godhood.

OPPOSITE: The man becomes a god. Xerxes prepares to depart on his transformational quest.

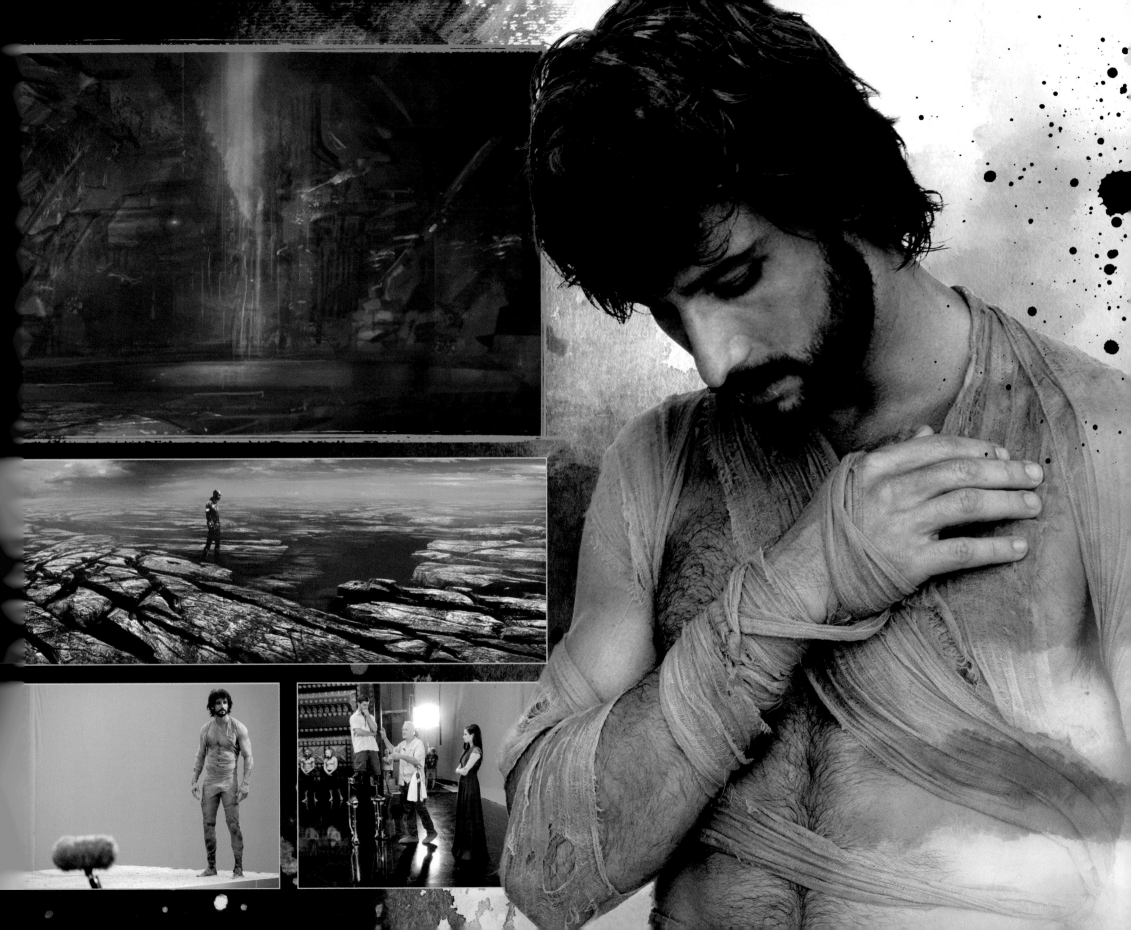

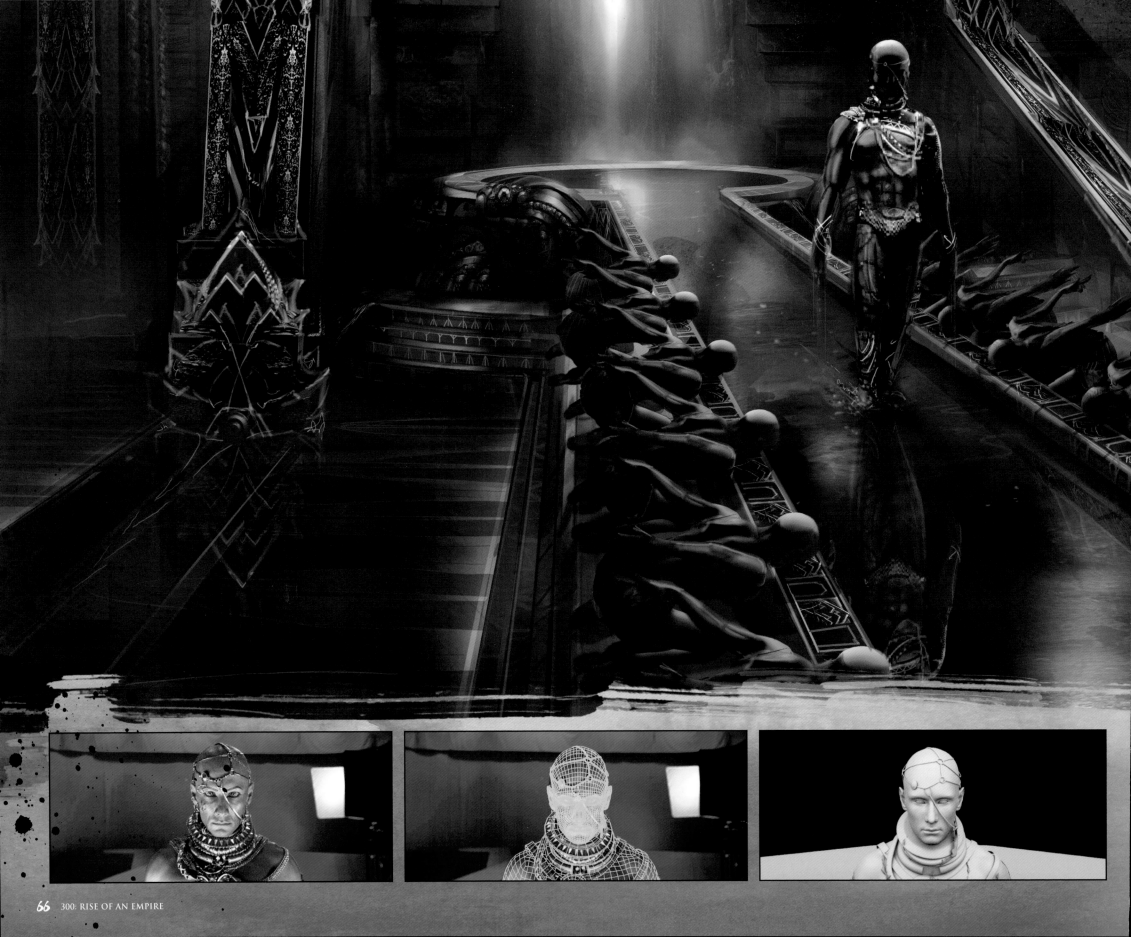

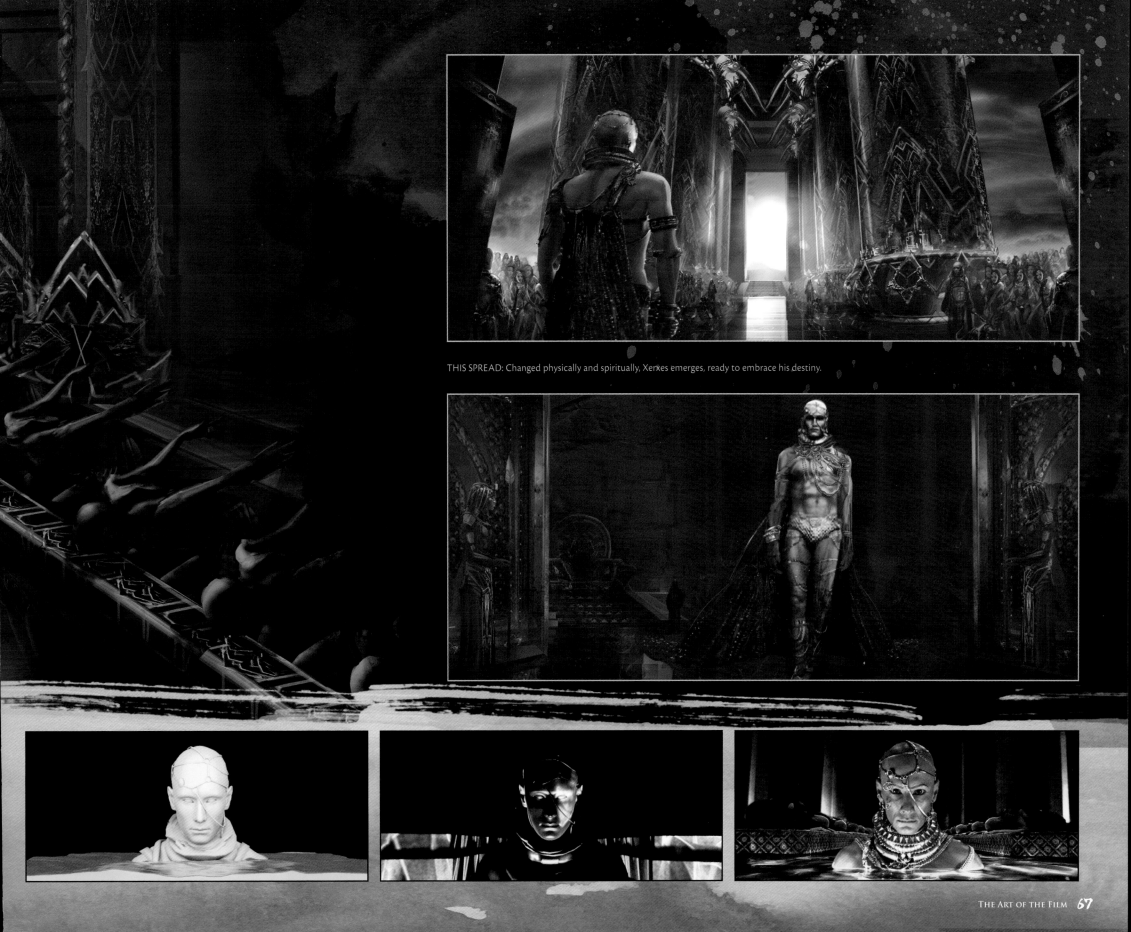

THIS SPREAD: Changed physically and spiritually, Xerxes emerges, ready to embrace his destiny.

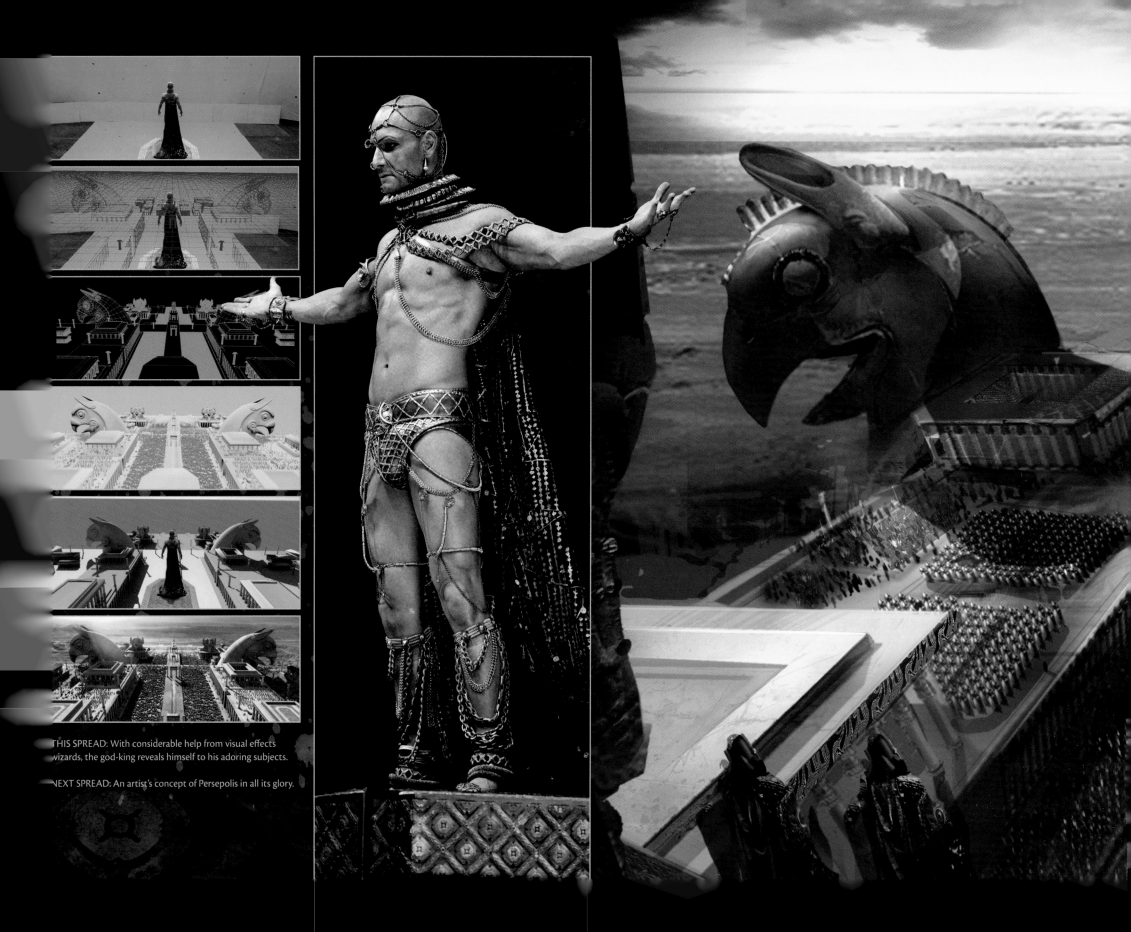

THIS SPREAD: With considerable help from visual effects wizards, the god-king reveals himself to his adoring subjects.

NEXT SPREAD: An artist's concept of Persepolis in all its glory.

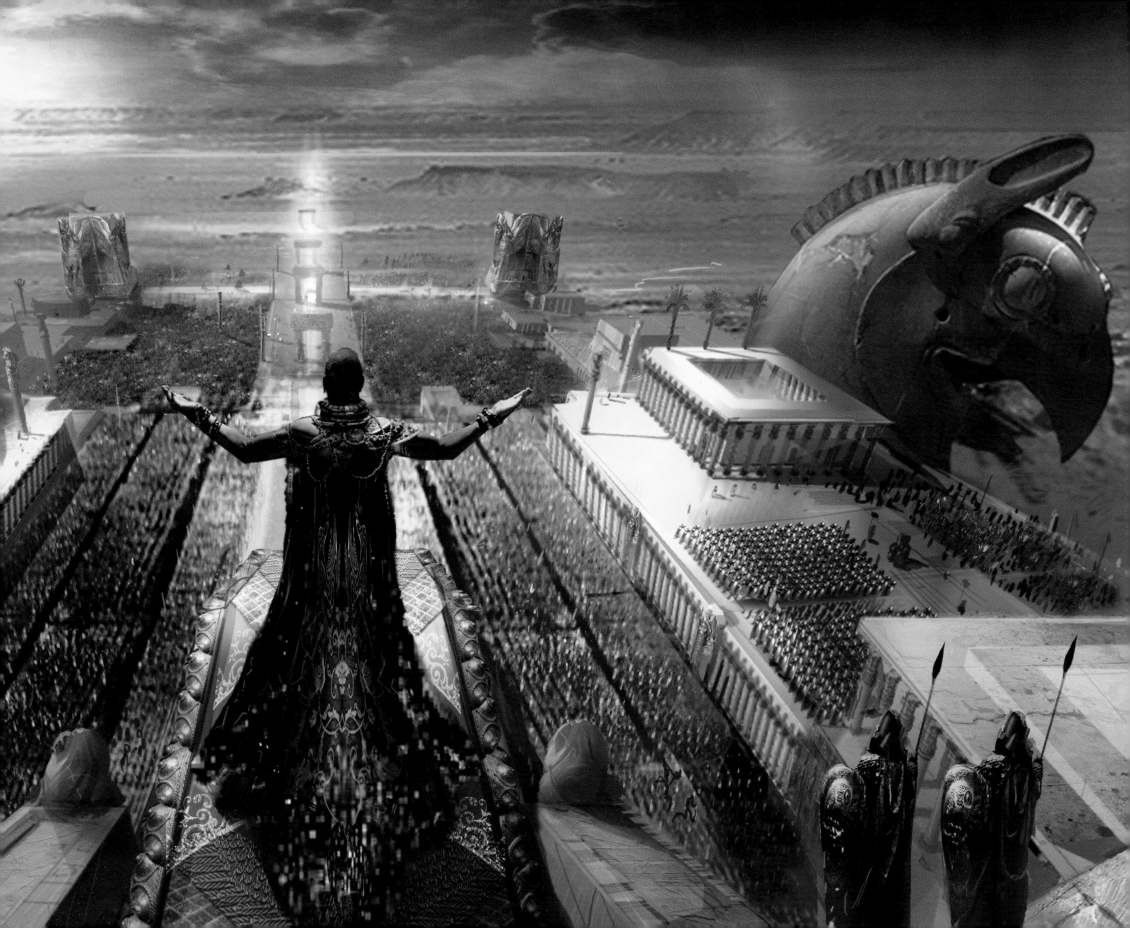

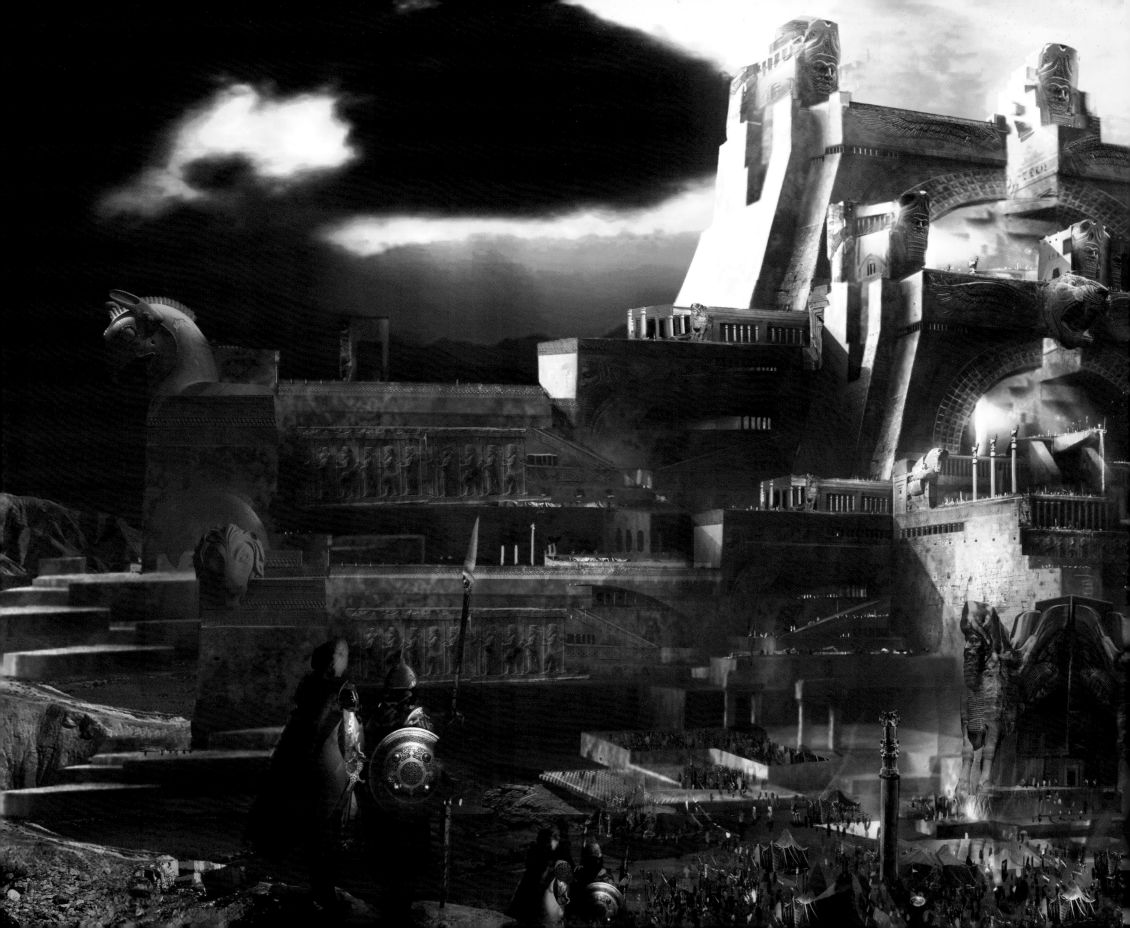

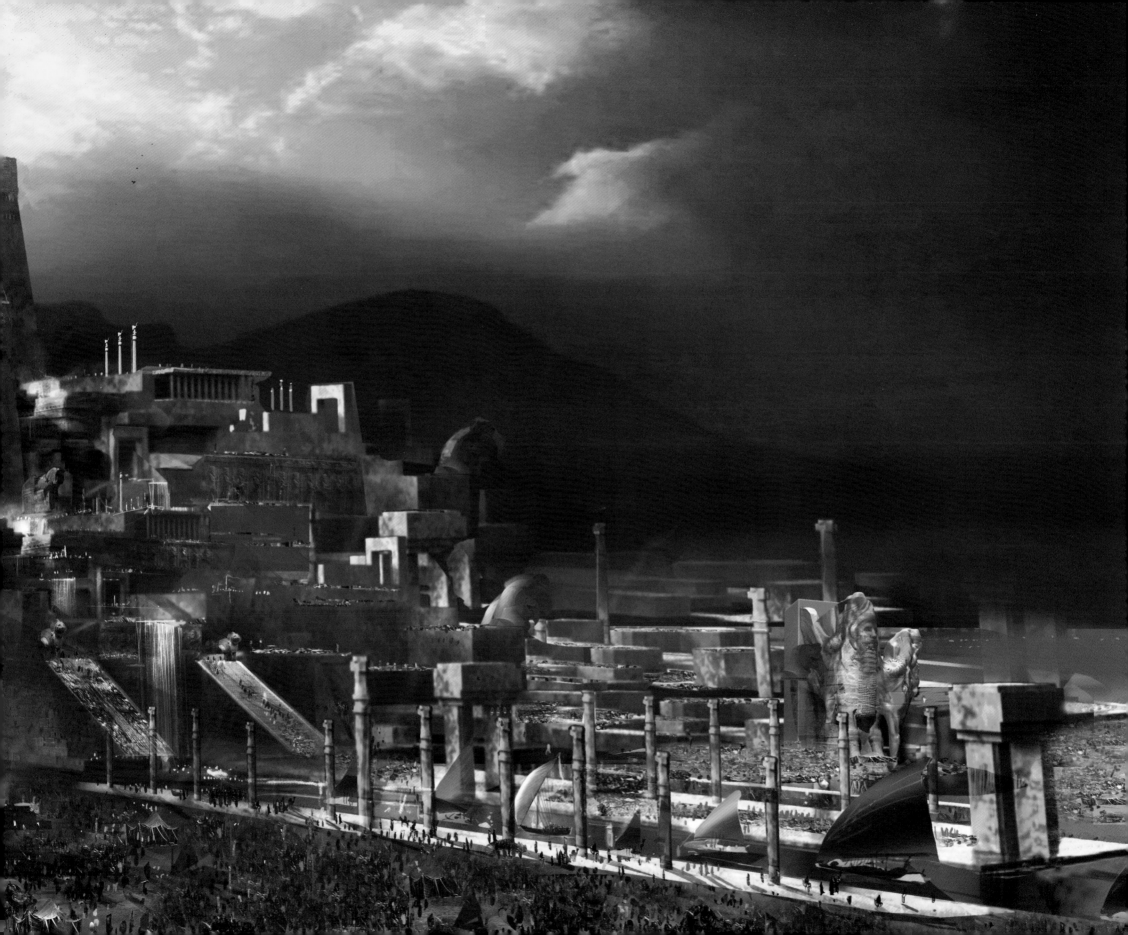

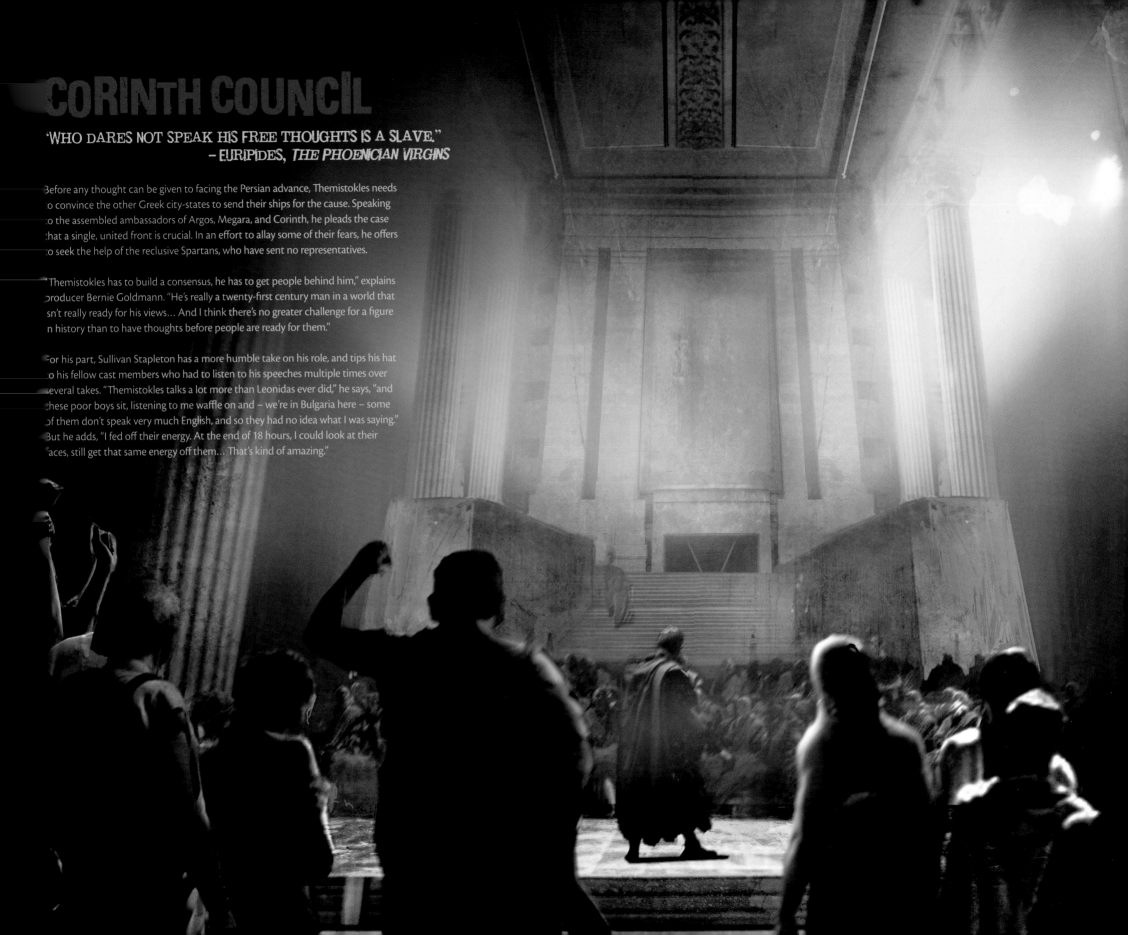

CORINTH COUNCIL

"WHO DARES NOT SPEAK HIS FREE THOUGHTS IS A SLAVE."
— EURIPIDES, *THE PHOENICIAN VIRGINS*

Before any thought can be given to facing the Persian advance, Themistokles needs to convince the other Greek city-states to send their ships for the cause. Speaking to the assembled ambassadors of Argos, Megara, and Corinth, he pleads the case that a single, united front is crucial. In an effort to allay some of their fears, he offers to seek the help of the reclusive Spartans, who have sent no representatives.

"Themistokles has to build a consensus, he has to get people behind him," explains producer Bernie Goldmann. "He's really a twenty-first century man in a world that isn't really ready for his views... And I think there's no greater challenge for a figure in history than to have thoughts before people are ready for them."

For his part, Sullivan Stapleton has a more humble take on his role, and tips his hat to his fellow cast members who had to listen to his speeches multiple times over several takes. "Themistokles talks a lot more than Leonidas ever did," he says, "and these poor boys sit, listening to me waffle on and – we're in Bulgaria here – some of them don't speak very much English, and so they had no idea what I was saying." But he adds, "I fed off their energy. At the end of 18 hours, I could look at their faces, still get that same energy off them... That's kind of amazing."

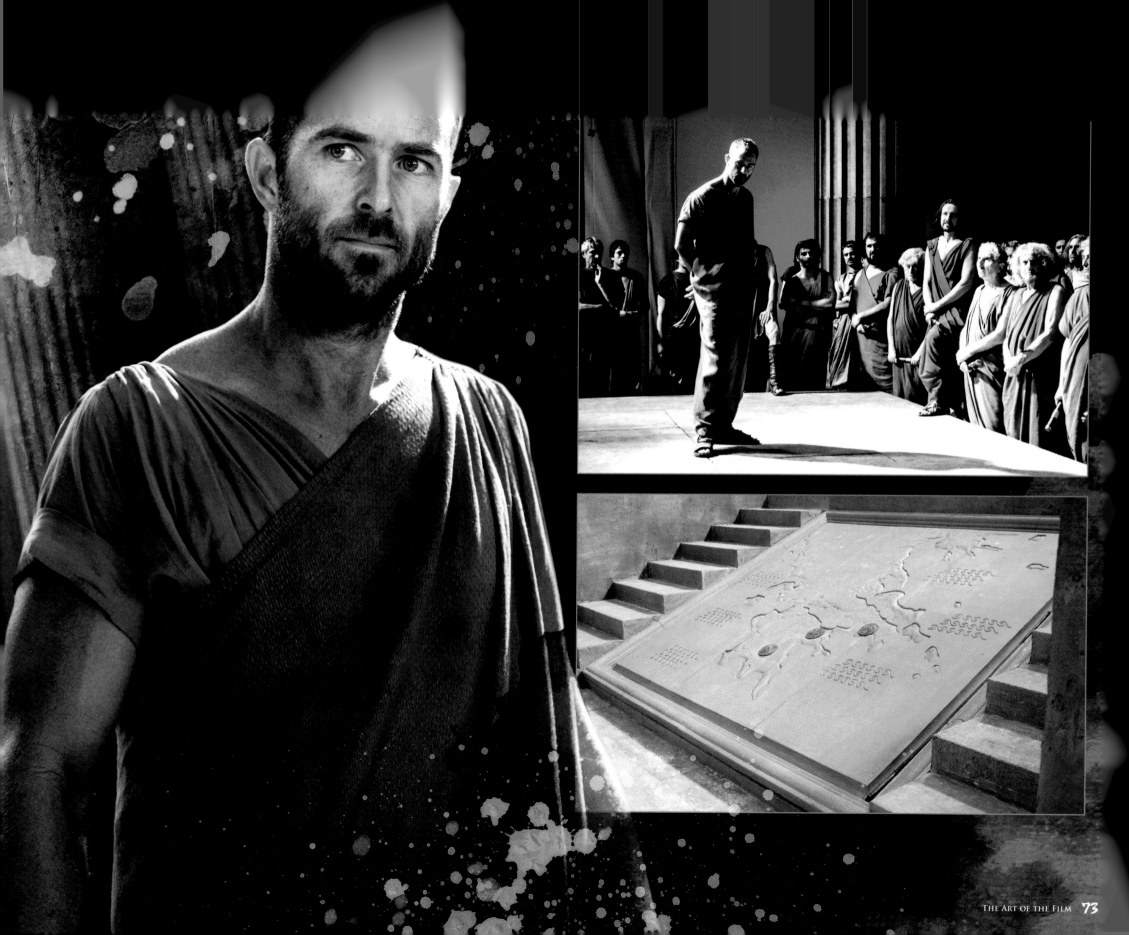

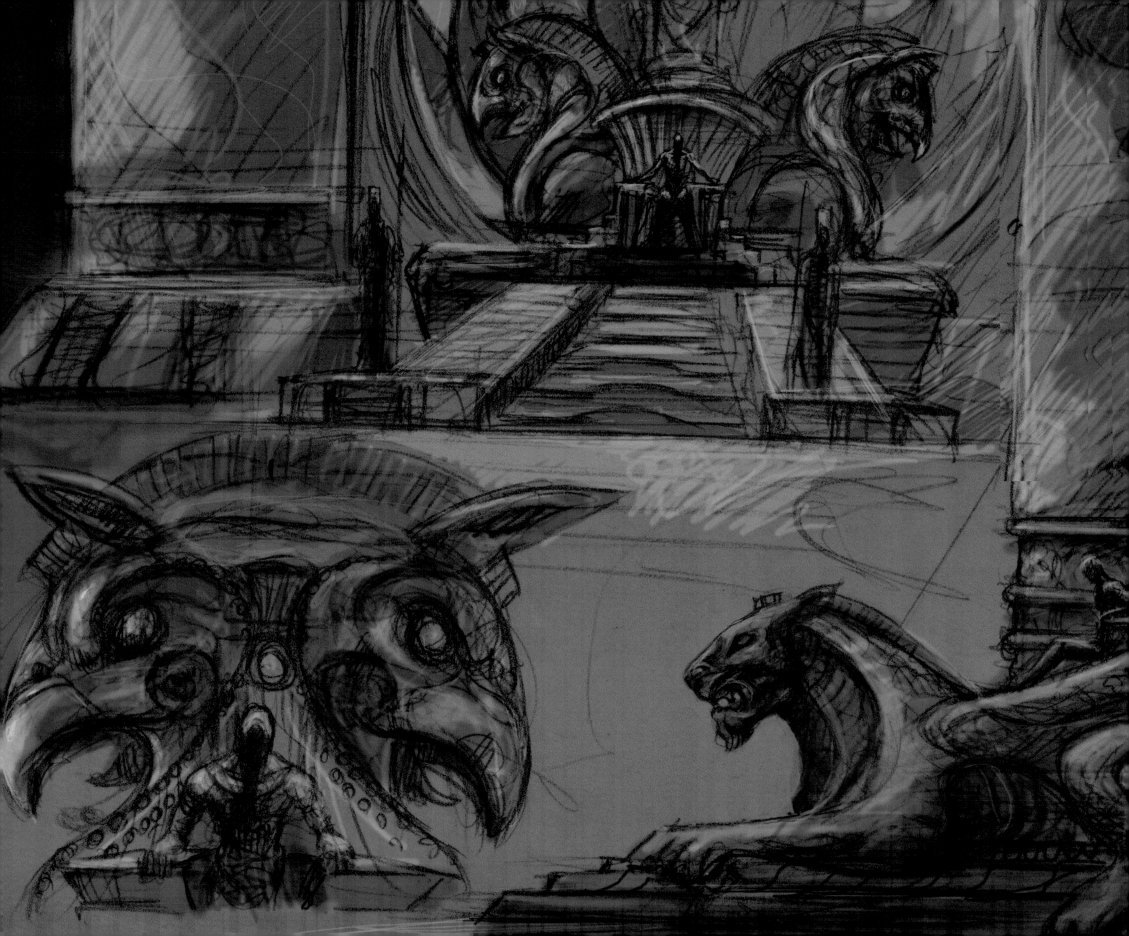

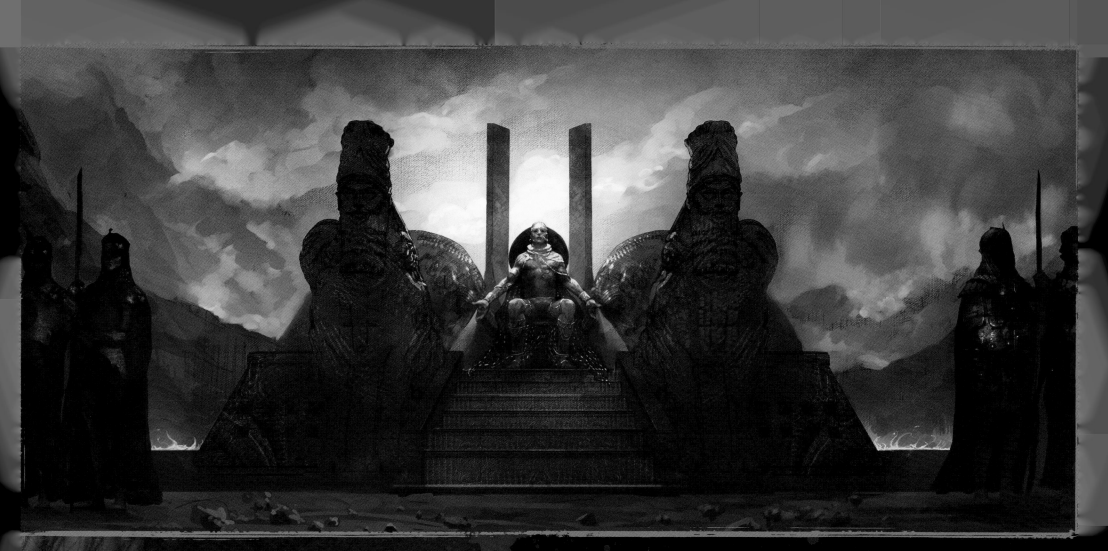

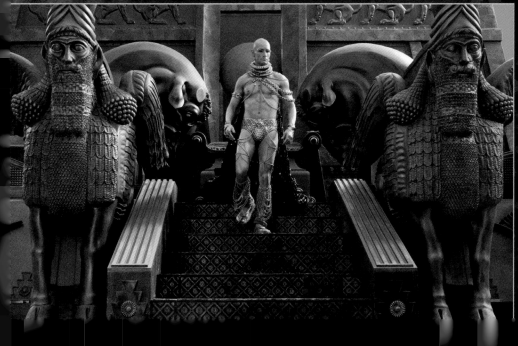

HELLESPONT

"HE DREAMED THAT HE COULD CHAIN, AS MEN CHAIN SLAVES,
THE HOLY HASTE OF HELLESPONTINE WAVES..." – AESKYLOS, THE PERSIANS

Xerxes' invasion force is so vast it must travel to Greece by both land and sea, requiring the unprecedented construction of a bridge between Europe and Asia over the surging waters of the Hellespont. There are some who claim that this is an act of supreme hubris that invites retribution from the gods themselves...

One of the many challenges in making a film of this scope, which uses considerable green screen for computer-generated (CG) backgrounds, is to keep the practical terrain the performers interact with not only varied and interesting, but also easy to alter and cost effective. Production Designer Patrick Tatopoulos took a lesson from the original 300 to solve this problem. "We had long skips, which were simply hills and a little valley at the bottom..." he explains. "We changed the actual ground texture, went from rocks to dirt to mud to green to whatever. You can reinvent the world in a second."

A similar flexibility was required from the armament used onscreen. For each model of sword there might be one incarnation made from rubber with a copper, fiberglass, and steel core for fighting; a half- or three-quarters length blade (to be extended by CGI) used for body strikes; a less wobbly aluminum copy for slow-motion shots, and a fully steel version for close-ups where no fighting is involved.

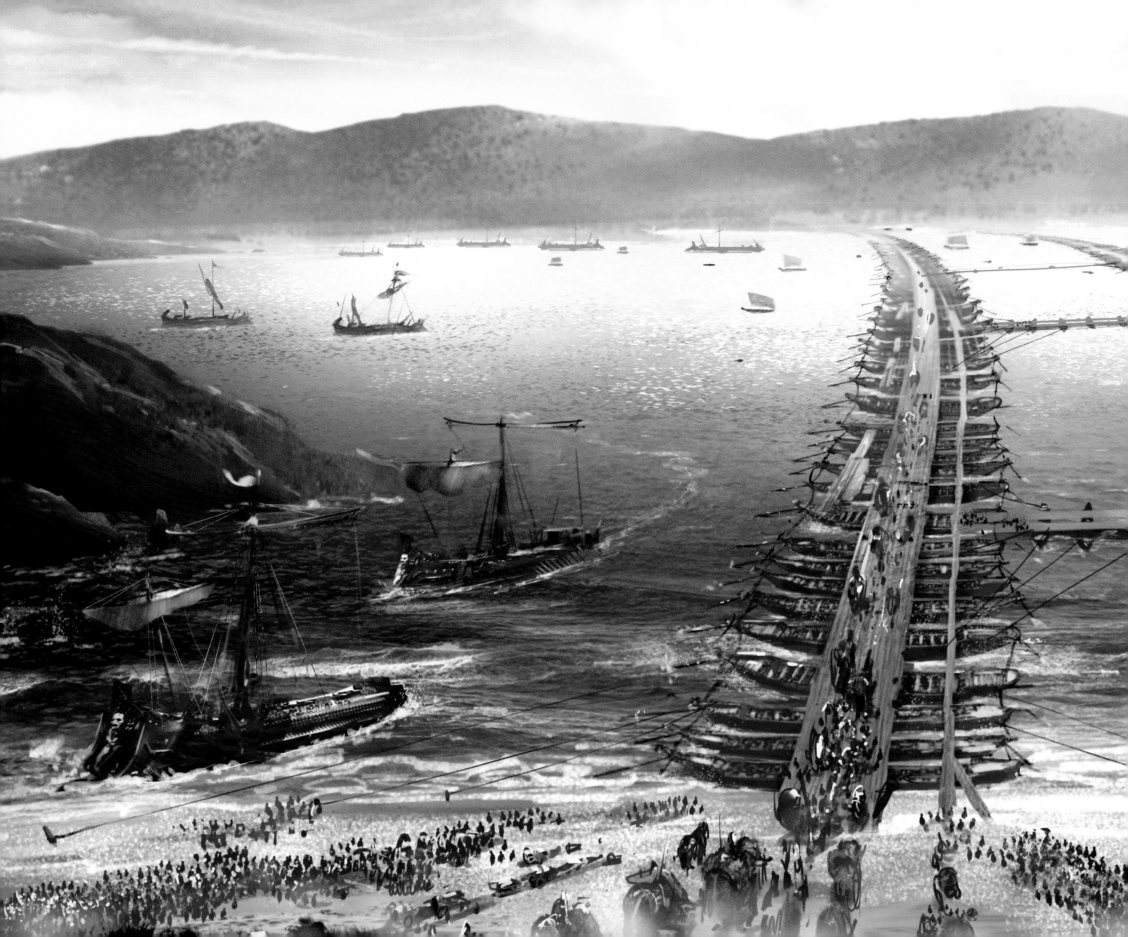

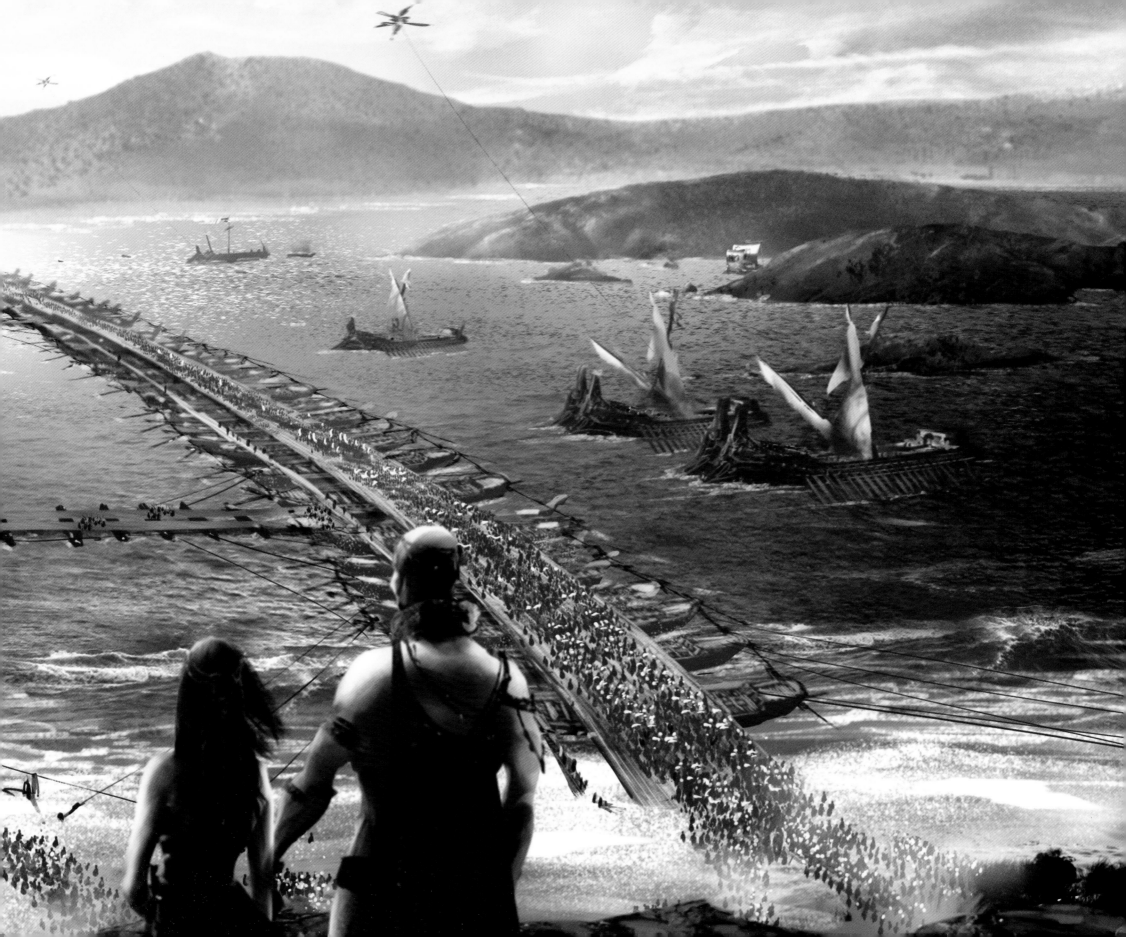

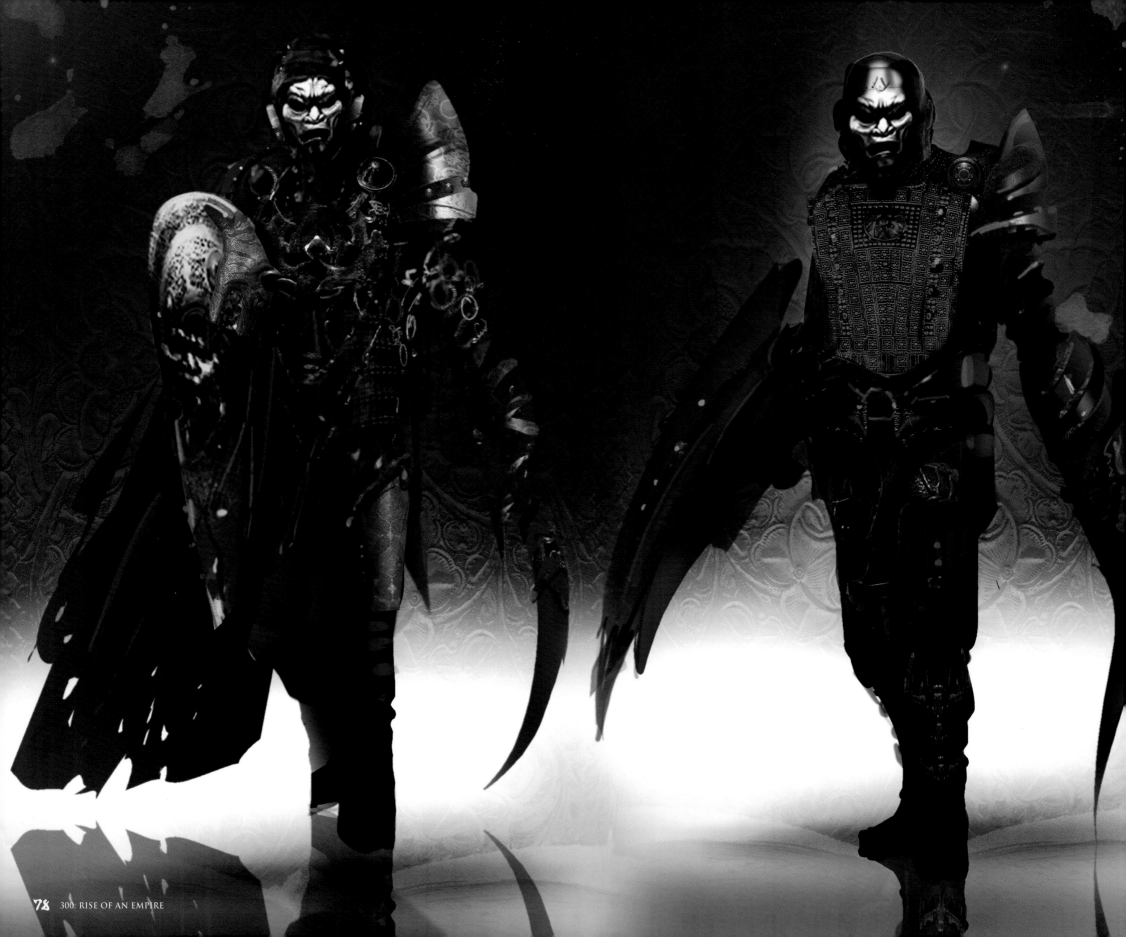

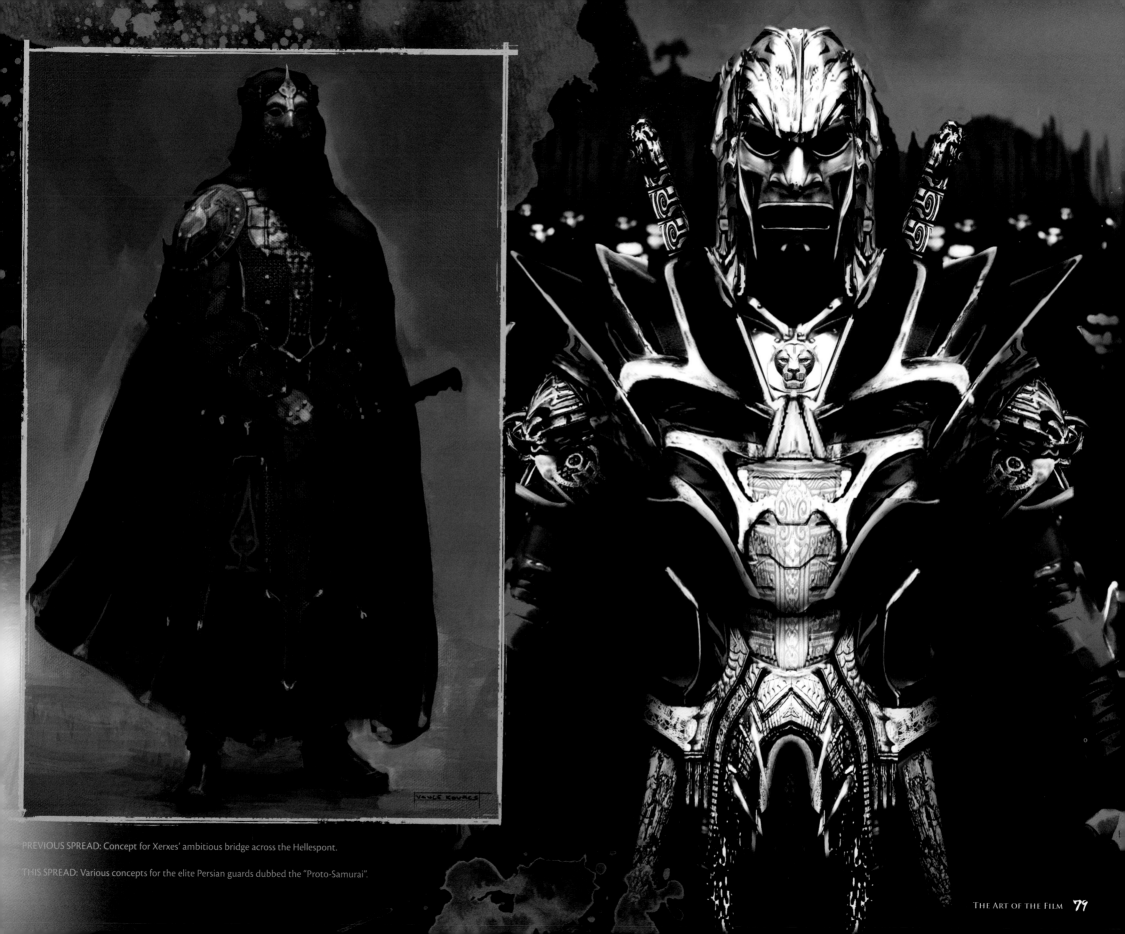

PREVIOUS SPREAD: Concept for Xerxes' ambitious bridge across the Hellespont.

THIS SPREAD: Various concepts for the elite Persian guards dubbed the "Proto-Samurai".

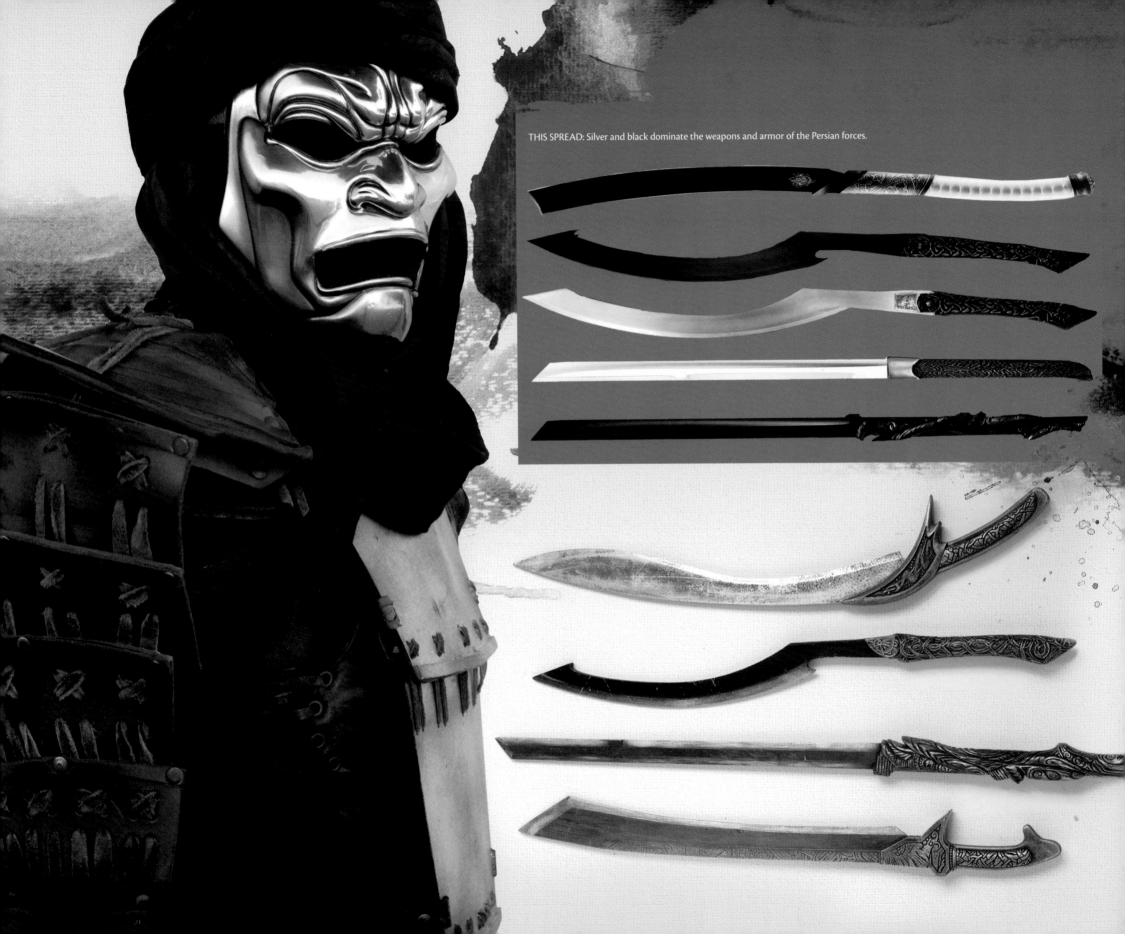

THIS SPREAD: Silver and black dominate the weapons and armor of the Persian forces.

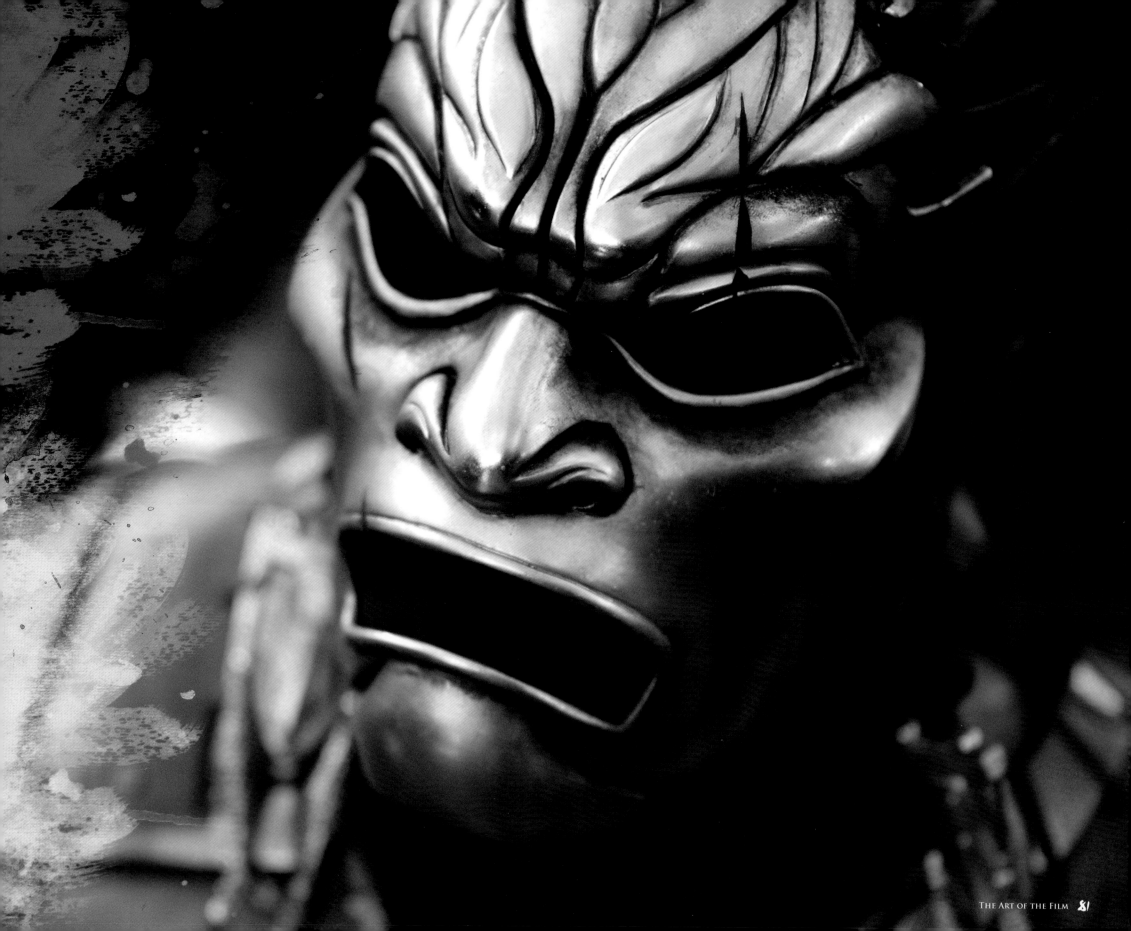

SPARTA

"WITHOUT A SIGN, HIS SWORD THE BRAVE MAN DRAWS,
AND ASKS NO OMEN, BUT HIS COUNTRY'S CAUSE."

– HOMER, *THE ILIAD*

While you could call *300: Rise of an Empire* a homecoming of sorts for many of the actors
and producers, it was almost literally that for production designer Patrick Tatopoulos.
"My roots are Greek and my family on my father's side is actually from Sparta, which is even
more incredible," he explains. "When I heard *300* was back, I said, 'I need to do this.'"

Landing the job allowed him to add certain personal touches to the landscape, such as a
recreation of a small parcel of his own property in southern Greece. "We dressed a little
corner piece with a tree, a bit of grass… It made me feel the emotion I feel when I'm in
Greece," Tatopoulos says.

For Sparta itself, although we do not visit precisely the same locations as in the first film,
Tatopoulos and Murro made the conscious choice not to reinvent the wheel. "We're going
to make it exactly the same: the shape of the columns, the way the city's set up," explains
Tatopoulous. "When you drop back into Sparta, you know you're in the same time period,
and in the same movie in some ways."

And that familiar Sparta, that forge of unparalleled warriors, as expressed in the
architecture, is an overwhelmingly austere and utilitarian place. It is a city where roles are
carved out at birth, where all are bred to hold order and duty as sacrosanct. "In Sparta, you
really know your place," says Zack Snyder. "You're not going to get ahead. You're either a

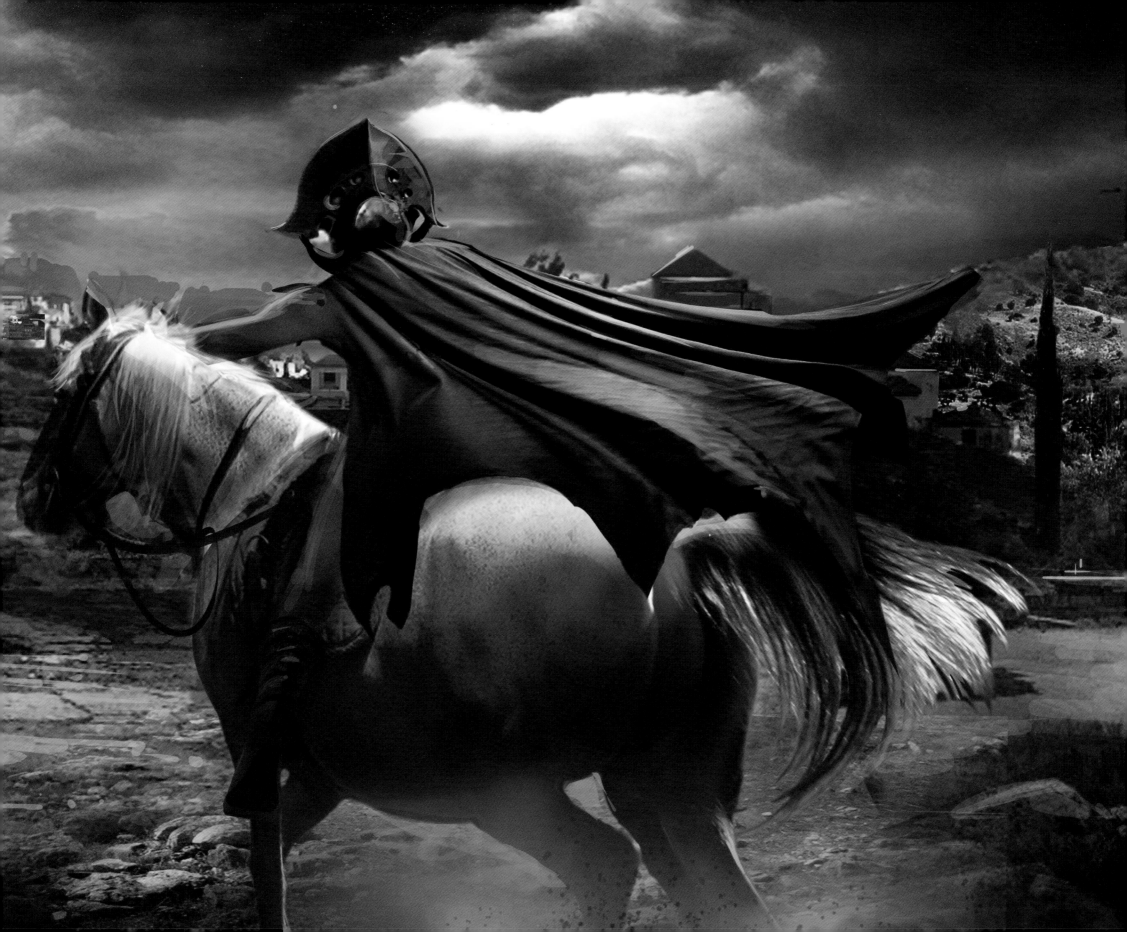

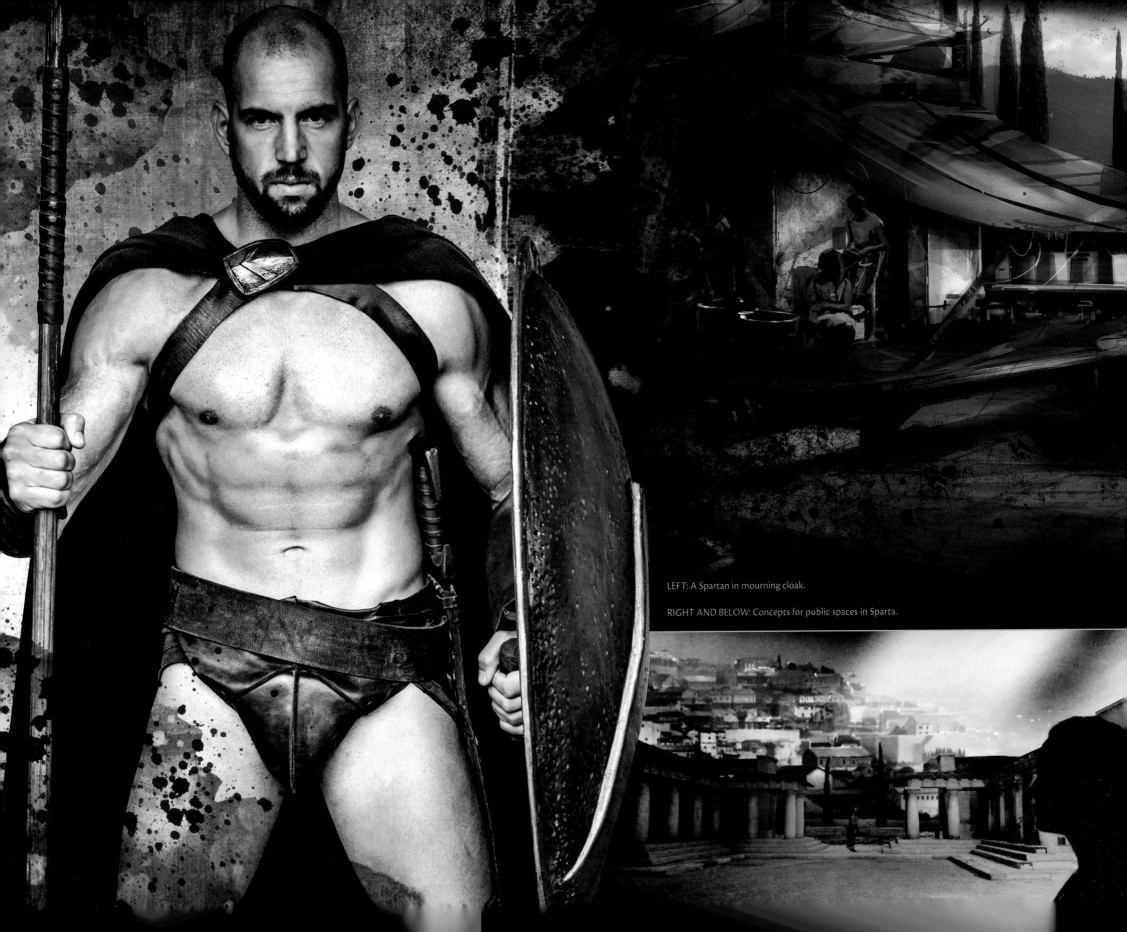

LEFT: A Spartan in mourning cloak.

RIGHT AND BELOW: Concepts for public spaces in Sparta.

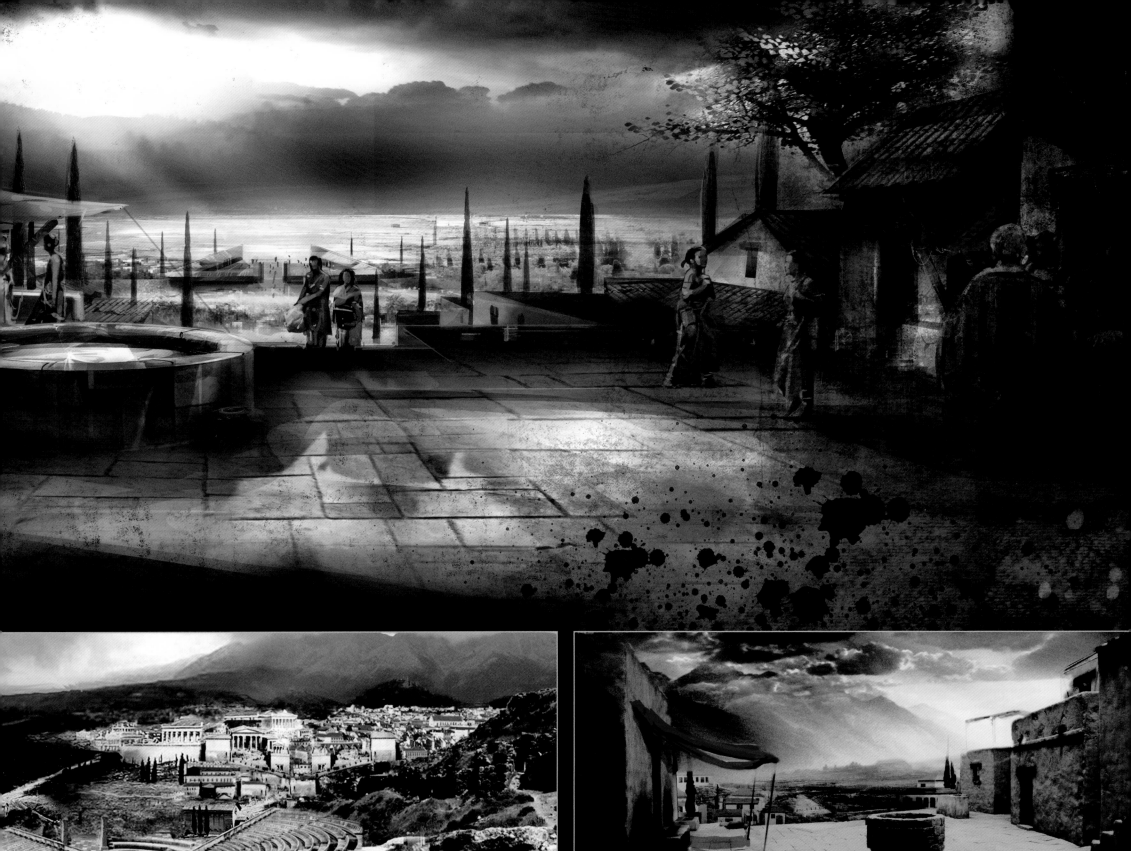

LAURENT BEN-MIMOUN

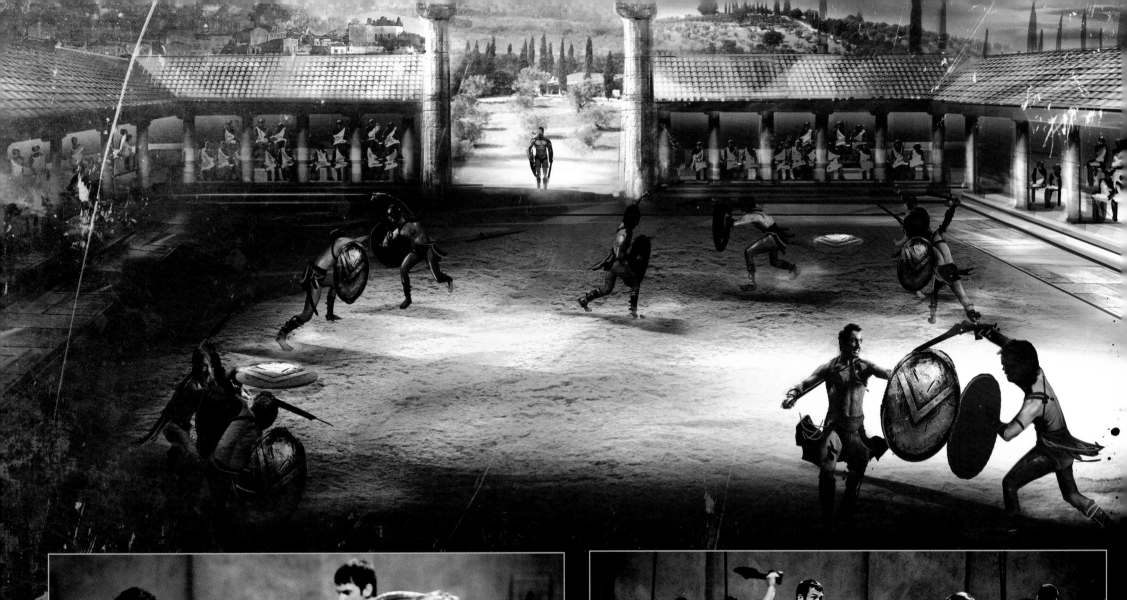

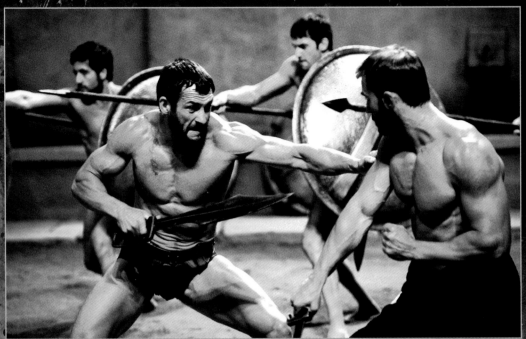

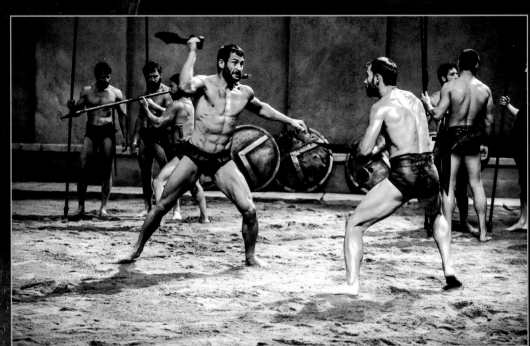

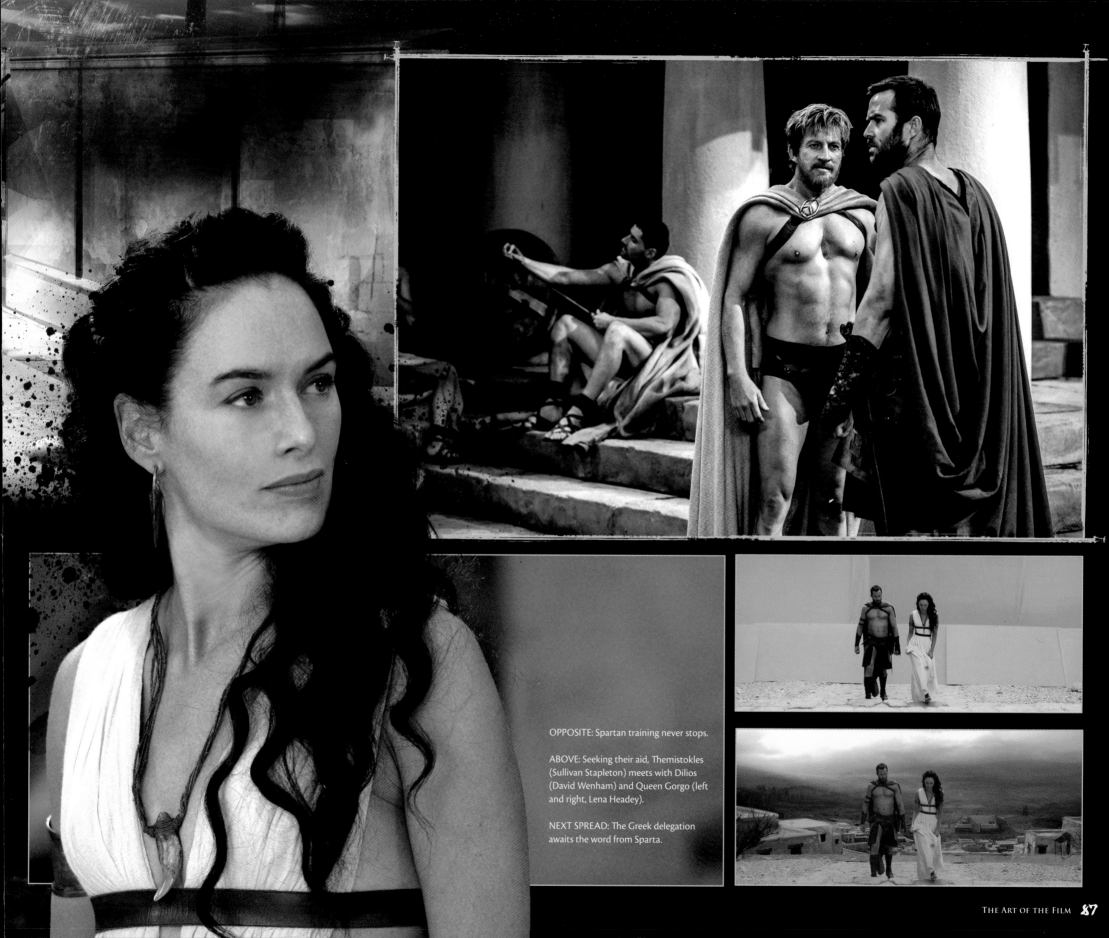

OPPOSITE: Spartan training never stops.

ABOVE: Seeking their aid, Themistokles (Sullivan Stapleton) meets with Dilios (David Wenham) and Queen Gorgo (left and right, Lena Headey).

NEXT SPREAD: The Greek delegation awaits the word from Sparta.

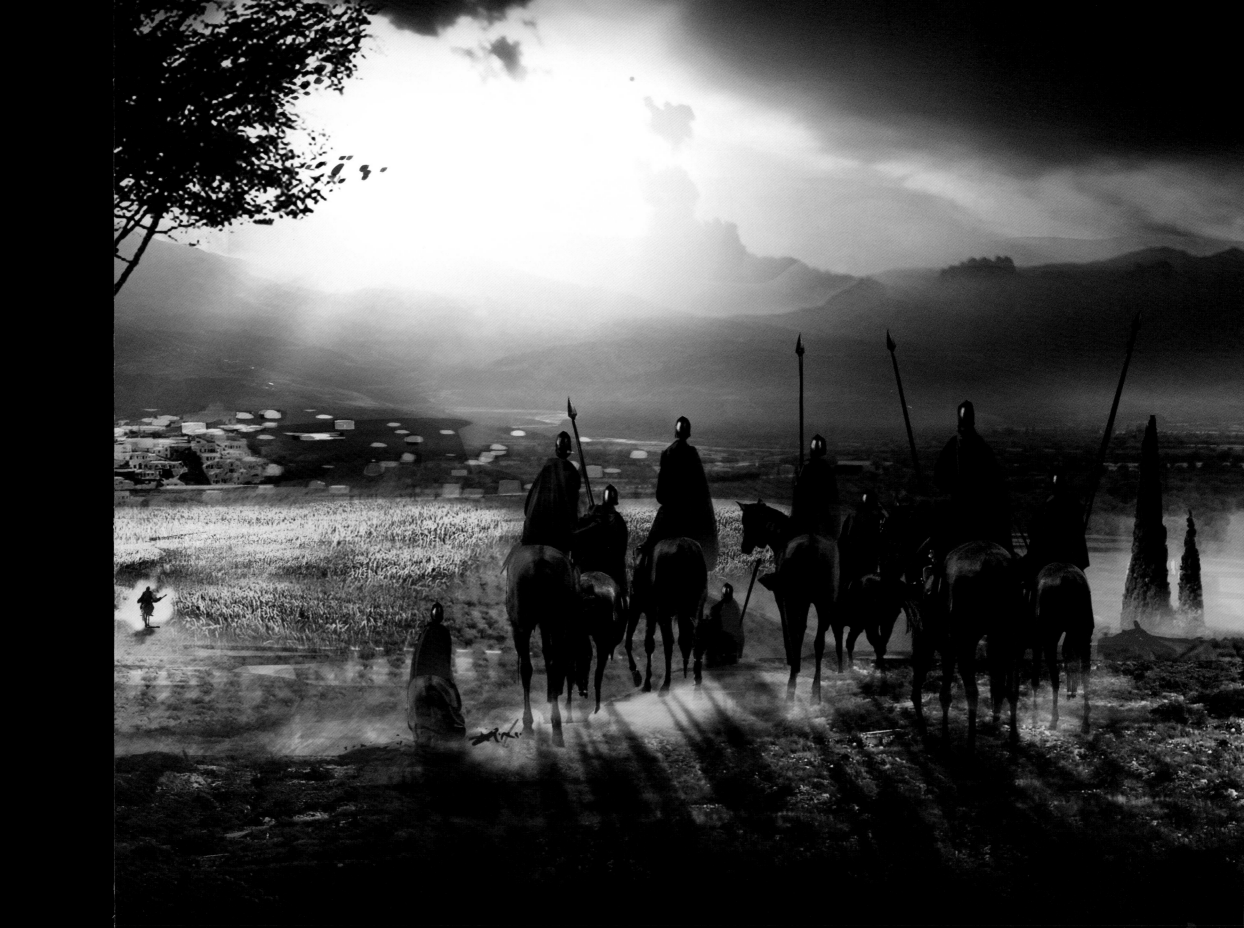

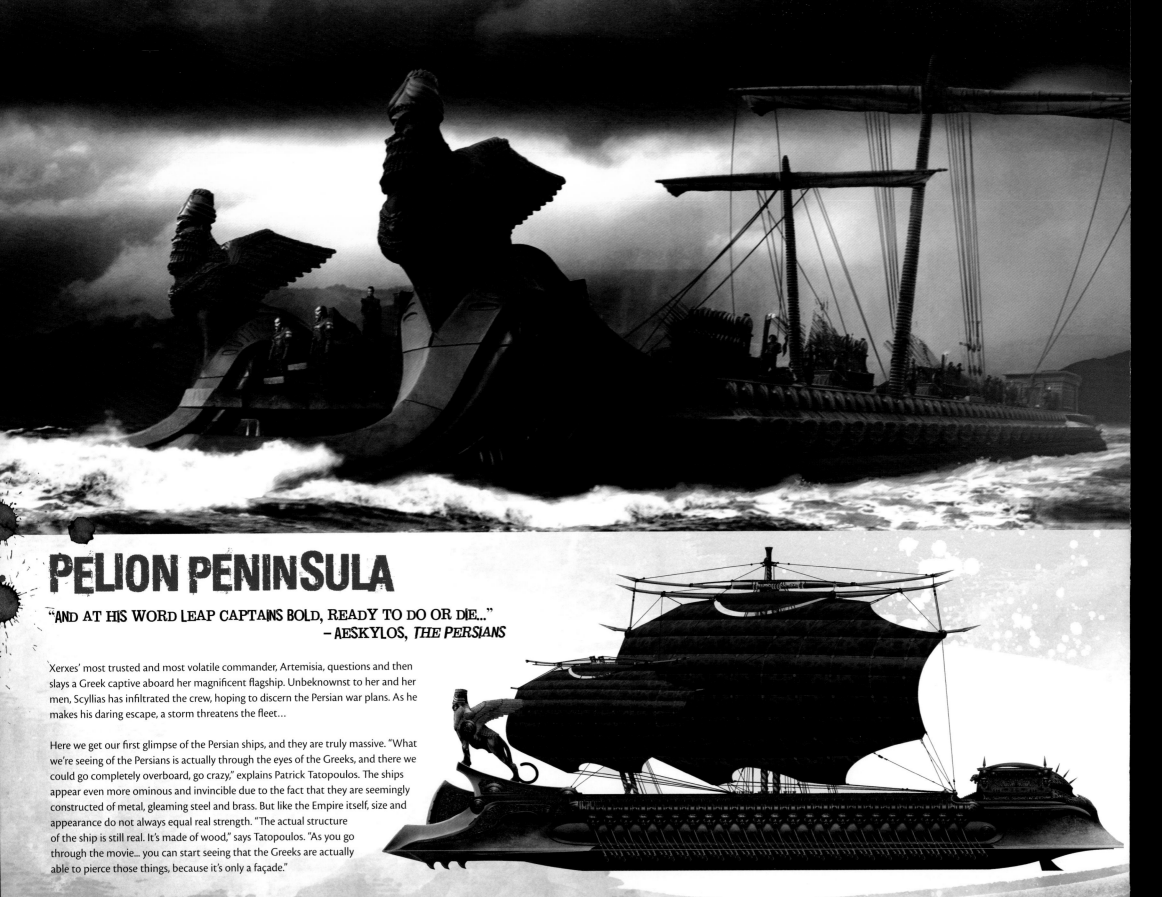

PELION PENINSULA

"AND AT HIS WORD LEAP CAPTAINS BOLD, READY TO DO OR DIE..."
– AESKYLOS, *THE PERSIANS*

Xerxes' most trusted and most volatile commander, Artemisia, questions and then slays a Greek captive aboard her magnificent flagship. Unbeknownst to her and her men, Scyllias has infiltrated the crew, hoping to discern the Persian war plans. As he makes his daring escape, a storm threatens the fleet...

Here we get our first glimpse of the Persian ships, and they are truly massive. "What we're seeing of the Persians is actually through the eyes of the Greeks, and there we could go completely overboard, go crazy," explains Patrick Tatopoulos. The ships appear even more ominous and invincible due to the fact that they are seemingly constructed of metal, gleaming steel and brass. But like the Empire itself, size and appearance do not always equal real strength. "The actual structure of the ship is still real. It's made of wood," says Tatopoulos. "As you go through the movie... you can start seeing that the Greeks are actually able to pierce those things, because it's only a façade."

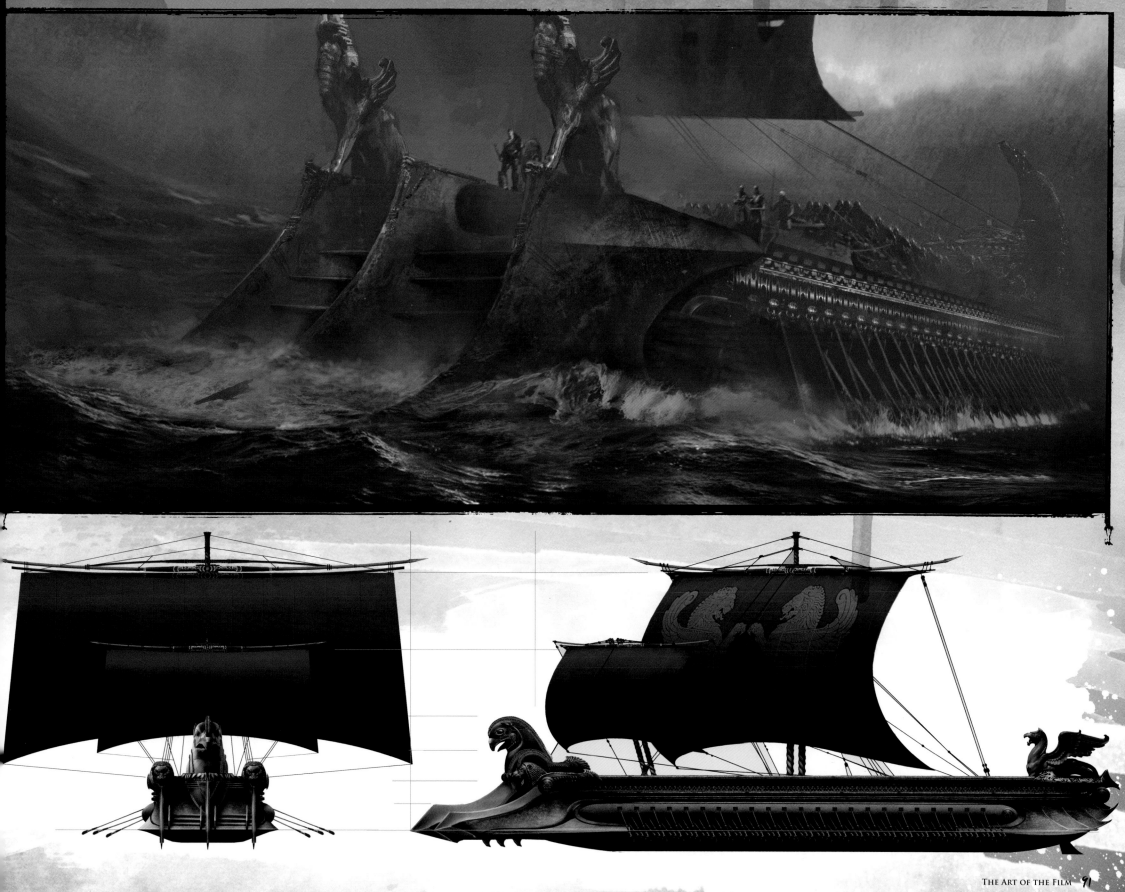

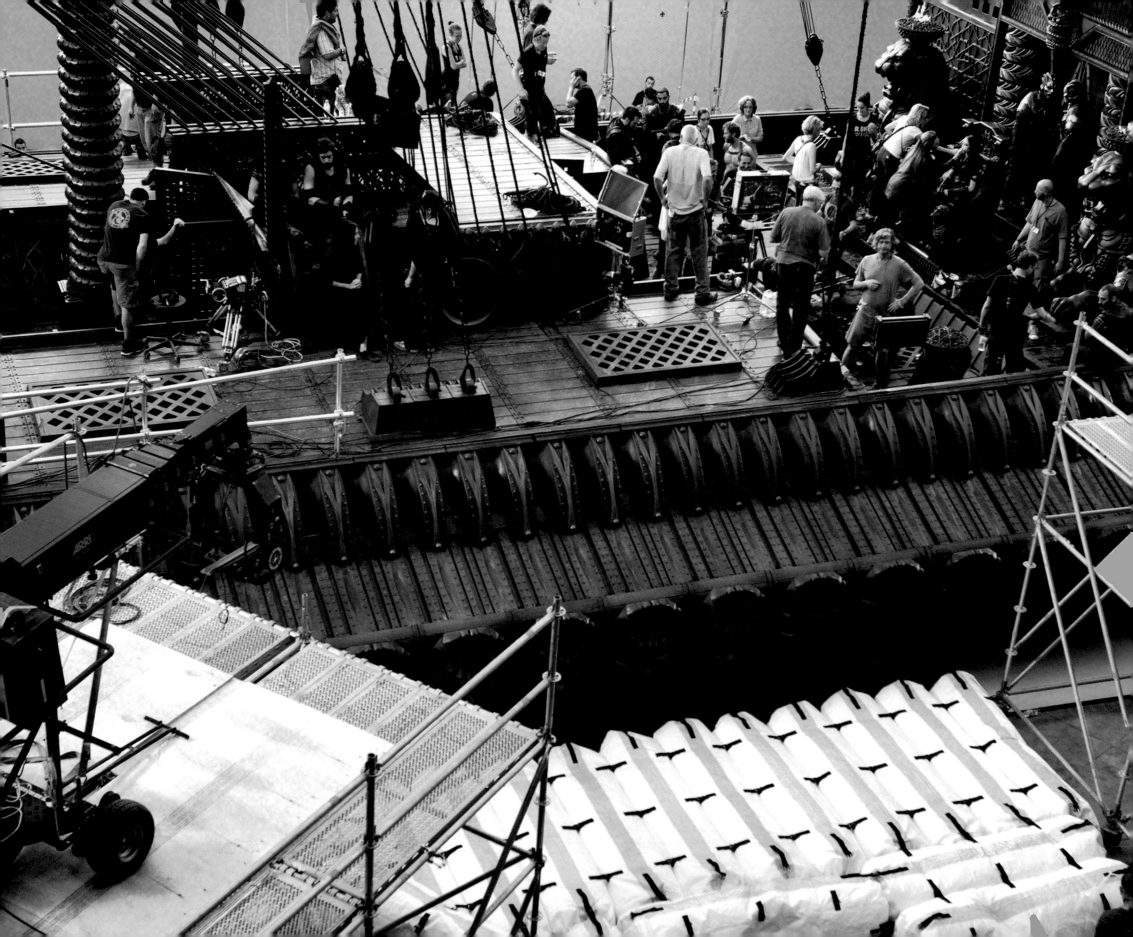

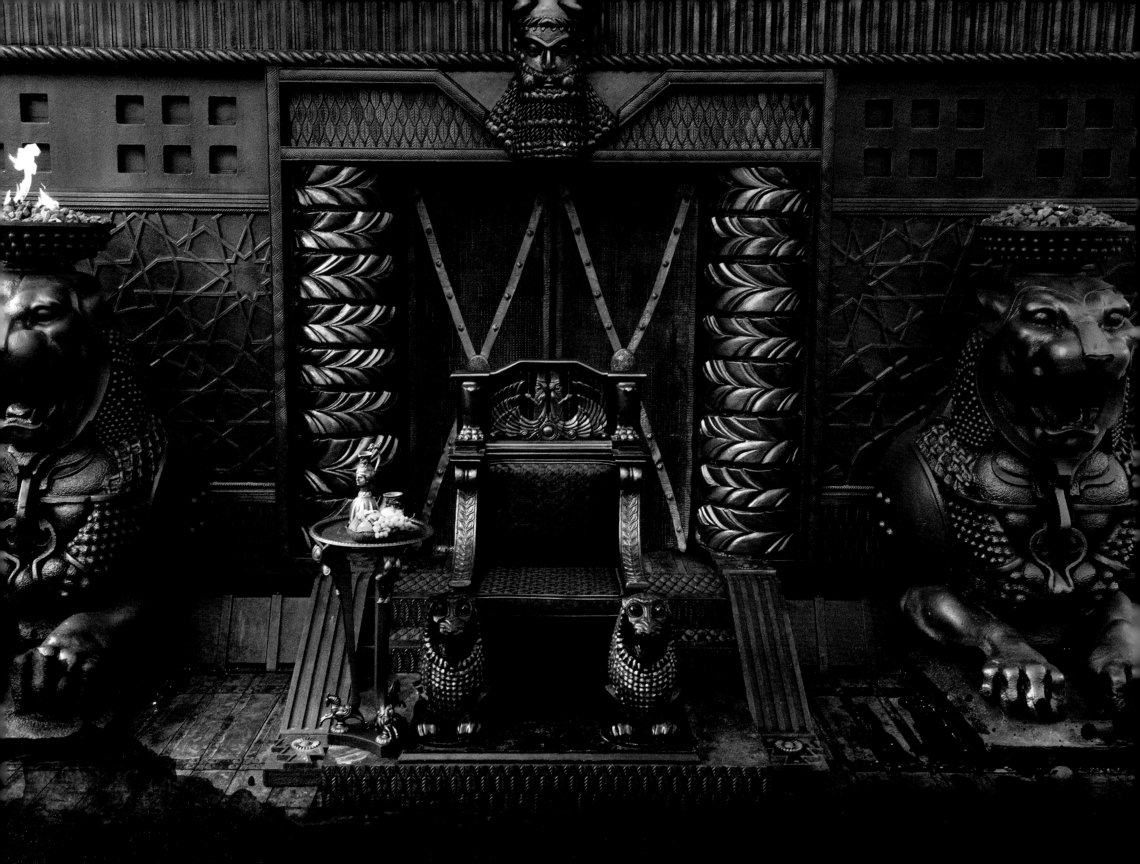

THIS SPREAD: Artemisia's ornate flagship requires a sizeable crew.

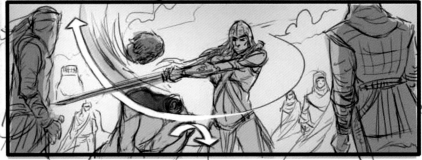

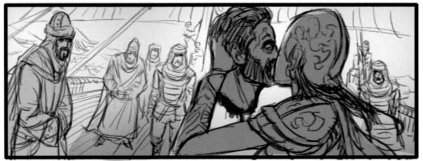

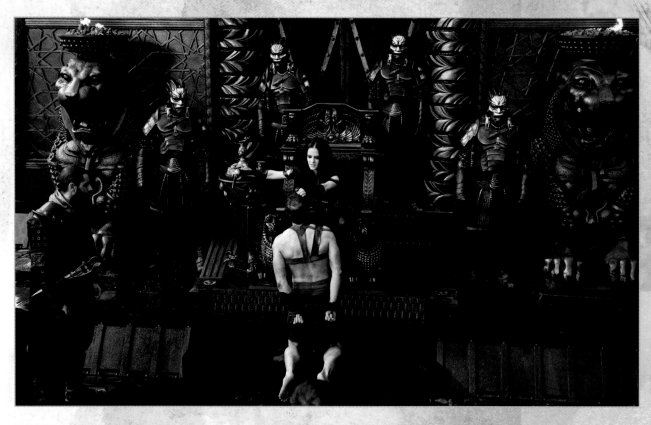

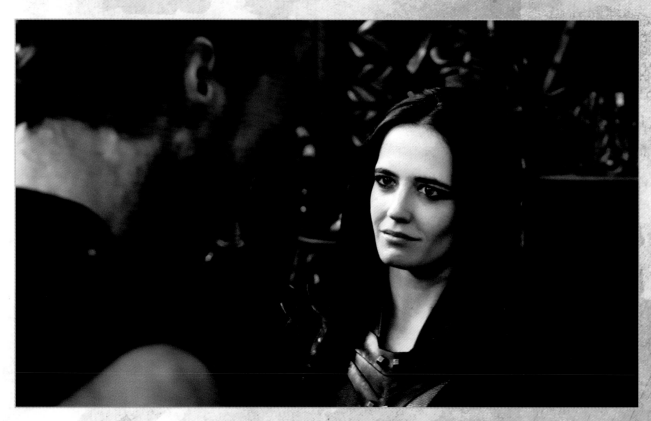

THIS SPREAD: Storyboards and raw footage from the beheading of the Greek marine and Scyllias' escape.

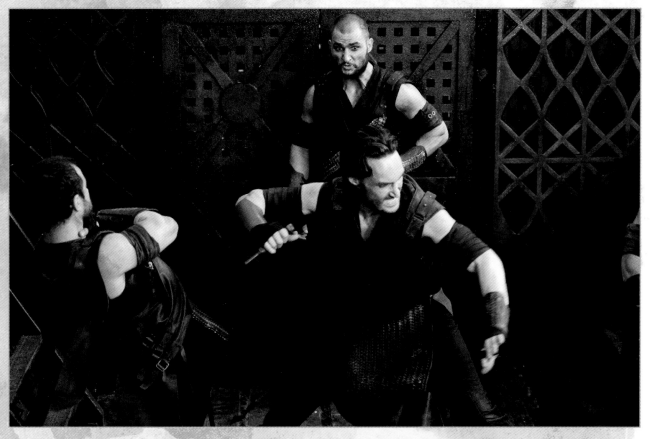
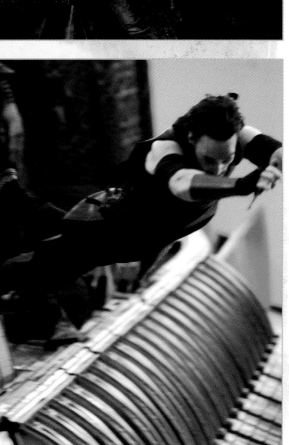
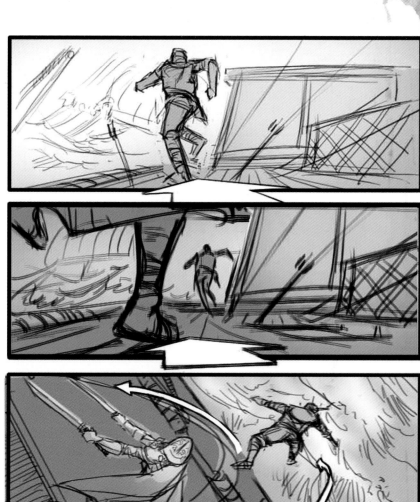
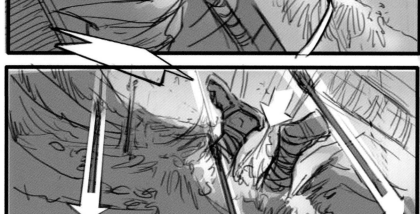
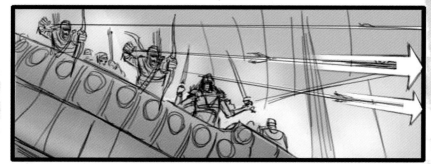

ATHENS

"HAPPINESS IS A CHOICE THAT REQUIRES EFFORT AT TIMES."
– AESKYLOS

Standing in stark contrast to the numbing magnificence of Persepolis and the staid asceticism of Sparta, Athens is a warm, lively place overflowing with possibilities. "It's a boisterous place, with brothels and roadside markets, and everyone's bustling and hustling," explains Zack Snyder. "In Athens, anyone can rise and become a council member." And that egalitarian and often messy vibe was what was needed to come through in the design.

"What he (director Noam Murro) was interested in was the people down in the lower part of Athens that are trying to make it work," says Patrick Tatopoulos. "They have heart, they have passion. They believe." The result is a hectic, almost grubby feel, more like a Brazilian favela or an inner city "barrio" than the picturesque city-state of gleaming white marble, pristine and perfect, which we recall from history books and vacation postcards.

At the center of this dynamic mass of humanity is the grand Temple of Athena atop the Acropolis (the predecessor to the Parthenon we know today). It is covered in scaffolding, still in the process of being built, as is much of the rest of the city. "Even that was not a finished piece," says Tatopoulos, "so we had a chance to create an Athens like you haven't seen before." All elements which remind the viewer that this is a fragile cradle of Democracy literally under construction.

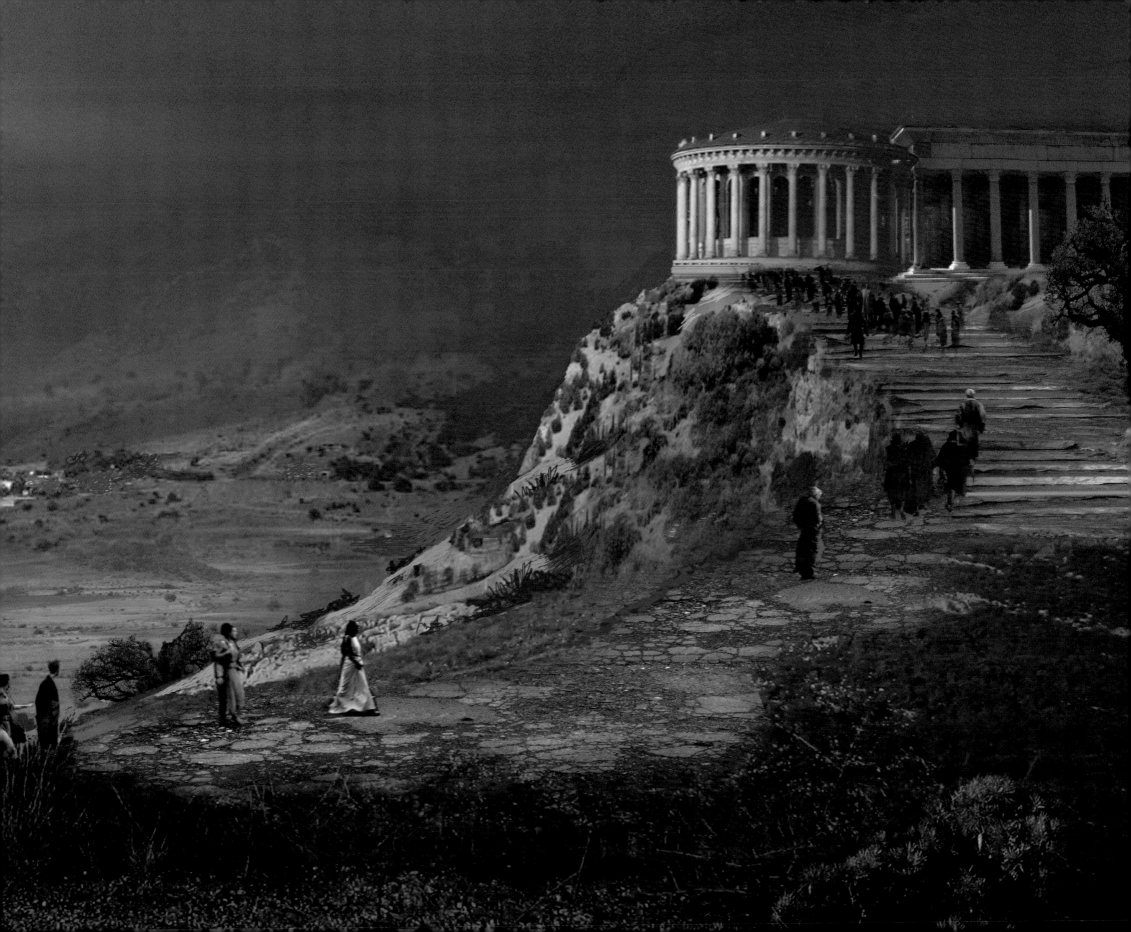

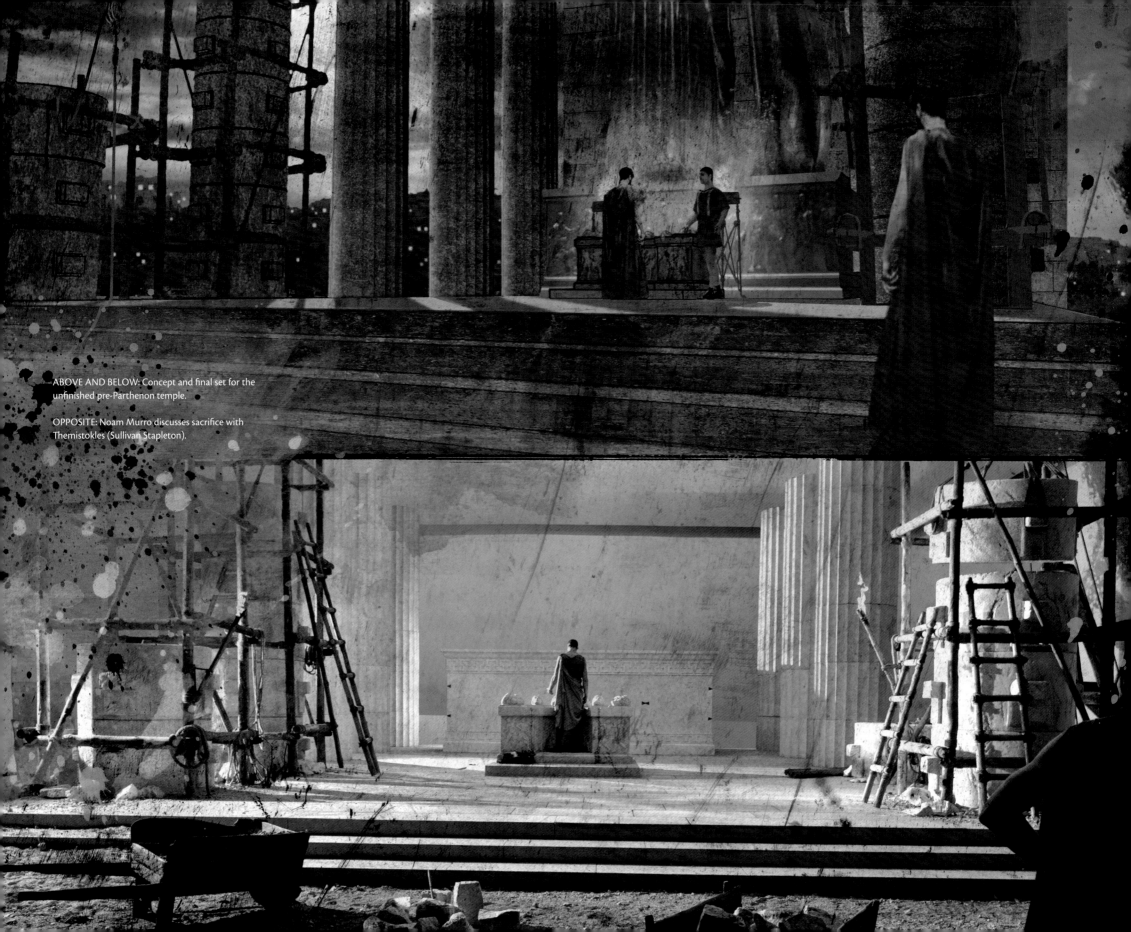

ABOVE AND BELOW: Concept and final set for the unfinished pre-Parthenon temple.

OPPOSITE: Noam Murro discusses sacrifice with Themistokles (Sullivan Stapleton).

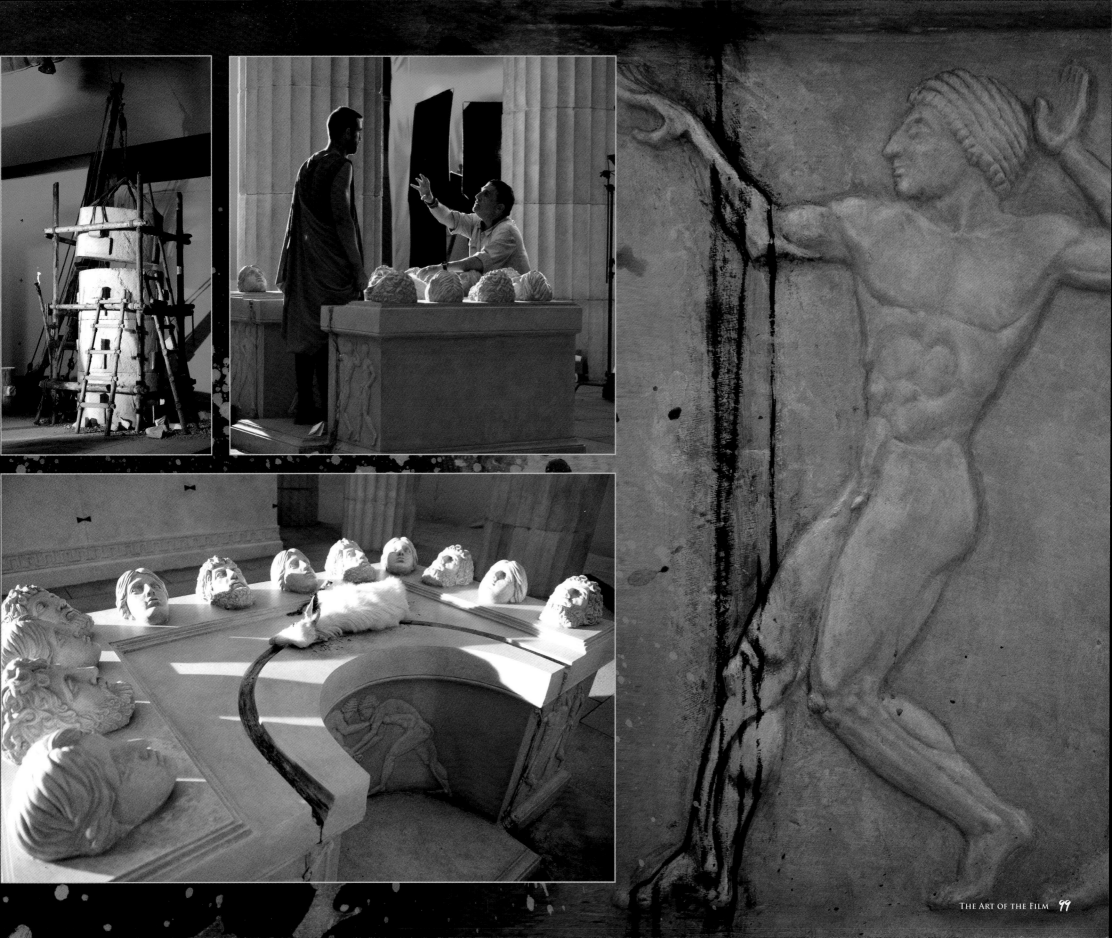

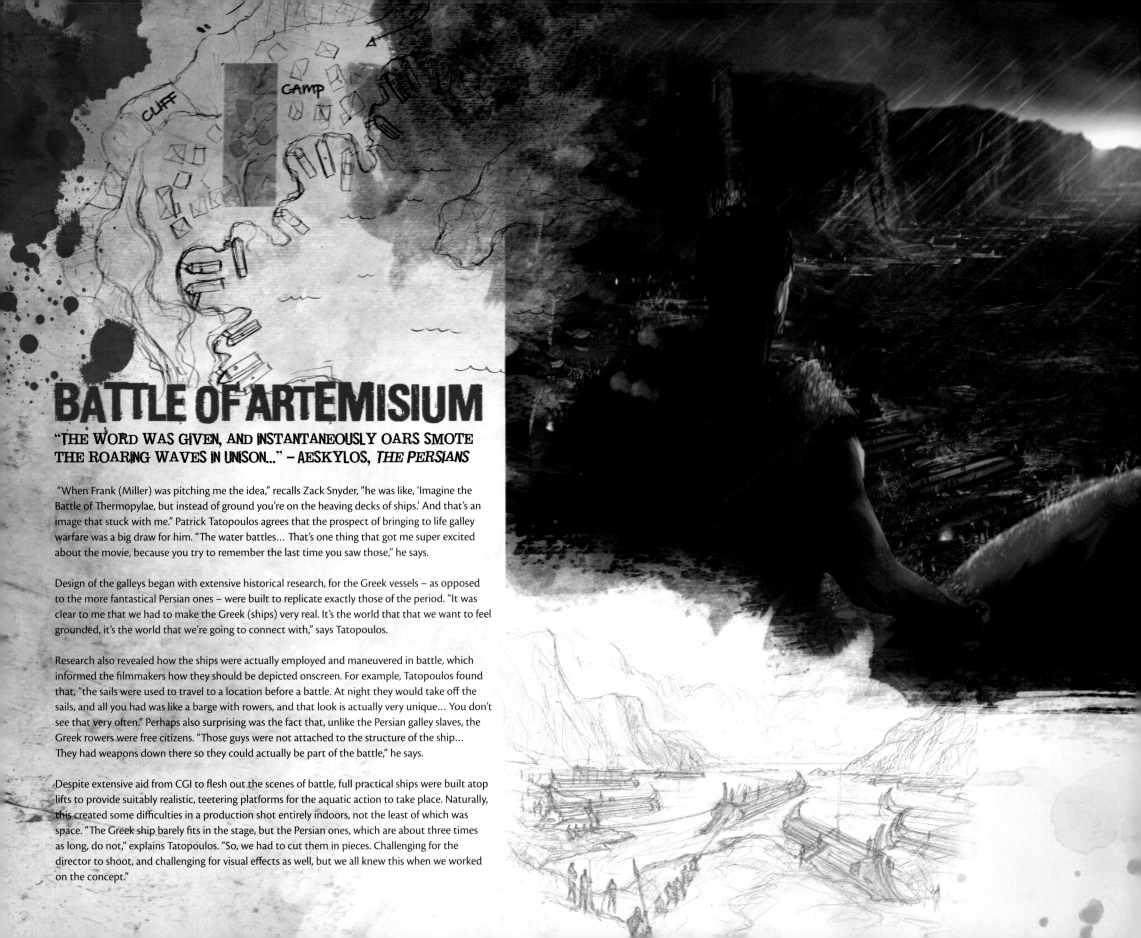

BATTLE OF ARTEMISIUM

"THE WORD WAS GIVEN, AND INSTANTANEOUSLY OARS SMOTE THE ROARING WAVES IN UNISON…" – AESKYLOS, *THE PERSIANS*

"When Frank (Miller) was pitching me the idea," recalls Zack Snyder, "he was like, 'Imagine the Battle of Thermopylae, but instead of ground you're on the heaving decks of ships.' And that's an image that stuck with me." Patrick Tatopoulos agrees that the prospect of bringing to life galley warfare was a big draw for him. "The water battles… That's one thing that got me super excited about the movie, because you try to remember the last time you saw those," he says.

Design of the galleys began with extensive historical research, for the Greek vessels – as opposed to the more fantastical Persian ones – were built to replicate exactly those of the period. "It was clear to me that we had to make the Greek (ships) very real. It's the world that that we want to feel grounded, it's the world that we're going to connect with," says Tatopoulos.

Research also revealed how the ships were actually employed and maneuvered in battle, which informed the filmmakers how they should be depicted onscreen. For example, Tatopoulos found that, "the sails were used to travel to a location before a battle. At night they would take off the sails, and all you had was like a barge with rowers, and that look is actually very unique… You don't see that very often." Perhaps also surprising was the fact that, unlike the Persian galley slaves, the Greek rowers were free citizens. "Those guys were not attached to the structure of the ship… They had weapons down there so they could actually be part of the battle," he says.

Despite extensive aid from CGI to flesh out the scenes of battle, full practical ships were built atop lifts to provide suitably realistic, teetering platforms for the aquatic action to take place. Naturally, this created some difficulties in a production shot entirely indoors, not the least of which was space. "The Greek ship barely fits in the stage, but the Persian ones, which are about three times as long, do not," explains Tatopoulos. "So, we had to cut them in pieces. Challenging for the director to shoot, and challenging for visual effects as well, but we all knew this when we worked on the concept."

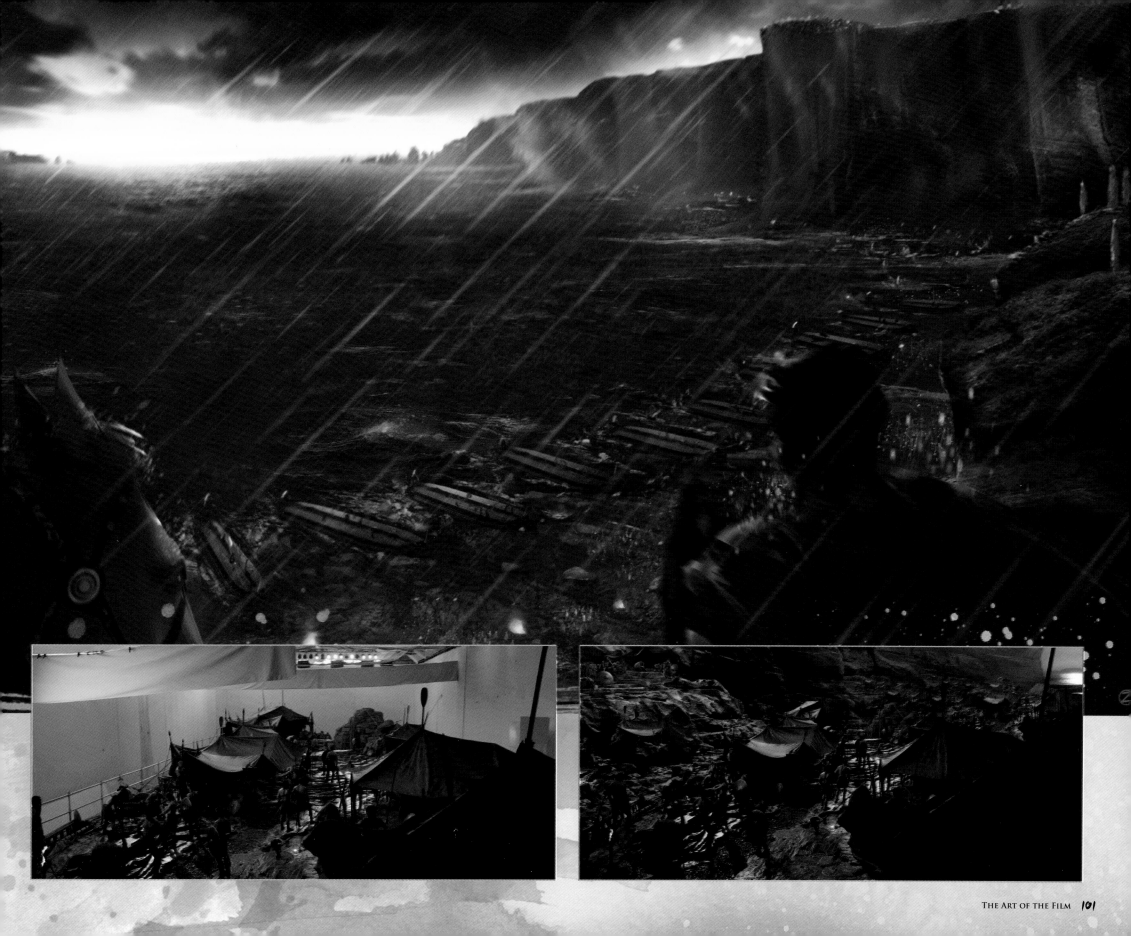

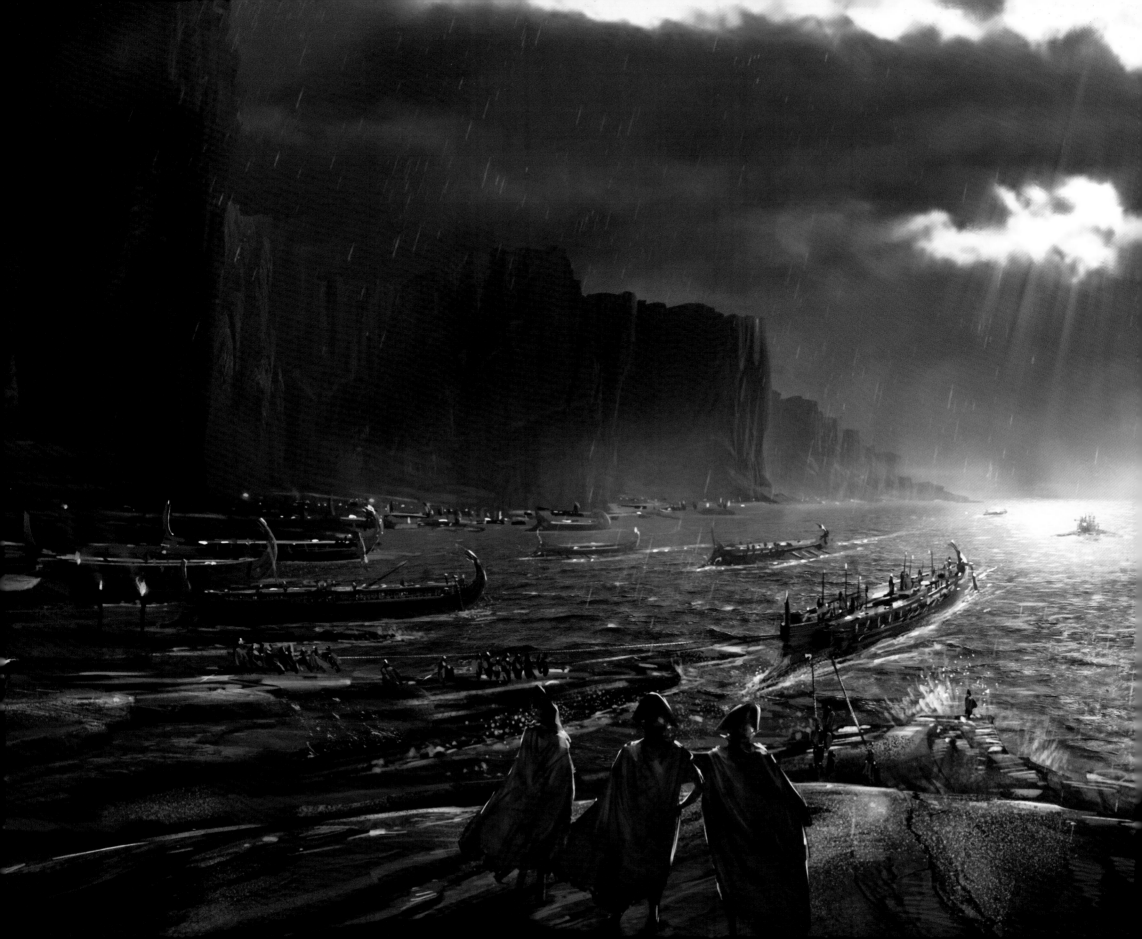

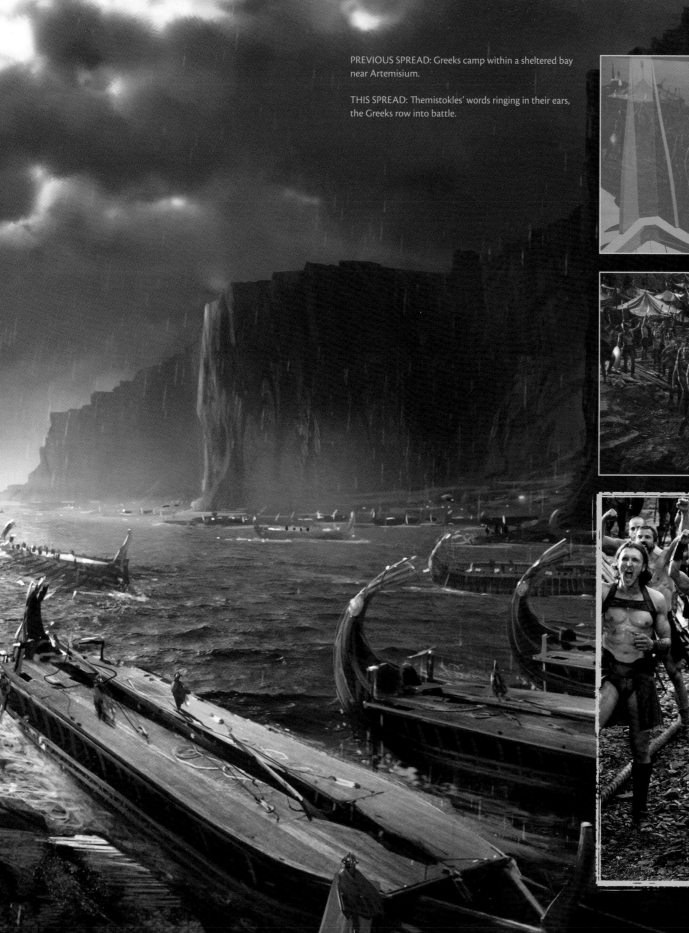

PREVIOUS SPREAD: Greeks camp within a sheltered bay near Artemisium.

THIS SPREAD: Themistokles' words ringing in their ears, the Greeks row into battle.

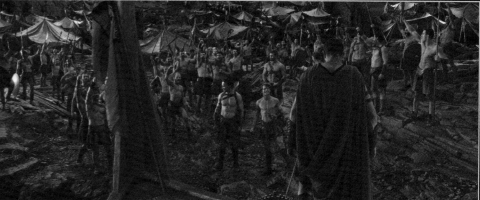

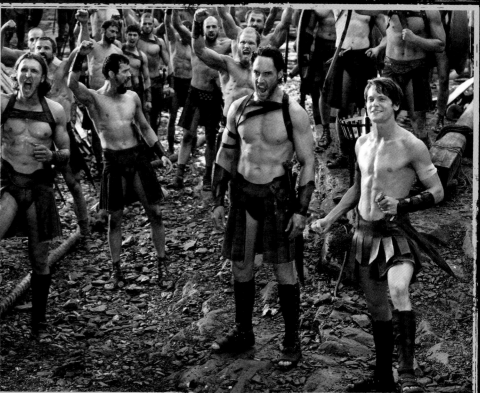

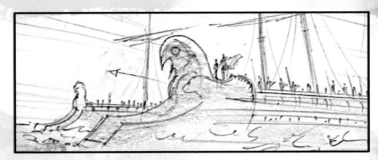

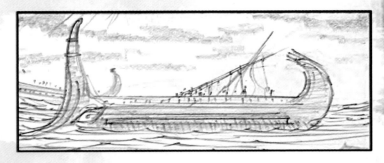

DAY ONE

When the Persian fleet ventures out at dawn on the day of battle, it is met with a curious sight: the Greeks have maneuvered their ships end-to-end, into a defensive formation consisting of multiple concentric rings. The Persians surge forward, increasing speed. But the Greeks pivot, allowing the invaders to pass by and enter the trap they have prepared. Once there, the more nimble Greek vessels turn and ram what prove to be the very vulnerable sides of the seemingly invulnerable Persian leviathans.

Artemisia watches the calamity from a distance with a mixture of anger and respect.

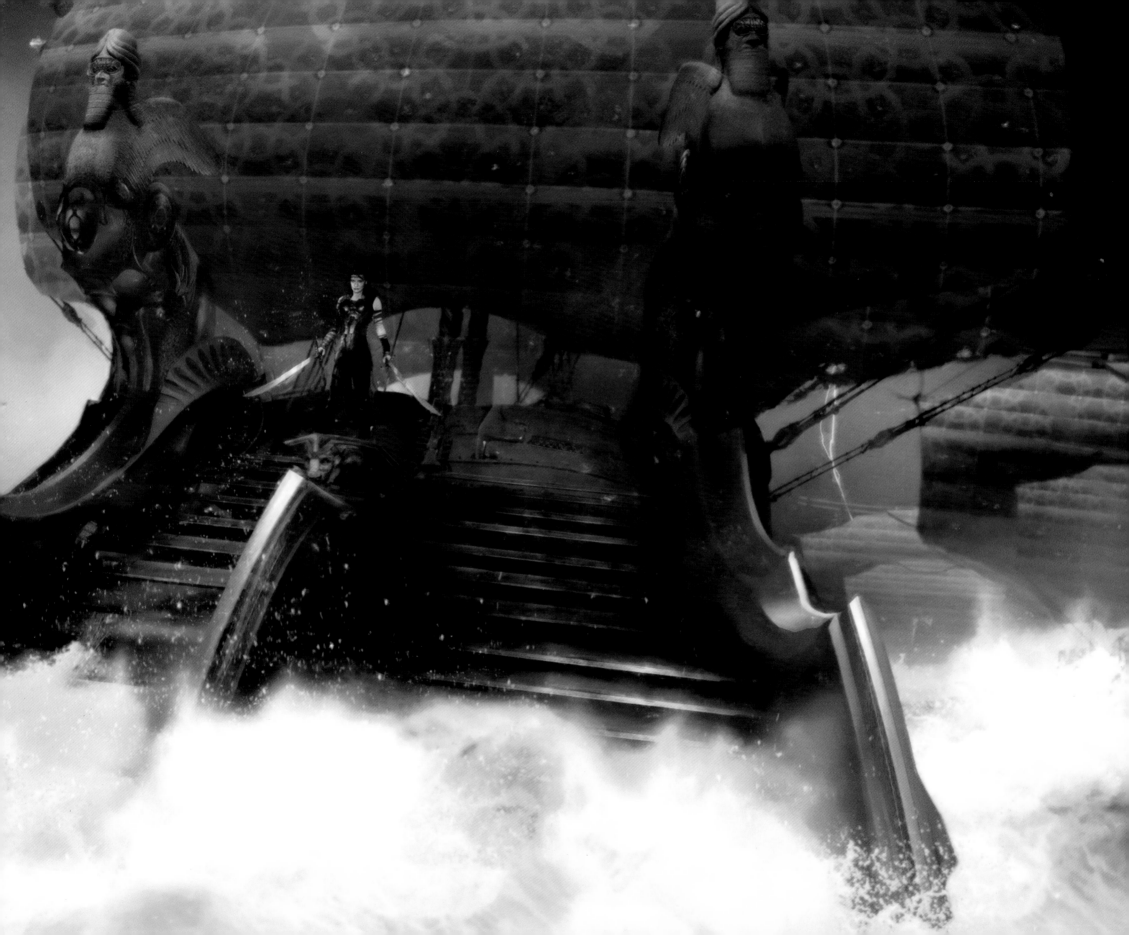

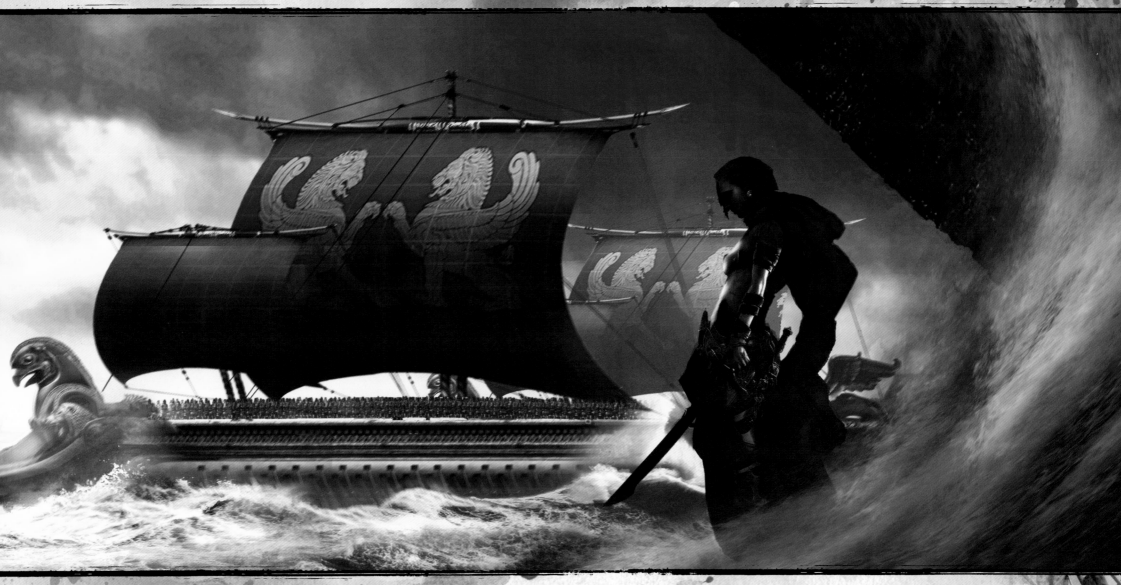

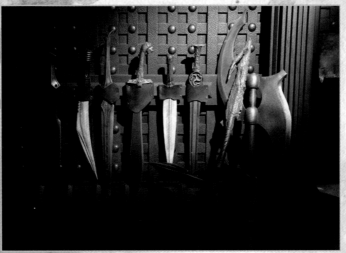

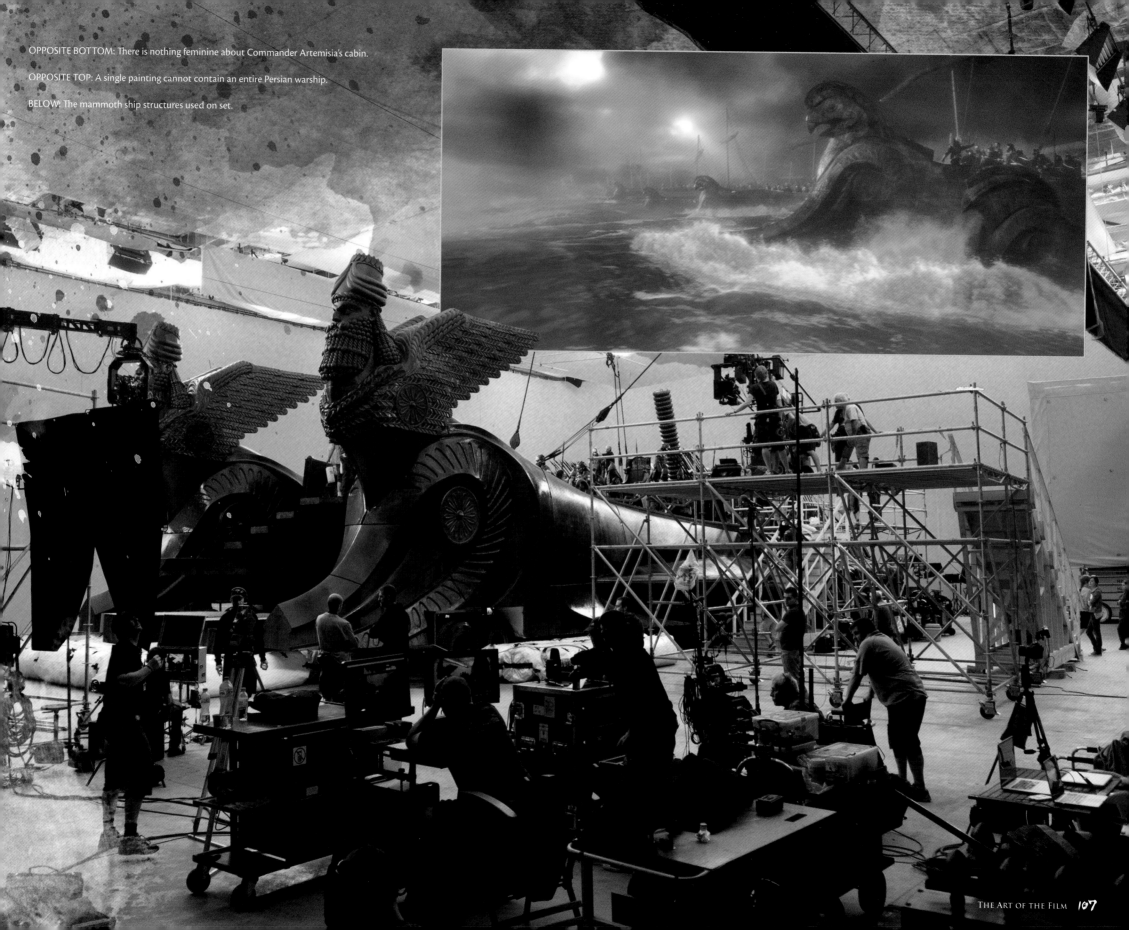

OPPOSITE BOTTOM: There is nothing feminine about Commander Artemisia's cabin.

OPPOSITE TOP: A single painting cannot contain an entire Persian warship.

BELOW: The mammoth ship structures used on set.

DAY TWO

Thinking to advance in Artemisia's estimation, General Kashani offers to lead the attack on the second day. He will soon regret that decision. The Greeks who row out to meet his squadron quickly reverse and row away, and he follows them. When they disappear into a fog bank, his pursuit becomes even more dogged. Too late does he realize he's been led into another trap: a narrow strait blocked by a derelict vessel. As the Persian ships pile into one another, Scyllias leads an attack from land. Warriors leap from the cliffs onto the decks to finish off their stricken foes.

Artemisia's rage can barely be contained, and she seeks another way to accomplish what her generals cannot. Inviting Themistokles aboard her flagship, she offers him wealth, power, and pleasure if he'll only turn his back on Greece and join forces with her. To her severe irritation, he takes the pleasure, but nothing else.

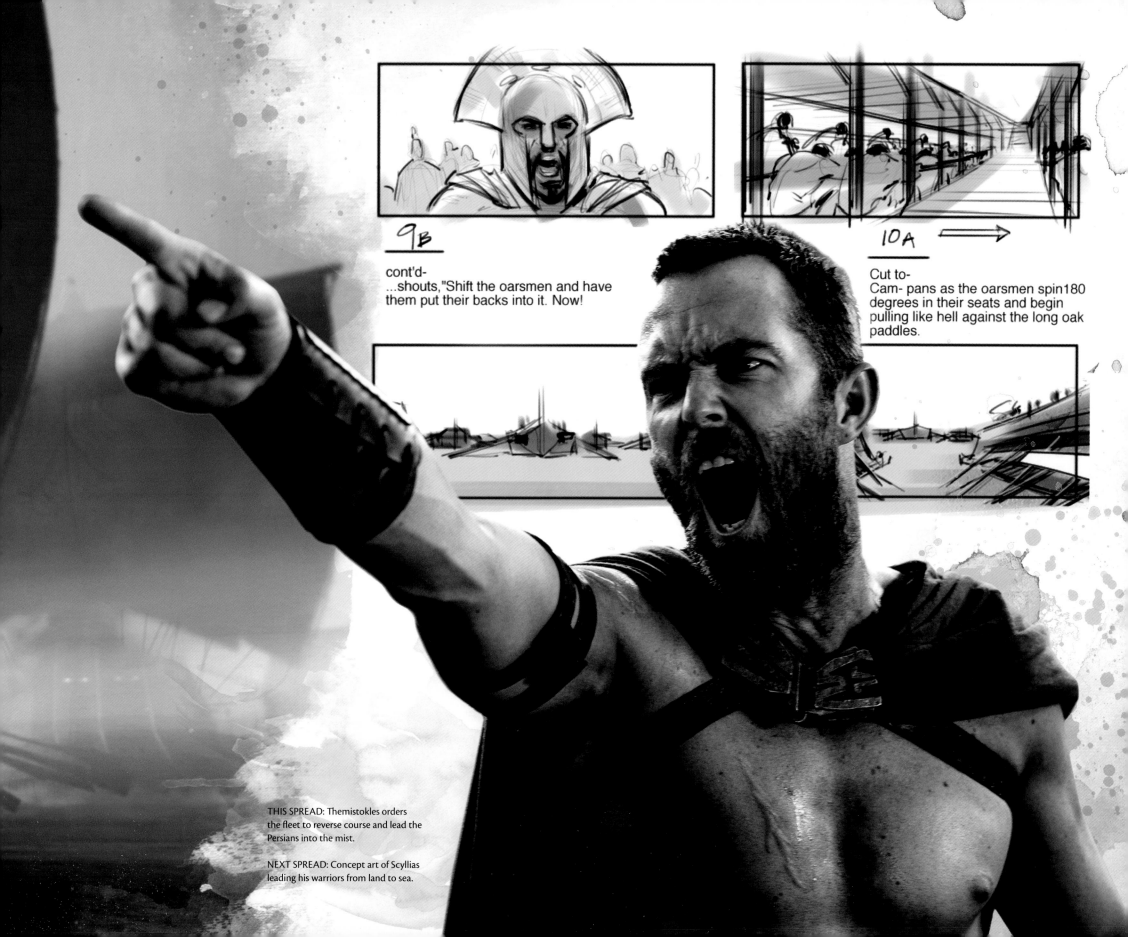

9B

cont'd-
...shouts, "Shift the oarsmen and have them put their backs into it. Now!

10A ⟹

Cut to-
Cam- pans as the oarsmen spin180 degrees in their seats and begin pulling like hell against the long oak paddles.

THIS SPREAD: Themistokles orders the fleet to reverse course and lead the Persians into the mist.

NEXT SPREAD: Concept art of Scyllias leading his warriors from land to sea.

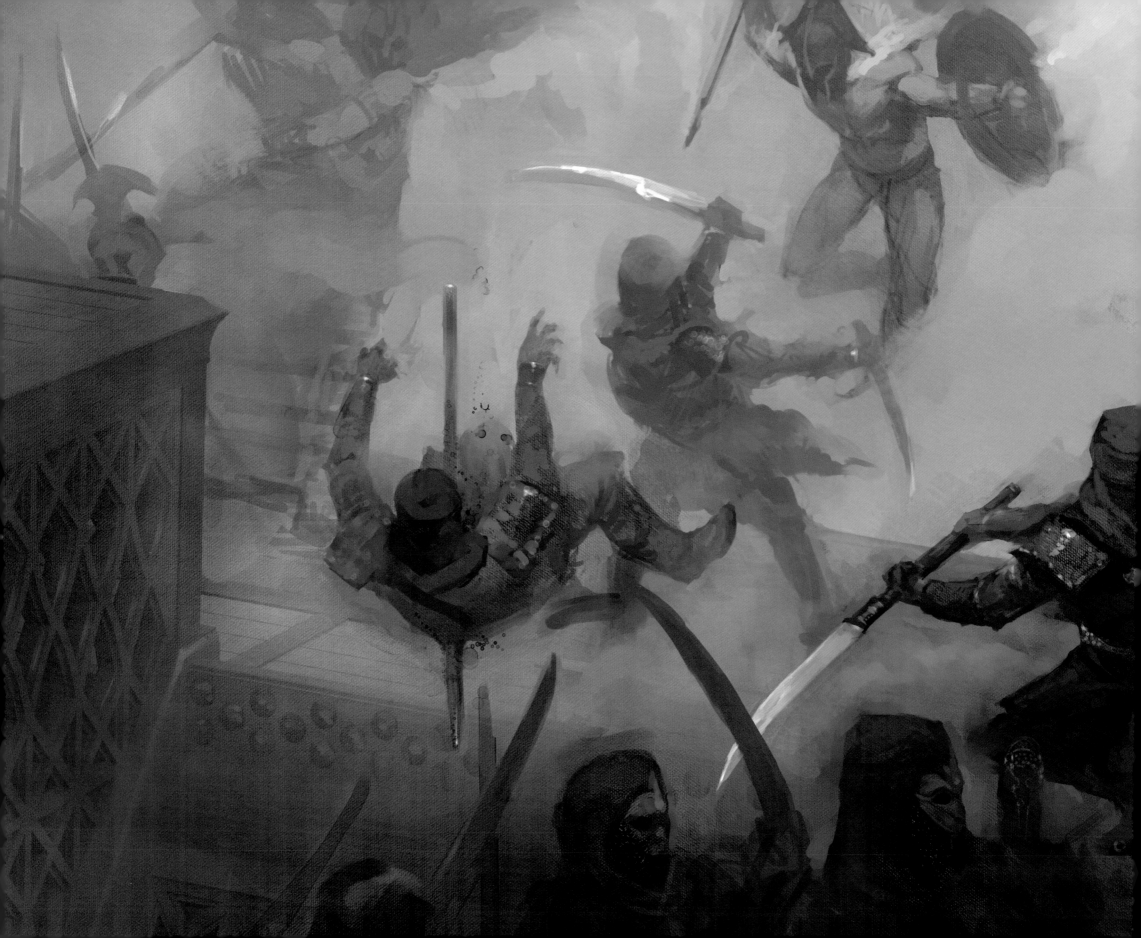

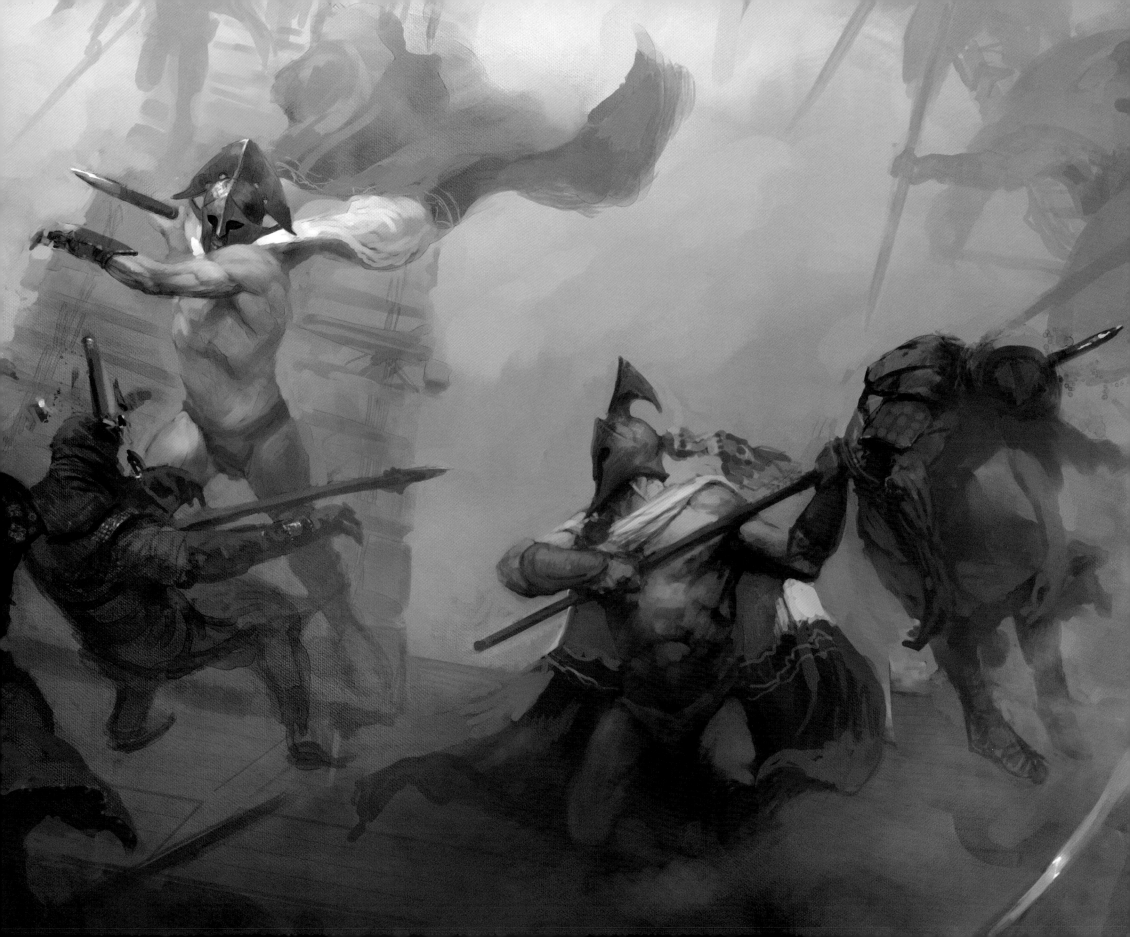

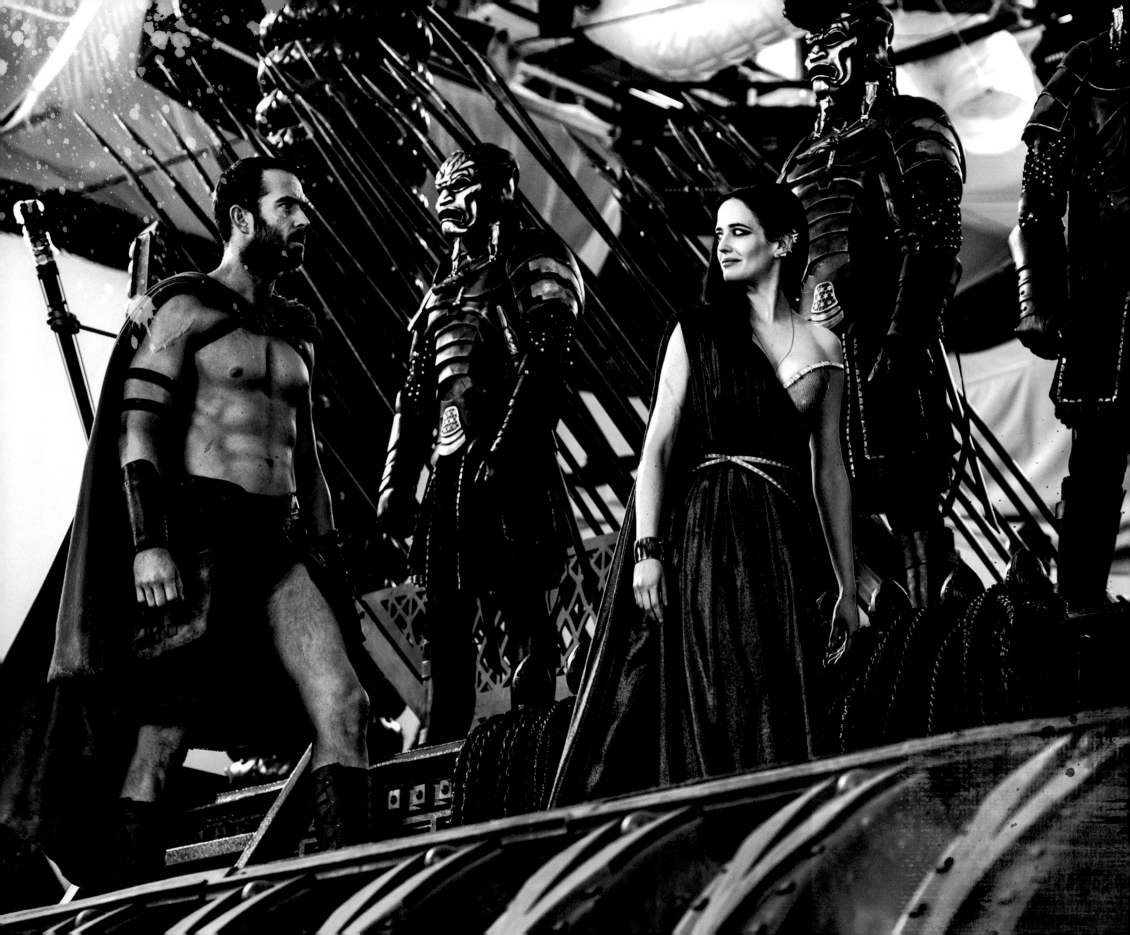

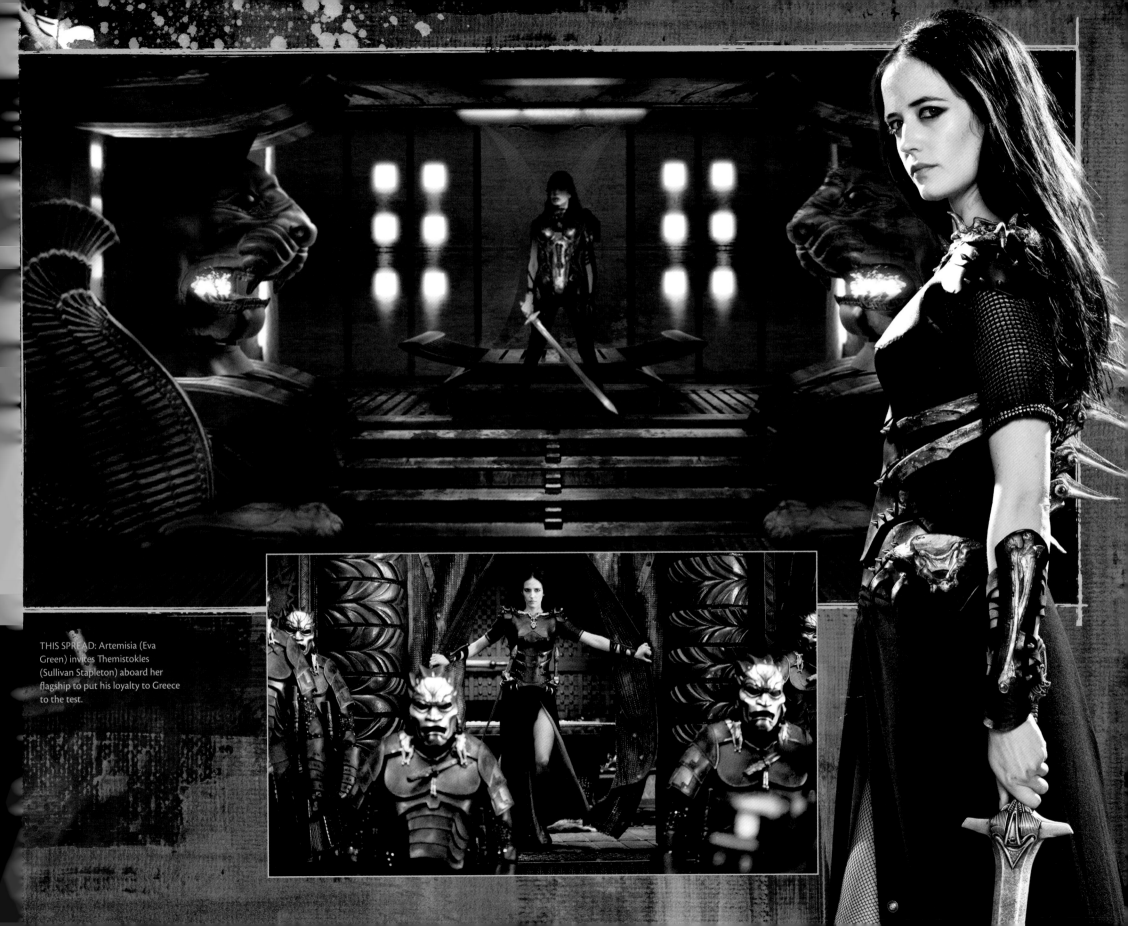

THIS SPREAD: Artemisia (Eva Green) invites Themistokles (Sullivan Stapleton) aboard her flagship to put his loyalty to Greece to the test.

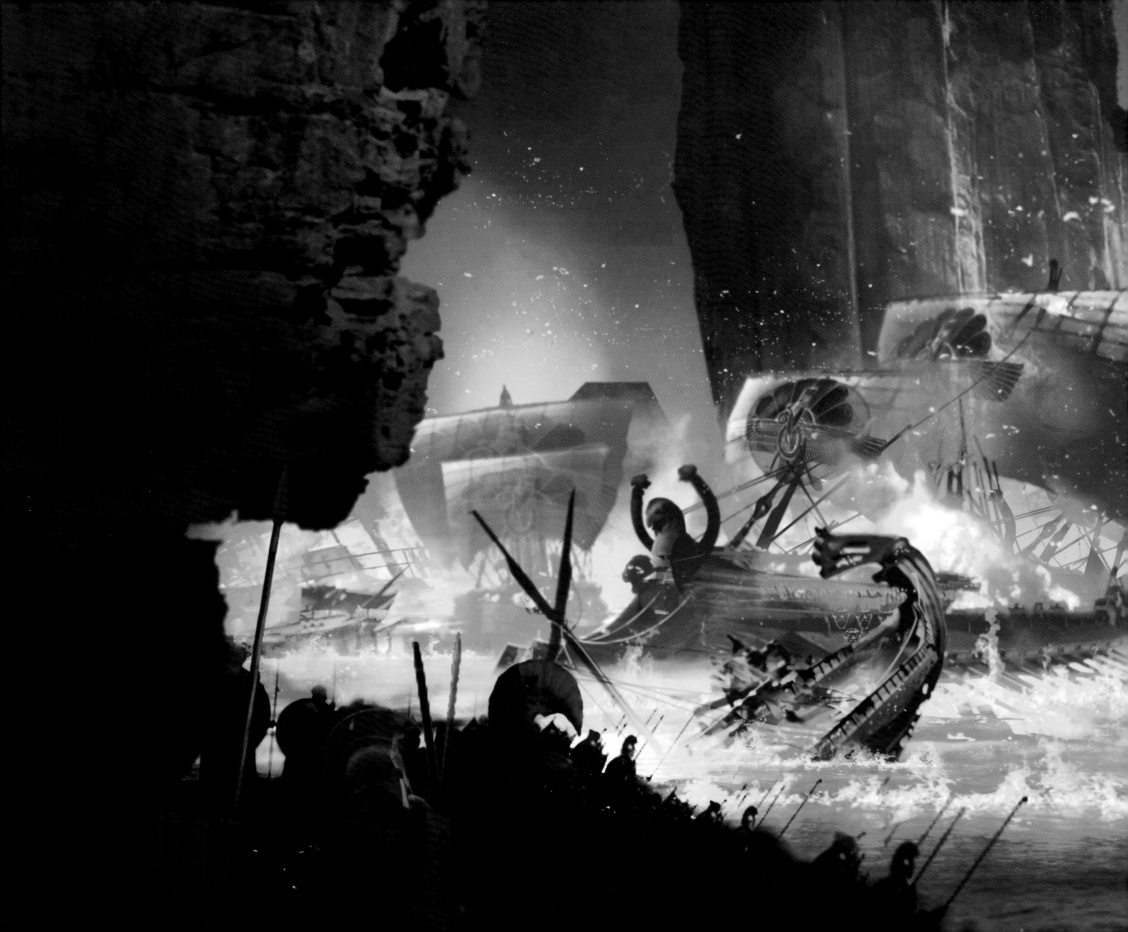

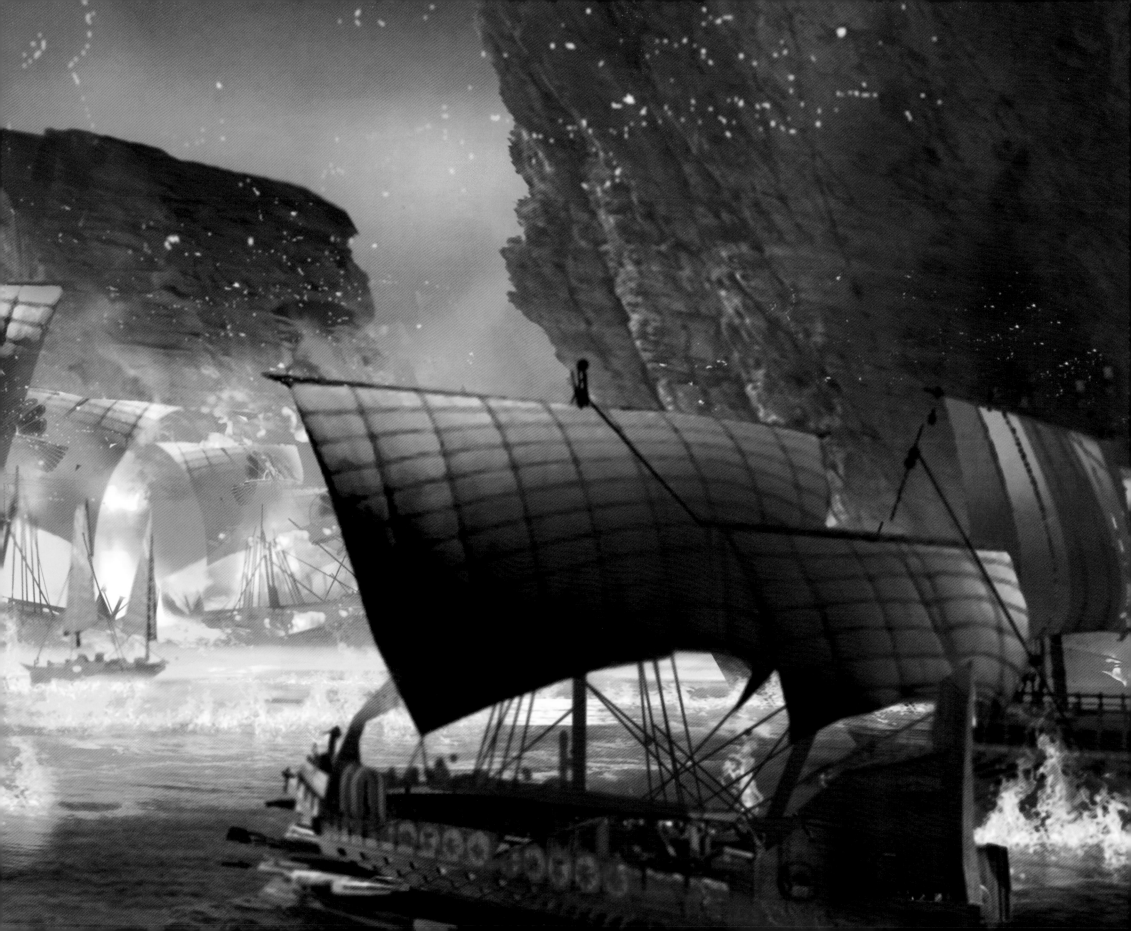

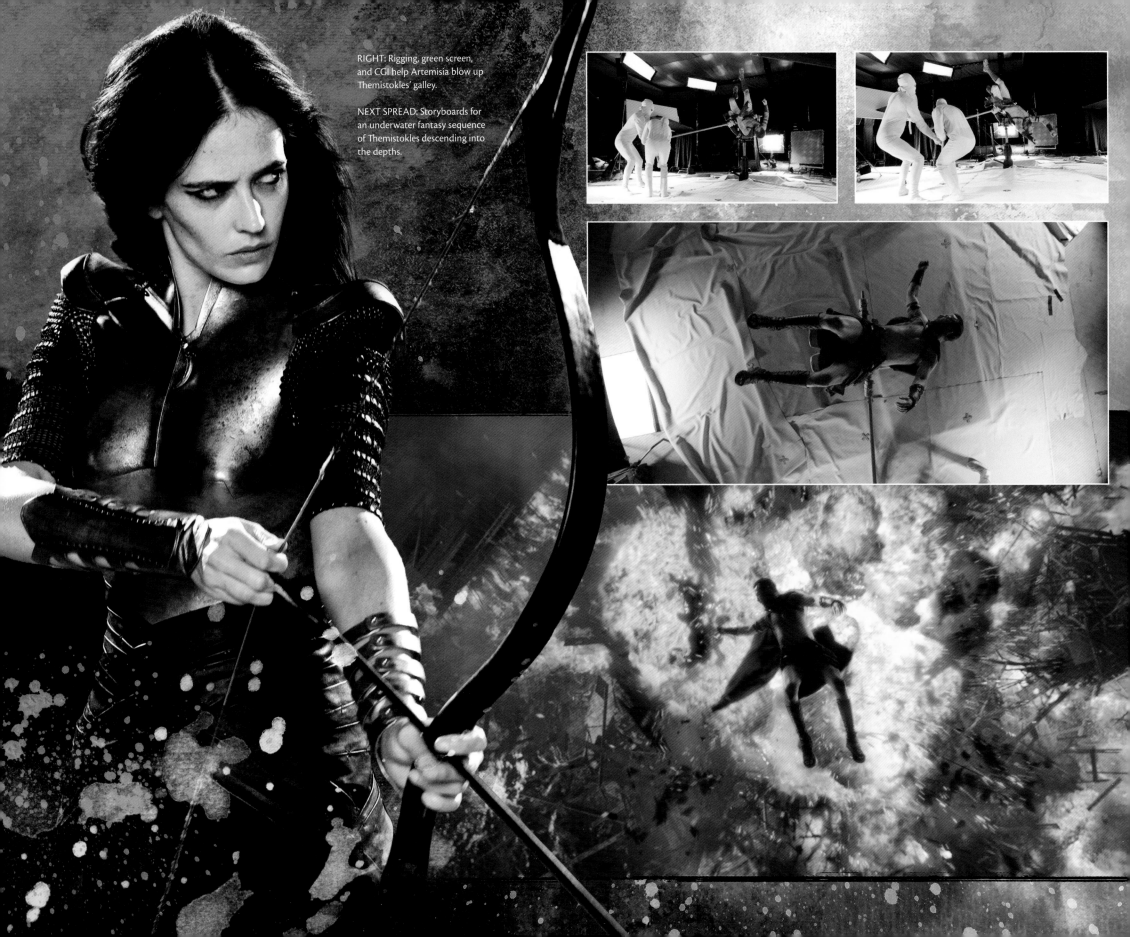

RIGHT: Rigging, green screen, and CGI help Artemisia blow up Themistokles' galley.

NEXT SPREAD: Storyboards for an underwater fantasy sequence of Themistokles descending into the depths.

ACTION NOTES	Shot 03	Panel 01

CUT TO REVERSE DOWNSHOT ON THEMISTOKLES AS HE FALLS AWAY FROM CAMERA. THE REFLECTION OF THE FIERY SURFACE CAN BE SEEN ON HIS EYES.

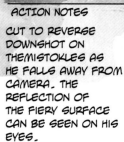
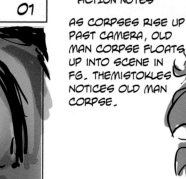

ACTION NOTES	Shot 03	Panel 02

ACTION NOTES	Shot 03	Panel 03

THEMISTOKLES CONTINUES TO DESCEND AWAY FROM CAMERA AS HE TRIES TO SWIM UPWARDS BUT HE'S TOO HEAVY FROM HIS ARMOR

ACTION NOTES	Shot 04	Panel 01

CUT WIDE ON AS THEMISTOKLES TRIES TO SWIM UP BUT HE CONTINUES TO SINK DEEPER AND DEEPER. REVEAL DEAD GREEK SOLDIERS IN FG

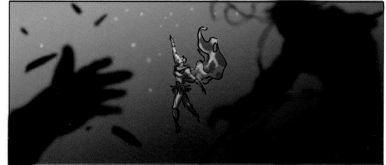

ACTION NOTES	Shot 07	Panel 02

AS CORPSES RISE UP PAST CAMERA, OLD MAN CORPSE FLOATS UP INTO SCENE IN FG. THEMISTOKLES NOTICES OLD MAN CORPSE.

ACTION NOTES	Shot 08	Panel 01

CUT TO THEMISTOKLES POV OF CORPSE OF OLD MAN FLOATING UP INTO FRAME

ACTION NOTES	Shot 08	Panel 02

ACTION NOTES	Shot 08	Panel 03

THE OLD MAN LOOKS UP AT THEMISTOKLES REVEALING HOLES WHERE HIS EYES USED TO BE...

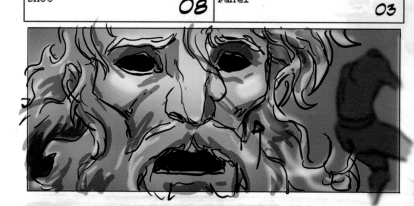

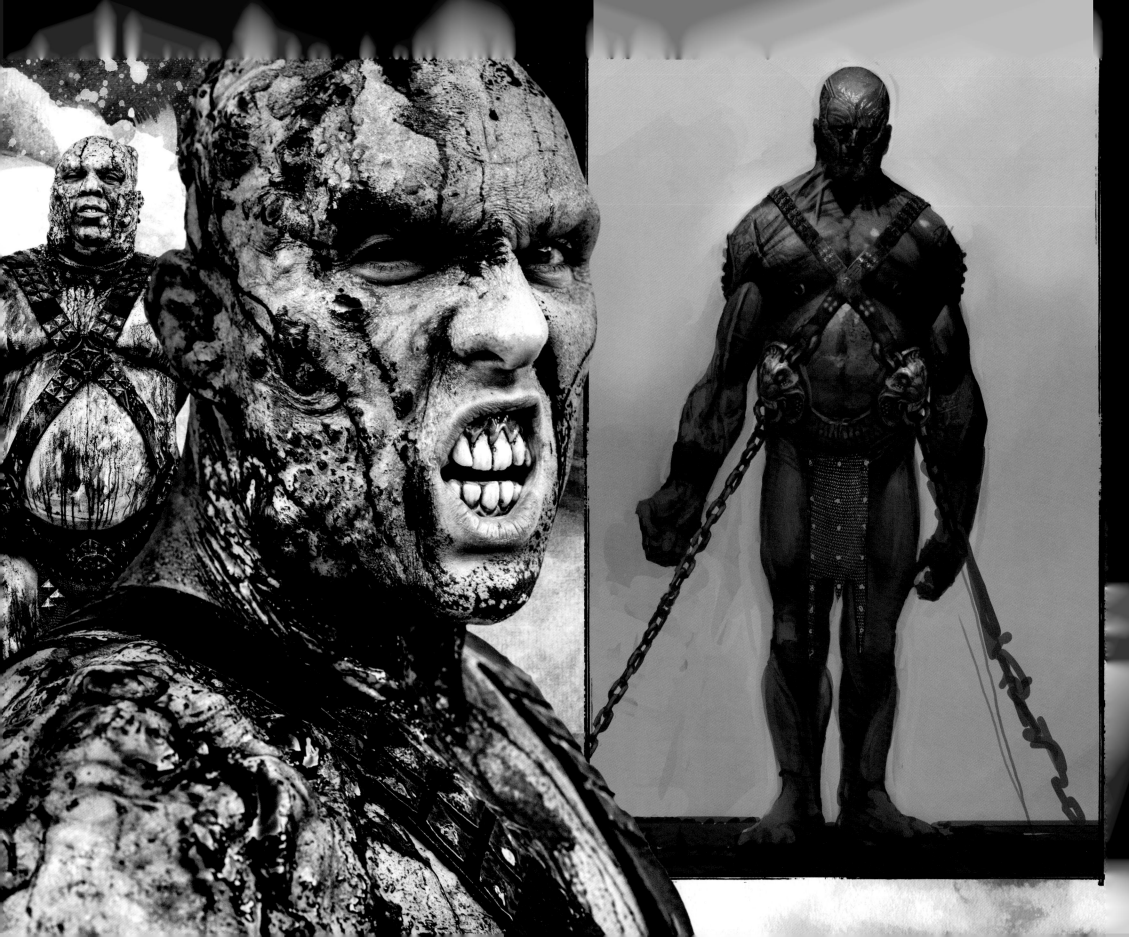

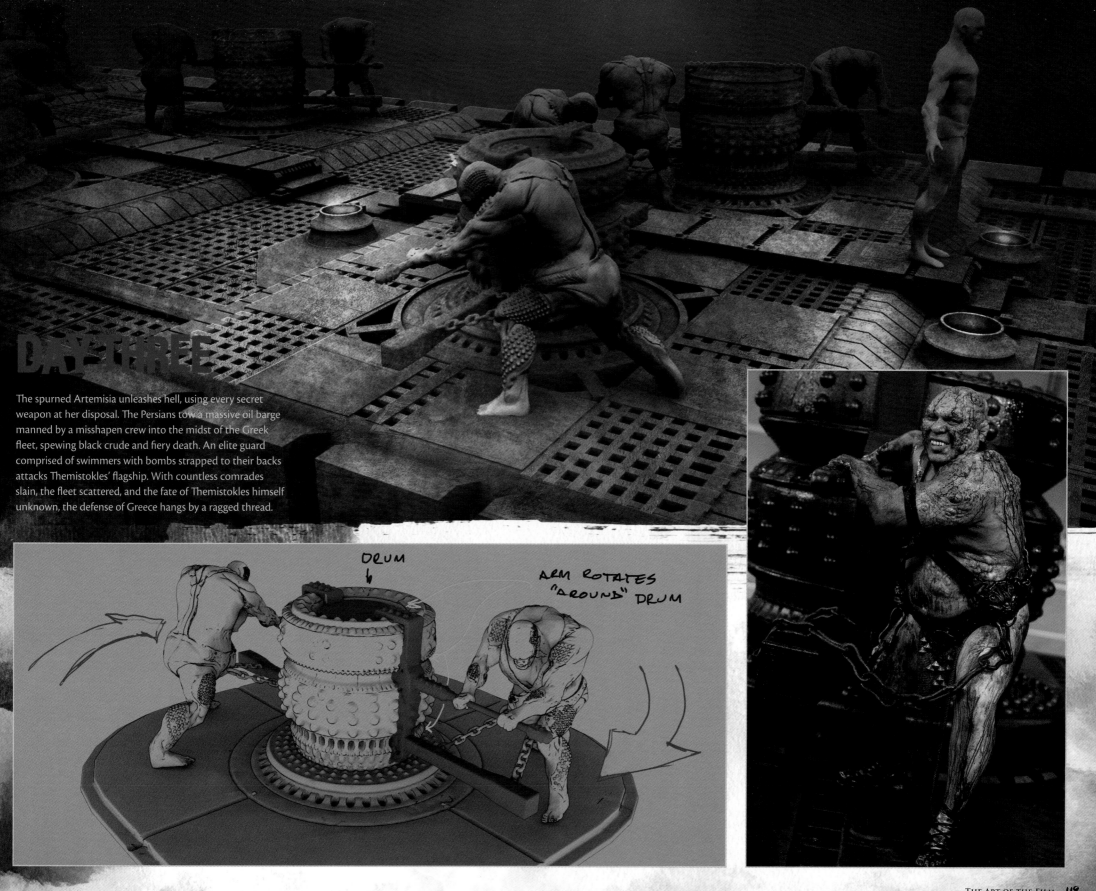

DAY THREE

The spurned Artemisia unleashes hell, using every secret weapon at her disposal. The Persians tow a massive oil barge manned by a misshapen crew into the midst of the Greek fleet, spewing black crude and fiery death. An elite guard comprised of swimmers with bombs strapped to their backs attacks Themistokles' flagship. With countless comrades slain, the fleet scattered, and the fate of Themistokles himself unknown, the defense of Greece hangs by a ragged thread.

DRUM

ARM ROTATES "AROUND" DRUM

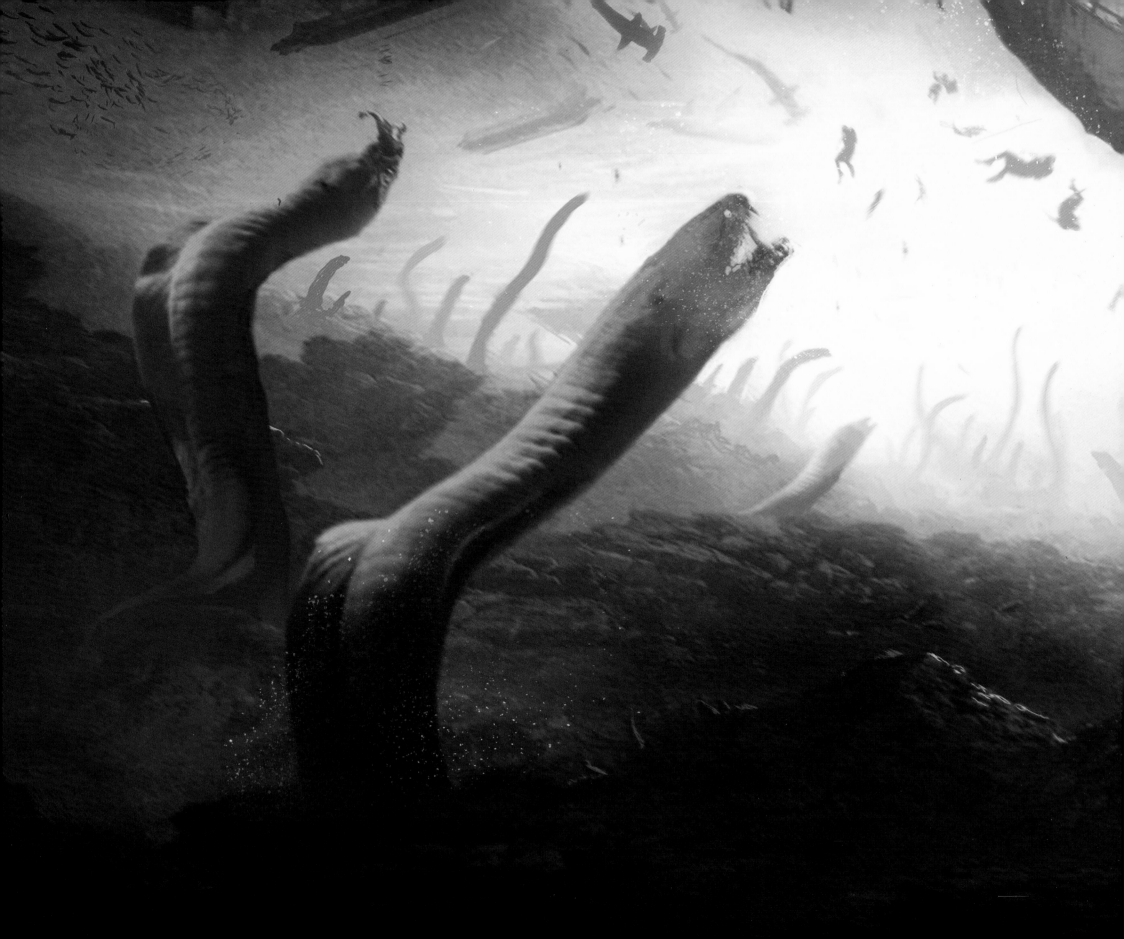

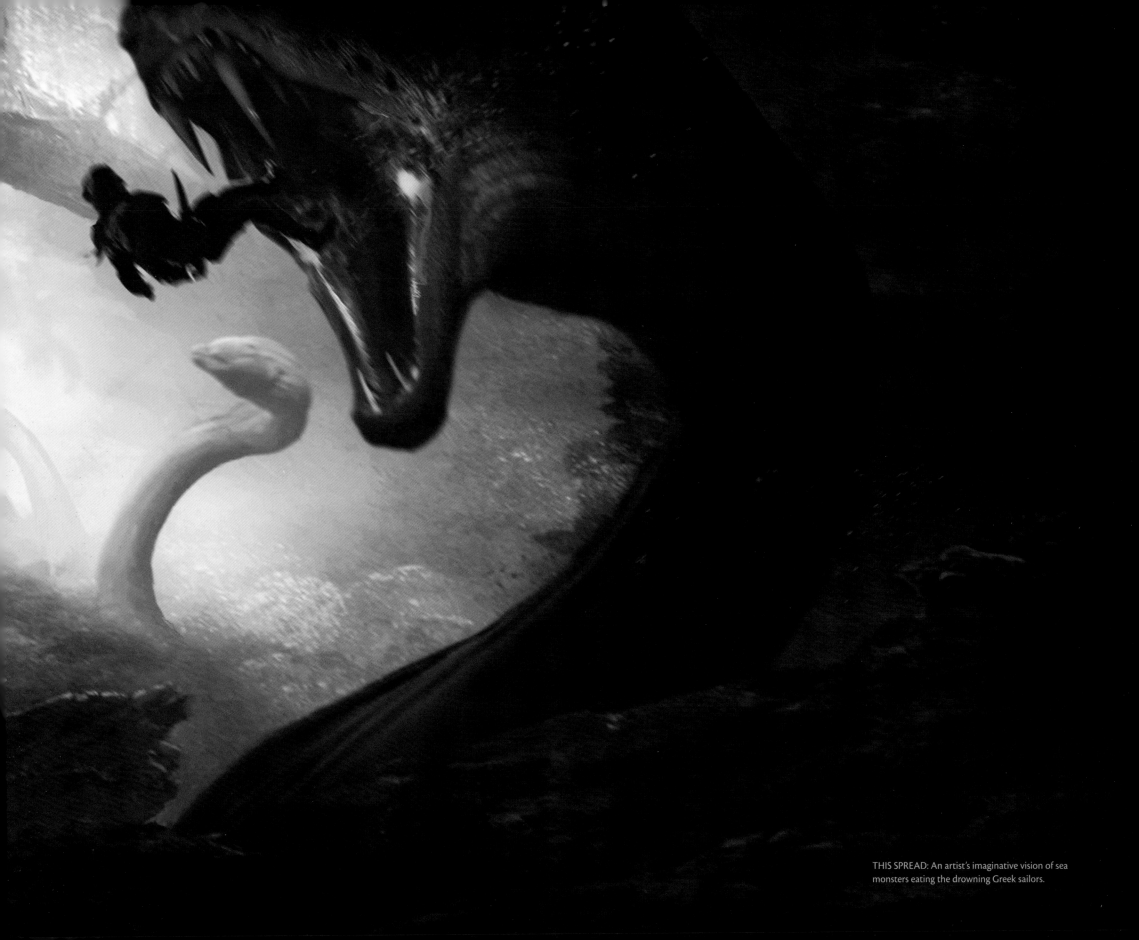

THIS SPREAD: An artist's imaginative vision of sea monsters eating the drowning Greek sailors.

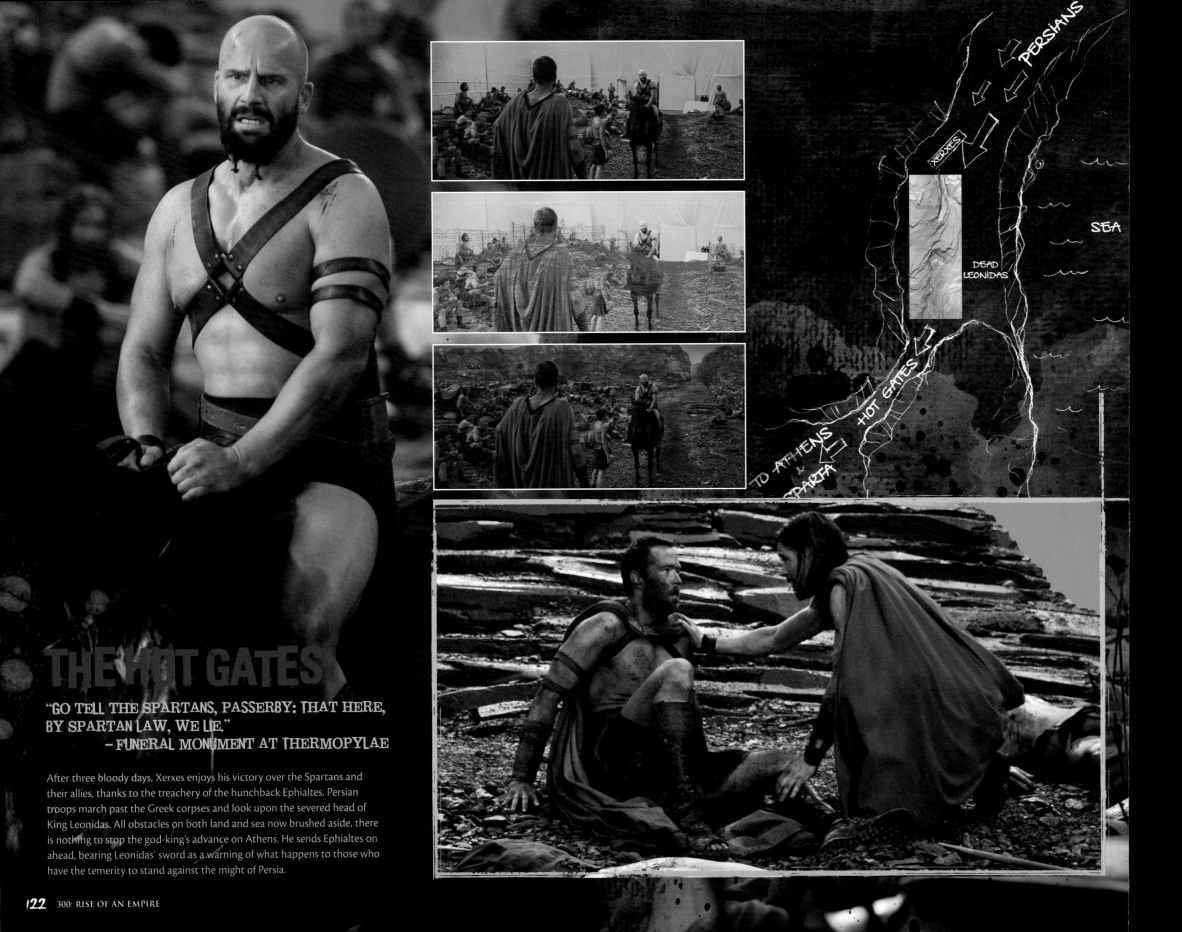

THE HOT GATES

"GO TELL THE SPARTANS, PASSERBY: THAT HERE,
BY SPARTAN LAW, WE LIE."
— FUNERAL MONUMENT AT THERMOPYLAE

After three bloody days, Xerxes enjoys his victory over the Spartans and
their allies, thanks to the treachery of the hunchback Ephialtes. Persian
troops march past the Greek corpses and look upon the severed head of
King Leonidas. All obstacles on both land and sea now brushed aside, there
is nothing to stop the god-king's advance on Athens. He sends Ephialtes on
ahead, bearing Leonidas' sword as a warning of what happens to those who
have the temerity to stand against the might of Persia.

PERSIANS

XERXES

SEA

DEAD
LEONIDAS

HOT GATES

TO ATHENS
&
SPARTA

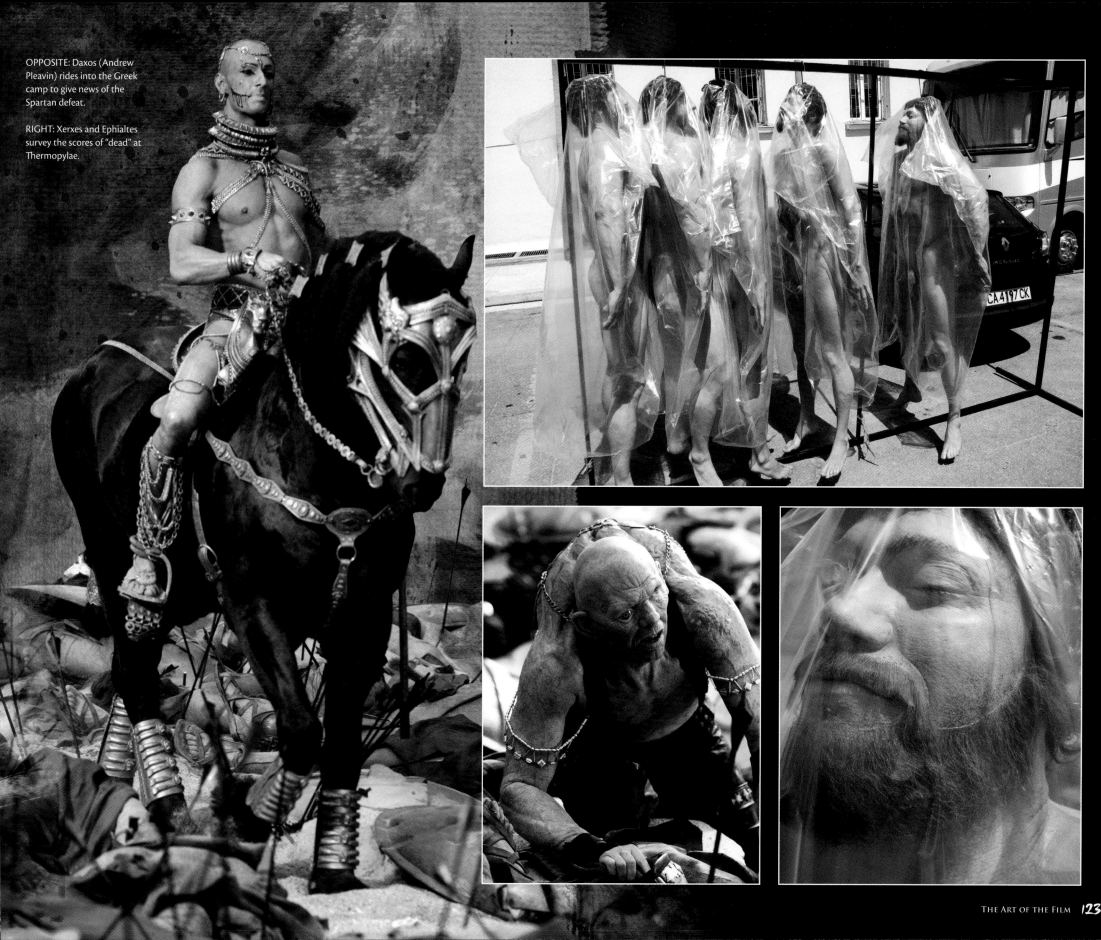

OPPOSITE: Daxos (Andrew Pleavin) rides into the Greek camp to give news of the Spartan defeat.

RIGHT: Xerxes and Ephialtes survey the scores of "dead" at Thermopylae.

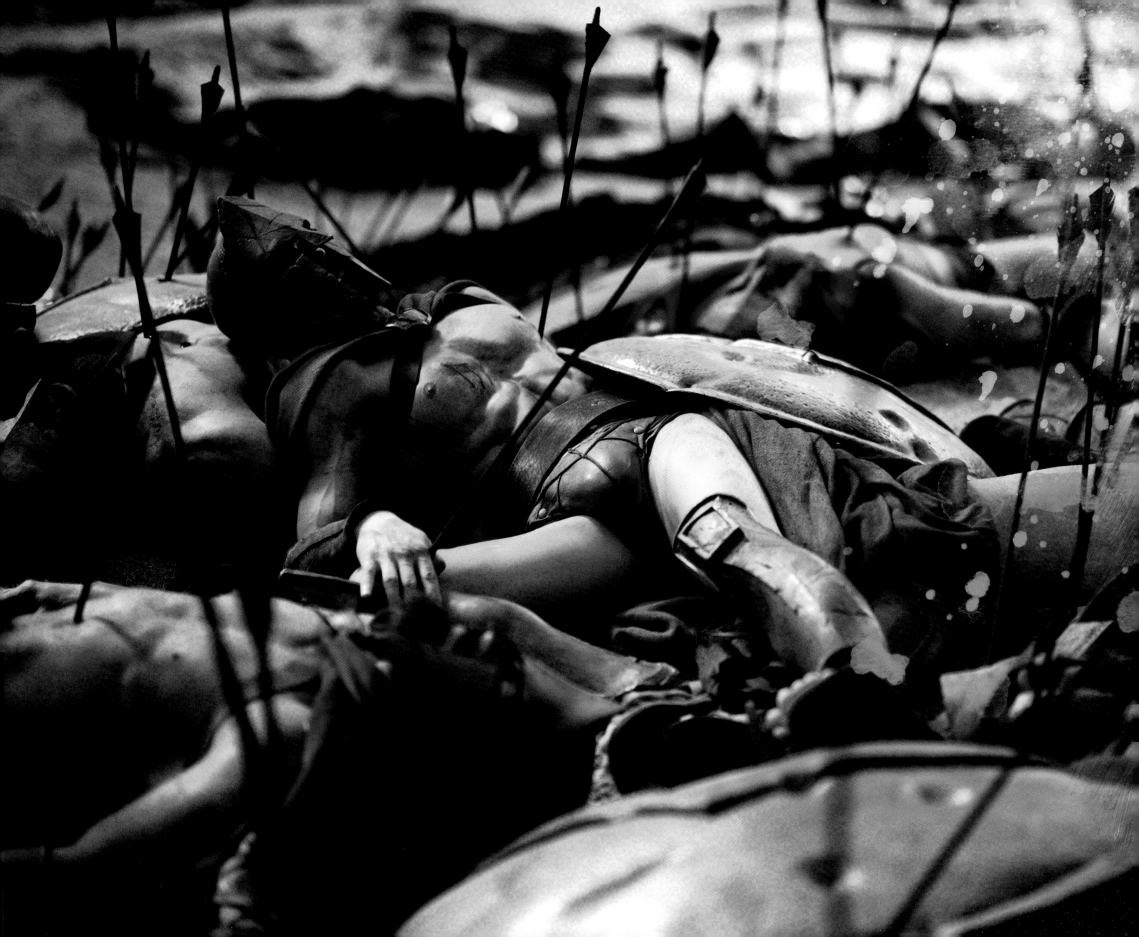

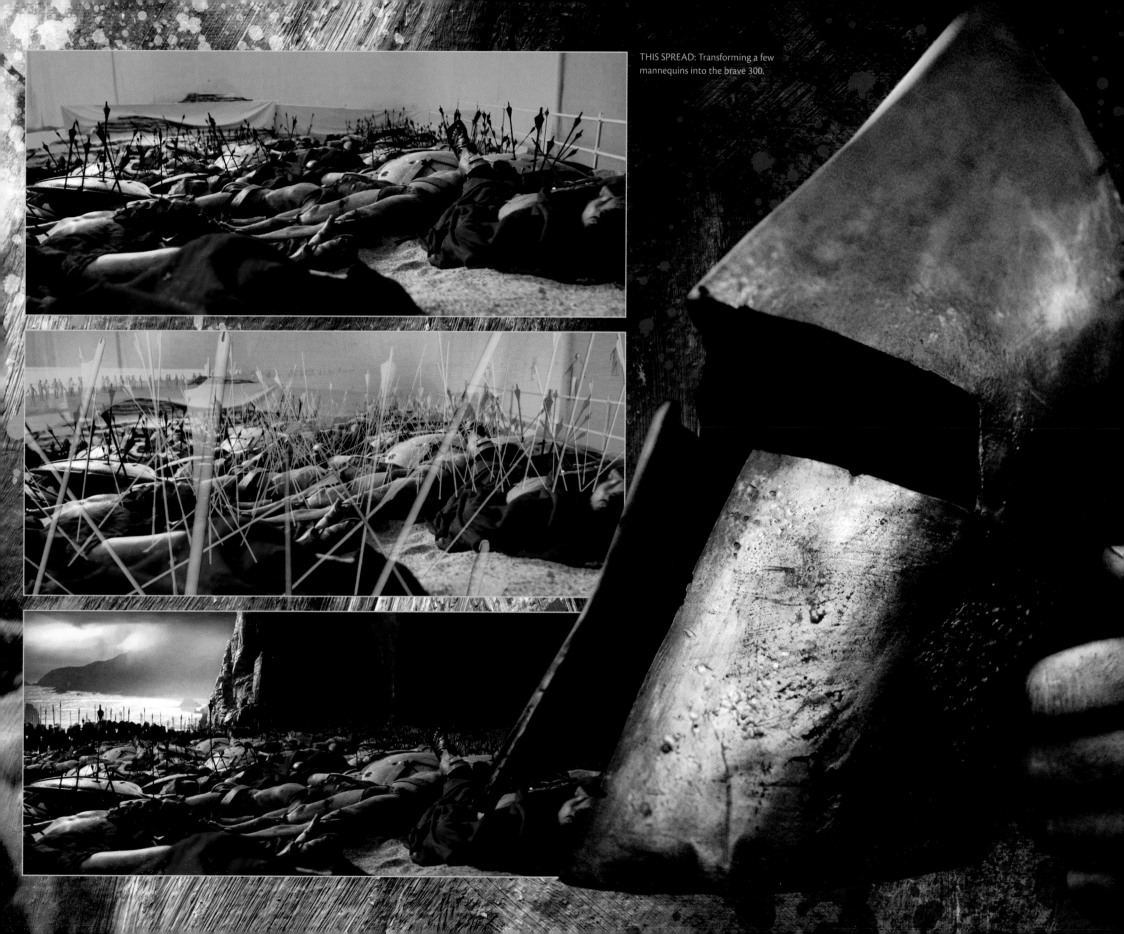

THIS SPREAD: Transforming a few mannequins into the brave 300.

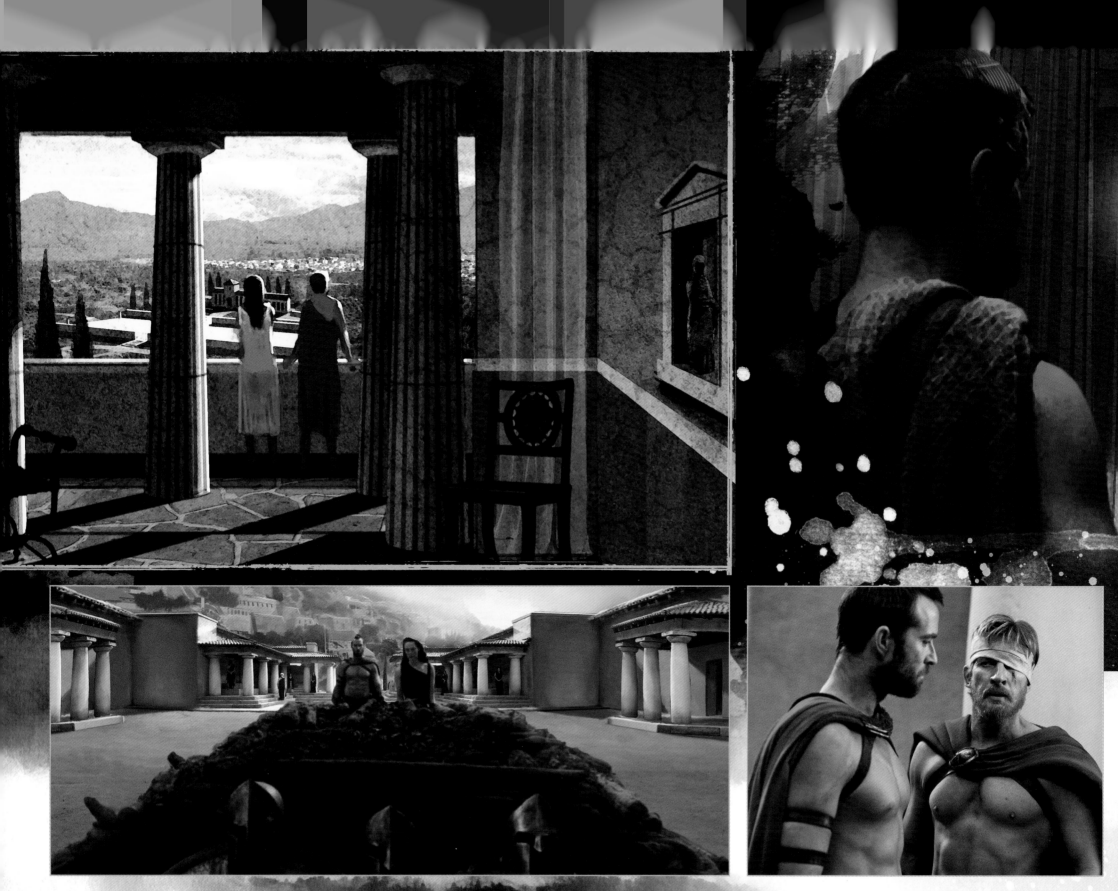

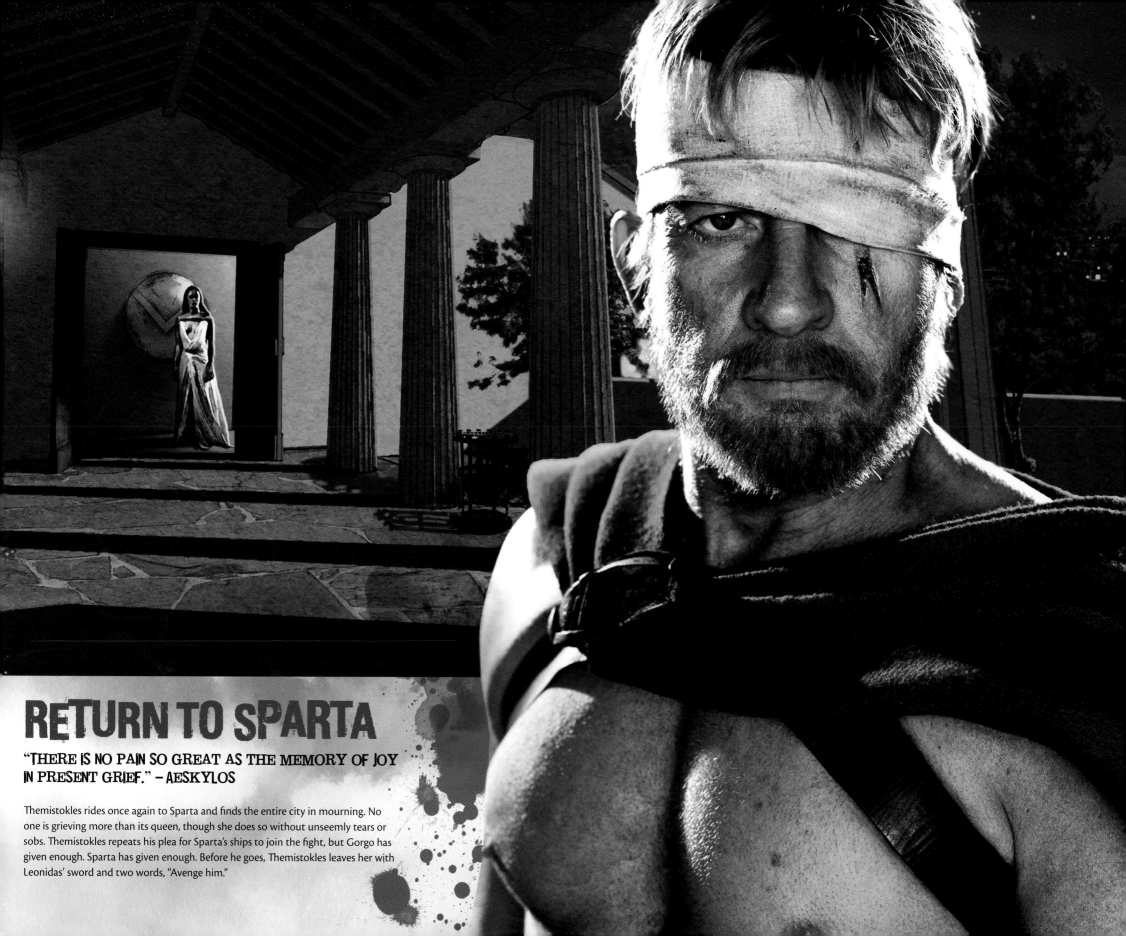

RETURN TO SPARTA

"THERE IS NO PAIN SO GREAT AS THE MEMORY OF JOY IN PRESENT GRIEF." – AESKYLOS

Themistokles rides once again to Sparta and finds the entire city in mourning. No one is grieving more than its queen, though she does so without unseemly tears or sobs. Themistokles repeats his plea for Sparta's ships to join the fight, but Gorgo has given enough. Sparta has given enough. Before he goes, Themistokles leaves her with Leonidas' sword and two words, "Avenge him."

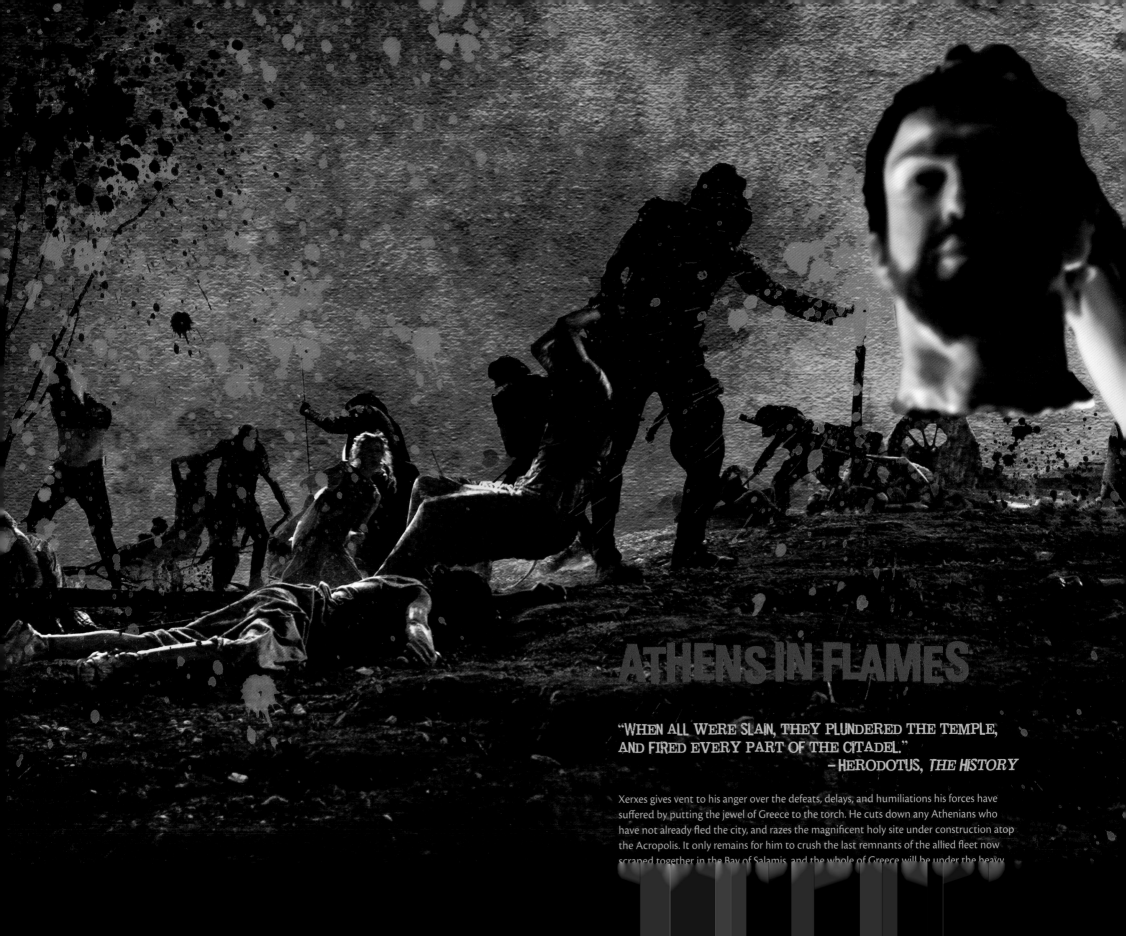

ATHENS IN FLAMES

"WHEN ALL WERE SLAIN, THEY PLUNDERED THE TEMPLE,
AND FIRED EVERY PART OF THE CITADEL."
— HERODOTUS, *THE HISTORY*

Xerxes gives vent to his anger over the defeats, delays, and humiliations his forces have
suffered by putting the jewel of Greece to the torch. He cuts down any Athenians who
have not already fled the city, and razes the magnificent holy site under construction atop
the Acropolis. It only remains for him to crush the last remnants of the allied fleet now
scraped together in the Bay of Salamis, and the whole of Greece will be under the heavy

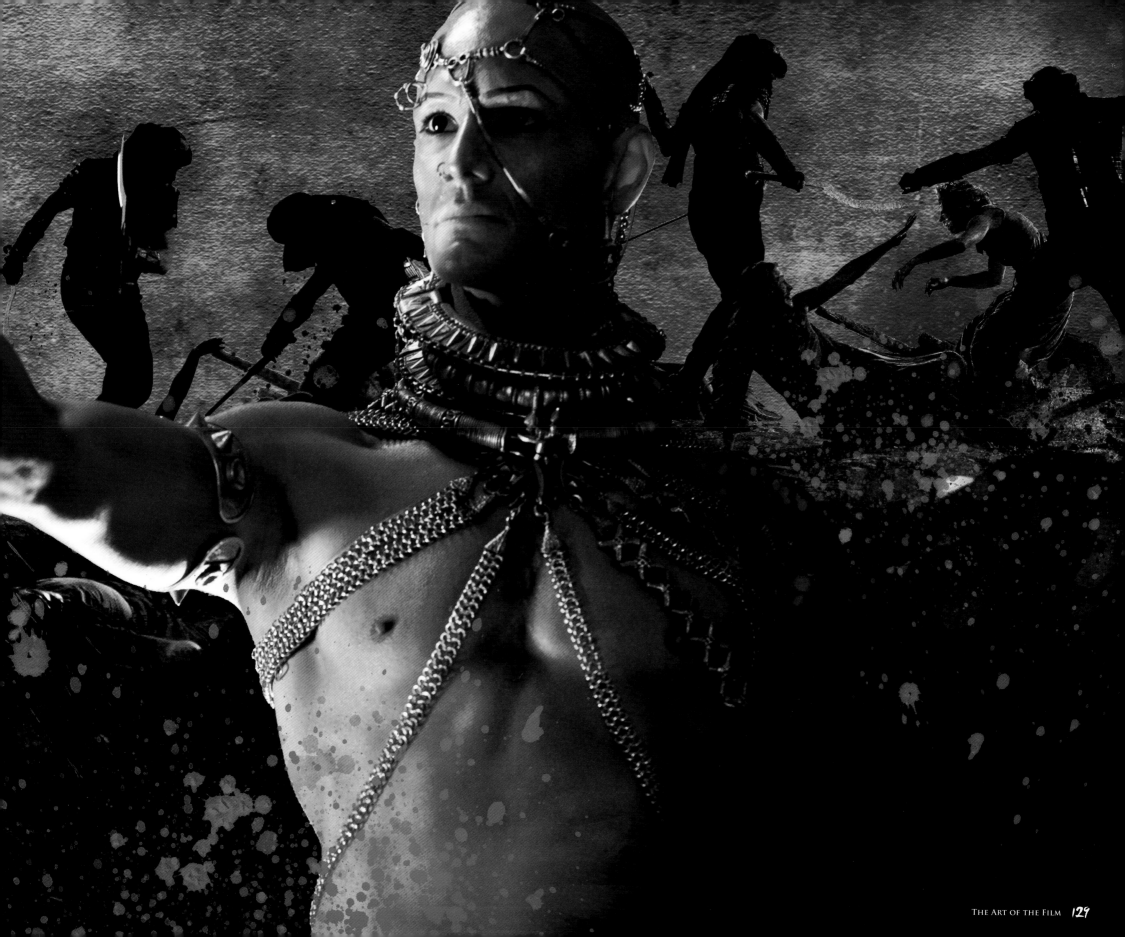

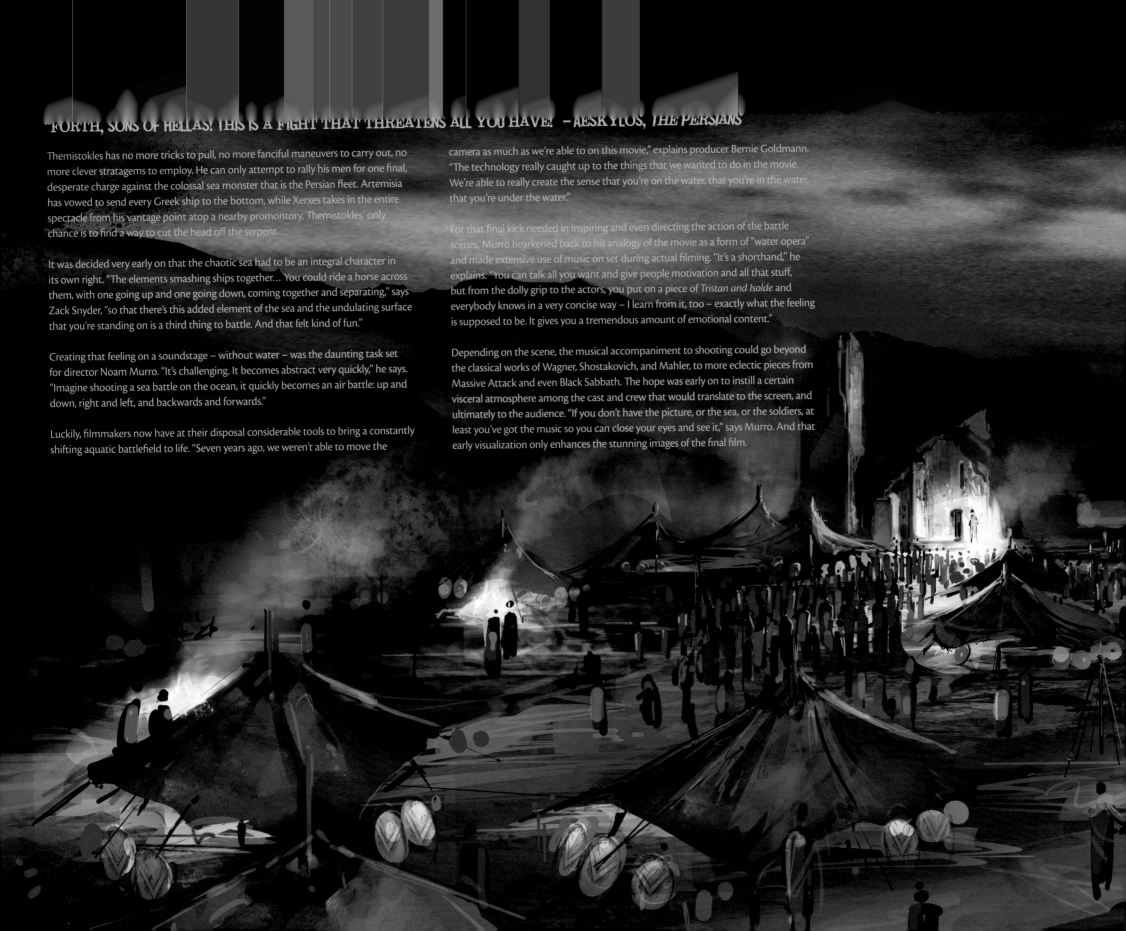

"FORTH, SONS OF HELLAS! THIS IS A FIGHT THAT THREATENS ALL YOU HAVE!" – AESKYLOS, *THE PERSIANS*

Themistokles has no more tricks to pull, no more fanciful maneuvers to carry out, no more clever stratagems to employ. He can only attempt to rally his men for one final, desperate charge against the colossal sea monster that is the Persian fleet. Artemisia has vowed to send every Greek ship to the bottom, while Xerxes takes in the entire spectacle from his vantage point atop a nearby promontory. Themistokles' only chance is to find a way to cut the head off the serpent…

It was decided very early on that the chaotic sea had to be an integral character in its own right. "The elements smashing ships together… You could ride a horse across them, with one going up and one going down, coming together and separating," says Zack Snyder, "so that there's this added element of the sea and the undulating surface that you're standing on is a third thing to battle. And that felt kind of fun."

Creating that feeling on a soundstage – without water – was the daunting task set for director Noam Murro. "It's challenging. It becomes abstract very quickly," he says. "Imagine shooting a sea battle on the ocean, it quickly becomes an air battle: up and down, right and left, and backwards and forwards."

Luckily, filmmakers now have at their disposal considerable tools to bring a constantly shifting aquatic battlefield to life. "Seven years ago, we weren't able to move the

camera as much as we're able to on this movie," explains producer Bernie Goldmann. "The technology really caught up to the things that we wanted to do in the movie. We're able to really create the sense that you're on the water, that you're in the water, that you're under the water."

For that final kick needed in inspiring and even directing the action of the battle scenes, Murro hearkened back to his analogy of the movie as a form of "water opera" and made extensive use of music on set during actual filming. "It's a shorthand," he explains. "You can talk all you want and give people motivation and all that stuff, but from the dolly grip to the actors, you put on a piece of *Tristan and Isolde* and everybody knows in a very concise way – I learn from it, too – exactly what the feeling is supposed to be. It gives you a tremendous amount of emotional content."

Depending on the scene, the musical accompaniment to shooting could go beyond the classical works of Wagner, Shostakovich, and Mahler, to more eclectic pieces from Massive Attack and even Black Sabbath. The hope was early on to instill a certain visceral atmosphere among the cast and crew that would translate to the screen, and ultimately to the audience. "If you don't have the picture, or the sea, or the soldiers, at least you've got the music so you can close your eyes and see it," says Murro. And that early visualization only enhances the stunning images of the final film.

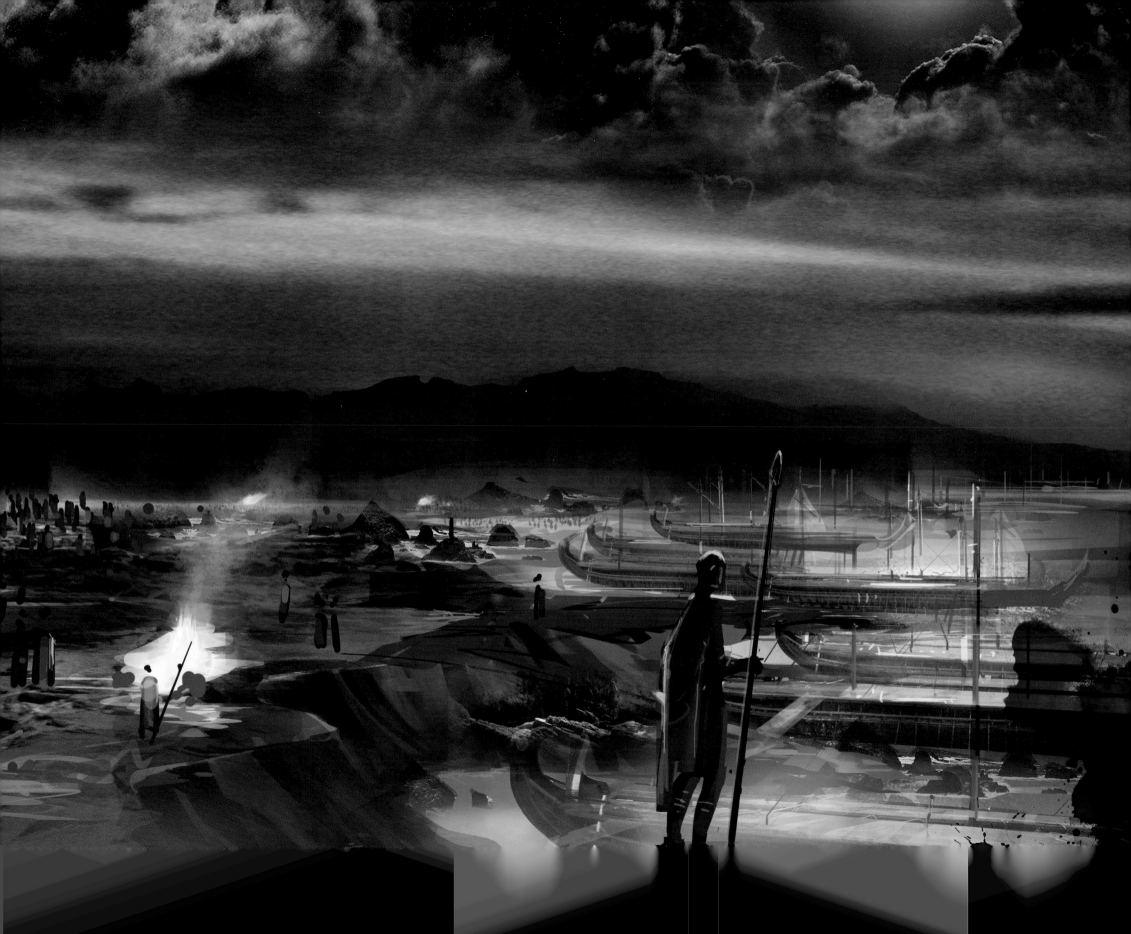

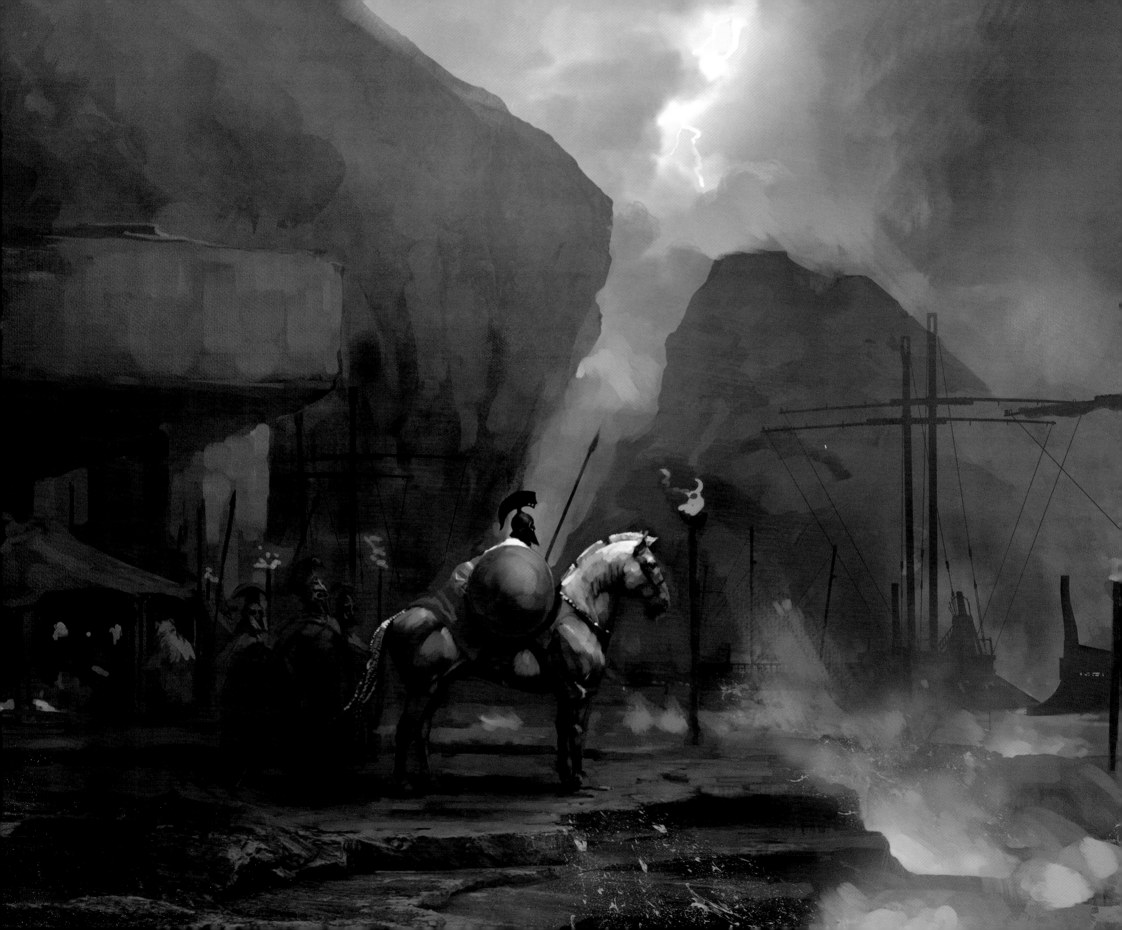

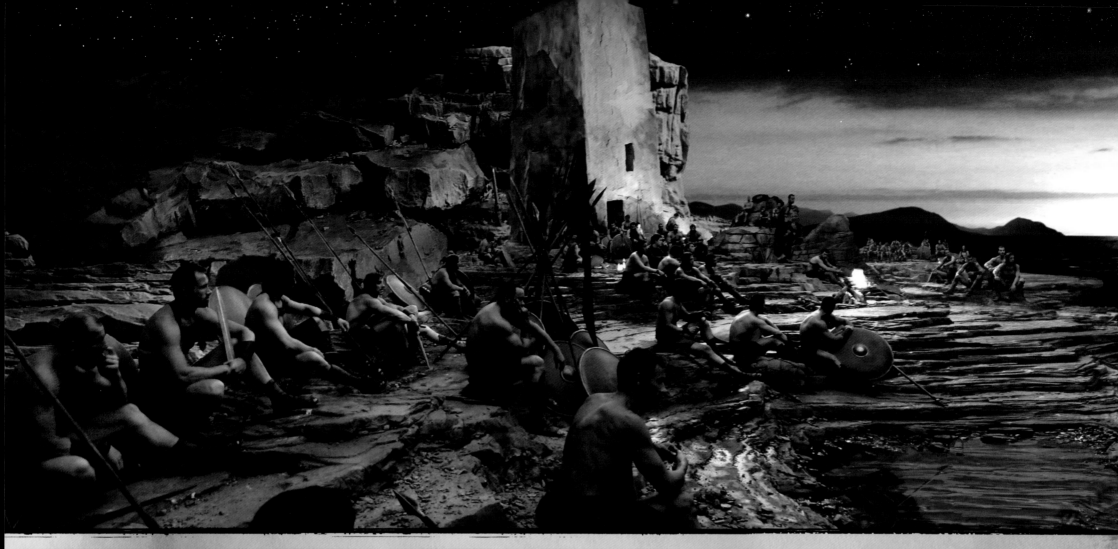

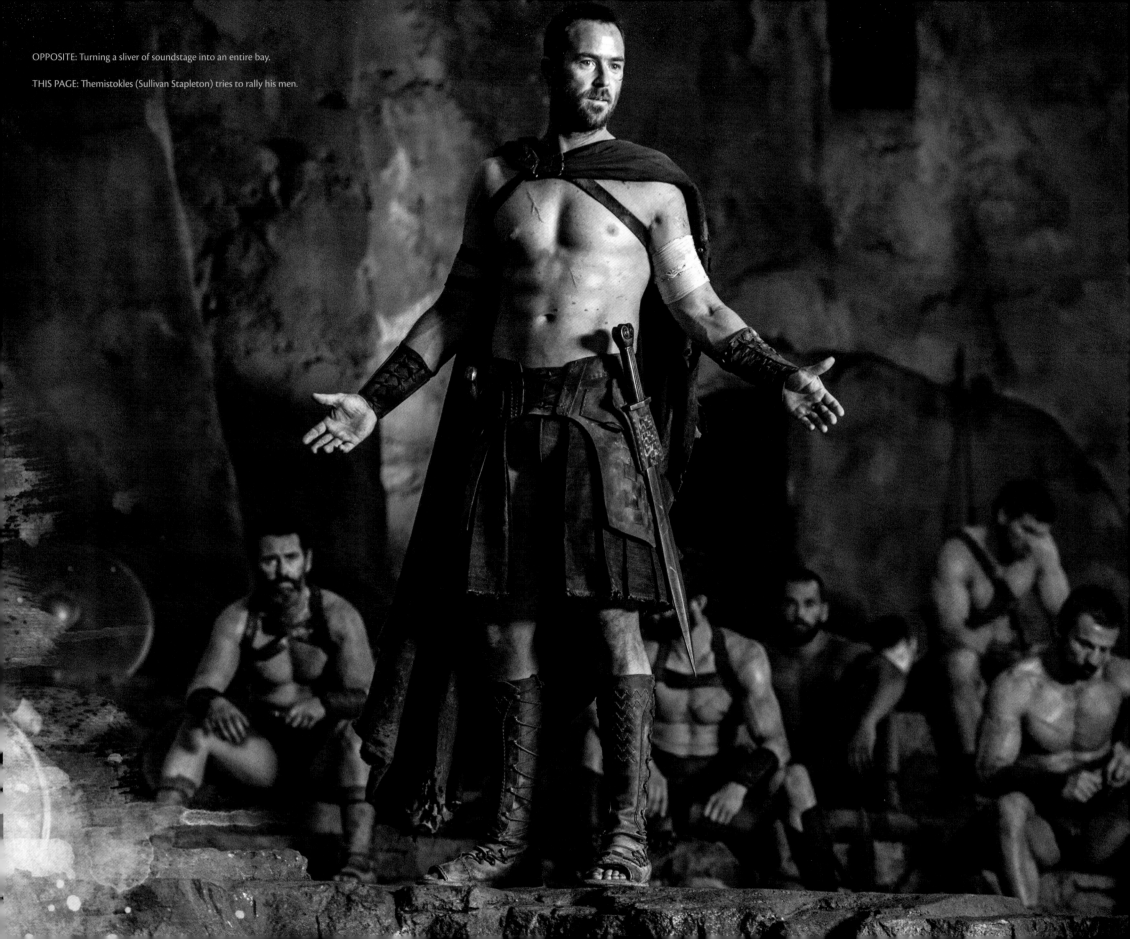

OPPOSITE: Turning a sliver of soundstage into an entire bay.

THIS PAGE: Themistokles (Sullivan Stapleton) tries to rally his men.

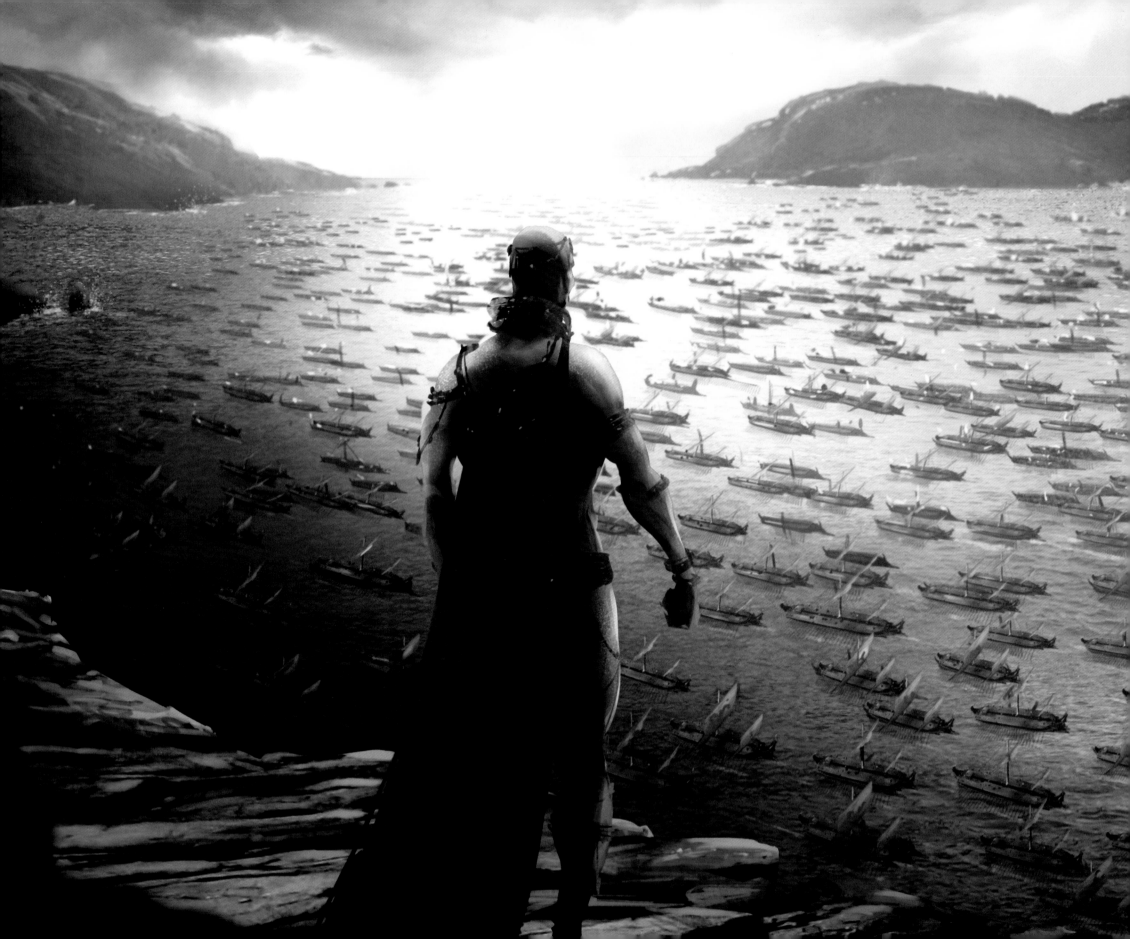

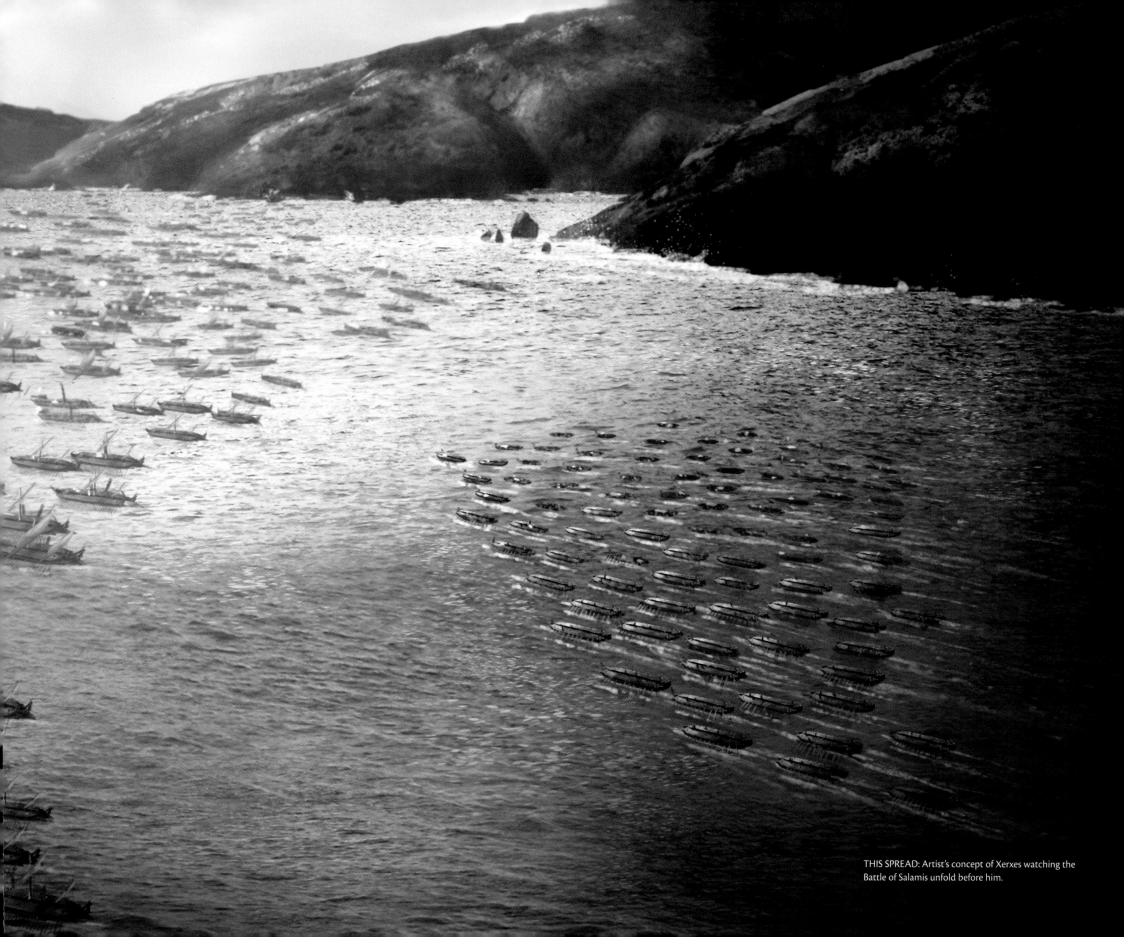

THIS SPREAD: Artist's concept of Xerxes watching the Battle of Salamis unfold before him.

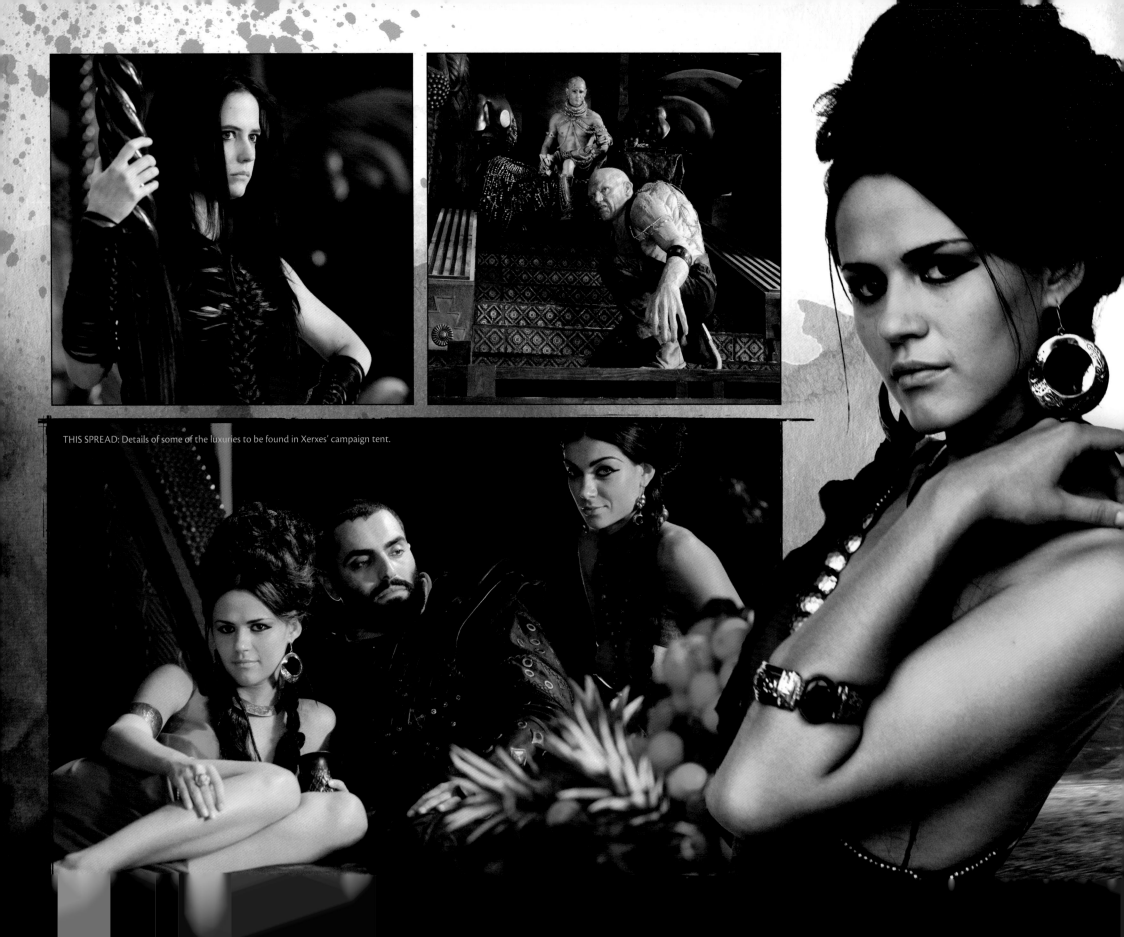

THIS SPREAD: Details of some of the luxuries to be found in Xerxes' campaign tent.

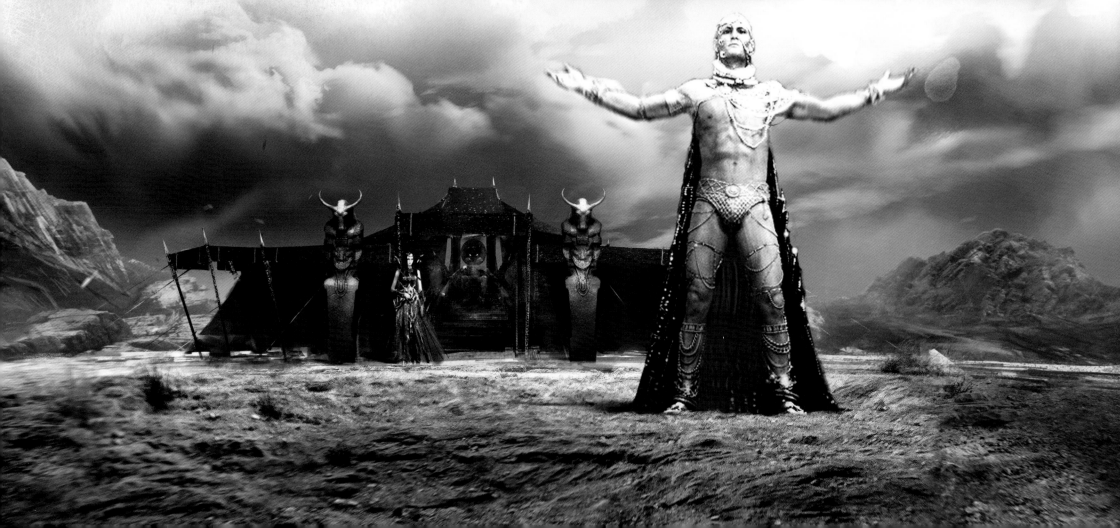

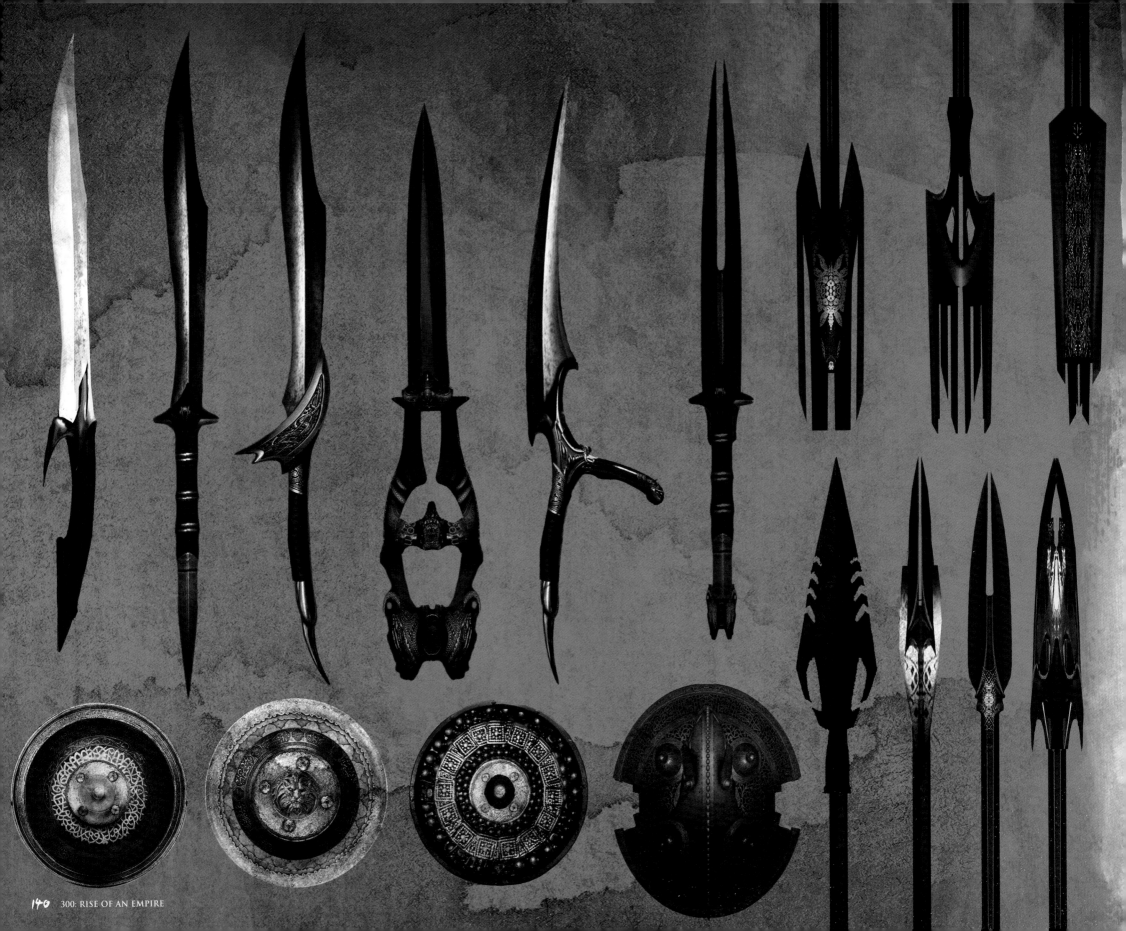

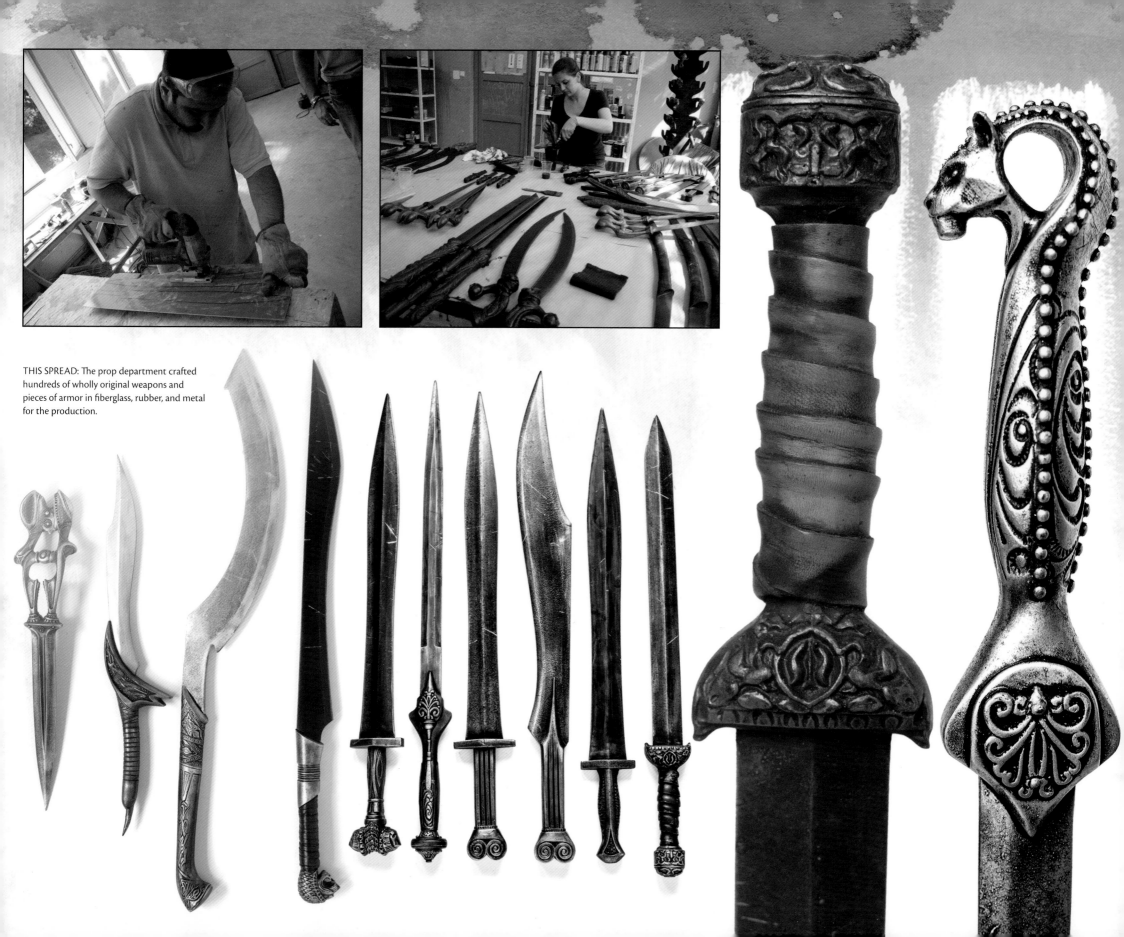

THIS SPREAD: The prop department crafted hundreds of wholly original weapons and pieces of armor in fiberglass, rubber, and metal for the production.

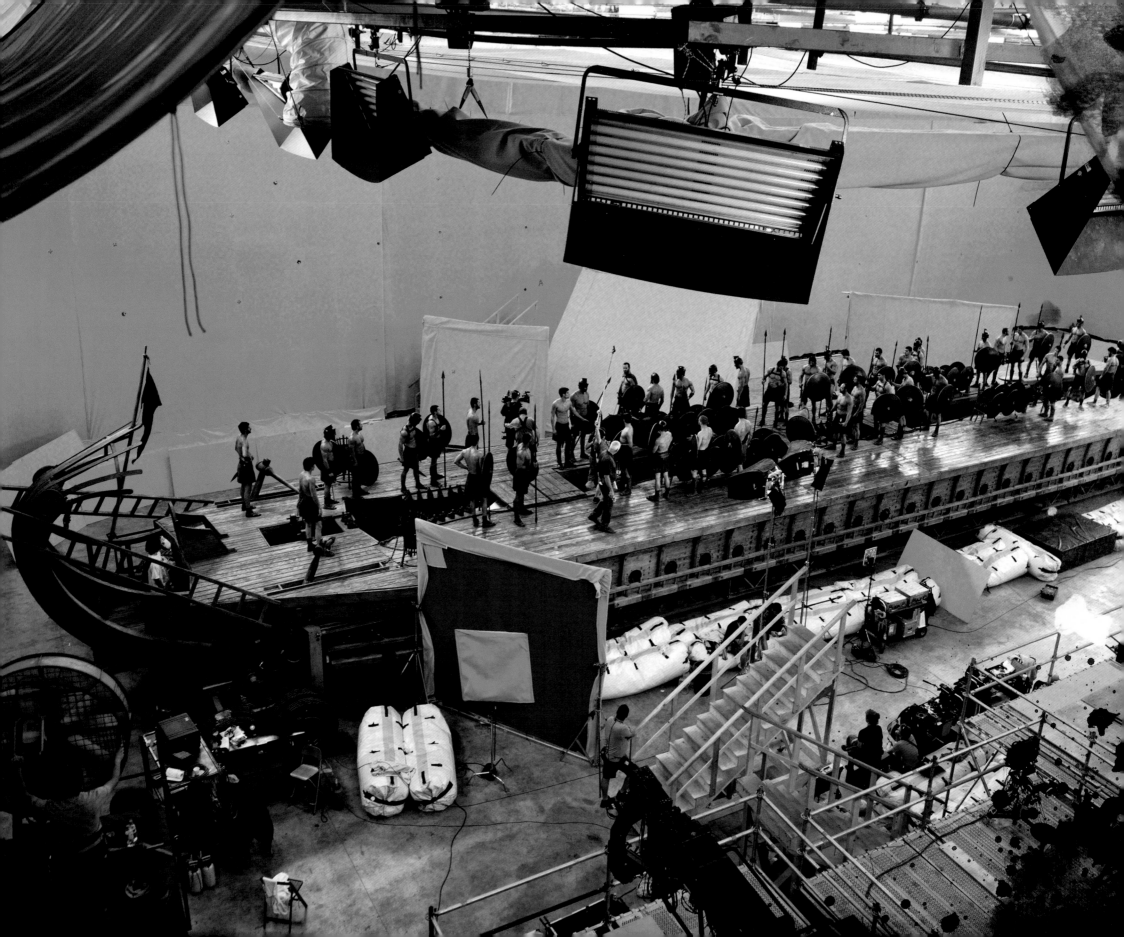

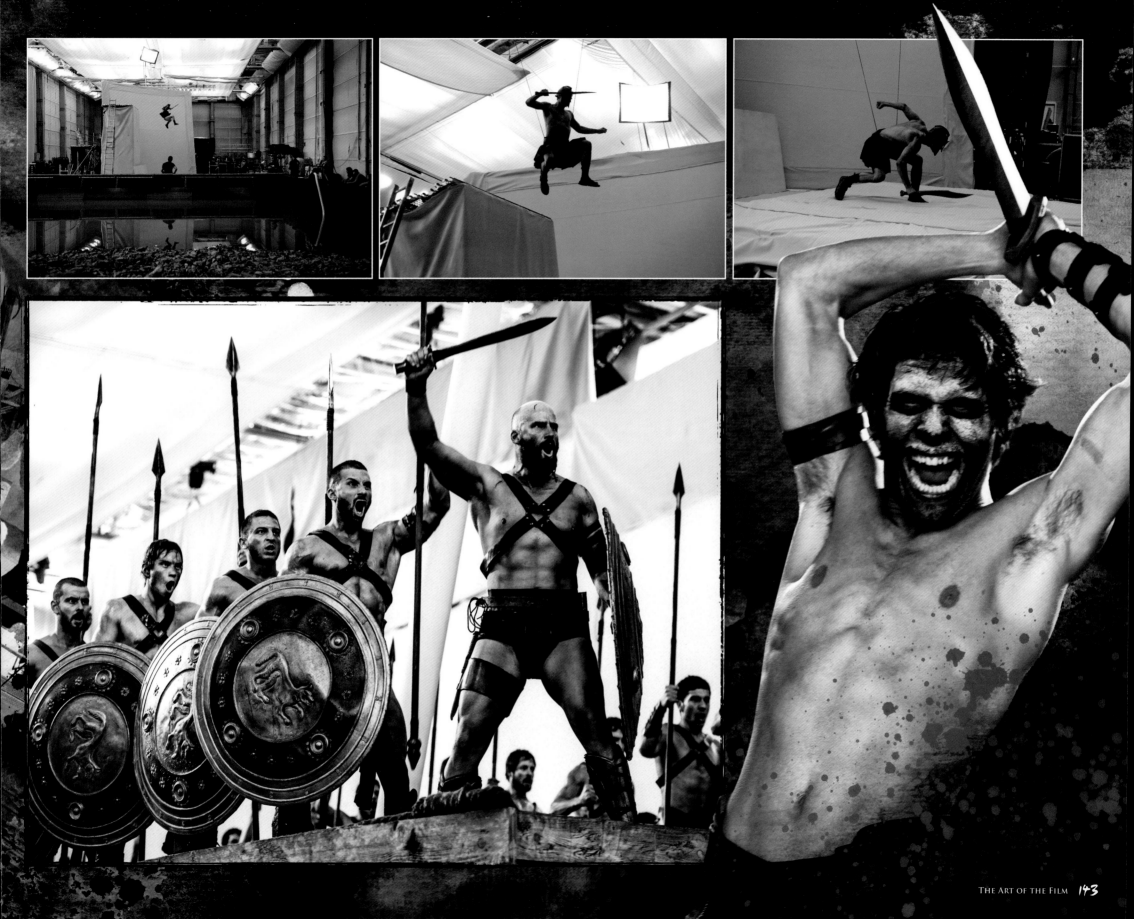

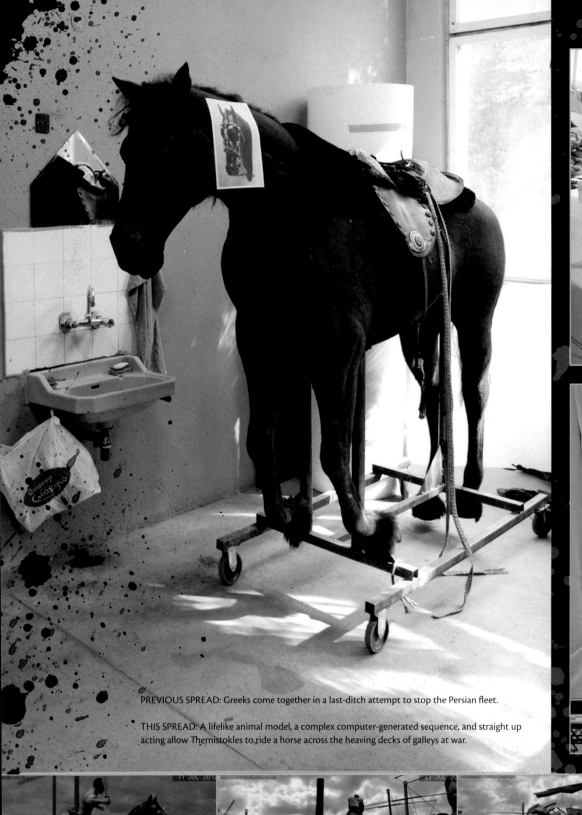

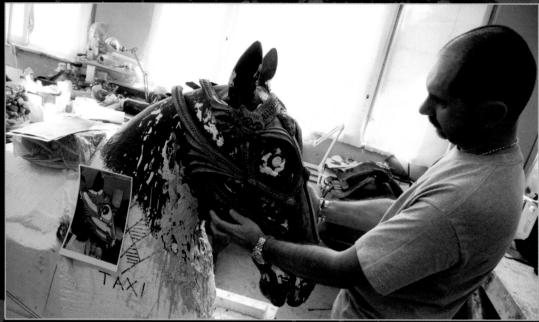

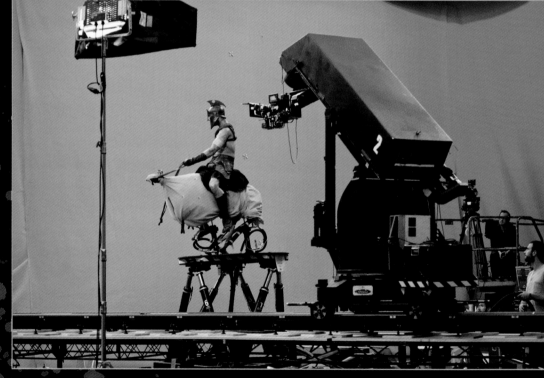

PREVIOUS SPREAD: Greeks come together in a last-ditch attempt to stop the Persian fleet.

THIS SPREAD: A lifelike animal model, a complex computer-generated sequence, and straight up acting allow Themistokles to ride a horse across the heaving decks of galleys at war.

THEMISTOKLES
Leave nothing living and let them send our souls straight to hell.

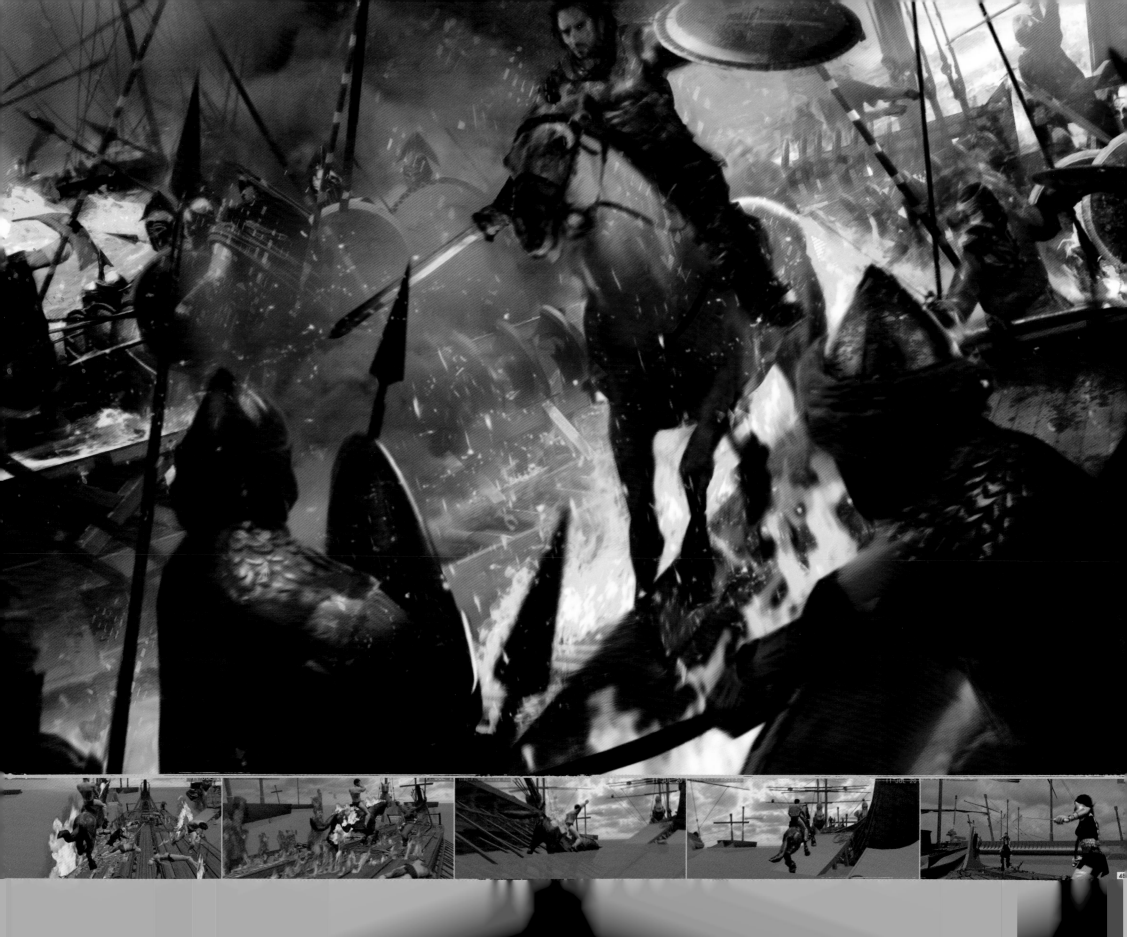

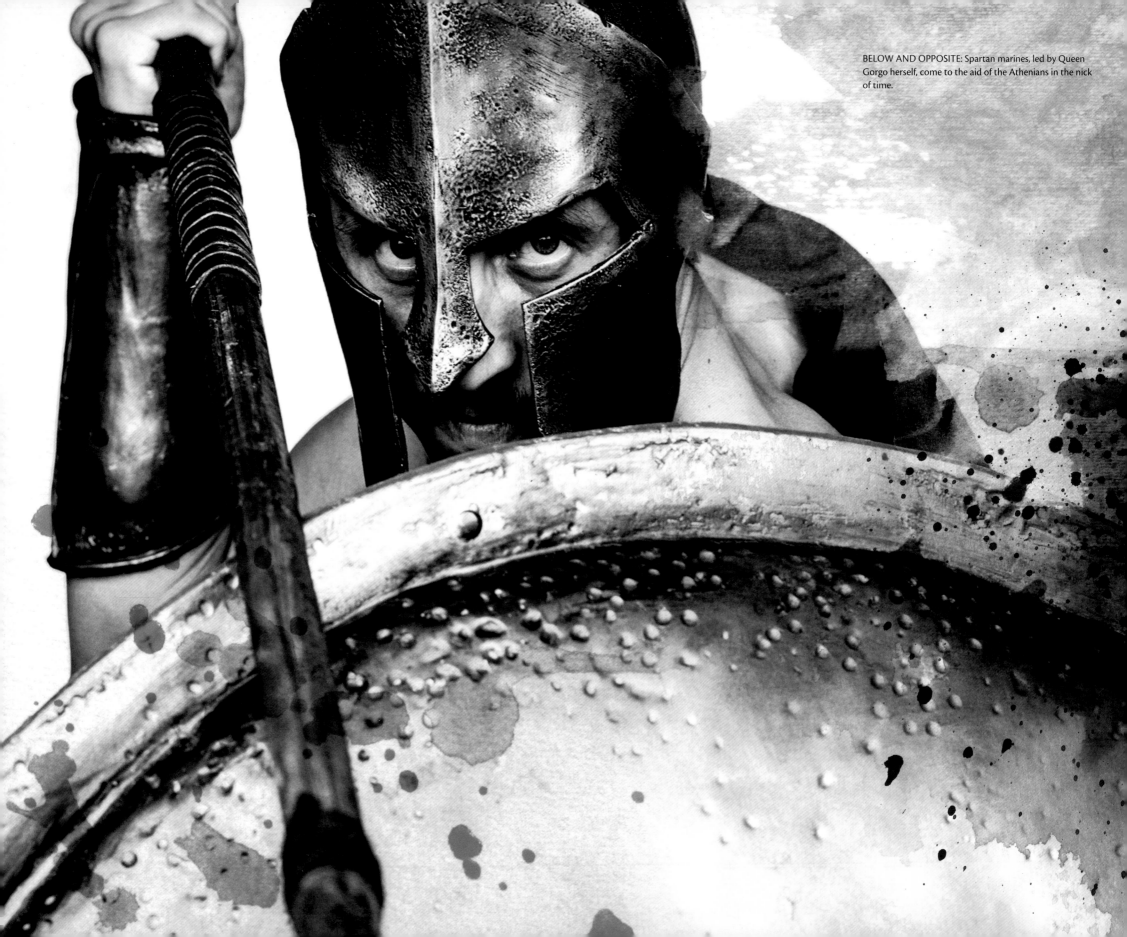

BELOW AND OPPOSITE: Spartan marines, led by Queen Gorgo herself, come to the aid of the Athenians in the nick of time.

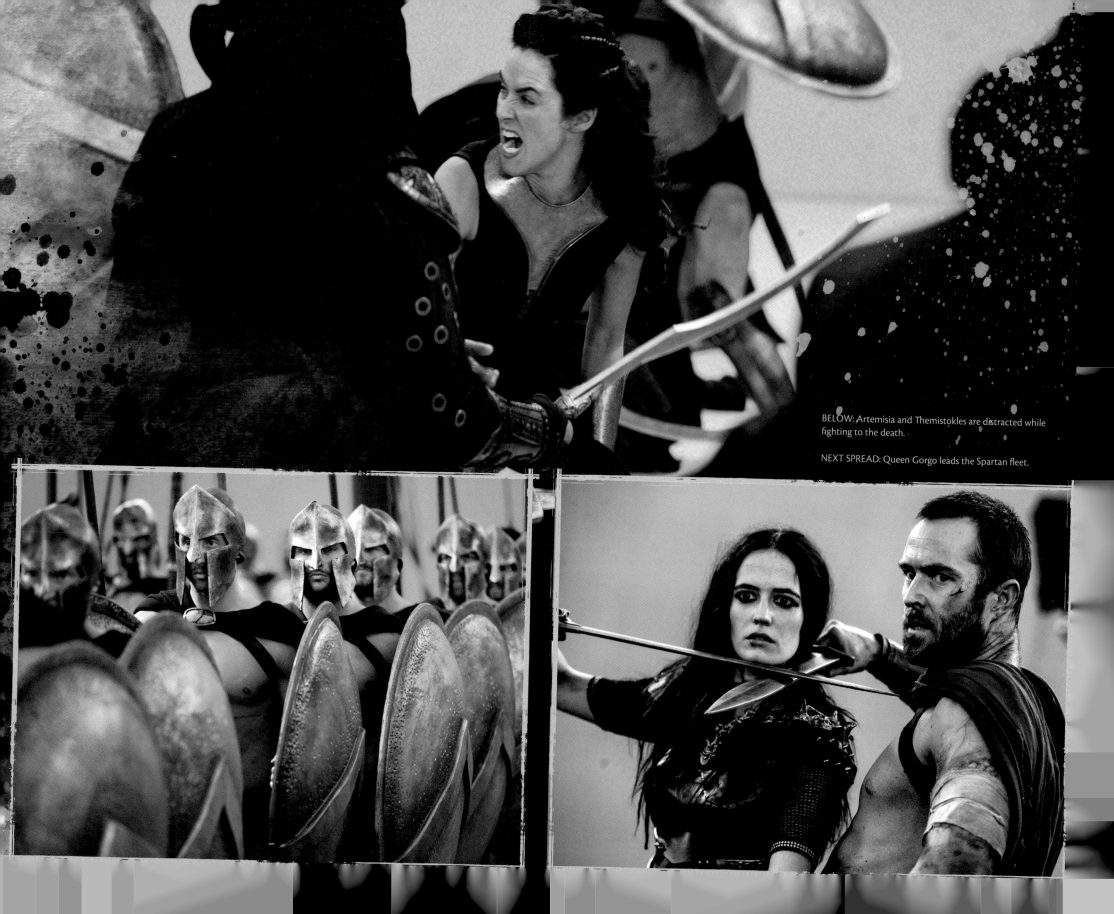

BELOW: Artemisia and Themistokles are distracted while fighting to the death.

NEXT SPREAD: Queen Gorgo leads the Spartan fleet.

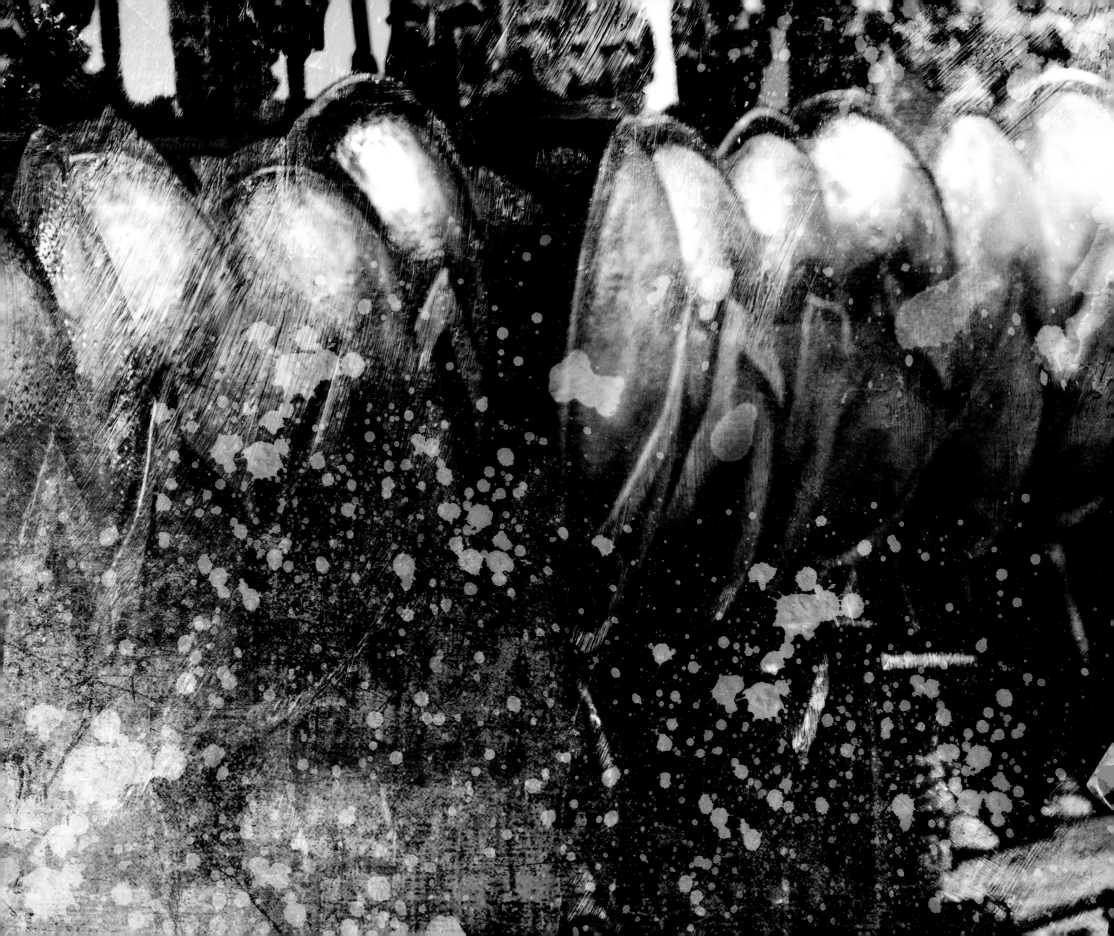

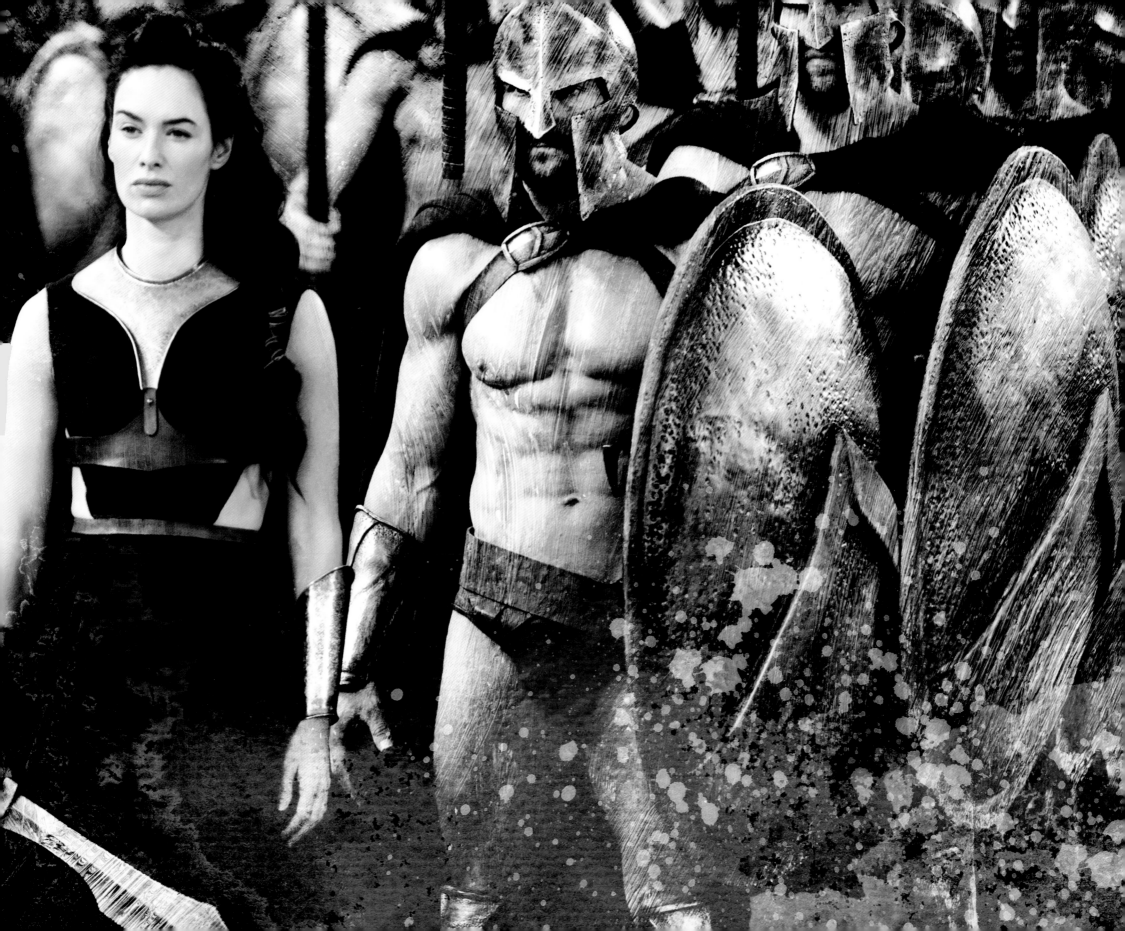

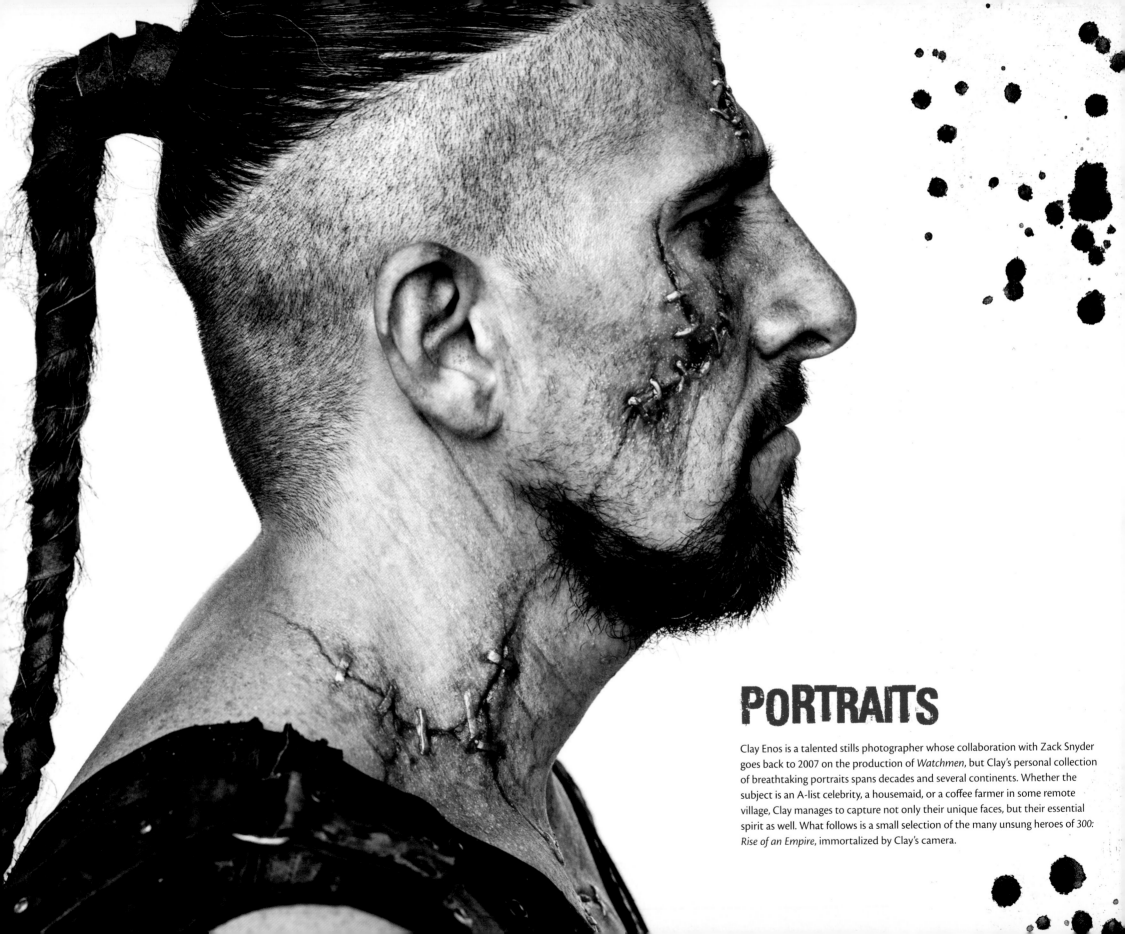

PORTRAITS

Clay Enos is a talented stills photographer whose collaboration with Zack Snyder goes back to 2007 on the production of *Watchmen*, but Clay's personal collection of breathtaking portraits spans decades and several continents. Whether the subject is an A-list celebrity, a housemaid, or a coffee farmer in some remote village, Clay manages to capture not only their unique faces, but their essential spirit as well. What follows is a small selection of the many unsung heroes of *300: Rise of an Empire*, immortalized by Clay's camera.

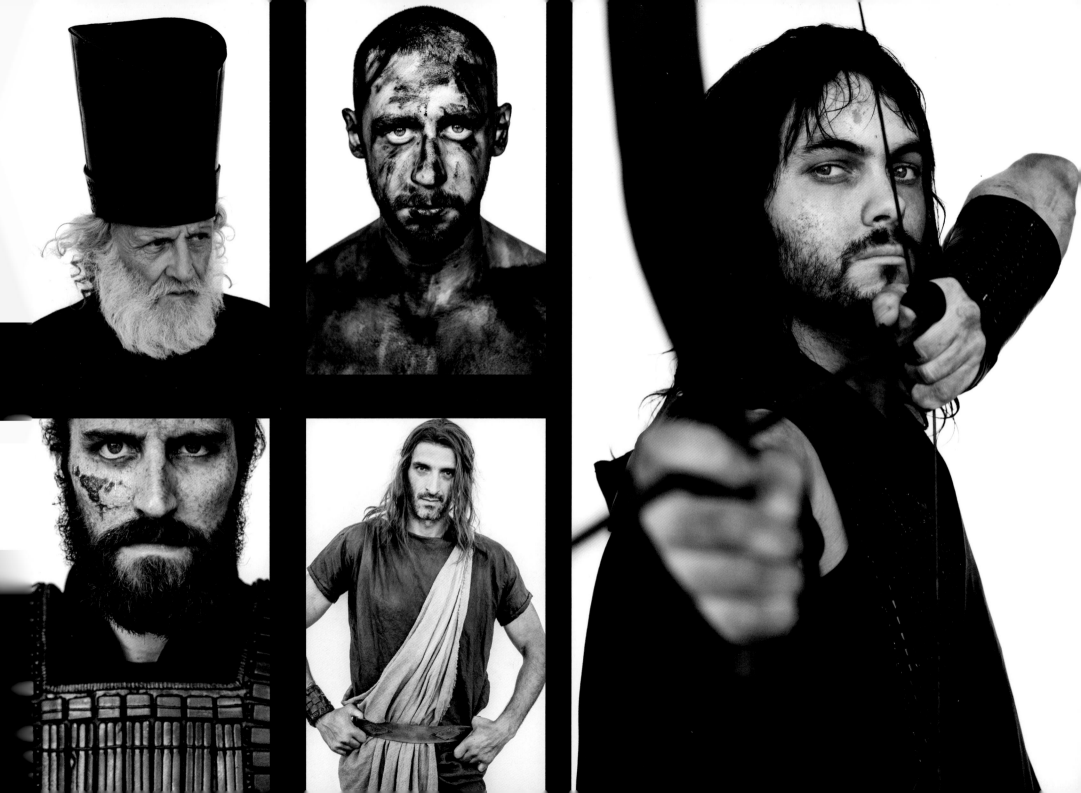

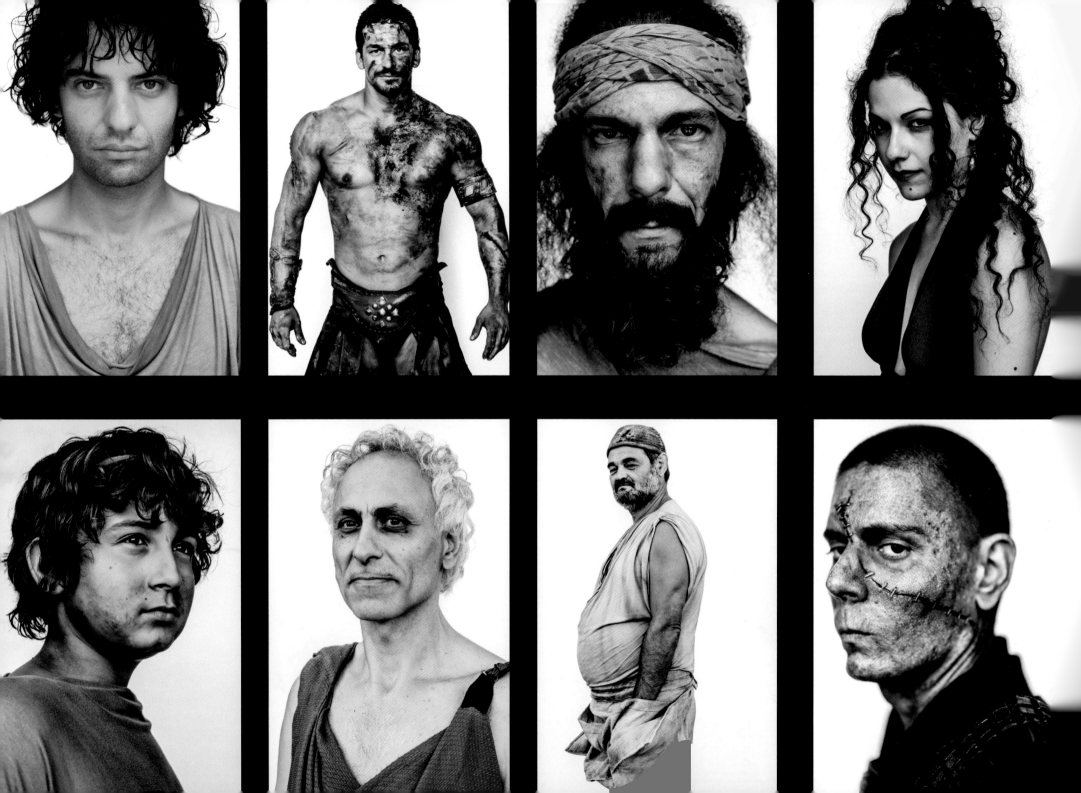

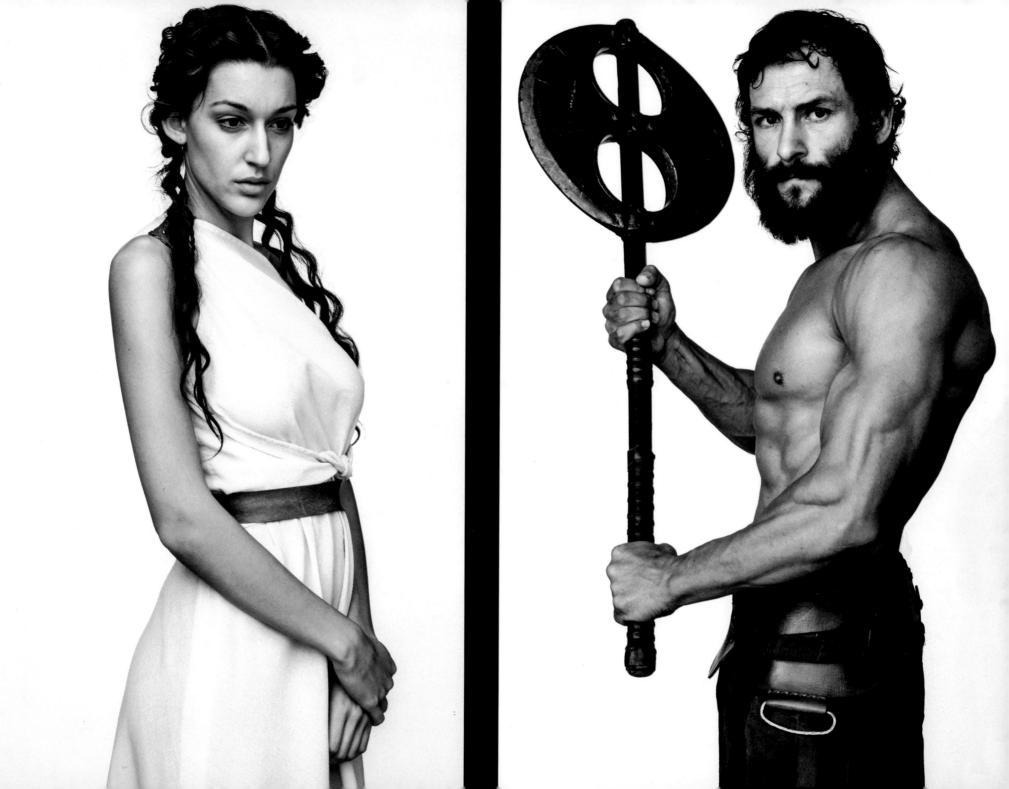

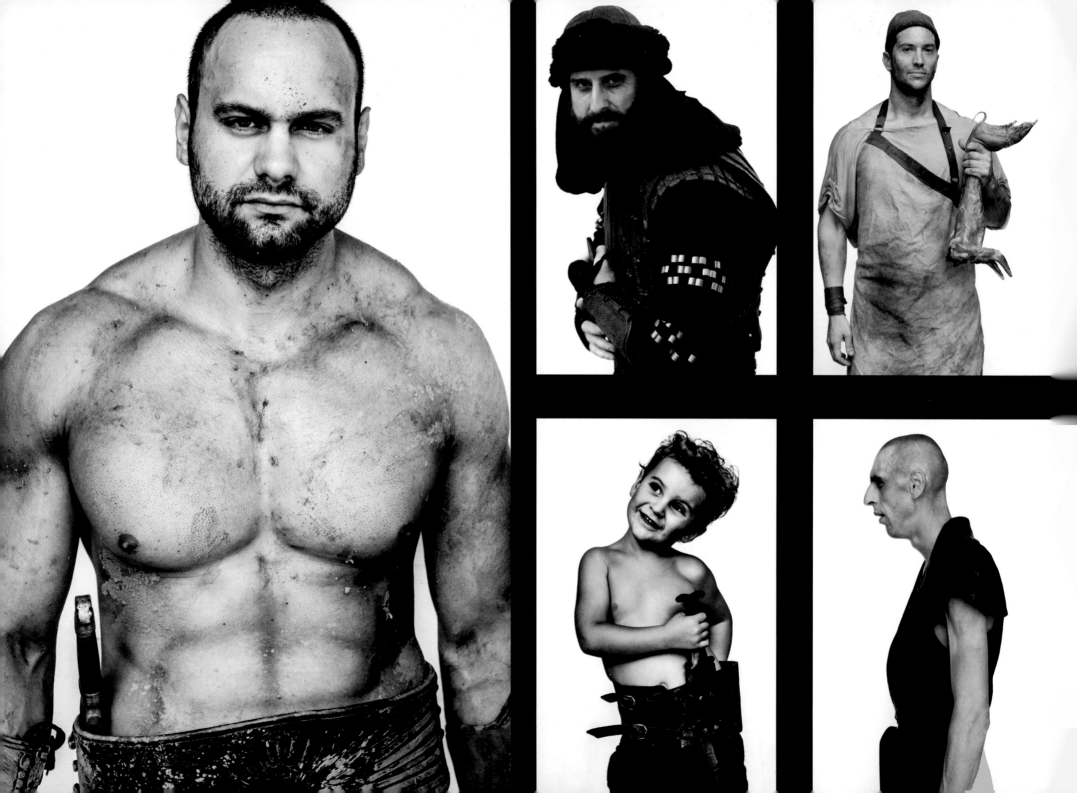

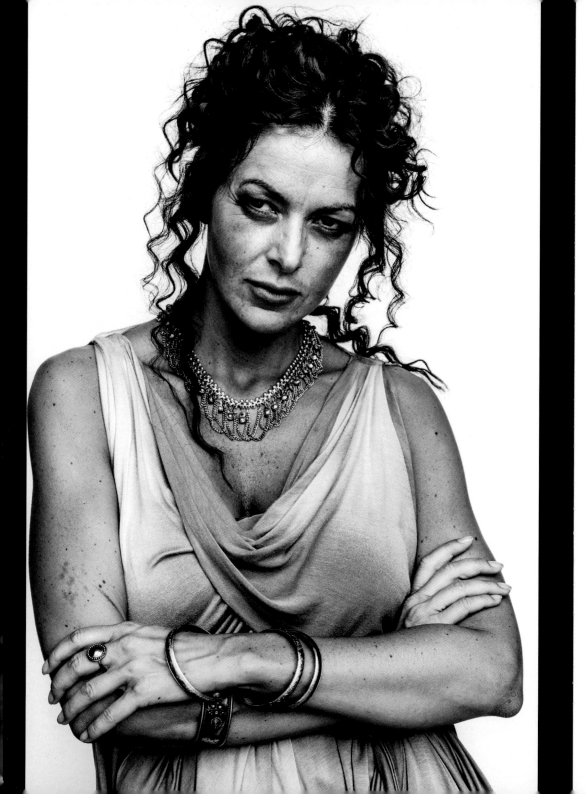
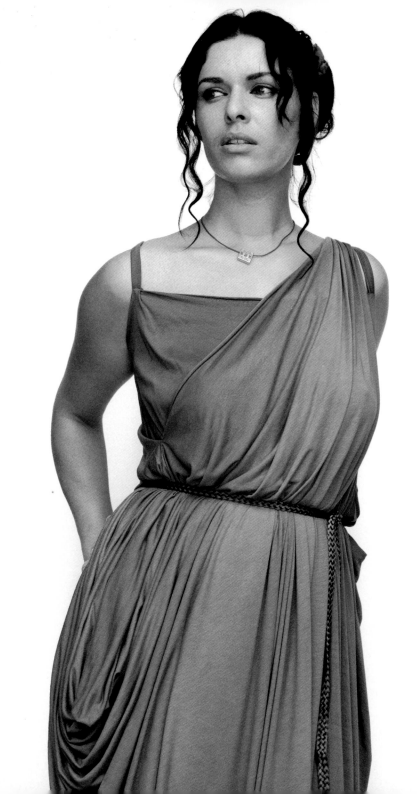

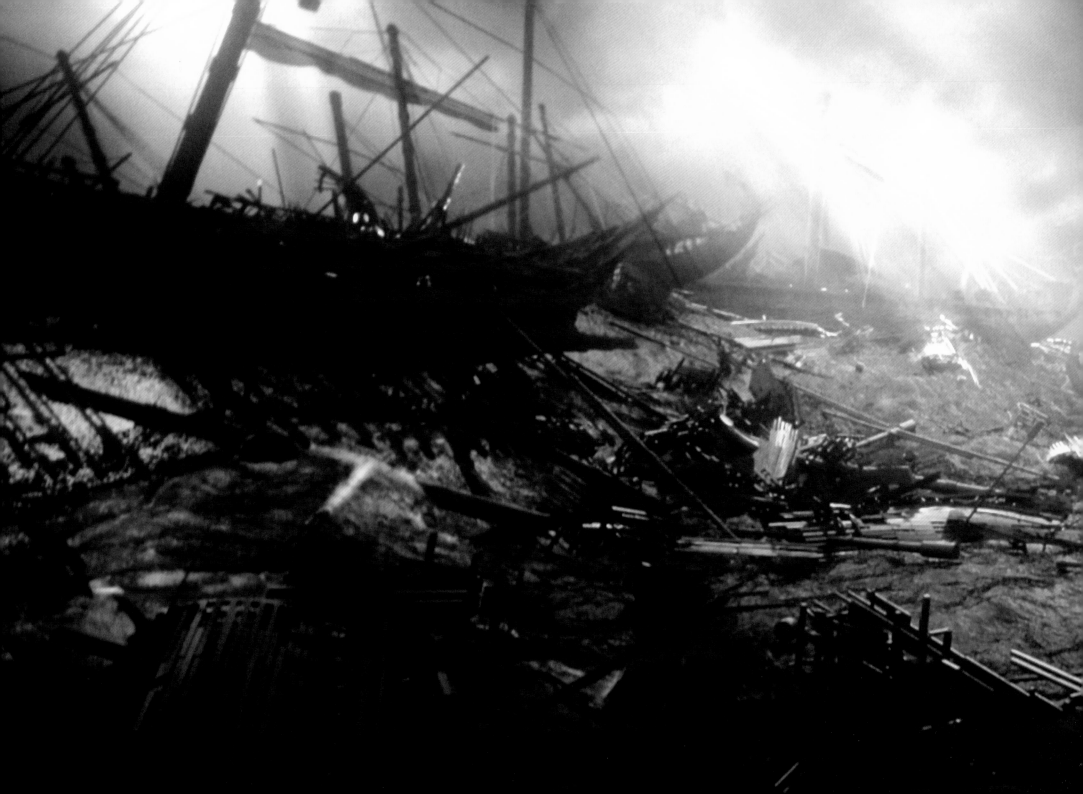

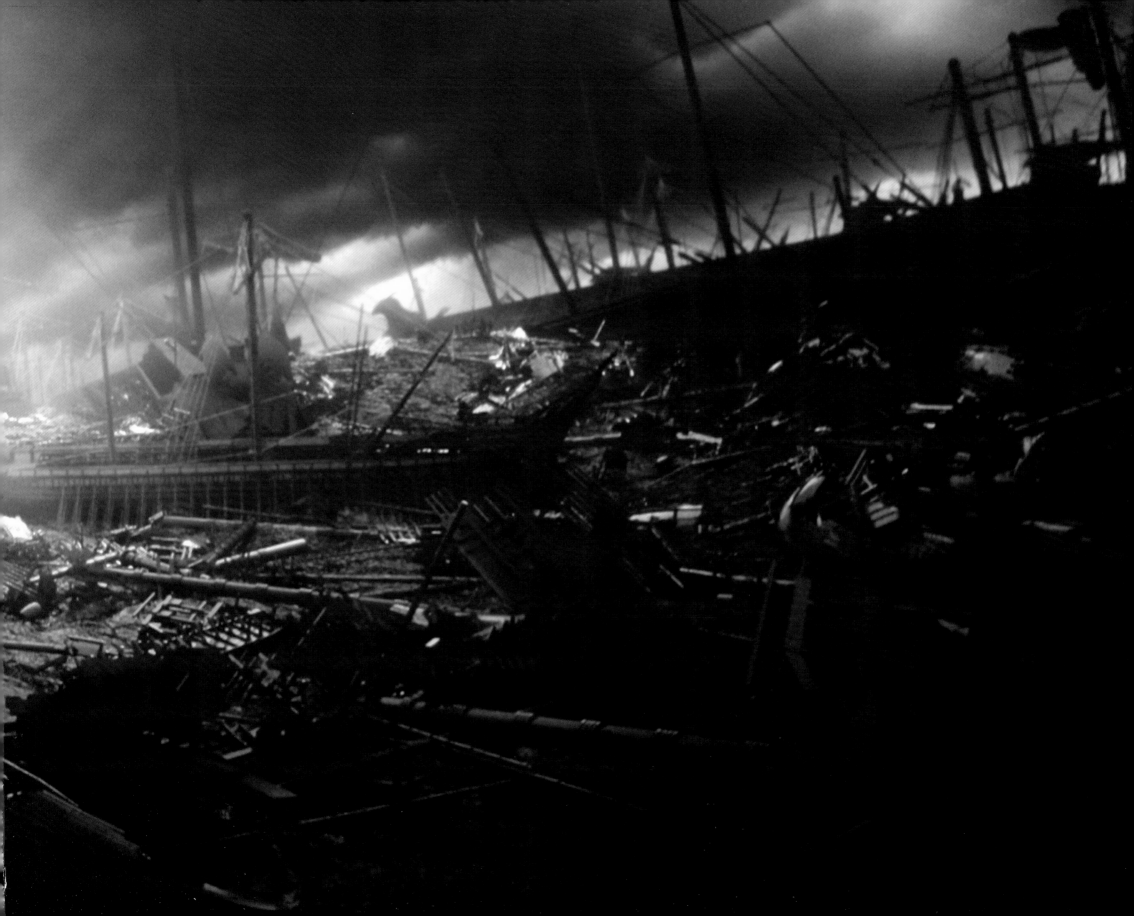

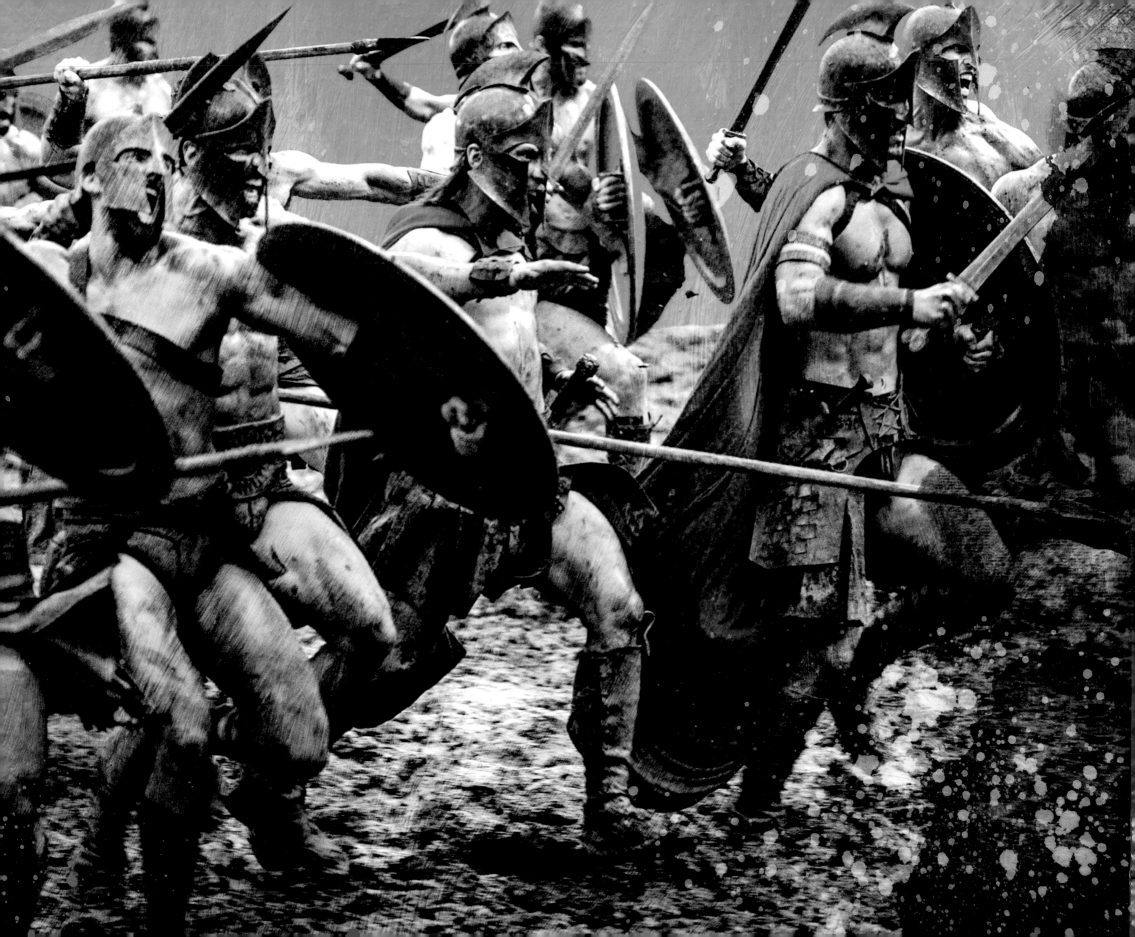

AFTERWORD
BY ZACK SNYDER

THEMISTOKLES WAS A POLITICIAN and a general, but more importantly he was a master strategist. When faced with a seemingly insurmountable opponent whose sheer size was almost unimaginable, he remained steadfast, relying on skill and wit to challenge the ominous, yet vulnerable, threat of simple brute force. Defending Greece would seem like a nearly impossible and costly feat to most; an inevitable, horrific and humiliating defeat poised to happen. A defeat which, if dealt to the Greeks, would cost every man, woman, and child everything, leaving nothing but devastation and loss in its wake. In spite of those frightening odds, Themistokles forged ahead. Fearless. Brave. Cunning.

The obstacles filmmakers find in their paths when making a movie are often as daunting as a horizon of fast-approaching triremes full of soldiers with swords drawn. The choice, they must make: Whether to retreat or stay the course. For Noam and his talented and dedicated troop of actors and crew, the choice was easy: Fight on.

Regardless of the magnitude of the project, the complexities of its visual effects or the intricate production logistics, Noam and his team boldly took on the challenge without fear or hesitation. Charging headlong into battle, they conquered those obstacles, and the result is dramatic, breathtaking, and surreal, with a healthy dose of action. In essence, everything a *300* film should be!

I, along with the producers of *300: Rise of an Empire,* would like to extend a sincere thank you to the incredible actors, artists, designers, photographers, technicians, and countless others who through their wealth of talent and tireless dedication helped bring this film to life. It is only with their unwavering support that it is possible to create such a fantastical world as this.

It has been an amazing journey. From the masterful words and illustrations of the legendary Frank Miller to the countless hours spent writing the screenplay with my writing partner Kurt Johnstad; from bustling stages to talent-packed editorial rooms and VFX houses; and now, finally, to theaters all around the world.

From the muddy battlefields of Marathon to the stormy seas of the Aegean, we have found inspiration and adventure at every turn, and we are incredibly grateful to have been able to share that journey with so many talented people along the way.

A special thanks to Clay Enos and Peter Aperlo. Without their talented contributions, this book wouldn't be possible.

In addition, we would like to express our most sincere gratitude to everyone at Warner Bros. and Legendary Pictures, who time and time again show their enthusiastic support for our films.

Zack Snyder

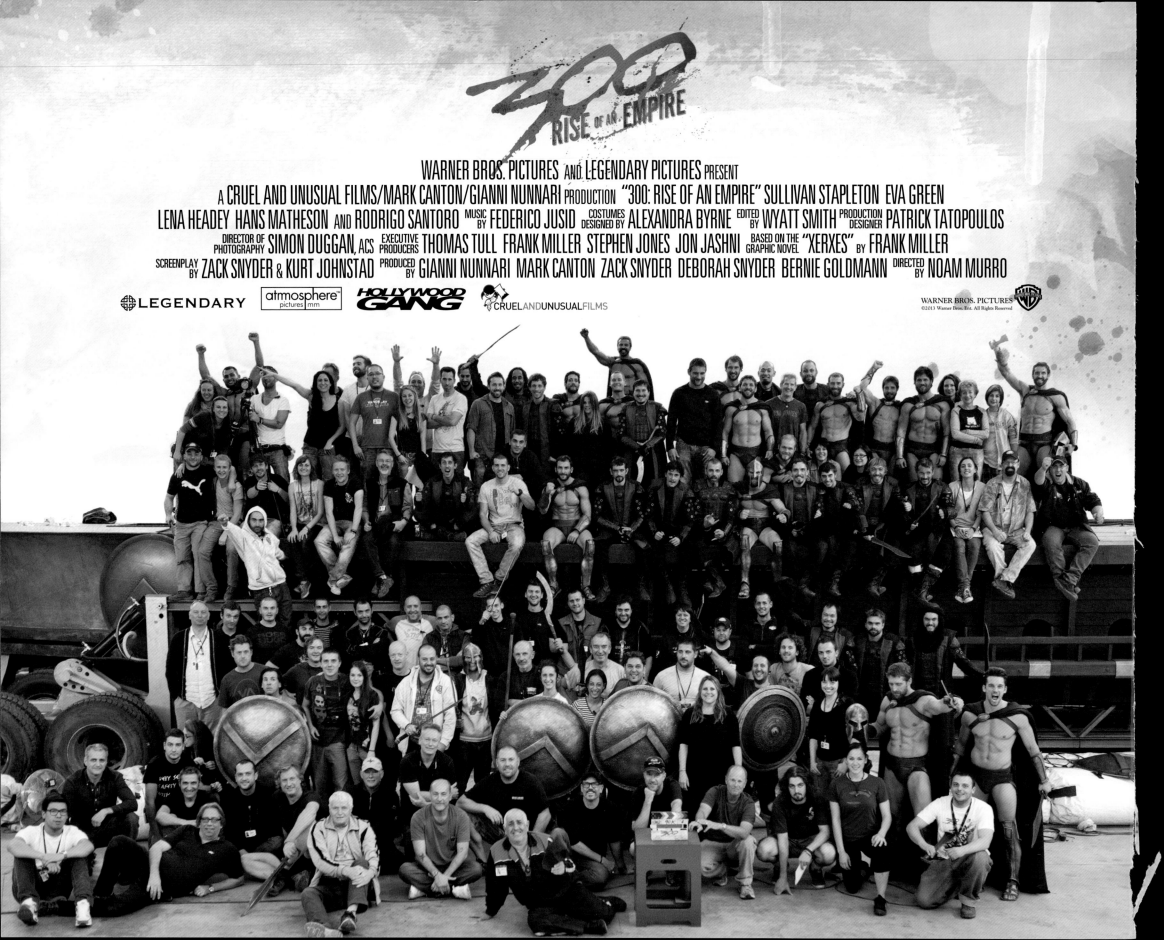